SPECTACULAR

MODERNITY

ILLUMINATIONS

CULTURAL FORMATIONS

OF THE AMERICAS SERIES

John Beverley and Sara Castro-Klarén, Editors

SPECTACULAR MODERNITY

DICTATORSHIP • SPACE

AND VISUALITY IN

VENEZUELA • 1948-1958

LISA BLACKMORE

UNIVERSITY OF PITTSBURGH PRESS

Published by the University of Pittsburgh Press, Pittsburgh, Pa., 15260
Manufactured in the United States of America
Printed on acid-free paper
10 9 8 7 6 5 4 3 2 1

Cataloging-in-Publication data is available from the Library of Congress

ISBN 13: 978-0-8229-6438-4
ISBN 10: 0-8229-6438-4

Cover art: A group of people look up at a trio of superblocks under construction in Caracas. Archivo Histórico de Miraflores.
Cover design by Stacey Hsi

For Jorge

CONTENTS

PART III • PERFORMING PROGRESS

ACKNOWLEDGMENTS

• This book is the result of relationships developed over the past fifteen years, both with the place I now consider my second home and with colleagues and acquaintances who have become friends and family. I first traveled to Venezuela during 2002 with the aim of spending a year there teaching English, but after a university strike began just days into the term I spent the following months exploring Caracas. The mark left by mid-century modern architecture was impossible to miss, and I found myself gravitating to places like the Centro Simón Bolívar and the Ciudad Universitaria. Then, one morning just before Christmas the phone rang. The British Council was concerned about escalating tensions and had decided to send its employees home. Within forty-eight hours sunny Venezuela had been replaced by snowy England and my urban explorations cut short. Although this turn of events curtailed my first experience, it instigated a series of journeys between London and Venezuela until I finally moved to Caracas in 2005 to begin the research that turned into this book.

In my traveling back and forth, many institutions and people provided invaluable support and insight. Scholarships from the Arts and

Humanities Research Council allowed me to commit full-time to my studies at Birkbeck College, where John Kraniauskas supported my work on the architectural and visual legacies of modernity in Venezuela, and whose courses on cultural theory, Peronism, and modernity in Argentina helped lay the groundwork for my later research. During that time, the modules taught by William Rowe and Luciana Martins also provided key methodological and theoretical tools to explore archives and documents during my frequent visits to Caracas, and I am thankful for the opportunity I had to share my early research with colleagues and fellow postgraduate students at Birkbeck.

The fact that it was even possible to unearth such a wealth of materials from the 1950s is thanks to the expertise of a host of archivists and technicians. I am sincerely grateful to the staff at the Biblioteca Nacional, particularly to Isabel Suárez, Vilena Figueira; the archivists at the Archivo Audiovisual, who patiently dug out scores of negatives, photographs, and cassettes; and the Hermeroteca's specialists in microfilm and print media for all their help. At the Archivo Fílmico, Oscar Garbisu was a source of encyclopedic knowledge and the technicians provided invaluable assistance as I holed up there to watch vintage films. At the Archivo Histórico de Miraflores I was blessed with Edward Pantoja's enthusiastic help when sifting through the photographic archive, and I am grateful to Jeanette Rondón for her assistance and to Marcos Fuenmayor for his kind permission to reproduce images from the archive. I would like to thank Vicente Ignacio Tinoco for providing copies of films made in the 1950s by his father, Manuel Vicente Tinoco, and for welcoming me into his office after I tracked him down by email. I am also grateful to Esso Álvarez for providing access to his Hamilton Wright Organization press releases, and to Charlie Riera for providing a photograph for the book. At an early stage of my research, Herman Sifontes offered valuable insight into the work of photographer Leo Matiz and, more recently, gave me access to the fascinating collections preserved so meticulously in the Archivo de Fotografía Urbana (AFU). There, I would also like to thank Diana López, Vasco Szinetar, and Verónica Fraiz for enabling me to include so many of AFU's pictures in these pages.

While a large part of this book stemmed from archival research, other aspects grew from conversations and exchanges across different latitudes. In Venezuela I am deeply grateful to a long list of

cómplices. Back in 2007 Luis Marin, at the Instituto Superior de las Artes Armando Reverón (IUESAPAR, now UNEARTE), helped with access to government archives and invited me to share my early work with students. Lorenzo González Casas, from the Architecture and Urban Planning Department at the Universidad Simón Bolívar, generously read early drafts of my writing and helped bring core arguments into focus. In 2009 I had the pleasure to share a working paper on propaganda and space with him, and with Henry Vicente and other colleagues from the department, while conversations with postgraduate students in Art Theory and History at the Universidad Central de Venezuela during a seminar I gave there in 2013 helped fine-tune ideas about visuality. At the much-missed contemporary art space, Periférico Caracas, Jesús Fuenmayor and Félix Suazo created a fruitful environment for thinking about modern legacies, and I am grateful to Félix, Gerardo Zavarce, Juan José Olavarría, and Sagrario Berti for enriching conversations about the junctures of space, photography, and memory. Roberto Mata's photography school offered a source of education and inspiration in making and thinking about images, while my colleagues at the Universidad Simón Bolívar—especially Iraida Casique, Gina Saraceni, and Daniuska González—supported newly emerging strands of research. Heartfelt thanks go to Ángela Bonadies and Juan Cristóbal Castro for nurturing our common *mal de archivo* and for offering insights into this and other projects. I am happy also for the opportunity to collaborate over recent years with Celeste Olalquiaga who, I discovered, shared an obsession with modernity and in whom I gained a companion to explore its architectural residues.

In Britain, I am indebted to Luis Rebaza-Soraluz and Valerie Fraser for their patient readings and helpful comments on how to shape this research into book form. I received valued encouragement from my former colleagues at the University of Leeds and am especially grateful to Thea Pitman and to Manuel Barcia for their warmth and support as I settled back into life in England. Since moving to the University of Zurich, I have been fortunate to renew links with Jens Andermann, whose work has long been a source of inspiration and whose critical insights greatly enriched this book. At the University of Pittsburgh Press, I am thankful to the series editors Sara Castro-Klarén and John Beverley for their support of the manuscript, the reviewers Patricio del Real and George Ciccariello-Maher for their

perceptive comments and constructive criticisms. Thanks also go to Pippa Letsky for her meticulous copyediting, Stacey Hsi for her skillful cover design, and to Josh Shanholtzer for his guidance throughout.

Last, but by no means least, my deepest gratitude goes to my family and friends, who are a source of unwavering support and love. Thank you to my parents, Martin and Lyn, and my sister, Sarah, for keeping me rooted while you taught me to expand my horizons, and for coming along on many journeys as I took that lesson literally. To my dearest friend, Helen, and to Sue and David, thank you for your warmth and encouragement over so many years. *A Isabel, Caris, Malena, Luis, y a todos allá y otros más acá, gracias por hacerme parte de su familia y por unirse a la mía.* Finally, I dedicate this book to my husband, Jorge Domínguez Dubuc. Your curiosity and vision, creativity and patience, and your enthusiasm and love make every day an adventure. With you I would go anywhere, and we have only just begun.

SPECTACULAR

MODERNITY

INTRODUCTION

RETHINKING THE POLITICS AND
AESTHETICS OF MODERNITY

The deeds spoke for themselves; there was no need for political
speech. As a spectator, el pueblo was invited to applaud them
silently.

 • FERNANDO CORONIL

We were going up like a rocket . . . today everything in Cara-
cas is tiny, minimalist and modest. The tragedy of this city is
that it has lost its pretensions.

 • JOSÉ IGNACIO CABRUJAS

• Midway through the twentieth century Caracas earned the nick-
name *sucursal del cielo*—an outpost of heaven on earth that boasted
all the possible comforts of a modern metropolis. Dubbed a city of
the future and the storefront for a land of opportunity, Venezuela's
capital underwent a dramatic makeover as it was stocked with em-
blems of progress contrived to dazzle locals and lure foreign investors
(figs. I.1–I.4). While bulldozers carved a highway linking the capital
to the coast, a cable car scaled the Ávila Mountain, taking passengers
above the clouds to the five-star Hotel Humboldt where they could
enjoy panoramic views out over the Caribbean Sea. In the city Carlos
Raúl Villanueva spearheaded an embrace of modernist architecture,
adapting it to the tropical climate and promoting a "Synthesis of the
Arts" through which he commissioned pioneering modern artists to
paint façades of fifteen-story *superbloques* (superblocks) and to fill
the new Ciudad Universitaria with sculptures and murals.[1] While
Venezuelans left rural provinces for expanding regional cities like
Valencia, Maracaibo, and Maturín, Caracas's urban population tre-
bled. By the end of 1953 a headline on the front page of *La Esfera*
newspaper declared the birth of "La nueva capital venezolana"—the

3

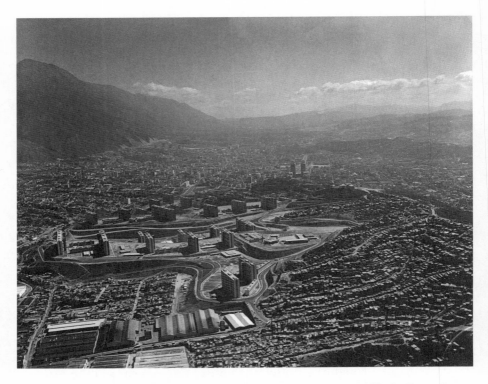

**Figure I.1. Unidad Residencial 2 de Diciembre (now 23 de Enero),
with the twin towers of the Centro Simón Bolívar in the background.**
Hamilton Wright Organization, circa 1957. Archivo de Fotografía Urbana.

new Venezuelan capital.[2] As readers flicked through the paper, they
encountered official instructions on new road networks and long
lists of bridges, schools, roads, and hospitals ready to be inaugurated
nationwide. The message was obvious: the country was being remade
in the mold of modernity.

A burgeoning oil industry fueled this boom-time atmosphere.
From 1948 to 1957, the number of active wells rose from some six
thousand to over ten thousand, bringing seven billion dollars into
the nation's coffers.[3] International events boosted prosperity; the
Suez Canal closure and the Korean War bolstered prices and helped
Venezuela cement its status as a leading oil exporter in global mar-
kets. Flush with revenues, the government assured the populace that
"the majority of our problems can be solved by engineering" and
bankrolled ambitious public works initiatives.[4] The road network

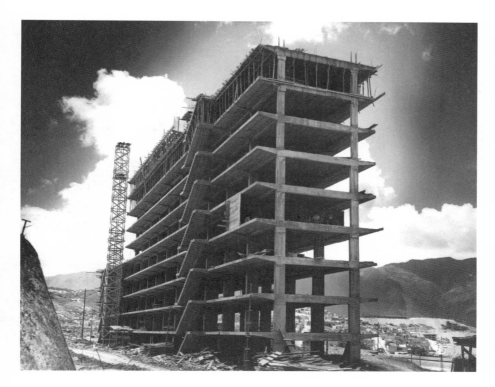

Figure I.2. *Superbloque* (superblock) under construction in Caracas.
Anonymous, circa 1953. Archivo Histórico de Miraflores.

all but quadrupled, and its forty-five hundred kilometers of asphalt
made literal inroads into the interior, providing access to emerging
steel and mining hubs, state-run agricultural communities, and a
chain of hotels created to incentivize tourism.[5] A fifteenfold increase
in industrial activity from 1950 to 1957 was accompanied by trebling
foreign investment and a growing import economy, filling show-
rooms with American cars, shops with newfangled televisions, and
canned groceries that promised progress at the dining table.[6] Foreign
journalists lauded the audacious architecture, mineral wealth, and
embrace of consumerism declaring—as did one English-language
documentary screened in cinemas abroad—that the world was wit-
nessing a "miracle in Venezuela."

Far from a miraculous act of grace, this jubilant narrative was a
meticulously crafted missive, constructed according to a specific po-
litical agenda. On November 24, 1948, military officers Marcos Pérez

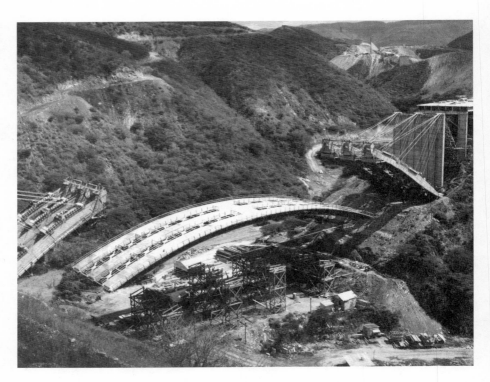

Figure I.3. Viaduct under construction on the Autopista Caracas–La Guaira, circa 1953. Archivo Histórico de Miraflores.

Jiménez, Carlos Delgado Chalbaud, and Luis Felipe Llovera Páez had led a coup that ousted the national novelist and Acción Democrática politician Rómulo Gallegos—the first president elected to office (in 1947) by popular vote after Venezuela began emerging from the long period of autocratic rule under Juan Vicente Gómez (1908–1935) that had dominated the twentieth century. However, the reforms instituted under Gallegos's tenure were not fast enough for some. Railing against alleged ineptitude and inefficiency, the Junta Militar argued that true democracy consisted in firm rule in line with a Nuevo Ideal Nacional—a New National Ideal that would discharge modernity by "getting rid of all that tradition of bajareque, spider webs, and soggy literature, penetrating in the jungle to create real cities there too," as one minister put it.[7] In Caracas, the quest to remake Venezuela meant removing traces of urban poverty. Makeshift homes built by families that had migrated to the capital were declared the enemy of

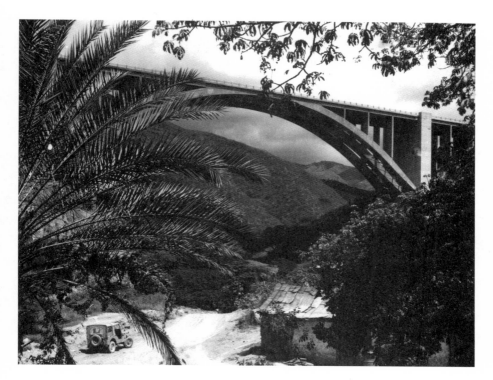

Figure I.4. Completed viaduct, circa 1953. Archivo Histórico de Mira-
flores.

the *Batalla contra el rancho* (Battle against makeshift homes), a state-
run plan to bulldoze unplanned settlements and rehouse residents
in high-rise blocks.

This pledge to build modernity made political legitimacy con-
tingent on the regime's construction capacity. It also linked the
nation's stability to the Junta's ability to engage Venezuelans in a
common quest for *superación* (literally, "overcoming"), a recurrent
term in the parlance of the era, used to refer both to ideals of social
improvement and to the prospect of national development. While
this regime buzzword offered personal and national progress, in the
shadows cast by towering bridges and modernist housing the military
government clenched its fist and began to rule by *mano dura* (with a
firm hand). First, it instituted censorship and demobilized political
parties and trade unions, then it reneged on a pledged return to
democracy by rigging the 1952 presidential elections and declaring

defense minister Marcos Pérez Jiménez victor. Five years later, as the dictator organized a plebiscite to ratify his presidency by calling for a yes/no vote on the public works program, he laid bare his political ideology. As the vote approached, he warned Venezuelans that democratic debate was tantamount to outright anarchy: "Think of a country convulsed in political battle between different parties, each trying to get votes by speeches filled with threats and defamation mixed with promises and offers of well-being; of streets in cities and towns painted and papered to saturation point with posters designed to incite; of the populace abandoned to discussion and mental struggles, to screaming and tumult."[8] Modern buildings, growing revenues, and upbeat propaganda served as palliatives to fill the silence of open political debate.

During the ten-year dictatorship, the political police—euphemistically called the Seguridad Nacional (National Security)—curbed dissent and neutralized detractors. A Junta de Censura cowed journalists into reproducing a consistent official libretto: "Nothing must reveal repression or incarceration. There can be no mention of public administration. Everything about the dictatorship is perfect."[9] Exiles and political activists in Venezuela circulated counternarratives complaining that the nation was living *bajo el signo del terror* (under the sign of terror), but outwardly Venezuela looked like a success story of capitalist development: rising GDP, industrialization, and the forward-looking aesthetics of its architectural overhaul were a recipe for a nation brand in tune with the times. As the Cold War inflected Pan-American politics, the dictatorship's vocal anticommunism and release of oil concessions kept the United States at bay, while the strongmen rulers in Columbia, the Dominican Republic, Paraguay, and Peru stood shoulder to shoulder with Venezuela's military leaders.

Even so, toward the end of the 1950s support at home waned. Military officers became disgruntled, grumbling about exclusion from the affluence that benefited the ruling clique. The economic downturn of 1957 fostered unrest among local entrepreneurs, and the plebiscite made it obvious that the elections enshrined in the Constitution were just dead letters.[10] A cross-party alliance, the Junta Patriótica, intensified calls for the reestablishment of democratic rule. As the year drew to a close, the New Year dawned with a military rebellion that—although unsuccessful—served to shatter the veneer of unity. After church and society mobilized for a strike on January

21, 1958, insurgent officers dealt a deathblow to the dictatorship, sending Pérez Jiménez fleeing to the Dominican Republic in the wee hours of January 23.[11] As moves were made to institute democracy anew, politicians, historians, and postdictatorship testimonies swiftly reframed the previous decade: it was not a golden age of progress as the military rulers professed, but a period in which darkness and hubris reigned.

However, despite this backlash it soon became clear that the idea of modernity retained affective purchase over large sectors of the population. Even after Pérez Jiménez was found guilty of embezzlement and sent to prison in 1968, his pledge to deliver modernity through public works continued to have traction: the idea that development could be discharged by firm governance retained its appeal. Pérez Jiménez fought back, leveraging sympathy at his imprisonment and reaffirming his commitment to build modernity. That same year he was elected to the National Assembly as a senator, but the courts barred him from occupying office.[12] The significance of the former dictator's election a decade after the demise of his regime should not be underestimated. His election disclosed ambivalences about the type of political regime that Venezuelans associated with progress, thus undermining the idea that democracy had dawned after dictatorship. At the same time, the enduring support for Pérez Jiménez's bid to build modernity disclosed a deep-rooted association among Venezuelans, who saw modernist aesthetics and monumental buildings as harbingers of progress.

CULTURAL TREASURES AND POLITICAL AMNESIA

Today, the legacy of the dictatorship's bid to build modernity is still visible and palpable. Visitors who arrive at Maiquetía airport, perched on the edge of the humid Caribbean coast, take the same multilane highway to the capital that was lauded as a hallmark of military efficiency. Just before entering the final tunnel, a cluster of modernist housing blocks suddenly appear, outsizing all other constructions around them but also showing their age. As the car emerges from the darkness, the valley of Caracas comes into view, its urban sprawl a three-dimensional map of towers, intersections, and sinuous barrios that hug the hills and ravines. Sixty years back, the city's population totaled barely one million; now the metropolitan area is home to five times as many. The pressures on water and power

supply, transportation, housing, and health care all weigh heavy on the capital's infrastructure, and with the population at some thirty million these pressures are replicated nationwide.

Against this backdrop, the construction and economic boom of the 1950s is often evoked with nostalgia, lauded as the unsurpassed peak of *la modernidad venezolana* (Venezuelan modernity) whose political circumstances are often dismissed by strategic caveats or outright amnesia. Yes, Pérez Jiménez was a dictator, some say; but look at his legacy—the man built this nation from the ground up; if only there were more like him. For others, the aesthetic modernism that flourished in the 1950s is a source of national pride that has nothing to do with politics but proves that Venezuela was an exceptional case, ahead of its time in spearheading the vanguard of modern art in South America. The artists and architects responsible for the modernist designs and monumental buildings that the regime claimed as proof of military efficiency were invested in aesthetic innovation. Excused from their collaborations with dictatorial leaders, these pioneers are credited with simply adopting "universal" styles and bringing visual culture "up to date."

These ambivalent and depoliticizing appraisals are symptomatic of a general tendency in cultural history, which correlates modernity to a celebrated canon of experiments in urban modernization and aesthetic modernism. Over recent years, modern legacies from Latin America have become more visible than ever before, as surveys of design, architecture, and geometric abstract art are commemorated as entry points for the region's nations into the modern world.[13] But while this visibility is positive insofar as it fosters awareness of important spatial and artistic developments from the mid-twentieth century, problems arise when conventional accounts shy away from the entanglement of modernist aesthetics with political agendas of modernization.

It is no challenge to see how picturing Latin America permanently "in construction" revives developmentalist tropes of the region as a preindustrial backwater or proto-modern space that "belongs specifically to the airplane."[14] Likewise, conjuring abstract artworks as evidence of a blanket cover of progressive politics omits the stake that authoritarian leaders had in mid-twentieth century modernism.[15] Beyond these dubious framings, a further problem arises in the flattening equation of modernity with a select canon of aesthetic

Figure I.5. Aerial view of Plaza O'Leary at Carlos Raúl Villanueva's Reurbanización El Silencio, circa 1950s. Archivo de Fotografía Urbana.

modernism, commemorated in art and architecture. Rooted at the interfaces of nationhood and heritage, commemoration tends to fetishize artifacts and to found compensatory and sometimes amnesiac narratives. Even as it seems to stimulate engagement with the past, the commemoration of exemplary heritage can create a screen that diverts attention from uncomfortable and often violent upheavals.[16] While recent scholarship is beginning to contribute more nuanced perspectives of the uneven and ambiguous territories of modernity, the challenge remains to avoid reducing modern legacies to fetishized "cultural treasures" whose contentious pasts are shrouded in collective amnesia.[17]

The legacy of Venezuelan modernity calls for a mode of cultural inquiry that addresses simultaneously—rather than separates—aesthetics and politics, modernism and modernization, progress and

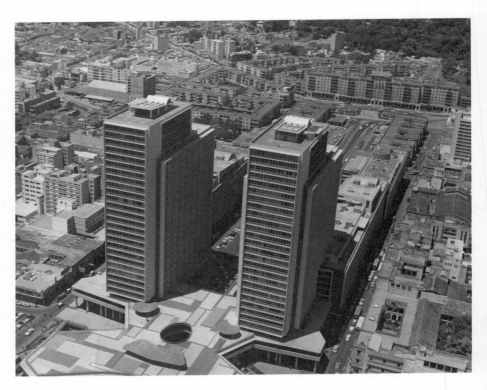

Figure I.6. Cipriano Domínguez's Centro Simón Bolívar, with El Silencio in the background, circa 1950s. Archivo de Fotografía Urbana.

dictatorship.[18] This task is crucial because commemorations of the 1950s as the zenith of Venezuela's "modern spirit" evade the question of how the country's aesthetic innovations served military ideology.[19]

In one conventional thesis, modernity appears as a teleological mode of progress whose linear thrust is traced through the changing aesthetics and expanding size of two adjacent iconic works of architecture located in downtown Caracas. Thus, Carlos Raúl Villanueva's 1940s Reurbanización El Silencio in the 1940s and Cipriano Domínguez's 1950s Centro Simón Bolívar are cited as evidence of the transition from *primera modernidad* to *plena modernidad*—from early to fully-fledged modernity. Villanueva is credited with "gently" introducing architectural modernism in dialogue with the urban overhaul that French planner Maurice Rotival drafted in his Plan Monumental (1939), through his combination of traditional internal

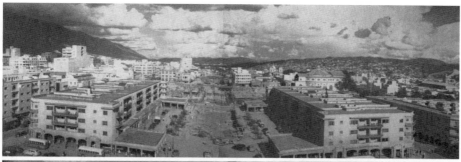

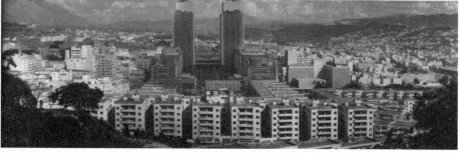

Figure I.7. El Silencio (*top*) and the Centro Simón Bolívar (*bottom*), in 1949 and 1955. *Así progresa un pueblo* (1955).

patios and covered walkways with functional apartment blocks and the bold statues Francisco Narváez made for the Plaza O'Leary (fig. I.5).[20] Architecture critics pinpoint Venezuela's fully modern credentials by citing Domínguez's embrace of Le Corbusier's "Five Points towards a New Architecture" (1926) and incorporation of a steel and reinforced concrete structure, *pilotis* (reinforced concrete stilts), and *brise-soleil* windows into the government and commercial complex.[21] The blend of twin towers and public squares, subterranean thoroughfare and bus station, raised terraces and underground services, is considered an exemplar of the interconnected and functional city envisaged by modernism advocates (figs. I.6–I.7).

Formal analyses such as these sustain the claim that the transition from one site to the other marked Venezuela's entry to modernity. Yet for all the insight into architectural style it offers, such scrutiny does little to clarify the connections between pioneering buildings and the political context in which they emerged.[22] More striking still, this linear reading is haunted by the undeviating path to progress that

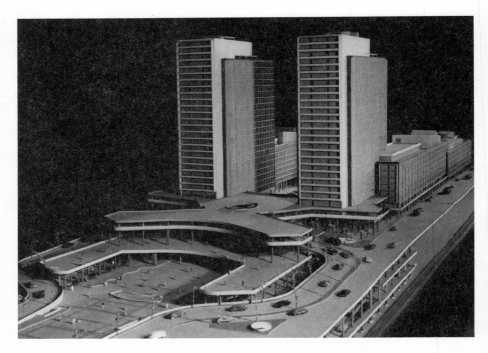

Figure I.8. Model of the Centro Simón Bolívar displayed in government exhibitions in the 1950s. Archivo de Fotografía Urbana.

formed the core of military propaganda, in which architectural models like that of the Centro Simón Bolívar were displayed as heralds of modernity and their realized forms lauded as symbols of the New Venezuela.[23] Whether Domínguez was a devotee of Le Corbusier or engaged the animated debates about the "new monumentality" was immaterial to the military rulers. What mattered was that modernist architecture was undeniable proof of progress that justified the rupture from democratic rule, borne out by before-and-after images of the changing urban landscape.[24] When contemporary accounts focus doggedly on celebrating the "heroic scale" and "titanic dimensions" of modernist buildings, it is no challenge to see how commemoration eclipses complexity in discussions about the 1950s (figs. I.8–I.9).

In another orthodox account, the rise of modernist aesthetics propelled Venezuela into the global echelons of the artistic avant-garde —placing the country *a la altura de los tiempos* (up to date; literally "at the level of the times"), as one critic has it.[25] This thesis hinges on

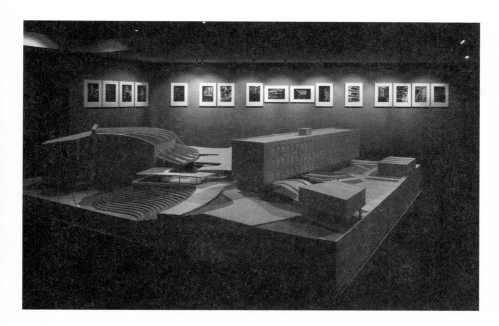

Figure I.9. Model of the Plaza Cubierta and Aula Magna at Villanueva's Ciudad Universitaria, *1950: El espíritu moderno,* **exhibition.**
Charlie Riera, 2005. Fundación Corp Banca, Caracas.

the rupture from figurative art realized in 1950, when Los Disidentes (The Dissidents), a group of Venezuelan artists based in Paris, published a manifesto rejecting Caracas's "bogus" artistic establishment and saying "no" to the tradition of landscape painting.[26] Once back in Venezuela, the group's members encountered a propitious environment for their break from convention, receiving commissions to contribute to public works like Villanueva's Ciudad Universitaria (fig. I.10). As well as a celebrated experiment in architectural modernism, the campus is credited with certifying Venezuela's entry to the visual culture of modernity, widening the rupture from figurative art by placing works by emerging Venezuelan artists like Alejandro Otero, Mateo Manaure, and Oswaldo Vigas among modern luminaries like Férnand Léger, Jean Arp, Victor Vasarely and Alexander Calder.[27] Even though figurative traditions and historical tableaux by no means disappeared from the visual arts or, indeed, from modern architecture itself in the 1950s, these "unfashionable" trends have been relegated to the wings of art history. As geometric abstraction

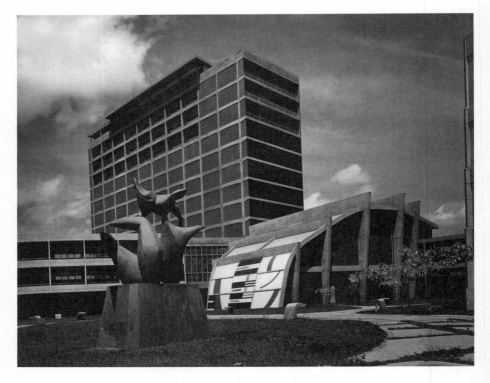

Figure I.10. Central Library with Spanish artist Baltasar Lobo's *Maternidad* **(1954) in the foreground and an untitled mural (1954) by Venezuelan artist Mateo Manaure on the wall of the concert hall.** Ciudad Universitaria, undated. Archivo de Fotografía Urbana.

dominated subsequent decades and resurgent interest has recently peaked, the spotlight has continued to illuminate the 1950s as the foundational period for Venezuela's "exceptional" modernism.[28]

Although commemorative discourses flatten the concept of Venezuelan modernity by equating it to a canon of aesthetic innovations, it is no challenge to pinpoint the entanglement of modern art and architecture with the political agenda of the 1950s. The Ciudad Universitaria is a case in point. No one would deny that the university city brought daring modernist aesthetics to the heart of Caracas. Yet the fact remains that the campus's speedy construction and ceremonial inauguration served more pragmatic ends. The military government was keen to assert its credibility and to confirm Venezuela's geopolitical im-

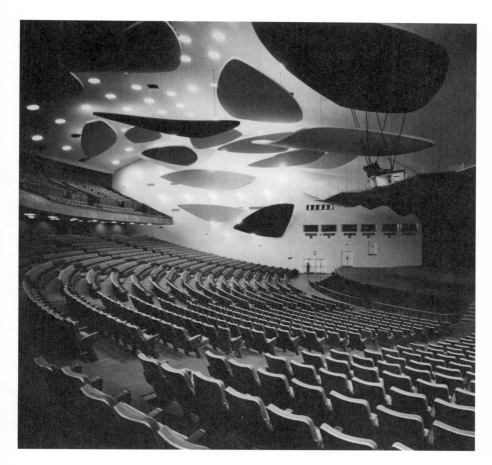

Figure I.11. Aula Magna with Alexander Calder's *Nubes* (Clouds) hanging from the ceiling. Ciudad Universitaria, undated. Archivo de Fotografía Urbana.

port on the world stage, so hosting the Inter-American Conference of 1954 at the Ciudad Universitaria was the perfect opportunity to do so.

As three thousand leaders and delegates from the region gathered in the Aula Magna for the start of the conference, all eyes were on Caracas. Once the inaugural events of March 1 were out of the way, the next day Pérez Jiménez led a series of public ceremonies, inaugurating twenty-five of the campus buildings in one fell swoop and thus ensuring that the fruits of his rule were visible to all (fig. I.11).[29] As the meetings and discussions ensued over the following

weeks, the United States lobbied leaders to wage a common fight against Communism, pushing the item at the top of its agenda. It was there, under the multicolored roof of Alexander Calder's *Nubes* in Villanueva's Aula Magna, that delegates signed the historical resolution that declared Communism an immediate threat to peace and security. For his part, Pérez Jiménez took full advantage of the events, standing center stage to receive the Legion of Merit medal that Secretary of State John Foster Dulles pinned to his military uniform.[30] As declassified documents later confirmed, what the United States really wanted was carte blanche to police ideologies in its "backyard" and legal justification for precisely the type of intervention that was realized in Guatemala just months later.[31] Both Pérez Jiménez's opportunistic use of the conference and the geopolitical turn the event brought for the region make it clear that neither Venezuelan modernity nor modernist aesthetics can be accounted for by the commemoration of "cultural treasures" alone.

DICTATORSHIP, SPACE, AND VISUALITY

In an interview in the 1990s Venezuelan playwright José Ignacio Cabrujas cast his mind back to the 1950s. Even though he opposed the dictatorship on political principle, he recalled vividly the exhilaration that its central tenet awoke in him. *Progresamos porque edificamos* (We progress because we build), the regime declared. *That* was the "real world," Cabrujas explained, the one being remade before everybody's eyes, whether or not they supported the regime. There was nothing exceptional about Pérez Jiménez's plan to promote public works; in fact, he was convinced that someone else could do it better. Later he realized this wasn't the case; "nobody did it better," he confessed in the interview, "it's almost blasphemous for me to say that, but it's the truth; or I feel like it's the truth."[32] Albeit a passing comment and a paraphrased one at that, Cabrujas's musings are significant. Identifying the reasonable doubt that becomes lodged between *the truth* and what *felt like the truth* serves to reorient discussions about the 1950s by illuminating a fundamental issue: how did the impression that military rule delivered modernity gain purchase as a widely accepted truth?

This question opens up further crucial concerns. If the decade of military rule *felt* like progress, what discursive, spatial, and visual

technics induced this sensation? What strategies justified the break from democracy and presented dictatorship as the guarantor of national development? And, how did aspects of daily life beyond the state naturalize and correlate mythologies of progress?

In reorienting discussions about Venezuelan modernity, these lines of inquiry do not necessarily demand the methodologies of political or social history, which might track the rise and fall of the dictatorship through a discussion of chronological events. Neither do they suggest that a "true" version of modernity can be uncovered and ratified over a "false" one. Rather, they invite a mode of analysis that conceives Venezuelan modernity as what Raymond William terms a dominant cultural formation: a sense of reality shaped by the complex interlocking of political, social, and cultural forces that permeates a whole body of practices, expectations, and aspects of life.[33]

Approaching modernity from this angle intersects the political contingencies of dictatorship with theories of space and visuality so as to engage a wider scope of artifacts than those commonly addressed by art historians or architectural critics. Such an inquiry calls for awareness of the 1950s' economic, ideological, and social conditions—and of earlier nation building and modernization projects—to probe the political discourse, spatial arrangements, visual regimes, public events, and consumer cultures that shaped the idea of modernity. The combination of historical background, cultural theory, and close analyses of artifacts provides a means to unravel the manifold forces that fabricated and naturalized a "spectacular" mode of modernity in the period 1948–1958. "Spectacular modernity" refers to the entanglement of the politics of dictatorship with aesthetic innovations in spatial arrangements and visual culture.

The concept of spectacular modernity builds on the core contention made by Fernando Coronil in his seminal study *The Magical State*. Coronil argues that the discovery of oil set the mold of the rent-oriented economy of the modern Venezuelan state and induced fantasies of instant modernity. Oil "enables state leaders to fashion political life into a dazzling spectacle of progress" that plays out as those in power mediate the interfaces of natural resources and political subjects—the nation's two bodies.[34] This magical logic infused distinct political mandates of the twentieth century with a performative dimension, where "by manufacturing dazzling development projects that engender collective fantasies of progress, [. . . the Ven-

ezuelan state] casts its spell over audience and performers alike."[35] During the military dictatorship of the 1950s, this meant using booming oil revenues to transplant conspicuous symbols of progress, such as hotels, highways, and high-rise buildings, onto Venezuelan soil and to claim that this impressive display amounted to modernity writ large. The claim that modernizing deeds were to speak for themselves, as Coronil puts it, simultaneously inferred that democratic debate was irrelevant and that under military rule Venezuelans were to be spectators, rather than political agents, of modernity.[36]

Situated within this context, the terms "spectacle" and "spectacular" gain connotations that go beyond their rather limited conventional definitions as eye-catching feats and beyond the fundamental passivity of spectatorship that limits Guy Debord's theory of spectacle. The term "spectacular modernity" raises questions about what type of spatial and visual technics were deployed to stage dazzling displays of progress under military rule. In turn, it compels an analysis of how modes of seeing, displaying, and viewing buttressed the dictatorship's attempt to redistribute political representation. This expanded definition in turn calls forth a long critical tradition in which modes of seeing, display, and spectating are not approached as natural, unmediated activities but as the "*effect[s] of an irreducibly heterogeneous system of discursive, social, technological, and institutional relations.*"[37] The pages to follow will draw on several core concepts to probe the interface of power, space, and visuality. Martin Heidegger's writing on technology offers useful concepts for thinking about spatial and visual capture as attempts to dominate social and territorial entities. His contention that modern man tends to organize the "world as picture" is a compelling way to call forth the performative dimension that shapes modes of seeing and cultures of display. Moreover, the related concept of "enframing" (*Gestell*), which refers to the act of setting-upon the land so as to marshal it into specific forms of order, proves especially relevant when thinking through the way that top-down modernization plans have an impact physical bodies.[38] Thinking about the politics of seeing is a productive route to unearthing connections between authoritarian hubris, modernization projects, and the synoptic gaze.[39] Timothy Mitchell takes up the term "enframing" in light of the Foucauldian analysis of disciplinary mechanisms; he uses the concept to designate the way in which grand designs conceived from the vantage point of top-down

government tender beguiling promises of development but are also apt to entail the subjugation of natural and social bodies alike.[40]

As well as the politics of the gaze implicit in the modernization plans for Venezuela's undeveloped hinterlands and urban landscapes, spectacular modernity also raises the question of how public events and monumental sites in Caracas served as stages for state-led performances of progress. Even though other urban centers such as Maracaibo or Valencia grew in the mid-twentieth century, Caracas was the undisputed storefront for the military regime, fulfilling the time-honored function of capital cities as normative symbols of nationhood. On a global scale, the symbolic role of capital cities was perpetuated and ratified through the modernist plans developed throughout the twentieth century, in which designers conceived new forms of spatial arrangements and even purpose-built cities such as Chandigarh and Brasília. As designers shook off the monumental aesthetics of previous eras, the landscapes they envisaged signaled a desire to leap into the future.

This was certainly the case in Latin America, and most dramatically in Brasília. There, modernist designs and urban modernization were not only platforms for innovating the tenets of architecture; they were expedient resources for leaders eager to place the state firmly at the vanguard of development. Lúcio Costa and Oscar Niemeyer's forward-looking designs for Brasília were both important contributions to reimagining space and the perfect evidence for president Juselino Kubitschek to claim, in his government slogan, that he had delivered his promise of "fifty years of progress in five."[41] Modern constructions now stand as privileged testaments to the political, aesthetic, and affective forces that have shaped the experience of modernity. Albeit on a more modest scale, the transformation undergone by Caracas in the 1950s compels analysis on these terms. Despite the ample literature on architectural form and building techniques, scant attention has been paid to the dictatorship's tactical leveraging of the capital and the propagandistic libretto that cast Caracas as "the illustrious head that wears the dazzling crown, which confers prestige on a Venezuela that is increasingly strong and dignified."[42] This eulogistic quote epitomizes the type of rhetoric used in official depictions of Venezuela's "miraculous" progress. Yet, returning to discourses and imaginaries produced *from* and *by* the state does not mean that they were the ultimate ciphers of modernity, nor that dictatorial hegemony was absolute.

The story of spectacular modernity is a more complex one, not least because military ideology was simultaneously benevolent and coercive. Even as the regime pursued Venezuelans' emotional investment in the project of national and individual superación by conjuring a social paradigm based on docile, aspirational subjects, political opponents remained mobilized and resistance endured throughout the decade. Moreover, the fact that a cross section of society—from officers to students, and businessmen to the urban poor—rallied to bring an end to military rule in 1958 proves that the spectacle of progress did not convince all who beheld it. Many were still invested in other forms of political representation, which did not relegate citizens to the role of passive spectators.

Just as the political sensibilities escaped any bids for total control, the flagship modern buildings erected during the dictatorship also resisted the restrictive framings of official discourse. For all their reinforced concrete, modern buildings were not intransigent monoliths that spoke only of military might. Built space and the people who inhabit it exceed and escape definitive circumscription, as can be seen in the swift moves to rename certain buildings to mark the end of an era after the regime's demise in 1958. In the case of the "2 de Diciembre" superblocks (so-called to honor Pérez Jiménez's fraudulent rise to power), the shift was so rapid that discrepancies emerged as to what the housing project was actually called. In one photograph held at an archive in Caracas, students celebrating Pérez Jiménez's fall brandish signs that declared: *¡Ahora el 2 de Diciembre se llama 21 de Enero!* (Now the December 2 will be called January 21). However, the move was preemptive, since the blocks were not renamed after the strike held on January 21 but were rechristened as the "23 de Enero" to mark the date Pérez Jiménez fled Venezuela aboard the presidential plane and democratic politics reentered the horizon of national debates.

This rush to rename landmarks erected on the modern landscape under military rule raises a further point about the mechanisms of political mythology and discourse summoned to rewrite history in line with fluctuating agendas. The decade-long dictatorship serves as a paradigm to think through the historiographical logic that keeps Venezuela constantly "submerged in an inaugural ritual, [where the country] never tires of constantly laying the first foundation stone," as historian María Sol Pérez Schael has asserted.[43] The 1950s serve as just one example of this propensity to shape history into convenient

narratives that justify past actions and herald promising futures. The move to rename the monuments of dictatorship mirror the earlier strategy through which the Junta Militar had repackaged the coup of 1948 as the foundation stone for a new stage in Venezuelan history.

Considering the "foundation stones" of Venezuelan modernity from the perspective of cultural history and theory speaks to broader critical turns that have emerged in other fields, where scholars scrutinize the turning points and underlying agendas of dominant narratives of Venezuelan history.[44] Coronil took up this task and brushed conventional accounts against the grain, reincorporating Juan Vicente Gómez as the "first magician" of the modern state to argue that modernity had its footholds in—rather than after—autocratic rule.[45] More recently, Alejandro Velasco's ethnographic study of popular politics in the "23 de Enero" superblocks resists the optimistic narrative that claims that the renaming of the complex in the wake of dictatorship represented a turning point in Venezuelan history that brought better times. Instead, by giving voice to the opinions and stories related by the buildings' residents, he charts enduring discord between the petrostate, Venezuela's political parties, and the urban poor, left unresolved by the system of political representation set in place after 1958 and written into the reinforced concrete of the superblocks.[46]

In short, although the focus of this book is firmly fixed on the decade in which military rulers leveraged discursive, spatial, and visual phenomena to claim they had delivered Venezuela to modernity, it is important to remember that optimistic promises and monumental constructions are not confined to the past. The afterlives of buildings from the 1950s alone attest to the enduring ideals of modernity that resurface in various guises: as a spectral and unrealized utopia, as an idealized form of cultural heritage, and as recurrent promises of national development voiced by politicians from across the ideological spectrum and throughout Venezuela's modern history. This transhistorical backdrop informs the inclusion in the final chapter of El Helicoide—a vast spiral-shaped shopping mall and cutting-edge industrial exhibition space in Caracas—whose construction began under dictatorship, stuttered during the shift to democracy, and was never entirely completed. By no means an anomaly, this truncated building, which today serves as a jail and police headquarters, stands as just one leftover of promises of instantaneous progress and economic cycles of boom and bust, joined more recently by the now

infamous Torre de David, a luxurious banking headquarters—abandoned in the 1990s and then turned into a squat in recent years.[47] Such spectacular visions of progress and their contemporary phantoms demand critical attention if modernity is to be understood as more than a moment of aesthetic innovation and fast-paced urban development.

STRUCTURE

This book is divided into three main sections: Part I, "Official Libretto"; Part II, "Setting the Scene"; and Part III, "Performing Progress." The first chapter, "Telling Stories," is an analysis of the historiographical mechanisms summoned by the Junta Militar to justify the coup as a necessary rupture in order to reroute the nation toward progress. This narrative logic informs the chapter's assessment of how the regime annexed preexisting modernization projects and meticulously produced an official account of progress to confirm that it had delivered the foretold modernity. The second chapter, "Ruling Ideology," is an exploration of the ideological and repressive thrusts of the New National Ideal, examining housing plans, model agricultural colonies, and health-care and education policies in order to show how the military rulers posed as benevolent mediators of national development and social improvement, before they turned to methods of demobilization and coercion.

In Part II the discussion departs from these narrative and ideological footholds so as to unearth the visual regime of dictatorship. The third chapter, "Nation Branding," explores the construction of an official public image through overt and covert propaganda, public relations campaigns, and corporate advertising. The analysis shows how photo reportage, newsreels, and advertisements served as conduits for proregime missives. The next chapter, "Spectacular Visuality," is a discussion in greater depth of the theoretical implications of "enframing" the national landscape, and it uncovers the way that Venezuelan thinkers from the 1940s onward summoned visual tropes to critique the transformations wrought by modernization. Here, close analyses of cartography, filmic images, and photographs accompany an assessment of the rational and affective purchase that the landscape acquired as aerial prospect, sublime scene, and didactic prompt devised to train the gaze to revere modernity. The fifth

chapter, "Exhibiting Modernity," departs from a key moment in the decade, to consider how the elections of 1952 and Pérez Jiménez's fraudulent rise to power inflected technologies of display and shaped a cult of visionary leadership. At first, the discussion covers the *Exposición Objetiva Nacional*, an official exhibition that displayed the fruits of four years of military rule as an overture to the elections, then the analysis turns to how the literary intertwinement of national history and Pérez Jiménez's personal biography mythologized his farsighted gaze as a condition for progress.[48]

Venezuelan modernity is not the story of one man, however. For this reason, the final part returns to collective settings in order to consider the performative dimension of spectacle. The sixth chapter, "Subjects Onstage," reveals how the parade ground and walkways of Sistema de la Nacionalidad put in place a legible articulation of identity and modernity through its monumental urban design and use in carnival pageants and civic-military parades devised as scripted productions of space that would assemble bodies and identities in festive tableaux. The last chapter, "Bringing Progress Home," reaches beyond the remit of the state to show how consumer culture and everyday life became imbricated with the dreamwork of progress and modern mythologies. Close analyses of marketing strategies, window displays, and shopping centers demonstrate how capitalist expansion encouraged Venezuelans to be consumers as well as spectators of modernity, while the discussion of El Helicoide considers overlaps between private and military investment in spectacular modernity and also the precarious grounds on which its dazzling promises were built.

• P A R T I •

O F F I C I A L
L I B R E T T O

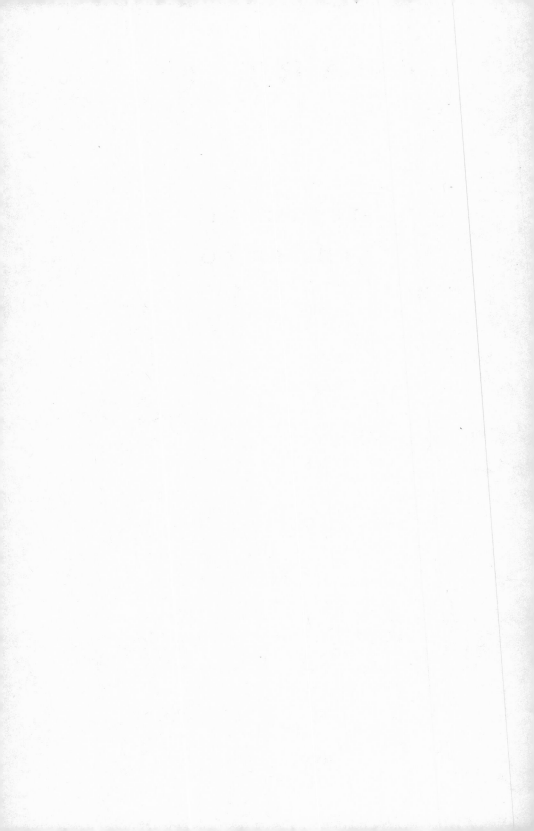

CHAPTER 1

TELLING STORIES

THE HISTORIOGRAPHICAL FOUNDATIONS OF MILITARY RULE

• Barely had the dust settled after the coup of November 24, 1948, and the Junta Militar set about crafting the story that would dominate the public realm for the next ten years. Military intervention was a necessary change of direction: a new chapter in Venezuelan history that would put an end to "painful stagnation" and reroute the nation toward a future of unprecedented development and guaranteed progress.[1] This new beginning brought a discursive repertoire at once pragmatic and poetic. The bulldozer was becoming "a familiar figure for Venezuelans, like the packhorse once was . . . a symbol of the modern nation that is . . . as worthy of respect as the horse that appears on our National Crest and which has already made history."[2] Modernization projects had affective purchase, stimulating a renewal of the emotional connection to nationhood. "We are witnessing the birth of a new Venezuela," the Junta's culture minister wrote in *Sentido Emocional de la Patria* (1953), and the country's changing landscape had forged a spiritual communion—a *patrimonio espiritual* (a spiritual patrimony) in which all would be born anew.[3]

Yet, while the coup of 1948 engendered this official libretto, it also birthed a Junta de Censura—an office of censors armed with

red pens who vetted news reports before publication. This was the point when the regime "comenzaba a hacerse de sus propios voceros" (began writing its own account of history), as José Agustín Catalá later noted, determining what could and could not be said about national life.[4] This simultaneous quest to write an official version of history and to police information in public circulation destabilizes contemporary appraisals of the 1950s as a golden age of modernity. Recognizing the strategic fabrication of narratives of nationhood and history as instruments of political hegemony casts promises of progress in a critical light, casting doubts on the motives behind them. While the military leaders who seized power in 1948 may well have acted with national interests in mind, the continuity of the regime depended on tactical maneuvers devised to bolster military rule. This convergence of vested interests and public narratives raises questions for thinking about how the Junta Militar accounted for its rise to power. How did the Junta fabricate an official libretto to explain the coup, and what historiographical mechanisms were deployed to make the libretto coherent and convincing?

INAUGURAL RUPTURES

History, Michel de Certeau argues, is first and foremost a human activity: an act of writing that shapes time into tactical tales adapted to vested interests and political agendas.[5] Historical "texts" are founded on inaugural ruptures and acts of separation that marshal asynchronous events into coherent narratives, which seem to unfold in a linear fashion so that a beginning explains an end. These teleological underpinnings in turn buttress social pacts, enabling history to conjure communities that are progressing toward common purpose rather than meandering along bifurcating paths. Yet, precisely because it is written by particular agents at particular moments, history provides a testimony to the ideological, political, and contemporary factors that shaped it: "as much as historiography might tend to have us believe, that a 'beginning' situated in a former time might explain the present: each historian situates elsewhere the inaugural rupture. . . . In fact, historians begin from present determinations. Current events are their real beginnings," writes de Certeau.[6]

This critical perspective summons a destabilization of dominant narratives and analytical tools so as to identify how stakeholders use

tactical procedures to write histories they hope will gain purchase. More specifically, the concept of the "inaugural rupture" offers a departure point to probe how, after the coup of 1948, the military rulers accounted for their rise to power as well as to assess how fluctuating political agents and projects modulate the writing of history on an ongoing basis.[7] In the aftermath of the coup, the military leaders preemptively adopted the guise of historians. Eager to shape recent upheavals into a historical narrative in which their ousting of Rómulo Gallegos made sense, they sought to engage Venezuelans in a collective journey and ultimately shore up the military mandate. By justifying the coup as a new national beginning, the Junta Militar made the first marks in its official libretto of modernity; but this narrative expanded to encompass a broader historical framework. Seeking to locate milestones on a collective path to progress, the military leaders wrote a story that began in Venezuela's quest for independence, developed through the military participation in the *Revolución de Octubre* of 1945 when officers made pacts with politicians from Acción Democrática to oust President Isaías Medina Angarita, and consolidated with the coup of 1948, the foundation stone for a new chapter in which the nation would recover its bygone glory.

The choice of beginning was a predictable one, as the military leaders updated the cult of Simón Bolívar recurrently leveraged by Venezuela's politicians.[8] They invoked the independence struggles waged under Bolívar as proof of the auspicious role of military leadership in securing the nation's footholds. Yet, after independence was secured, they claimed that this exemplary action lapsed into inertia and "the absence of an appropriate ideal maintained the nation in a long period of painful stagnation, during which, without a common denominator to guide the fatherland, we wasted our energy destroying each other or vegetating amid unplumbed possibilities, while other nations transformed their hardships into stimuli for creation and progress."[9] By compressing nearly a century and a half of history into a single period of "painful stagnation," the incoming leaders presented themselves as heirs to Bolívar who would renew his illustrious legacy. Denying previous leaders any credit for following in the Liberator's footsteps, the new rulers declared that their commitment to emulating his example was a guarantor of Venezuela's successful development in the future.

Having condensed more than a century into a period of darkness, the official history turned to more recent settings and upheavals.

Although Juan Vicente Gómez's autocratic rule had ended with his death in 1935, his departure did not birth a modern state. Even as Eleazar López Contreras (1935–1941) and Isaías Medina Angarita (1941–1945) allowed for some political reform, they perpetuated controls inherited from their predecessor, fueling decades of struggle in which parties called for democratization and attempted to capture votes from the middle class and working constituencies now involved in the nation's political scene.[10] As Medina's tenure drew to a close, he handpicked a successor vetted and approved by Acción Democrática (AD), the nation's main party. But when ill health forced Medina's candidate to withdraw and his replacement did not meet with AD's approval, the party formed an alliance with the Unión Patriótica Militar (UPM), a group of officers headed by Pérez Jiménez that wanted reform and modernization in the Armed Forces.

The civic-military allies conspired to seize power on October 18, 1945, and although Medina got wind of the plan and arrested Pérez Jiménez, the coup succeeded. The Revolución de Octubre, as it was dubbed, ordained Rómulo Betancourt as president of the Junta Revolucionaria de Gobierno alongside fellow *adecos* (supporters of Acción Democrática) and two military officers, Carlos Delgado Chalbaud and Mario Vargas. AD swiftly defined the coup as a revolutionary turning point that had spliced history into two distinct periods, assuming the role of agents of progress who had put nails in the coffin of Gómez's enduring legacy and initiated a new period of democracy. "Suddenly, the birth of modern Venezuela was shifted to 1945, turning the date as well into the moment of Gómez's 'historical' death," notes Fernando Coronil.[11] As Rómulo Gallegos was voted to office by universal suffrage, in the wings AD's military collaborators felt sidelined and became restless. Frustrated by the political debates and what they perceived as sluggish growth, they hatched plans to wrest back power by launching the coup of November 24, 1948.

This backstory offers a corrective to claims of inaugural rupture by giving a context to the historical and political conditions that shape the writing of history. After it seized power in 1948, the military regime crafted a version of events to displace AD's political project and to recast history once again. This entailed annexing the Revolución de Octubre, erasing AD's left-leaning agenda of democratic representation, and reaffirming military agency. Hence, Pérez Jiménez presented himself as a "soldier of the Fatherland . . . inspired

by the ideals that on October 18 led *us* to begin a new history of Venezuela," to return the Armed Forces to the vanguard of national development by excluding AD from his use of the first-person plural "us."[12] The statement, along with others, became something of a trademark declaration; a sound bite quoted repeatedly in state propaganda over subsequent years. A speech that marked the ten-year anniversary of the events of 1945 also exemplified the annexation and redeployment of the Revolución as a prelude that laid the "ideological foundations" for the military coup of 1948.[13] In the speech Pérez Jiménez presented AD's political agenda as a fiasco and accused its representatives of attempting to neutralize the power of the Armed Forces. Democracy had allowed passions to run amok and political fanaticism to blossom into wicked instincts, he said. "A disastrous and long series of incidents carried out and promoted by the party in power forced the military institution to take a direct part in the political life of the Nation. That is how November 24, 1948, came to pass."[14] Not even deigning to mention AD by name, he presented the coup as compulsory military intervention. Rather than a curtailment of democratic rights, the coup was a heroic act to recover the postulates of progress and national development that he claimed AD had cast aside.

Rewriting the Revolución de Octubre by claiming the AD government had deviated from the true purpose of the military-civic alliance of 1945 and reclaiming the date as an overture for the coup of 1948 enabled the Junta Militar to return to the political stage as the "enterprising government that dedicated itself to guiding Venezuelan life through channels of healthy freedom, order and work."[15] AD's initial appeal to 1945 as an inaugural rupture of democracy and the military regime's subsequent rewriting of the same historical event to justify the coup of 1948 confirm that historiographical procedures form the bedrock of fluctuating political discourses and begin to bring to light the shaping of the official libretto that would dominate the period of 1948–1958.

THE NEW NATIONAL IDEAL

When Pérez Jiménez revisited the Revolución de Octubre in his speech marking its ten-year anniversary, he aimed not just to recover ideological bases for the beginning of a new national history. His intention

was also to advocate the New National Ideal instituted by military rule. If the coup of 1948 was a foundation stone, then the edifice buttressed by the coup was the Nuevo Ideal Nacional—the overarching ethos for all government policies, which cemented the promise that military rule would deliver modernity. Although just a few lines long, the New National Ideal was the synthesis of the military ideology of modernity. After Pérez Jiménez first mentioned it publicly in 1949, the text was regularly invoked in speeches, publications, and exhibitions.[16] Its fundamental claim was that technological and architectural modifications to the national territory would propel Venezuela toward a better future for all. Ostensibly at least, the criteria were straightforward: the more radical the transformation the more vigorous the development it would discharge. Yet the discursive configuration of the New National Ideal is not necessarily self-evident. By vindicating military rulers as masterminds of the prospective leap to modernity, the New National Ideal updated the paradigm of the *gendarme necesario*—the necessary strongman who would bring order to the nation.[17] It also endorsed the Armed Forces as agents of national development by projecting a causal chain of events, in which military mediation of the relationship of citizens to the national landscape would engender modernity. The new rulers would spearhead construction projects (buildings, roads, schools, and so on) that they promised would discharge affective and behavioral modifications in the Venezuelan people, thus securing qualitative transformations of territory and society alike.[18]

It was precisely this dialectic of pragmatic action and affective response that posited the military state as the necessary agent and mediator of Venezuela's path to modernity. Brief enough to reflect the regime's technocratic and developmentalist agenda, yet capacious enough to inspire nationalist sentiment, the doctrine set out a number of positivist promises:

> The New National Ideal consists in securing for Venezuela a place of honor among nations and making it ever more dignified, prosperous, and strong. It is based on our historical tradition, natural resources, and geographical position. Its objectives are the transformation of the physical environment and the moral, intellectual, and material improvement of the country's inhabitants. Its central doctrine is national well-being, according to which the government's work is envisaged according to the needs of the nation.[19]

Although short, the text contains all the promises of how the official libretto of military-led modernization was supposed to play out. Optimizing natural resources would fast-forward development and renew Venezuela's geopolitical import. The transformed landscape would induce social improvement in citizens and inspire patriotic sentiments of a new *mística nacional* (belief in the nation). And, military rule would ensure well-being for all. This nationalist formulation mandated a type of political leadership that was focused on creating rational plans to systematize space, industrialize the economy, and improve society and on implementing them with resolute determination. By promising that "the true demonstration of our national consciousness is the materialization of the abstract concept of the Fatherland in ambitious works," the New National Ideal made it clear that the leaders' legitimacy was contingent not on popular support but on making progress visible.[20]

Its foundational paradigm was frugal, at least in formal terms; nevertheless the deeds-not-words mandate was predicated on the idea that dazzling development projects would "engender collective fantasies of progress."[21] Who would argue with the promise of better living conditions, economic well-being, and modernized infrastructure on offer to one and all? What sense would it make to oppose a regime that declared quantifiable progress as the litmus test for its legitimacy and then delivered visible results? By using a lexicon that presented military rule as simple common sense, the New National Ideal reached out to Venezuelans on appealing terms. After he had finished glossing the upheavals of 1945 and 1948, Pérez Jiménez continued his unusually lengthy speech by reciting a stream of statistics, which described the expanding road network, rising jobs, growing schools, burgeoning industry, increased housing, unprecedented military capacity, and so on. Leaving the broad historical framework behind, he devoted several pages to comparing measures of national infrastructure in 1945 to their equivalents in 1955. This counterpoint between these two dates, a decade apart, was supposed to ratify the thesis that democracy induced only sluggish growth by demonstrating exponential growth and, in so doing, to convince Venezuelans that, as promised, military intervention had set the nation on course for rapid modernization. In short, sacrificing narrative complexity served the official agenda by substantiating the horizons of future

growth that the New National Ideal had conjured: things could only get better.

By reframing modernity as a national rather than a partisan project, the first step was taken to banishing debates about democratic representation; later that door would be shut altogether. Retracing this same period of history, Ocarina Castillo offers a precise counterpoint to the promises embedded in the New National Ideal. The bulldozer years, as she terms the decade of military rule, were indeed a linear journey, but one that brought a shift from *dictablanda* (a "soft" dictatorship) to a repressive *dictadura*. Deploying tools of historiography to critical ends, Castillo proposes correctives to the military rulers' version of events: the coup of 1948 divulged irreparable fissures in the civilian-military alliance formed in 1945 and the Armed Forces' rejection of AD's populist mandate. The coup marked the start of a specific political and ideological project with three distinct stages. From November 1948 to 1952, the Junta formulated the New National Ideal and reestablished social order; from December 1952 until May 1957, Pérez Jiménez implemented a developmentalist doctrine of modernization through public works; and in the remaining time up until January 23, 1958, popular support for the modernizing project waned and discontent grew.[22]

This framework clarifies a further aspect to the New National Ideal's contribution to the official libretto of military rule: the doctrine justified the neutralization of political mobilization and debate. Immediately after the coup, Carlos Delgado Chalbaud—leader of the Junta Militar until his kidnap and murder in 1950—promised that presidential elections would take place in December 1952, and so they did.[23] However, when barefaced fraud foreclosed the Venezuelan people's right to democratic choice, the scope of political debate was further curtailed and military rule entrenched. Similarly, when the presidential elections enshrined in the constitution were replaced in 1957 with a plebiscite this was billed as a ratification of the New National Ideal's public works projects, which had garnered broad-ranging support from Venezuelans. The trajectory of exponential growth promised after the coup of 1948 and formalized as a doctrine in the New National Ideal effectively replaced the diversity of political parties and competing national projects, with promises of fast-tracked modernity in which transformed landscapes and reinforced concrete were the most important measures of progress.[24]

As history was written to make sense of the upheavals that initiated military rule and to justify the perpetuity of that rule, Venezuelans were repeatedly told that the lead characters in this story, the only ones who could deliver this promise of instant modernity formed a government that was "neither left nor right-wing . . . [but] simply Venezuelan."[25] Military rule was a simple matter of patriotic common sense, and the regime's durability in power was the guarantor to ensure that the story of the nation's entry to modernity made sense. This act of separation from political ideologies once again deployed historiographical procedures to establish a counterpoint between the promise of stability and the upheavals of recent years. Military rule was a corrective to the distracting contentions of party politics, which made leadership subservient to collective well-being (the *bien nacional* enshrined in the New National Ideal) and promised Venezuelans that they could measure the legitimacy of the leadership by the size of the construction projects they saw growing around them.

UNPRECEDENTED MODERNIZATION?

Throughout the dictatorship, one of the most frequent claims was that since 1948 more public works had been inaugurated than in the entire period since Venezuelan independence. While the oft-repeated statistics are most likely accurate, another historiographical operation transpires in this insistence on the unprecedented scope of modernization delivered by military rule. Making public works a litmus test of political legitimacy presented an opportunity for military leaders to consolidate their role as lead characters in the tale of progress they had crafted. At the same time, the idea that built space indexed progress represented a challenge: to claim the modern landscape as solely of their own making, the men in uniform required a constantly growing list of projects to inaugurate. This, in turn, made the traction of the narrative of exponential modernization contingent on the annexation of existing construction plans, which could be stripped of their own beginnings under previous governments and rebranded with the seal of military efficiency.

Taking a long view at modernization does not reveal a turning point forged exclusively in the 1950s but, rather, recurrent promises of progress and a series of asynchronous efforts to transform the na-

tional landscape. Discussions about building a modern nation-state by developing industry, modernizing infrastructure, and erecting monumental architecture are generally traced back to the period after 1870, when Venezuela entered a period of greater political stability. Before this, post-independence efforts were focused on securing the nascent republic's social, political, and judicial organization, sovereignty, and territorial integration and founding a collective imaginary based on the demarcation of territorial and economic promise that informed Augustín Codazzi's *Atlas físico y político de Venezuela* (1840) and the shared history related in José María Baralt's *Resumen de la historia de Venezuela* (1841).[26] The political and social upheavals of the Guerras Federales of 1859–1863 maintained the nation fragmented and underdeveloped, but by the mid-1860s constitutional order was established, and in 1874 a dedicated Ministry of Public works was created to oversee modernization works.

In the late 1800s, the ruling criollo class premised modernization on the recovery of former glory and future economic growth. General Antonio Guzmán Blanco (1870–1877, 1879–1884, 1886–1887) pledged to insert Venezuela into the global capitalist order, advocating European culture and building infrastructure, which was leveraged to credit the leader with delivering modernity.[27] The 1870s brought the first national census, new bridges and aqueducts, a railway linking Caracas to La Guaira, and commemorations of independence that remade the Plaza Mayor as the Plaza Bolívar. While neoclassical and neo-Gothic aesthetics for the Capitolio building (1872) and Universidad Central (1876) represented progress in the capital, public exhibitions and international pavilions projected the image of a nation ripe for foreign investment.[28] State construction continued into the twentieth century, which dawned with Juan Vicente Gómez's promise to make Venezuela "strong, vigorous, cultured and prosperous." As well as presaging the New National Ideal's pledge for increasing prosperity, dignity, and strength, the espousal of Positivist tenets among Gómez's acolytes, who used the empirical lenses of sociology, economy, politics, sanitation, education, and technology to conduct a nationwide "diagnosis," prefigured the mid-twentieth century embrace of technocratic principles.[29]

While historians identify a sea change in the style and scope of modernization in tandem with the post-1935 quest to forge the modern state, even a brief historical panorama suggests that—notwith-

standing differences in political contexts and ideologies—pledges for transformation were as much a feature of incipient democratic projects as they were insignia of autocratic leaders such as Guzmán Blanco and Gómez.[30] In short, the promise of delivering modernity through tangible works was no novelty; it was—and continues to be—an enduring form of political capital. In this sense, as military rulers advocated a New National Ideal that cast public works as portals to modernity, they rallied Venezuelans on familiar terms. The lexicon of modernization served the regime's mission to provide coherence for the break from democratization and popular political participation. Even though its political ethos was antidemocratic, the regime's core concerns of economic growth, industrialization, and social well-being were the same as ever; they simply needed to be assembled into a meticulous discursive package. With the legacy of authoritarianism looming large after Gómez's recent departure and a population unversed in democratic rights, the main challenge for the military rulers was to lay claim to earlier modernization plans to reinforce the claim that they were the ones, and no one else, who had secured national progress.

Here again, Carlos Raúl Villanueva's Reurbanización El Silencio offers particular insight, since it shows the overlap between the lexicon and projects of modernization from the 1940s and the language the military rulers used to claim that they alone had induced definitive spatial transformation after 1948. Villanueva's project resulted from the Plan Monumental de Caracas (1939), drafted by French urban planner Maurice Rotival for the Dirección de Urbanismo after the city was reinstated as the nation's political and cultural capital following the death of long-term autocrat Juan Vicente Gómez in 1935. After the Ministerio de Sanidad y Asistencia Social had deemed El Silencio "one of the most dangerous hubs for infection and contagion of venereal disease" in the capital, in 1941 Medina Angarita commissioned a Plan de Urbanismo to initiate a radical transformation (*transformación radical*) of Caracas's historical center through the clearing of suburban neighborhoods (*evacuación de barrios suburbanos*). Pickaxe in hand, the president organized a photo shoot in which he personally began the demolition works, but in charge of supervising the project was the Banco Obrero (Workers' Bank), a state institution that had been created under Gómez in 1928 to provide hygienic and cheap housing for low-income laborers.[31]

After 1948 the same language of rational plans and sanitation became watchwords of the military regime's modernization plans. Medina Angarita's photo shoot at the demolition works foretold the bulldozer's conversion into a national insignia, and the growth of centralized planning after the coup, through which its leaders annexed and expanded existing plans and institutions. In effect, the incoming leaders repackaged Medina Angarita's Plan de Urbanismo as the Comisión Nacional de Planificación. Former calls for radical transformation were reiterated verbatim, while the clearing of suburban areas morphed into the stigmatizing lexicon of the military regime's *Batalla contra el rancho*—its battle against makeshift homes that were considered a blight on the landscape. Equally, the Junta Militar incorporated and expanded the Banco Obrero, bringing it under the auspices of the Ministerio de Obras Públicas and enhancing its construction capacity by founding the Taller de Arquitectura del Banco Obrero (TABO) under Villanueva.

Comprehensive surveys of urban planning in the first half of the twentieth century evince further continuities, overlaps, and adaptations of modernizing plans.[32] As the Junta Militar thrust its weight behind existing projects such as the Ciudad Universitaria and the Centro Simón Bolívar, the monumental scale and novel aesthetics that they materialized on the urban landscape were much more a fortuitous occurrence than a result of military discernment or interest in the global spread of modernist architecture. By consequence, rather than a drastic departure or unprecedented era, the post-1948 accent on public works renewed long-standing associations between modernization projects and political legitimacy. Even as they positioned themselves as lead characters of a new period in Venezuelan history, the military leaders were not sole authors of the changing landscape but, rather, astute agents that tapped opportunistically into long-standing concerns and public works projects that could be added to a long list of ribbon-cutting ceremonies.

ARCHIVAL IMPULSES

While the writing of history depends on establishing ruptures and turning points that assemble heterogeneous experiences into a linear story, the purchase of dominant narratives depends on their ability to unfold coherently and endure over time. This was especially true for

the narrative entrenched after 1948; its very coherence demanded that the New Venezuela the military rulers were promising to deliver became a visible reality. As in other modes of discourse, to become coherent and convincing this tale of definitive progress depended on the regime's capacity to establish an overarching logic: a "system of enunciability" that would organize distinct figures and statements into a coherent whole.[33] Put another way, the narrative coherence of the New Venezuela—and military legitimacy, more broadly—demanded two core components: an accumulation of physical sites that indexed transformation and a collection of documents to ensure that this story of instant modernity could be told and retold.

The coherence of official narratives and their implications for social order inevitably brings to mind the forms and functions of "the archive" that Jacques Derrida teased out from the term's etymological roots. The archive, he noted, signifies both a commencement and a commandment: a physical site containing a collection of documents that enable the writing of history and the formulation and preservation of social order. In its service to historiographical authorship and political authority alike, the archive offers a place to consign scriptural, typographic, or visual impressions, and the repository then enables reimpression, through memorization, repetition, and reproduction.[34]

By ensuring the necessary conditions to tell and retell stories, which have an illusion of completion and coherence, totality and continuity, the archive has a function akin to that of architecture. Both assemble discrete elements into a bigger structure, thus fostering a relay in which particular ingredients can be gathered into a general picture, narrative, or edifice. Moreover, according to the governing logic of consistent accumulation, the content of the archive and often the building itself both become markers of political and social stability, thus reinforcing the notion of order associated with these structures and the collections they house.

These archival forms and functions elucidate a historiographical force field in which power, architecture, document, and memory are all implicated. The archive, in this sense, has multiple implications for thinking about writing history and building modernity in Venezuela, not least because the vested interests that converge in the archive dovetail with the agendas in which, as Jacques Le Goff argues, document and monument become inseparable. "The document is a monument. It is the result of historical societies' efforts to impose upon the

future—consciously or unconsciously—the image they projected of themselves. Without a doubt, there is no document of truth. All documents are fabrications. The historian's job is not to be an ingénue."[35] In the story of Venezuela's entry to modernity crafted under military rule, this will to project a conscious image of progress transpires in the way the regime leveraged modern architecture as a form of modern monument and on the stress placed on accumulating documents in government archives that would secure the legacy of military rule. As they inform architecture and artifact, these two modes of imposing a specific history on the future engage the archive on slightly different terms. First, the bid to build modernity posited the national territory as a storage facility, a space envisaged as a repository of monumental structures that indexed exponential development. Second, the archive emerges in a literal guise through photographic collections amassed in institutions tasked with writing an official history of the 1950s and bequeathing materials for the future retelling of this history.

While the New National Ideal promised nationwide transformation, Caracas became the paradigmatic space for modern monuments. There, as one government elegy put it, "amid the blue haze of time, today tall buildings rise up, towering above the red tiled roofs. All around, iron and cement proclaim the hymn to progress of this city of the Ávila, stirred now by its resounding quest for progress."[36] Moreover, as new constructions rose up from amid the modest buildings organized according to Caracas's colonial grid and oriented inward to private patios, it is easy to see why the regime regarded modernist buildings as monuments. Their novel forms and vertical growth transformed the skyline and inscribed the history of progress in steel structures, geometric façades, and brise-soleils. Drawing on the etymological roots of the term "monument," whose role is to stimulate memory by illuminating the actions of specific historical actors, official discourse cast outsize edifices from highways to superblocks as edifying constructions imbued with nationalist sentiment.

This material-spiritual communion recalls the "deliberate commemorative value" that Alois Riegl associated with the monument, whose contribution to the writing of history derives from its status as "a work of man erected for the specific purpose of keeping particular human deeds or destinies (or a complex accumulation thereof) alive and present in the consciousness of future generations."[37] Although he claims that these "'deliberate' monuments" are rare features of

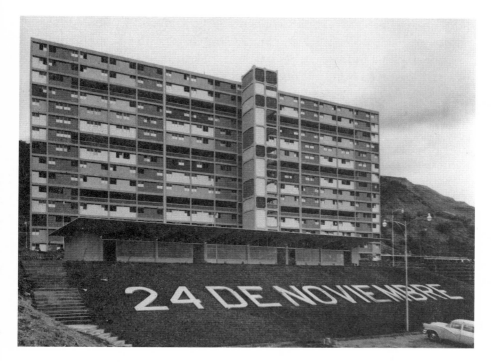

Figure 1.1. A housing block named in honor of the coup of November 24, 1948. Archivo de Fotografía Urbana.

modern landscapes, Riegl's definition is perfectly applicable to the case in hand. Beyond celebrations of their physical scale, the government's tactic of naming modern housing blocks "24 de Noviembre" to honor the 1948 coup and "2 de Diciembre" to mark Pérez Jiménez's rise to the presidency, sheds light on the interface of architecture and historiography (fig. 1.1). In these two cases, the constructions quite literally became document-monuments: metonymic relays of name and form that connected inaugural ruptures to the materialization of modernity. In so doing, such buildings made the political order legible and visible, wedding the regime's historical milestones to the urban landscape.

The military rulers also summoned the document-monument in another mode, capturing new constructions—and government events more broadly—in visual records consigned to official archives. These carefully policed repositories fostered a system of enunciability that would safeguard the consistency and coherence of official missives.

While archival taxonomies shaped the government's public-facing discourse into recognizable themes and tropes, the accumulation of documents buttressed the narrative of exponential development. The forty-seven hundred photographs from the presidential bureau during Pérez Jiménez's administration (1952–1958), now housed at Archivo Histórico de Miraflores, exemplify the taxonomies of space and public events that bolstered conventional narratives.[38] Architectural models, construction works, education and health-care facilities, and industrial and agricultural infrastructure, all provided visual proof of the modern landscape while official inaugurations, presidential portraits, diplomatic meetings, and awards ceremonies buttressed the authority of the military rulers who claimed to be making history.

Similar tropes characterize the photographs collated at the Oficina Central de Información (OCI), whose meticulous organization evinces the investment made in writing history through visual documents. There, hundreds of large-format negatives from the 1950s are archived in identical chronological boxes of individually coded, chronologically organized envelopes that group images by location or event. Inside the catalog, the documents themselves reinforce narrative coherence through a recurrent chronological arc that transpires in the documentation of modern spaces. First, flagship projects appear as architectural models, often displayed at government exhibitions; then they feature as emerging works under construction; and finally, they are captured as finished buildings inaugurated mainly by Pérez Jiménez. This tracking of projects from inception to completion reproduces the historiographical operations of the official writing of history by demonstrating that the inaugural rupture of the 1948 coup bore fruit in the inaugural ceremonies of public works.

Following Le Goff, it is easy to see that such documents were not innocuous; they were the product of the ruling forces that fabricated them so as to craft a specific historical narrative for the present and a legacy for the future. These documents did not languish in the penumbra of official archives. The centralization of government propaganda saw to it that they were channeled into an accomplished system of official information that disseminated success stories of modernization, crafted to inspire patriotic sentiment and evince military efficacy. Throughout the decade, a wealth of heavily illustrated print media disseminated standardized narratives of national renewal. Centralized institutions like the Servicio Informativo Venezolano,

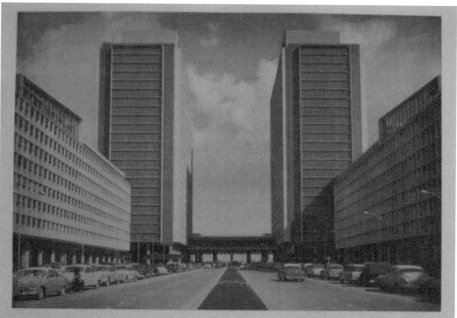

Aspecto occidental de las "Torres" del Centro Simón Bolívar.

Acueductos y Cloacas:

En obras de ingeniería sanitaria se invirtieron Bs. 35.753.162,87.

En esta materia, como en todas, el Gobierno del Presidente Pérez Jiménez ha tenido el propósito de que el beneficio llegue hasta los últimos rincones del país. El saneamiento ambiental, las campañas sanitarias, los planes de crédito y auxilio técnico se distribuyen, sin discriminaciones ni preferencias a toda la República, en este ramo, tomando en cuenta las características esenciales de las regiones.

Entre las principales obras que el Gobierno del Presidente Pérez Jiménez entregó al servicio público, se pueden señalar: el Sistema de Cloacas de Barcelona con un costo de Bs. 4.362.063,36; el Sistema de Cloacas de Mérida con un valor de Bs. 7.738.076,62; la construcción de ochenta acueductos en pueblos y aldeas de los distintos Estados de la República; la ampliación de los sistemas de cloacas de Maracay; nuevas ampliaciones del Acueducto de la misma ciudad, Bs. 1.325.610,97; la dotación de servicios para los gigantescos super-bloques construidos en Caracas en cumplimiento del Plan de Vivienda Social, y las cloacas y redes que exigieron las nuevas avenidas construidas en la capital y en otras ciudades.

Figure 1.2. Detail from the Dirección de Información Nacional publication *Venezuela 1954: Expresiones del Nuevo Ideal Nacional.*

the Dirección de Información Nacional, and the Oficina Central de Información produced elaborate hardback books such as the *Venezuela bajo el Nuevo Ideal Nacional* (1953–1955) and frequently took out full-page spreads in national newspapers. The Imprenta Nacional provided the mechanical means to disseminate propaganda; the photographic talents such as Leo Matiz and Alfred Brandler provided strong visual content for government publications, while editors such as Colombian journalist Plinio Apluyeo Mendoza, who relocated to

Caracas after the murder of the liberal politician Jorge Gaitán in 1948, provided insight and expertise to optimize content, design, and dissemination. Ministries and state institutions also did their part, commissioning lavishly illustrated compendiums like *Así es Caracas* (1951), incentivizing tourism by publishing guides to new state hotel chains, and creating periodicals such as the *Revista del Banco Obrero, Revista de las Fuerzas Armadas, Cuadernos de Información Económica Venezolana,* and *Revista de Hidrocarburo y Minas,* to name just a few.[39]

Regardless of platform, the style and substance of print media followed a generally homogenous script: facts and figures evoked technocratic efficiency while elegiac language sketched rosy contours of the New Venezuela, declaring the country's awakening a tangible reality and unmitigated success. The texts and rich imagery in *Venezuela 1954: Expresiones del Nuevo Ideal Nacional*—a large color album edited by Mendoza y Mendoza for the Dirección de Información Nacional—exemplify the strategic blend of lists and lyricism (fig. 1.2). Progress under military rule needed no embellishment, readers were told, since the "simple enumeration of constructions and their cost indicates the achievements of the official program of action and the efficiency of the doctrine that inspires and guides all official activities."[40] Yet, to ensure that this positive message gained emotional traction, the book turned to photographs and hyperbolic adjectives to drive home the message that Venezuela's *vertiginoso* (vertiginous) and *modernísimo* (cutting-edge) transformation was a triumphant outcome of the coup of 1948, the military leadership, and the New National Ideal's doctrine of rational development and spiritual renaissance.

•

Following Benedict Anderson, the accent that the incoming leaders placed on telling the story of the New Venezuela in print media and visual documents aimed to entrench a specific sense of nation-ness capable of engaging an imagined community in a common project.[41] Under military rule, the idea of modernity was drawn into a carefully honed narrative, one in which progress figured as the ultimate bright object on the new horizon the coup leaders claimed to have inaugurated in 1948. Through the exploration of the political contingencies and historiographical procedures that shaped this optimistic tale, the contours of an official libretto start to come into view.

The political upheavals of 1945 and 1948, the formulation of the New National Ideal, the annexation of existing modernization plans, and the archival inflections of monuments and documents, all had a role to play in this official libretto. Identifying these historiographical operations adds clarity to the idea that military-induced modernity *felt like the truth*. At the same time, though, the parallels these operations have with other historical periods and actors who deployed similar mechanisms makes it clear that the act of writing history is a recurrent tool in political discourse. While dates and referents are adapted in accordance with shifting ideological agendas, the basic narrative logic and archival principles endure. From Guzmán Blanco's recovery of Bolívar to the adecos' celebration of the Revolución de Octubre, and indeed up to the association of social housing projects with contemporary politics in Venezuela, the writing of history and proclivity to monumentalization invite analysis as enduring traditions as well as modes of political leverage deployed to buttress specific regimes.[42]

In the period at hand, it is clear that the military leaders quickly realized that telling a coherent story of the deviation from democratic rule was a top priority. Engaging Venezuelans in a patriotic project based on the promise to refound the nation, they hoped, would soften the blow of demobilization. Next, furnishing the landscape with monumental buildings would shore up political legitimacy and prove to the populace that this story of progress was really taking shape in the real world. What emerges from this analysis is a more prosaic scenario: the more engrained the inaugural rupture, the more monuments built and documents amassed in archives, the more purchase the New Venezuela would find in the public imaginary. And if this story of military rule and national refounding took root, maybe, just maybe, people would continue to retell it in the future.

CHAPTER 2

RULING IDEOLOGY

RADICAL TRANSFORMATIONS OF
SPACE AND BODY

• The prospect of modernity, as the New National Ideal made clear, hinged on the premise that centralized rational planning would deliver both spatial transformation and social improvement. To achieve this twofold *superación* (improvement), the only viable framework was to design state policies for the good of the nation and not in the service of a political ideology. This, in turn, had an obvious implication: only a military government could respect the principle of *bien nacional* (the national good) and pave the way to progress. Sitting in his palatial home in Madrid nearly thirty years after he was ousted from power, Marcos Pérez Jiménez stood by this code. The program set out in the New National Ideal was the right one and he still believed fervently that "there will be no great Venezuelan nation without an equally great Armed Forces."[1] This meant that the nation and its citizens marched in time with its military leaders, he told his interviewer. That was the route to building a strong territory and an obedient populace.

For all the promises of well-being, this image of citizens marking military time elicits the inescapable caveat of the New National Ideal. The parameters for defining *what* was in the nation's interest were determined by a regime that had risen to power by seizing it and

then refused to let go. Under the cover of nationalism, the military leaders presented political debate and civil society as hindrances to the high modernist model of development they envisaged in line with "linear progress, absolute truths, and rational planning of ideal social orders."[2] *All* Venezuelans would be gathered under this framework of the national good, the military rulers promised. Yet this, in turn, empowered the rulers to formulate and impose the spatial and social orders that were required to realize the modern nation *they* had envisaged.

This caveat adds another dimension to the promise of modernity and reframes the New National Ideal in more critical terms as "an ideological manipulation in which the exercise and control of power relied on a sort of messianic conception that claimed the Armed Forces were rescuing the country from chaos and disorder."[3] The military regime, in this sense, comprised a dual prospect of both liberation and subjugation, akin to the ideological and repressive functions of the state apparatus that the philosopher Louis Althusser theorized in his work on ideology. The political economy of military rule stipulated that even as noncoercive conduits such as housing projects, increased education, health care, and culture offered well-being, divergent behaviors were regulated through censorship, repression, and incarceration in order to maintain the social and political order.[4]

These concomitant mechanisms shed light on the complex ways that the military regime mediated space and society. The modernization policies set in place during the decade of dictatorship cannot be reduced to either a transformative idyll or a totalitarian dystopia; their implications and people's experience of them were more complex. At least until the economic slowdown and plebiscite of 1957, scholars argue that large numbers of Venezuelans were generally invested in national development and social improvement and found ways to justify the dictatorship.[5] At the same time, the persistence of political activism throughout the decade makes it clear that not all sectors accepted the conditions set for modernization and those who did not accept the new political order suffered violent consequences for that. This complex scenario compels an assessment of the impacts and implications of flagship plans to transform space and society through housing and agriculture, health and education, alongside an analysis of mechanisms devised to discipline and punish noncompliant constituents of the New Venezuela. The modernization

project itself departed from the idea that the national territory and social body were undeveloped and deficient. Hence, this raises the question of how this assumption shaped state-formulated plans to pursue the calculated management of life.

HOUSING PROJECTS AND SOCIAL IMPROVEMENT

From the very outset, mass housing was a pillar of the military regime. The formulation of ambitious plans to provide suitable housing for the population on a nationwide scale departed from the conviction that if people and problems could be quantified and analyzed, they could also be solved by urban planning and architectural design. The regime embraced technocratic tenets and proposed that modernist blocks would fine-tune the body and induce social improvement, while also giving the urban landscape a distinctly modern appearance. In so doing, it—most likely unwittingly—echoed the rationalist and functionalist axioms that Le Corbusier had popularized earlier in the twentieth century. A house should be "a machine for living in," a standardized cell-unit organized in a modular fashion, which could be built en masse in high-rise blocks. This innovation in residential design dovetailed with his visions for the modern city and plans for South American capitals, which were reimagined through urban designs that privileged legible designs, high-speed circulation, and vertical growth, adapted to growing societies.[6]

In Venezuela, the Junta Militar swiftly commissioned a Plan Nacional de Vivienda (National Housing Plan) drafted for the period 1951–1955. The program cemented the association of collective well-being with modernist architecture and furthered the expansion of high modernist state planning. This is especially evident in the creation in May 1951 of the Taller de Arquitectura del Banco Obrero (TABO), which Carlos Raúl Villanueva ran until January 1958.[7] The ambitious housing plan drafted by Venezuelan and foreign architects became a flagship of military efficiency: in seven years twenty-eight thousand homes were built, more than double the amount constructed over the previous twenty-three years. In line with its role as the storefront of modernization, Caracas received the lion's share of the new homes that the Banco Obrero promoted in public exhibitions as *una alegría de vivir* (a joyful way of living).[8]

Before this joyful living experience could materialize, the govern-

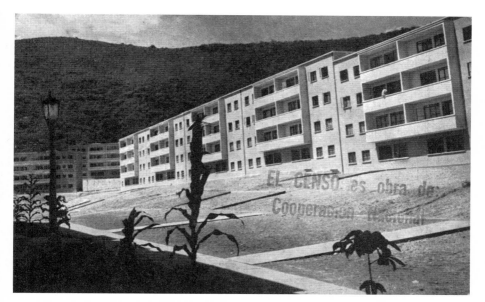

Figure 2.1. Census postcard sent out by the government in 1950.
Archivo Audiovisual, Biblioteca Nacional.

ment had taken steps to gather exact demographic calculations to
determine needs by organizing a national census in 1950. Measuring
growth and urbanization against figures from 1936 and 1941 would
provide rational and scientific grounds for the regime's master plan.
Even though the population had only just passed five million, cities
were growing as the shift to the oil economy created an inward pull
to urban centers and this made mass housing a clear necessity.[9] To
encourage participation, the Oficina Central del Censo Nacional
issued a postcard featuring the Urbanización Generalísimo Francis-
co de Miranda: a housing estate in Caracas's western reaches, com-
prising ninety-six housing blocks, with gardens and playgrounds,
designed by Villanueva and built in the late 1940s. The postcard
illuminates the way the regime advanced the idea that modern space
would induce social improvement and also how state institutions
sought to engage Venezuelans in "bettering" themselves (fig. 2.1).

The postcard created a bridge between centralized planners and
citizenry. Framed by the official slogan "Venezuela progresa," the
census was immediately linked to the promise of modernization and
the broader premises of the New National Ideal. Through the post-

card, the state called on Venezuelans to "Help ensure that the building, house or premises where you live is properly and opportunely registered in the census," thus appealing to them to become engaged in the collective project of modernization. A stamp, which told the recipient that "El censo es obra de cooperación nacional" (The census is a work of national cooperation), reinforced the idea that individual participation was part of a social duty—a single step in the march to progress led by the nation's military rulers. Indeed, the intimation was that only by standing up to be counted would citizens be recognized within the quantifiable social body for whom provisions were being made. This ideological mode of interpellation reframes the census as more than a planning tool. Being counted in the census was a port of entry to the polis—an opportunity to access social housing and a place among the body politic recognized by the state.

The photograph of state-built apartments establishes a relation between architectural norm and social improvement, enhanced by the composition's juxtaposition between urban and natural spaces. Against a verdant backdrop, the new residential buildings stand out as a recent development and a drastic alteration of apparently virgin vegetation. Next, a garden of silhouetted flowers in the foreground stands out against the apartment blocks. Like a carefully crafted scenography, the vista dramatizes the promise of superación: the natural backdrop is gradually surpassed (*superado*) as the modern housing and domesticated garden dominate the scene and the foreground. This condensed tale of spatial transformation foretells the prospect that the resident too will become transformed if, like the flowers, he or she takes root in the civilized space of modern home and garden. With the exception of a diminutive figure on one of the balconies, the postcard presents the buildings as a space ripe for the taking: a future possibility made available to cooperative citizens.

As the housing plan advanced, the homes and picturesque gardens pictured on the census postcard paled in comparison to the bigger and bolder superblocks that dominated the TABO's agenda. The high-rise blocks were much more than materializations of oil wealth; they were envisaged as a means to shape the social order advocated by military rule. This extreme makeover of domestic dwellings was to trigger an aspirational desire for superación that would "aburguesar el proletariado"—turning the proletariat into a bourgeois class and propelling them up the social ladder.[10] When they seized power, the

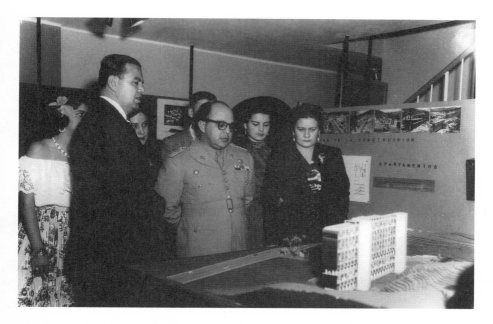

Figure 2.2. Pérez Jiménez at the inauguration of the Exposición Banco Obrero, November 27, 1953. Archivo Audiovisual, Biblioteca Nacional.

military leaders stigmatized the makeshift dwellings where almost 40 percent of the national population lived. If the bulldozer was a symbol of progress, ranchos were insignia for the "backward" culture the leaders promised to uproot. By consequence, alongside the construction plans for housing, the regime declared a *Batalla contra el rancho* (battle against makeshift homes).The urban poor and their homes of wooden and *bajareque* (*tapia*) walls, palm roofs, and dirt floors were declared "a serious social, urban, and aesthetic problem," which should be expunged from the modern landscape.[11] Conveniently for the regime, as Alejandro Velasco has shown, in some cases relocation into superblocks also provided an opportunity to dismantle the urban fabric of communities that had become mobilized and politically engaged.[12] The "battle" against such spaces thus disclosed a Janus face of spatial transformation in which the lexicon of progress was enunciated by top-down plans rather than by popular politics.

Indeed, official missives were unequivocal and even promoted in public exhibitions (fig. 2.2). Modern houses would "totally change

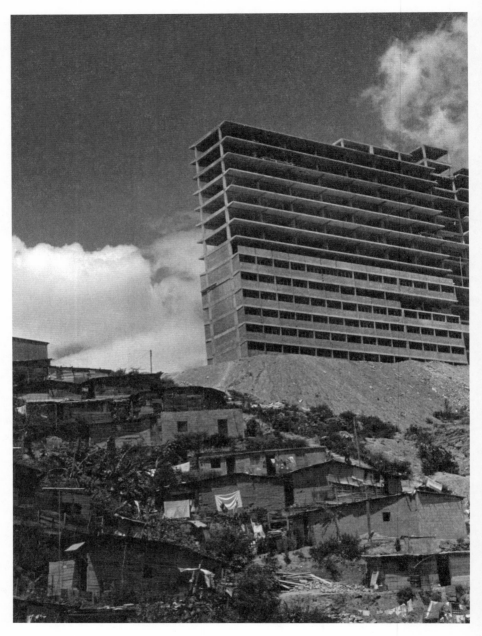

Figure 2.3. A superblock under construction towers over ranchos below in the mid-1950s. Archivo Histórico de Miraflores.

the way of life of people who live in those ranchos, by putting them in contact with a new socioeconomic reality and fostering in them a necessary and logical desire for self-improvement."[13] Moreover, the fervent advocacy of architectural and urban overhauls and high-density housing prototypes as springboards to a modern way of life and national development that was in vogue at the time, lent weight to the regime's claim.[14] Tellingly, Villanueva's team drew inspiration from Le Corbusier's Unité d'Habitation, recently debuted in Marseille (1952) and used his Atelier des Bâtisseurs as their operation model to create prototypes. After streamlining the diversity of design features to satisfy government demands for speedy construction, by 1953 the Venezuelan superblocks were ready (fig. 2.3). Better still, they would take just forty-two days to build.[15] After test runs at the Cerro Piloto and El Paraíso confirmed feasibility, the regime gave the green light. Superblocks were rolled out en masse, and by 1955 some thirty thousand people were now relocated into high-rise towers. The plans continued apace throughout the 1950s, reaching fever pitch in 1957 when there was a 500 percent increase in expropriations.[16] The investment was clearly paying off. Despite some rough edges, the blocks drew praise abroad, not least from the Museum of Modern Art curator Henry-Russell Hitchcock. Writing in the catalog for the 1955 exhibition *Latin American Architecture since 1945*, he described the building in scenographic terms as landmarks whose "wooded backdrop serves as a splendid background" and as vantage points that provide "magnificent views from all the windows."[17]

The blocks reached their zenith at the Unidad Residencial 2 de Diciembre, which transformed the Caracas skyline (fig. 2.4). The complex comprised thirteen fifteen-story blocks and fifty-two four-story blocks, distributed into four groups, each with kindergartens, schools, playgrounds, sports grounds, shopping centers, police stations, and first aid services. Their colorful painted façades, designed by rising stars of artistic abstraction, could hardly have struck a more radical contrast with the small colonial homes of Caracas's traditional neighborhoods or the rough-and-ready shacks erected along hills and ravines. The combination of housing, schools, churches, leisure spaces, and supermarkets in a functional urban microcosm resounded with the official conviction that a new urban fabric would bring order to the landscape and remake the social body. Against the stigmatizing connotations of *miseria* (squalor) and misdemeanor

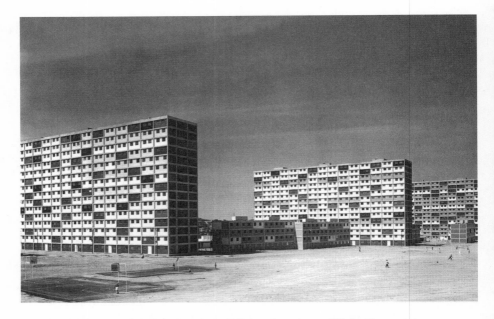

Figure 2.4. Urbanización 2 de Diciembre (now 23 de Enero). Archivo
Histórico de Miraflores.

linked to the Batalla contra el rancho, the superblocks were lauded
as the true face of modernity.

The state declared them a success at every turn, but their trans-
formative impact was by no means instantaneous. Many inhabitants,
rather than immediately being upscaled into a metropolitan middle
class, moved rural habits in with them and found it hard to adapt to
the streets in the sky.[18] This hiatus foretold the latter backlash against
modernist design as a program for top-down social change, as well as
the enduring conflicts and complexities of life in the superblocks.[19]
In more immediate terms, though, the deferral of the instantaneous
transformation promised by the military leaders threatened to un-
dermine the New National Ideal. This might explain why in 1954
the *Revista del Banco* contrived a public relations stunt to celebrate
the arrival of the first child born at the state's maiden housing proj-
ect at the Cerro Piloto. This was the perfect opportunity to show
how the New National Ideal's transformative pledge was delivering
fast-paced material and moral improvement. The parents and their
three children had faced hard times before moving into their new

apartment two months hence, readers were told; but fortunately their fourth child was born in the tranquility and comfort of their modern apartment. As the caption that appeared alongside a large photo of mother and baby put it: "A comfortable and safe home will provide a better environment to bring up the newborn. Yesterday his parents and siblings lived in a rancho, today the Banco Obrero has given them an apartment that will make them active citizens."[20]

The moral of the tale was a simple one: by taking up residence in the superblock the family had literally crossed the threshold to modernity. And, if this explicit association of modern architecture and social improvement was not obvious enough, the article drove it home through a further staged photograph in which the head of the Banco Obrero press office handed the new mother an envelope of cash. Here personified was the military state, acting out its benevolent paternalism in the modern apartments that were the matrix of modernity. As the superblock "birthed" its firstborn, a new generation of citizens added to official discourse a literal genealogy of progress to prove that state mediation of Venezuela's natural and social bodies was engendering a modern nation.

AGRICULTURAL COLONIES AND MISCEGENATION

The pledge that nation and citizens would be born anew was not just a rhetorical conceit; in some policies it had literal consequences. Given the official claim that engineering would solve the nation's problems, it is perhaps unsurprising that the regime conceived social improvement not only through modern housing but also in biological and genetic terms. As Pérez Jiménez explained in the same interview cited above, modernization also meant improving the nation's "ethnic makeup" because Venezuelans had "a series of defects that we must correct." Summoning hackneyed cultural stereotypes and dubious biological determinism, he claimed that in essence Venezuelans were indolent and Europeans were hardworking. Mixing the two would instill in Venezuelans "an enterprising spirit" that would improve productivity and profit. Not only this, he even went on to imply that the nation's success rate in Miss World and Miss Universe contests could be explained by this genetic upgrade.[21]

These prejudices informed official plans to entice migrants from the old continent into the new world. The regime called on its diplo-

matic missions to support a campaign run by the Comité Intergubernamental para las Migraciones Europeas (Intergovernmental Committee for European Migration) designed to lobby Europeans to leave the postwar ruin and rubble and to relocate to Venezuela, where they would find a land of opportunity, abundance, and modernity. By 1955 official publications boasted that some 382,950 people had arrived at the nation's shores from Europe and a range of other countries as far flung as New Zealand whether on their own account or through the state-run programs.[22] The colloquial expression *mejorar la sangre* (improving bloodlines) had effectively been translated into official policy.

Amid this general drive for migration came a plan to attract Europeans to move to Venezuela and populate the rural interior. The National Agrarian Institute (Instituto Agrario Nacional [IAN]) set up *Misiones de Inmigración* (immigration mission posts) in Munich, Rome, Madrid, and Tenerife, calling on skilled agricultural workers to move to the agricultural colonies the state was founding to develop rural backwaters. These model enclaves would serve a dual purpose, at once modernizing agriculture by mechanizing farming methods and "improving" bloodlines and Venezuelans' work ethic by mixing European migrants and local settlers. The investment in centralized planning and scientific plans to optimize land and body, plant and human life, effectively brought biopower to bear on modernization.[23] Progress meant tasking scientists and planners to formulate plans that would reshape the social and economic order of nation-state by mapping, calculating, and developing the nation's territorial and corporal topographies. Put another way, the agricultural colonies revealed the regime's investment in the idea that nation and body could both be reengineered in line with industrialization and capitalist production.

The settlements required several stages of planning and construction. First came studies to identify fertile lands, then efforts to clear dense forests, build roads and irrigation networks, and equip sites with infrastructure and machinery. By the mid-1950s, their transformative impact on space was evident: sugar and grain production hubs spanned more than twelve thousand hectares of land, almost a third of which had been made available through deforestation.[24] Once colonized, the sites now had to be populated with a workforce. Preparing to welcome tens of thousands of Portuguese, Spanish, and Italians en route to Venezuela, the IAN updated the colonial con-

Figure 2.5. Still from *Turén*, directed by Manuel Vicente Tinoco, undated.

cepts of conquest and *mestizaje* (miscegenation), casting the migrants as pioneers who would forge "the lineages of the racial conglomerate of tomorrow's Venezuela" and bring further progress through racial mixing.[25] After stepping ashore, migrants headed inland to the *colonias* (colonies) and *unidades agrícolas* (agricultural units), such as the Central El Tocuyo, Motatán, and Cumanocoa. By 1952, 12,425 Europeans had settled in the colonias, populating 12,000 of the 20,600 hectares under development, and in the middle of the decade, of the 4,650 families working the land, 566 had come from abroad.[26] To celebrate this news, one day after the commemoration of the fourth anniversary of its coup, the Junta published a full-page spread in *El Nacional* that depicted a family set against the transatlantic vessel that had just delivered them to Venezuelan shores. Venezuela was, the article professed, "casa abierta para el hombre de capacidad y trabajo"—an open house for skilled, hardworking men.[27]

To garner support for the program, the regime commissioned *Turén*, an eighteen-minute film about the eponymous agricultural unit in Portuguesa state.[28] The film started with a description of technical matters, featuring shots of landscapes and offices with an explanation of the process required to colonize these backlands and tracing the development of that process from aerial reconnaissance through to the high-tech methods of harvesting and processing. After this, the camera turned to the social side of the colony, presenting shots of modern housing and educational facilities built for workers' families, while underscoring the enterprising and harmonious spirit of the model community. After the informative précis of

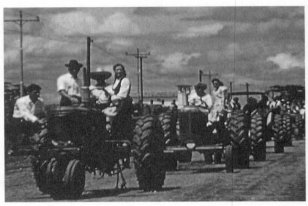

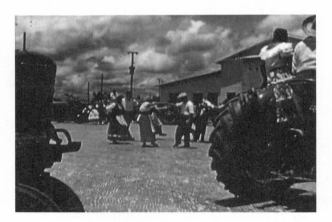

Figures 2.6–2.8. Stills from *Turén*, directed by Manuel Vicente Tinoco, undated.

Figure 2.9. Still from *Turén*, directed by Manuel Vicente Tinoco, undated.

life on the land, the remaining and longest scenes were dedicated to endorsing the plans to mejorar la sangre (improve the bloodlines) through what the voice-over described as a "picturesque country party" staged especially for the camera (figs. 2.5–2.9). To a rousing soundtrack played by the Orquesta Sinfónica de Venezuela, the first sequence begins as farming families clad in their respective national costumes ride down a dusty track, sitting atop brand-new tractors that then served as seating for the spectacle to follow. Next, with the tractors arranged in a circle among barns and outhouses, settlers from Germany, Spain, Italy, and Hungary all took turns performing their traditional dances.

After each group had finished its performance, all the nationalities danced together with their local counterparts, spinning and bopping to a lively *joropo*, the national dance of Venezuela. As the narrator mused that the settlers would "gradually transplant their music into the fertile lands of Turén," the film intimated that music and dancing were just preliminary steps to more intimate encounters. To underscore this insinuation, *Turén* followed the dancing into the night. Now in a dark interior, where the new community lined the walls, the camera dwelt for several minutes on a "beautiful girl from the steppes of Central Europe" and a "young lad from the Venezuelan Llanos" as they twirled gingerly to another local tune. Interspersed with close-up shots of other settlers clapping rapturously, the narrator glossed the scene in unambiguous terms: as they dance "to the chords of our folk music, [the young dancers] summarize one of the most thrilling realities of Turén. The Venezuela of tomorrow

will keep growing like this: with new blood, new men and new ideas."
Singled out as a paradigm of superación, the children were cast as
exemplars of all that the nation could be: a land in which this updat-
ed tale of territorial conquest and intercultural encounters would
harness Venezuela's potential and secure its future.

SANITATION AND EDUCATION

Alongside the quest for social improvement and biopolitical control
exercised through building projects and immigration plans, through
policies for sanitation, health care, nutrition, and physical education
modernization exerted further impacts on people's bodies. Here,
the military regime assumed the benevolent role of provider of a
blanket of well-being, leading "the intense and vigorous increase in
official protection of human masses in every corner of the territory
of the fatherland" by opening *centros sanito-asistenciales* (sanitation
and welfare centers).[29] State planning and the promise of material,
moral improvements enshrined by the New National Ideal project-
ed a territory populated by healthy and hygienic bodies. This goal
made social security innovations a key aspect of the public message
of progress and with fanfare the regime opened institutions such
as the large research-led clinic at Villanueva's Ciudad Universitaria;
the Instituto Nacional de Tuberculosis de El Algodonal; the Instituto
de Neurología e Investigaciones Cerebrales; the *comedores populares*
(soup kitchens) that provided meals for the impoverished; and the
hospitals and medical centers managed by the Seguros Sociales. In
1954 the annual review of sanitation and health care declared that
the scale of development was so titanic it was virtually impossible to
summarize. Despite the hyperbole, the data accounted for an invest-
ment of almost 50 million dollars into the expansion of ten hospitals;
the creation of eight rural medical centers; regional social security
headquarters; twenty-four rural and urban clinics; laundries and
public baths; 14,983 latrines; more than a dozen medical pediatric
institutions; school canteens; and the huge Colonia Psiquiátrica de
Bárbula, a former coffee- and sugar-producing hacienda turned into
a psychiatric hospital.

As state institutions sought to bring bodies into the fold of prog-
ress, education offered a further platform to produce "improved"
and compliant citizens. The regime boasted of the surge in educa-

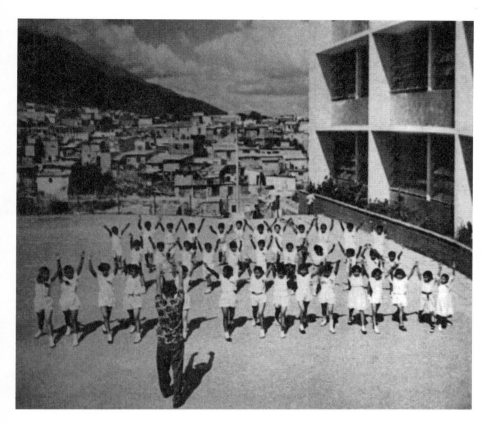

Figure 2.10. Detail from *Venezuela bajo el Nuevo Ideal Nacional* **(1954).**

tion funding, which from 1945 to 1955 rose from 27 million to 163 million bolivars, trebling high school attendance and increasing university enrollment from 3,109 to more than 8,000 students.[30] In the government report *Venezuela bajo el Nuevo Ideal Nacional* published in 1954, the philosophy behind education was laid bare: with the military regime, order, discipline, and patriotism had become pillars of the school curricula. The double-page spread devoted to primary education divulged this message through photographs of a Caracas school and the captions that accompanied them (fig. 2.10). Taken from above, the central image shows a teacher leading a group of children in a physical education class. Each is dressed nearly identically in bright white T-shirts and shorts, arms outstretched toward the sunny skies. The composition serves as an analogy of superación:

the children stand next to a modern school building of reinforced concrete, their backs turned to the ranchos and humble homes, which the superblocks were devised to replace. The accompanying caption synthesizes this idea: "In Venezuela's modern schools special attention is paid to disciplining children's physical development," it noted. "The Government wants to form a healthy and strong people. . . . Physical exercise helps both children's development and inculcates in them order and discipline."[31]

While health transpired as the bedrock of education policy, it also emerged as a precondition for aspired order and discipline that restated the civil-military collaboration envisaged for the New Venezuela. The next page of *Venezuela bajo el Nuevo Ideal Nacional* (1954) builds on this paradigm by establishing a direct association between order, literacy, and national territory through another almost aerial photograph (fig. 2.11). This one depicts the school's playground and a large-scale map of Venezuela made of grass that sprouts from the gridded pattern of the concrete. The children sit around the map's contours, creating a demarcation that binds the nation's territorial and human corpora into unified expression. Resonating with the New National Ideal's postulation of material and spiritual improvement, the miniaturized map is presented as a didactic stimulus for patriotic sentiment. "From the first day, together with the alphabet, amid games and songs, the Venezuelan children start to get to know the map of the fatherland," the article notes, thus positing that physical contact with this representation of the national territory develops both literal and emotional literacy.[32]

In this sense, the collective portrait of the children synthesizes another prospect of the "improved" social body envisaged by the New National Ideal. Through education patriotic subjects would emerge in the mold of the nation's transformed spaces, ready to march in time with the military leaders who herald Venezuela's auspicious future. Here, education provides a further noncoercive conduit for the military inflection of the body as a disciplined and orderly entity, shaped by optimistic promises of patriotic sentiment and physical well-being. Seen in this way, the photographs are more than mere snapshots of school life. They direct the gaze to the naturalized operations with which state institutions inscribe given forms of social order on the body. In so doing, they clarify Michel de Certeau's contention that "there is no law that is not inscribed on bodies. From

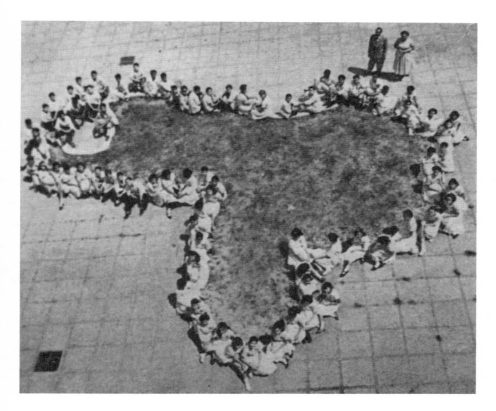

Figure 2.11. Detail from *Venezuela bajo el Nuevo Ideal Nacional* **(1954).**

birth to mourning after death, law 'takes hold of' bodies in order to make them its text. Through all sorts of initiations (in rituals, at school, etc.), it transforms them into tables of the law, into living tableaux of rules and customs, into actors in the drama organized by a social order."[33] In the photographs of these young children acquiring skills in linguistic and patriotic literacy while gathered around the map of Venezuela, it is possible to glimpse one such living tableau in action.

FROM DEMOBILIZATION TO INCARCERATION

Beyond the frame of such contrived images that displayed modern subjects in the making lay a more problematic reality. Incorporating children into model depictions of patriotism posed little challenge

since education promised formative prospects and well-being. Similarly, the residents of the new superblocks had been drawn into the modern polis, even if they were not necessarily active or voluntary supporters of the regime. By contrast, dissident subjects—reticent and resistant about the coup of 1948 and the ensuing transformation of political representation—proved more challenging bodies for the inscription of the military ideology of modernity. Consequently, alongside policies that heralded well-being and social improvement, the mediation of space and body in line with the New National Ideal also entailed demobilizing, regulatory, and repressive apparatuses devised to manage those subjects invested in precisely the political freedoms that the military regime had set out to curb.

A few pages on from the education article discussed above, the 1954 edition of *Venezuela bajo el Nuevo Ideal Nacional* carried a feature celebrating the inauguration of a new headquarters for trade union members.[34] Among the general messages of progress through housing, health, and transport infrastructure, the article presented trade union centers as proof of state concern for Venezuelan workers. In 1954 the regime founded a training and leisure body, the Instituto para Capacitacion y Recreación de los Trabajadores (INCRET), to oversee culture and welfare programs such as the construction of social centers for workers, whose flagship was the Ciudad Vacacional Los Caracas, a holiday complex for twenty-five hundred people on the Caribbean coast. INCRET's organization of a range of cultural activities was one of its leading efforts, and official publications boasted of the conferences, exhibitions, publications, libraries, as well as the concerts, recitals, theater performances, and educational film screenings at the institute.[35] Trade union centers were designed to be self-contained social hubs, equipped with conference and meeting rooms, accommodation, canteens, a library, swimming pools, playing fields, an auditorium, bars, cafes, radio, television, internal newspaper, and health care. Widely praised in government publications and propaganda, the compound in Caracas stood as a symbol of state benevolence to workers.

Along with all the facilities just mentioned, the Casa Sindical also featured a seven-floor school for the arts, which served as the headquarters for the Teatro del Pueblo troupe and the folk dance ensemble the Retablo de las Maravillas—whose name the Tableau of Marvels echoed the glorified terms and carefully stage-managed

scenes used to depict military-led modernity. Rather than just internal entertainment, the ensemble became an insignia of the regime's administration, regularly featured in official events nationwide and also exported for presentations abroad as a marker of traditional culture and proof of the "enthusiastic cooperation of young working people in the spiritual exaltation of Venezuela."[36] By replicating this style of compound in eight other locations, the military regime reformulated syndicalism by creating places where "workers can spend in a happy manner the time their work regulations apportion to leisure." That is to say, trade unionist centers were not exactly hotbeds of debate or political activity. As the article put it, they were everything people could expect in a modern social club.[37]

The novel diversions provided by these multifunctional centers shifted attention away from the state's systematic debilitation of the trade union movement, casting into the background its actual repression of worker strikes. In 1948 the Junta Militar had not only dissolved Congress, shut down Acción Democrática (AD), and dismantled Venezuela's electoral bodies; it soon began demobilizing trade unions, notably by dissolving the Confederación de Trabajadores Venezolanos on February 25, 1949. The following year, when oil workers' unions declared a strike to protest political restrictions, the Junta Militar closed them down and ordered the army to take over the oil fields. These actions were part of the broader move to neutralize and dissolve political networks set up by AD and the Partido Comunista, and in their place, the regime established the Movimiento Sindical Independiente, which (like the Frente Electoral Independiente it set up for the presidential elections of 1952) was far from independent.[38] Amid this neutralization of political debate and dissent, the construction of the Casa Sindical in Caracas and smaller versions nationwide provided a simulation of trade unionist activism—with a building that big who could say that syndicalism had been eliminated? Here, of course, the regime could emerge in a positive guise that promoted well-being even as it attempted to co-opt the critical mass of syndicalism and limit spaces for dissent. A "gift" to the working masses from a benevolent state, the Casa Sindical combined stealth with coercion, making modern infrastructure an entertaining prosthesis for the phantom limb of political agency.

This is not to say that either the neutralization of political struggle or military hegemony were faits accomplis. Rather, the revelation

of ideological maneuvering divulges cracks in the discursive edifice erected to buttress and legitimize dictatorship. The clandestine activities and resistance that ran parallel to the military regime worked to preserve spaces for dissent and political debate by assembling counterinformation to oppose the optimistic story of the New Venezuela. Clandestine groups were the only potential mouthpieces for criticism during the dictatorship; the population comprised a kaleidoscope of opinions, from tentative qualms about military rule quietly discussed at home, through inflammatory pamphlets that undermined the glossy images of progress that dominated official propaganda.

Although analysis of select actions and sites provides only a glimpse of resistance strategies, it does expedite the task of uncovering a number of formative and coercive measures upon which military rule was sustained and modernity was built. Soon after the coup of 1948, resistance to the military annexation of power was channeled through publications produced by Venezuela's political parties, and a range of strategies problematized upbeat narratives of modernity and showed opposition to the new status quo. After the censorship office began synchronizing public information with official narratives, editors of two publications devised an ingenious tactic to reveal the military muzzle. When censors cut text, it remained within the pages of the newspaper, replaced by the letters K, X, or W, which stood as an alphabetic code to index repression. Before long a crackdown ensued, and in 1950 the regime shut down *Tribuna Popular* and *El Gráfico,* run respectively by the Partido Comunista and Comité de Organización Política Electoral Independiente (COPEI).[39] Moving underground, COPEI devised an alternate tactic and founded a clandestine publication called *Tiela* whose slogan "Contra un nuevo 2 de Diciembre" (Against another December 2) appropriated the date of the electoral fraud that brought Pérez Jiménez to power in 1952 and raised a cry against any repetition of such antidemocratic acts.[40] Beyond national borders, exiled members of Acción Democrática compiled newsletters to counter optimistic reports of life under the New National Ideal, resorting at times to shock tactics such as the publication in the May 1953 edition of *Noticias de Venezuela* of a graphic photograph of lawyer Germán González lying dead on the ground with a caption claiming he had been murdered by the Seguridad Nacional police force inside its headquarters.[41]

Clandestine publications attested to dissent; they also brought real consequences. Political activism and counternarratives of modernity fueled the repressive apparatus, and when dubious information was detected the Seguridad Nacional would open a file on the perpetrator.[42] According to José Agustín Catalá, whose Editorial Ávila Gráfica printed materials for AD during the dictatorship and who went on to become the chief publisher for postdictatorship testimony, the Seguridad Nacional under its director Pedro Estrada amassed 136,000 files on suspected dissidents, conducted raids on more than half a million homes, and resorted to violent punishments from persecution to extrajudicial killings.[43] Evidently, the production of nonconformist information was a risky endeavor, as is shown by the seminal clandestine text of the dictatorship, the *Libro negro de una dictadura: Venezuela bajo el signo del terror, 1948–1952*. Political activists compiled the 438 pages in secret as a counterarchive that wrote a history that was dramatically different from the rose-tinted accounts promulgated in official propaganda. José Vicente Abreu, a collaborator on the volume, recalled in evocative terms the precarious circumstances in which this compilation of manifestos, government telegraphs, and records of persecution, imprisonment, and torture "had to move silently in the shadows, without leaving a trace, perhaps with the beating heart that was passed onto it by humans."[44] This humanizing description and the references to the book's covert circulation suggest an entanglement of space, biopower, and repression, in which the bodies of those who countered the dominant narrative of progress were relegated to a perilous existence.

It is telling that at the same time the regime promoted the modernization of the health-care infrastructure, its leaders also commissioned the expansion of Venezuela's carceral institutions.[45] Visibly, the regime gave the impression of promoting humane forms of restoring and fostering social order, using state publications to showcase the Penitenciaría General de Venezuela, in San Juan de los Morros, Guárico state, as a reformist utopia of enterprising activity, fitted out with a host of workshops from shoemaking to carpentry; quarries for cement-block manufacturing; and agricultural production from corn, fruit trees, and flowers to cattle and chickens.[46]

Clandestine documents tell a different story. The jail served to kidnap dissidents, who were kept locked up in their cells, not allowed visits or contact with their families, and deprived of medical assis-

tance.[47] Against the glowing reports of updated jails, postdictatorship testimonies described Venezuela as "una sola prisión"—one big prison of *sótanos* (basements) and *cámaras de tortura* (torture chambers) at the Seguridad Nacional headquarters, and a roll-call of sites of torture and reclusion, including Ojo de Agua, El Junquito, and prisons like the Cárcel Modelo in Caracas, the jails of Ciudad Bolívar, San Juan de Los Moros, Maracaibo, Trujillo, San Cristóbal, Tucupita, Maturín, and Barcelona, and even modest provincial police stations, which became "antros carcelarios" (prison dumps).[48]

While descriptions of the spaces of confinement are scant, the human body comes to the fore, beaten, burnt with cigarette butts, jolted by electricity, and deprived of food. Using an unembellished forensic style of description, Catalá's "Nómina parcial de torturados" (Partial list of torture victims) illustrates the diversity of physical abuses and detailed accounts of torture. For one trade unionist who refused to toe the line, this meant having his body bound, cuffed, beaten, then hung naked over blocks of ice, and receiving electric shocks to his ears.[49] The repertoire of torture techniques that appear in the multiple records published after 1958 suggest that, at its most repressive, the regime methodically undermined its own protective and formative role by building sites and deploying mechanisms that violated precisely the promise of well-being and physical integrity ostensibly safeguarded by the state institutions.

The collapse of this promise is best illustrated by a detention center reactivated during the dictatorship on the remote island of Guasina, located eight hundred kilometers away from Caracas in the tangled river ways of the Orinoco Delta.[50] Here, amid barbed wire and crumbling prison blocks, the civilizing and transformative foundations on which superblocks, public spaces, and hospitals were built were systematically reversed and a cruel face of modernity disclosed.[51] While the regime promoted a polis for docile bodies, it expelled problematic subjects to geographical hinterlands like Guasina, as well as the Colonias Móviles de El Dorado and the Cárcel de Ciudad Bolívar in the far southeastern reaches of Venezuela's Bolívar state. Guasina began as a temporary center for undocumented immigrants during World War II but was later closed when it was deemed unfit for human life. In early November 1951, the first boatload of 443 political prisoners from jails in Caracas, Barcelona, Cumaná, Carúpano, and Tucupita were shipped to the insalubrious and inhos-

pitable island and forced to rebuild the decaying cabins erected for previous occupants. A second group joined them in April 1952, and a third and final convoy arrived in July before Pérez Jiménez closed the camp on December 21, 1952, in a postfraud, pre-Christmas act of benevolence.[52] This "huge breeding ground for larva," as Guasina was later described, divulges an antithesis to the celebrated ideals of transformative spaces designed to dispense social improvement, showing that the official discourse of unrelenting progress also had footholds in the systematic mechanisms to curb spaces for political activity and to repress dissident bodies.[53]

•

This overview of housing and welfare, demobilization, and incarceration sketches a more complex picture of the New National Ideal comprised both of liberating promises and subjugating thrusts. There can be little doubt that the dictatorship took committed steps to remedy the housing deficit and provide affordable and sanitary homes. Nor could one deny the evident commitment to expanding health care and promoting nutrition and education. Nevertheless, just as the New National Ideal mandated a radical transformation of space, so too did it advance the paradigm of an ideal social corpus, which had real and regulatory impacts on people's bodies. The updated mode of mestizaje (miscegenation) based on cultural stereotypes and dubious biological grounds and the advocacy of core military values of order and discipline in educational settings make it clear that state plans for superación mustered biopower in order to tailor Venezuelans to a vision of the nation controlled from the top down.

Shielded by the pledge to govern *only* in the name of national well-being, spatial transformation, and social improvement, the rulers co-opted the political agency of unions, eliminated partisan politics, and censored nonconformist ideas. As the military rulers simultaneously demobilized syndicates and built the modern Casa Sindical, the borders between benevolence and coercion became irredeemably blurred. When dissident activities called into question high modernist prospects of progress and undermined the new political regime, the regime quickly substituted harsher measures for benign mediation and formative policies. Most gravely, the infrapolitical conditions of Guasina and the implementation of violence

against the same bodies whose protection was enshrined by the New National Ideal reveal the precarious foundations on which the ideology of progress also rested.

The central pledge of bien nacional (the national good) obviously provided a capacious setting for state intervention into the space and life of the nation, but while the promise of material and spiritual improvement took shape as a tangible reality, so too did the violent impact on the bodies of those who offered resistance to military rule. Remembering these overlapping realities casts the legacy of modernity in more nuanced terms. The 1950s were indeed a period of innovative design, modernist architecture, and ambitious projects for social change. At the same time, the decade brought a political scenario in which an antidemocratic government felt empowered not just to envisage a master plan for Venezuela's development but also to resort to repressive means to bring back into line subjects who refused to march obediently behind the nation's military leaders.

• PART II •

SETTING
THE SCENE

CHAPTER 3

NATION BRANDING

FROM COVERT PROPAGANDA
TO CORPORATE PUBLICITY

• Even though the Junta Militar moved quickly to craft the official libretto that promised Venezuela would become "ever more prosperous, dignified, and strong" and rolled out public works projects to secure rapid change, in the months after the coup much still hung in the balance. As one regime insider put it, the stakes were high: "A government that is just starting and is undergoing a period of struggle like ours can only be sustained by people whose loyalty is beyond doubt and who feel compelled to defend it with their own lives."[1] Engaging Venezuelans in the promise of progress was key to upholding social and political order. But as the Junta used censorship and propaganda to claim only military rulers could deliver Venezuela to modernity, the risk was that people would realize this optimistic story was essentially a monologue. The call for the Junta to close ranks had come from Pedro Estrada. In early 1949, before his appointment as director of the Seguridad Nacional (National Security political police force), Estrada had been sent on a lengthy tour of the Caribbean and the United States, tasked with gauging the threats posed by exiled dissidents who were cooking up conspiracies to overthrow the regime.

Midway through his mission, Estrada sat down at the desk in his room in the swanky St. Moritz Hotel in Central Park, New York, to write a letter apprising his allies of what he had found out so far.[2] Although he said a detailed account would produce a report several kilometers long, over five pages the Junta's envoy gave concise and candid assessments of existing diplomatic staff, details of potential informants, and the espionage and private detectives needed to track dissidents. He elaborated on meetings with foreign leaders such as Dominican dictator Rafael Trujillo who were prepared to collaborate with the incoming rulers and reported on those less sympathetic to the recent turn of events in Venezuela. Contrary to his legendary urbanity, when it came to describing the regime's public image abroad, Estrada did not mince his words. "Pro-government propaganda is managed appallingly," he wrote, and diplomatic envoys were not committed to demonstrating the "truth" about Venezuela. Unless the government got a grip on public relations, he warned, *estaremos muy mal* (we'll have serious problems).

Through his roles as image consultant, political advisor, and mastermind of police repression Estrada personifies the blend of persuasion and coercion that shaped the military project to build the New Venezuela. More specifically, his reconnaissance mission for the Junta sheds light on the way in which nation branding and public relations became linchpins of political legitimacy, as the regime exercised behind-the-scenes control of coverage of Venezuela in mass media both at home and abroad. Nation branding is a relatively recent concept, which clarifies the Junta Militar's control of state propaganda and sets out critical terrain on which to think how other agents and stakeholders echoed these same promises of progress or formulated complementary missives that served their own vested interests. In this sense, as scholars of nation branding stress, the term is not a mere synonym for public relations but, rather, designates a composite of narratives and representations that shape the meanings associated with a particular territory: an amalgam of ideas that reflects clusters of economic and cultural factors in which other agents, in and beyond the state, craft, reaffirm, and contest specific messages.[3]

To unpack the forces that constructed Venezuela's nation brand in the 1950s, it is important to consider the range of representational strategies that reinforced the notion that military leadership, public

works, and capitalist development were a recipe for progress. The military regime followed in the footsteps of governments from Egypt to Argentina who tapped into what Scott M. Cutlip terms the "unseen power" of public relations professionals who acted as mediators between political leaders and public audiences in the roles of promoters, propagandists, and lobbyists.[4] In the broader economic landscape, relations between the military regime and public works contractors created positive feedback for the New National Ideal through corporate publicity, while oil culture also had a role to play in reaffirming messages of progress. The blurred boundaries of military propaganda, covert public relations, and corporate publicity provide a means of thinking through the way economic relations that buttressed the official slogan *¡Venezuela progresa!*

STATE PROPAGANDA AS "STRAIGHT" JOURNALISM

In 1954 *Life* magazine published a ten-page photo report on Venezuela, dubbed a "New Latin Boom Land." To tell the story of this sudden success, the article opened with a landscape view of the rising dawn in the capital and a text that narrated the nation's awakening in whimsical and exotic terms: "Until 10 years ago, Caracas, the capital of Venezuela, drowsed in colonial charm—a place of perpetual spring, of bird sellers and of guarded señoritas who were courted through barred windows. Then a great gush of oil from a fabulous pool brought Caracas suddenly alive."[5] The article blended official discourse with probusiness pragmatism, situating the photographs with subtitles like "The New Caracas" and "Under a firm rule, freedom to spend," which cast Venezuela as a land of opportunity for local residents and foreign investors alike. To confirm the burgeoning industrialization and investment prospects, an aerial view of the "Mountain of Iron" at the Cerro Bolívar in the south depicted a verdant mound crisscrossed with terracotta-red routes to provide access for the heavy machinery at the service of American companies' two-billion-dollar stake in steel and mining. Next, the "ultramodern" architecture of the Laguna Beach Club and Hotel Tamanaco, state-built apartments and a luxurious modernist mansion designed by American architect Don Hatch, offered readers proof that the exportation of primary materials was stimulating a construction boom and rising prosperity in this Caribbean playground. The article did

not skirt the political context but featured a photograph of Pérez Jiménez in full military attire next to a straight-talking caption that referenced the "bloodless coup" that had originated his "dictatorial rule." "But," the article offered an immediate rationalization, "under his firm hand the currency stayed rock-stable and strikes were eliminated." The reportage concluded with two landscape vistas: while the first picture of an equestrian club evoked Venezuela as a playground for the wealthy, the pastoral scene that concluded the article depicted a river filled with donkeys, people, and shiny American cars. This "Laundry for everyone" conjured a symbolic scene—one in which the rural traditions and the flows of capitalist development converged in the river.

Just like official propaganda, the report proclaimed Venezuela a land of bounty, turning on fulcrums of industrialization, architecture, firm governance, and prosperity. There was a reason why the *Life* article was so in tune with military rhetoric: the report issued from an ambitious public relations campaign devised to pass off state propaganda as straight journalism. Back in 1949 Pedro Estrada had laid the foundations for such covert strategies. After detecting the weaknesses in Venezuela's nation brand abroad, Estrada had leveraged his personal connections with U.S. media moguls in order to negotiate better promotion for the Junta Militar. "The day before yesterday I spoke with my personal friend Mr. Barnard J. Luce, the nephew of Henry Luce from *Time* and *Life* etc. Luce's vast networks make him a very important man in this country. He has agreed to work in our favor," he told his colleagues back in Caracas.[6] To cement the pact, Estrada escorted Luce to the Venezuelan Embassy in Washington so that the necessary arrangements could be made.

After the informal accords brokered by Estrada with "Father Time," a more concerted public relations plan soon emerged that enabled the regime to channel official discourse into direct and indirect forms of propaganda that reached audiences the world over, but especially in Latin America and the United States. The state commissioned films and articles, accepted positive coverage from friendly states, and facilitated access to journalists who were guaranteed to depict the national project in a flattering light.[7] Within this multifaceted strategy, though, one particular arrangement had unparalleled scope. In 1951 the Junta began conversations with the Hamilton Wright Organization (HWO), a U.S. public relations firm

based at the Rockefeller Center in New York. By April 1952 the regime had signed a contract with the firm to conduct an ambitious publicity campaign that lasted until Pérez Jiménez's overthrow in 1958. The company—founded in 1908 by Hamilton Wright and later run by his son, Hamilton Wright II—was a pioneer of public relations and worked for governments in Argentina, Canada, Ecuador, Egypt, Italy, Mexico, and Morocco producing newsreel and photographs, distributed with press notes or as free handouts to publications and motion picture houses around the world.[8]

From its Caracas bureau, HWO's mandate was to duplicate the core stratagems of state propaganda: to enhance the sheer volume and mass dissemination of proregime messages. The contract set out the company's pledge to publish 2,500 photographs 20,000 times in the United States, and in Central and South America; full-page photographs in U.S. newspapers; free distribution of 750 color photographs; and the provision of the best "typical shots" of Venezuela to Sunday magazines in thirty key newspapers in the United States. Audiovisual production totaled 165 documentaries and newsreels made on behalf of government institutions and ministries and co-produced with companies like Warner Brothers and Universal International for domestic or international distribution within a month of production.[9] Finally, just like the meticulous storage of documents at state archives, all photographs would be archived for posterity at the HWO headquarters at the Rockefeller Center and made available to the press for free.

"PICTURES DON'T LIE"

Beyond the quantity of material produced and the scope of distribution, HWO offered clients a unique selling point. Its brand of "pictorial publicity" provided a means of fabricating credibility for clients by inserting covert propaganda into mainstream media. The strategy was the perfect fit for a regime that presented modernist architecture as the hallmark of modernity and governmental efficiency. The role of HWO would be to expand the scope of the existing methodology of verifying the emergence of a New Venezuela through the changing landscape. The firm prioritized visual content on the basis that images transmitted instantaneous, apparently unmediated messages. As Hamilton Wright II put it, the agency offered a one-way

channel of communication to engage readers and viewers, promising that "pictures don't lie—you get the message instantly."[10] In this sense, HWO engaged a long-standing epistemological paradigm that bound photographic images to objectivity, truth, and authenticity. According to William Fox-Talbot, one of the founding fathers of photography, the camera's mechanical "eye" surpassed the inconsistencies of the human hand, becoming a pencil of nature that captured and fixed the external world onto paper.[11] This principle continued to have traction a century and a half later as photo reportage and magazines such as *Life* offered viewers objective windows onto the world. As John Berger pointed out in *About Looking*, the fundamental promise behind the magazine was that its photographs were not *like* life, they *were* life.[12]

Critics like Berger and Roland Barthes have shown that, before photo reportages or handouts appear on the pages of glossy magazines, the photographic message is carefully constructed. Because the photographic document is "irrefutable as evidence but weak in meaning," the accompanying captions produce the effect of certainty and dogmatic assertion.[13] Even a cursory look at HWO handouts reveals a recurrent paradigm that gave voice to the same type of triumphant discourse propagated by the regime. The headlines and captions glued to the back of press photographs obeyed consistent rhetorical strategies: to drive home the message of burgeoning modernity and the emergence of Venezuela onto the world stage hyperbole, analogy, and metaphor all held sway over accuracy. By this logic, a picture of a half-built arena comes with the headline "Venezuela to Hold Greatest Sports Festival: Invests $10,000,000 in 'Super' Olympics Stadiums," thus combining superlative adjectives and quotation marks to highlight the "super" scale of investment and to confer prestige on the endeavor. In a press release entitled "Super Bridge in the Andes," geographical precision gives way to mythmaking as the text evokes South America's famous cordillera to describe a highway far away on Venezuela's Caribbean coast. Similarly, an aerial view of the Centro Simón Bolívar is presented as "A magnificent view of the 'Rockefeller Center' project as seen from a helicopter."[14] Here, the use of a metaphor to describe the building *as* the iconic complex in New York—rather than *like* it—simultaneously evokes in Caracas the metropolitan skyline of the city's northern doppelgänger while contextualizing Venezuela's transformation for

international audiences by way of this favorable comparison. HWO photo reportages sent to different publications restated the conventional imaginary and standardized tenets of state propaganda under the cover of "straight journalism," circulating for foreign eyes images of modernist architecture, extractive industries in the south, and oil derricks in Lake Maracaibo under optimistic titles that evoked the nation's overhaul.

This covert campaign that blurred the boundaries between public relations and journalism was by no means exceptional. Throughout the 1950s official discourse was automatic fodder for supposedly objective reporting, and broadcasting propaganda on "radio or television, the daily and Sunday newspapers, [and] the illustrated magazines or 'slick' publications" was fair game.[15] Only in the mid-1960s did the Fulbright Committee bring the ambiguous interface of public relations and journalism to light for the first time. Perhaps in anticipation of a potential backlash, HWO was careful to maintain a façade of objectivity and used subtle methods to engineer positive coverage for the dictatorship. The agency extended personal invitations to handpicked journalists who were guaranteed to "fulfill the requirements of the information campaign" and created tailor-made itineraries that would cover strategic locations decided in advance.[16] Evidently, such stories were by no means "straight."

The vigilance paid off, favorable reports resounded in high-profile print media, and on February 28, 1955, Pérez Jiménez even appeared on the front cover of *Time*. Clad in ceremonial military dress and sash, the dictator was set against a backdrop of tropical forests, oil derricks, modern buildings, and the snowy tips of the Andes. The painted collage summarized the best typical views of Venezuela that HWO had pledged to distribute. Inside, no holds were barred as the journalist sycophantically dubbed him "Skipper of the Dreamboat," a youthful, sports car–driving president at the helm of Venezuela's buoyant oil economy. Caracas, for its part, was "a bursting city overhauling itself so fast that the visitor who returns only once a year can easily get lost. Under clouds of dust, half pulverized rubble and half cement, new super-boulevards crash through old slums, and lavender-painted buses soon roll along them." As well as legitimizing the military administration by casting the dictator in a favorable light and presenting the public works as his personal plans, the article made no mention of political opposition, suggesting instead that

all Venezuelans were on board this "dreamboat" as it made its way to a glorious future, just as the New National Ideal had promised.[17]

PROGRESS ON THE SILVER SCREEN

Similar diligence applied to the films and newsreels produced under the HWO contract by Metro News, Fox Movietone, Paramount News, and Universal International Newsreel. Not only were these short features distributed to more than two dozen local cinemas, they were also screened in the United States, Latin America, and as far afield as the Philippines and Egypt.[18] Official records show that HWO newsreels, from Fox Movietone, Metro, Paramount, United Universal, and Universal Pictures reached a staggering total of 68 million viewers.[19] The format served the regime well; the expansion of cinema increased audience numbers and the luxurious movie halls built in the mid-twentieth century lent a frisson of glamour to the news of Venezuela's progress. Amid the rustle of people taking their seats, the lights would dim and then would come the rousing music of short segments of global news segments dubbed, in Paramount Picture's case, "The Eyes and Ears of the World."

In 1953 at least three newsreels showcased the inauguration of the Autopista Caracas–La Guaira—the brand-new highway linking the capital to the coast. The magnum opus had been rushed to completion after Pérez Jiménez's fraudulent rise to power in 1952 and thus took on particular significance in the quest to legitimize the dictator and offer proof of his capacity to deliver results in record time.[20] The slightly different turns of phrase and montage of footage in the newsreels reinforced a consistent message of expedited progress, while also simulating a diversity of coverage that made this event seem newsworthy. In each film, the voice-over marveled at the road's modern engineering before attributing the accomplishment to Pérez Jiménez's administrative efficiency. To highlight the magnitude of the project, aerial shots emphasized the road's length (fig. 3.1), ground-level shots showed how tunnels cut through the mountains, and close-up shots of the Viaducto No. 1—a huge bridge built over one of the deep ravines along the route—revealed the challenging nature of the topography. From here, the films shifted the focus onto the crowds of the more than one hundred thousand Venezuelans who had gathered to see the ceremonial inauguration, cutting to the throng

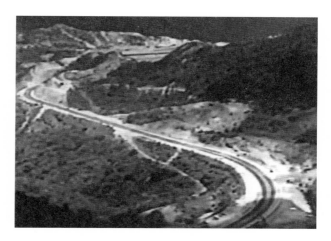

Figures 3.1 and 3.2. Stills from "Inauguración de una carreterade $60,000,000 en Venezuela." Noticiario Movietone, 1953.

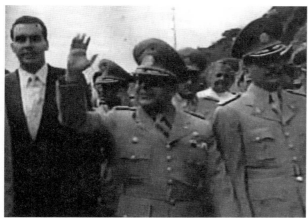

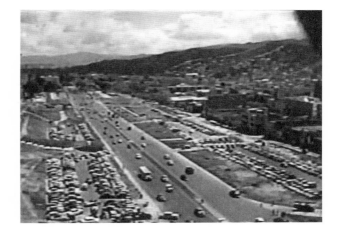

Figure 3.3. Still from "Inauguración de Obras Públicas." Paramount News, 1953.

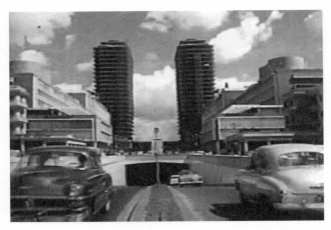

Figures 3.4–3.6. Stills from "Inauguración de Obras Públicas." Paramount News, 1953.

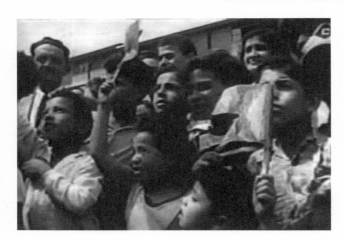

of photographers covering the event, and showing Pérez Jiménez greeting people and snipping the inaugural ribbon (fig. 3.2). All the while, the voice-over put the event in context, explaining to viewers by referencing the cost of the investment that they were witnessing a feat of engineering as audacious as the Panama Canal: proof that Venezuela was progressing *a pasos agigantados* (by gigantic leaps).

Newsreels created the same year to cover a broader corpus of public works inaugurations made these gigantic leaps a hallmark of Venezuelan progress, thus enhancing the modern built environment as a core element of the official nation brand. While Universal Pictures repeated the phrase verbatim, Paramount News tweaked it to claim "Venezuela continues its gigantic public works plan at a truly rapid rate."[21] The montage also followed a standard recipe, coding Venezuela's dramatic changes visually through aerial establishing shots that dropped to ground level and then panned up over new public works, training the gaze to encompass the full extent of the city's transformation, as well as the details of modernist design. In the Paramount film, the camera panned along the valley before cutting to a wide shot of the Avenida Bolívar (fig. 3.3), then "looking" 180 degrees in the other direction toward the Centro Simón Bolívar, whose two towers still under construction were lauded as an exemplar of the "gigantic public works plan, rarely matched and never surpassed in our times" (fig. 3.4). Next, still at ground level, tilt shots veered up over towers' façades before cutting to military officers and crowds of children and adults, who applauded the inaugurations of housing and state institutions and waved handheld flags (figs. 3.5–3.6). As the film concluded by equating the "spectacular" Centro Simón Bolívar with the Rockefeller Center, the HWO hallmark emerged into view, recycling an analogy that became a cornerstone of their proregime message. Even as tweaks in montage or script masked the fact that all these different newsreels came from one source, the same propagandistic libretto prevailed: as a modern marvel, viewers had to see Venezuela's transformation to believe it. Pictures didn't lie.

RED CARPETS, KHAKI UNIFORMS

In Venezuela the borders between public relations and official rhetoric were less blurred in films and newsreels commissioned to bolster

the official nation brand, since the regime contracted local production companies Bolívar Films and Tiuna Films to summarize public works and certify modernity. In these films the overlap of conventional propaganda and voice-over script was so evident that it is hard to believe any cinema-going Venezuelan would not have intuited where these messages came from.[22] Bolívar Film's Technicolor news segment "La Cinemateca del Aire" produced from December 1955, is a case in point, which epitomizes the expediency of film montage and voice-over as tools to reinforce the official libretto. One episode of "La Cinemateca del Aire," offered an annual overview of government activities that replicated the annual reports circulated in print by the regime.[23] As the footage moved from military installations to public works, the voice-over narrated the manifold achievements of the regime without stopping to catch a breath. The reel began by lauding the modern and functional architecture, harmonious play of color and light, and extensive thirty thousand square meters of gardens of the brand-new Club de Oficiales in Maracay. Shifting from contemplative to festive ambiences, the narrator first noted how "each new angle of the architectural details is picturesque and different," then the footage swiftly cut to the gala reception where Pérez Jiménez started off the inaugural dance with the wife of the commander of the Armed Forces. After this jovial interlude, the film turned to business: Pérez Jiménez inspected parading troops and new aircraft at the Boca del Río base. Next up on this whirlwind tour, the president unveiled a statue in Caracas, snipped a ribbon at a health institution, then hopped aboard the new cable car for its inaugural ascent of the Ávila Mountain, and cut the ceremonial ribbon to open a new section of the Coche–Los Teques highway, which offered "unprecedented panoramic charm." After brief shots of more health institutions, plazas, ports, lakes, roads, and housing, the film reaffirmed that what the viewer had just witnessed were "concrete projects of extraordinary dimensions that consolidate the New National Ideal."

While newsreels such as these served as overtures for movies, feature-length documentaries on Venezuela graced the silver screen to translate state propaganda into longer and more lyrical accounts of vertiginous progress, patriotism, and renewed glory. The most prolific filmmaker of this particular genre was Manuel Vicente Tinoco, who produced proregime films either on direct commissions, in

collaboration with HWO, or on his own initiative. Whatever the contractual agreement, the films provided favorable, even sycophantic coverage for the military modernization project. The titles speak for themselves: *Caracas hoy y mañana* and *La Nueva Venezuela* evoked military rule as a new chapter in history. *Paisaje de la patria, Baluarte de la Patria*, and *La Semana de la Patria* reinforce the nationalist thrust of the regime. *Dinámica de un ideal* and *Miracle in Venezuela* reiterate the marvels and vigor of transformation. *Paraíso del Trabajador: Colonia Vacacional Los Caracas* celebrates the holiday complex designed and built for the nation's workers.[24] The content of the films also served to cast Venezuela as a nation of discipline and diversion, rational plans and astonishing results. While *Baluarte de la Patria* documented military installations and simulated warfare scenarios, *Paraíso del Trabajador* transported viewers to the beach resort's nightclub where a merengue band played for workers. In the Technicolor *Miracle in Venezuela* set to the soundtrack of the national anthem, as the camera panned up over ranchos to the superblocks, Tinoco interposed details about the housing plans with exclamations about the nation's astonishing transformations.

The scope of this branch of propaganda is shown by the number of films, the diversity of shooting locations, and their distribution in Venezuela and abroad. Moreover, the fact that the official collection of images at the Archivo Histórico de Miraflores contains still photographs from behind the scenes reveals the investment in optimizing positive exposure for the government by all means (figs. 3.7–3.8). To compound the equation of modernity with a form of social and geopolitical prestige, propaganda films in Venezuela received red carpet treatment. Framed by the glamour of gala screenings attended by men in uniforms and ladies in silk dresses with fur stoles, press advertisements for the films emphasized the honor of showing them to military and diplomatic dignitaries. When Cines Unidos announced the gala premiere of Tinoco's *Dinámica de un ideal* in March 1955, a film "inspired by the ideology and work of the government presided over by Coronel Marcos Pérez Jiménez," the company made a point of publicizing his attendance by capitalizing his name and noting that the First Lady, the cabinet, diplomatic corps, congressmen, representatives from the highest echelons of the judiciary, and the Armed Forces would also be in attendance.[25] Indeed, the notice emphasized exclusivity, telling readers only those bearing the

Figure 3.7. On location making the film *Miracle in Venezuela*. Archivo Histórico de Miraflores.

invitation sent out by government minister Vallenilla Lanz and his wife would be allowed entry. The issue of distribution was just as important as prestige, since what was the use of mass media if only a few people had access? The announcement promised the film would soon be available in all Caracas movie halls and in the provinces, while subsequent news articles stressed that documentaries would be "profusely" copied and sent to social and educational institutions to multiply their impact, assuring readers that spectators abroad would also get their chance to witness the nation's progress. As one article stated, a month after the gala premiere of *Dinámica de un ideal* the production company signed a distribution contract with Republic Pictures in the United States. This film of the progress of the nation, the article promised, would be subtitled into five languages, shown in *all* of Venezuela's cinemas, and then screened for an estimated 90 million viewers worldwide.[26]

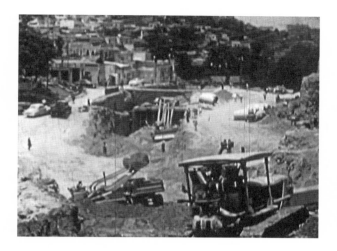

Figure 3.8. Still from *Miracle in Venezuela,* **directed by Manuel Vicente Tinoco, 1956.**

VESTED INTERESTS AND CORPORATE ENDORSEMENTS

Covert propaganda was not the only channel for official discourse to circulate beyond the state. Companies voluntarily assisted in this task, advocating spatial transformation and industrialization as catalysts for *superación* and claiming that together military rulers, corporations, and the population were all striding toward progress. This echo chamber of optimistic messages was an effect of the economic relations that public works projects forged between government and private sector. Housing, road building, and other infrastructure projects were key props for military rule and received generous funding, so private companies had much to gain from fostering congenial relations with the men in power. In 1955 alone, despite the substantial funds allocated for public works in Caracas, the government ended up overspending by more than half its original calculation, and this was no exception.[27] The benefits were mutual: the majority of contractors had direct ties to the military regime and the congenial tradeoff endured until the end of the dictatorship as the construction industry took advantage of lucrative government contracts.[28] In return, corporations and contractors endorsed military rule, top-down planning, and industrialized capitalist production: cement was building the nation; bulldozers were driving development; motor oil was greasing the engines of progress. . . . And on it went.

A key example of how companies became mouthpieces for official discourse transpires in announcements published about the

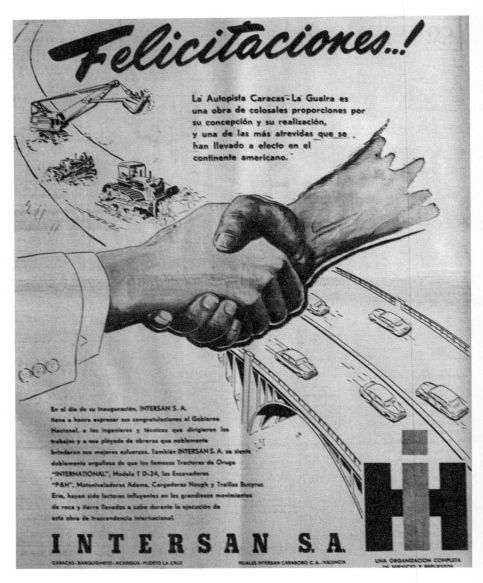

Figure 3.9. "Felicitaciones . . !" *La Esfera,* **December 2, 1953.**

Caracas–La Guaira Highway. The sixty-million-dollar road was a much-publicized flagship of Marcos Pérez Jiménez's dictatorship and the promise that modern infrastructure would accelerate Venezuela's transformation. The road's knock-on effects were billed as

wide-ranging. The link between the capital, the Maiquetía airport, and the seaport at La Guaira would impact on trade and leisure alike. HWO made much of the surge of imported vehicles, sending out press releases that showed cars lined up along the seawall awaiting transfer to the decadent showrooms in the capital.[29] Local drivers would no longer have to zigzag down the old road to the coast. Now, the highway fast-tracked them to smart new resorts like Marina Grande, dubbed the "barrio marítimo de Caracas" (Caracas's seaside neighborhood), and the resort of Playa Grande, where Pérez Jiménez himself had a beach house.[30] The highway and new littoral avenues built along the coast greatly improved access to its beaches and were also instrumental to the construction of the Ciudad Vacacional Los Caracas, some fifty kilometers east of Maiquetía. Much more than a long strip of cement, the highway symbolized keystones of Venezuela's nation brand of firm governance, burgeoning marketplace, and Caribbean paradise.[31]

As a site where vested interests and positive connotations converged, the highway became a staple of corporate publicity. The coverage it received from the private sector both reinforced military rule as a cipher of progress and enhanced the brand images of the companies involved in the road's construction. On inauguration day, a full-page announcement placed by Intersan—a brand of heavy machinery used in the road's construction—confirmed the military leaders' role as forerunners of Venezuelan modernity (fig. 3.9). Under the congratulatory headline "¡Felicitaciones . . !" a drawing of the road traced its route from construction to completion. The handshake that bisected the drawing of the highway, which showed it under construction and after completion, served to symbolize the public-private collaboration that brought it to fruition while the accompanying text gave the company the opportunity to reinforce the established hierarchy of contractual relations. The Intersan advertisement made scant mention of the company's machines and instead placed the focus on commending the regime on *its* completion of the highway. In short, this appropriation of the message of progress through construction served two functions: it upheld the balance of power between government and contractor yet also incorporated Intersan's products into the conventional and upbeat narrative of Venezuela's journey toward progress.

This annexation and amplification of standard tropes from military discourse also informed an announcement by Cemento Vence-

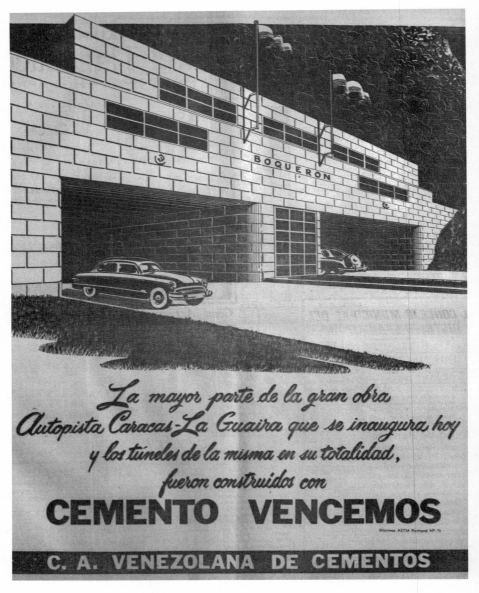

La mayor parte de la gran obra Autopista Caracas-La Guaira que se inaugura hoy y los túneles de la misma en su totalidad, fueron construidos con

CEMENTO VENCEMOS

C. A. VENEZOLANA DE CEMENTOS

Figure 3.10. "Cemento Vencemos." *La Esfera*, **December 2, 1953.**

mos, published in the same newspaper (fig. 3.10). Here, the overlap of official discourse and corporate publicity transpires in the brand name "Vencemos," whose literal meaning (We Vanquish) drew on

the New National Ideal's equation of built space to military victory. While the first-person plural proposes modernization as a nationalist endeavor from which all of Venezuela's imagined community emerges triumphant, the military lexicon reiterates the Armed Forces as ciphers of this "battle" to secure Venezuela's return to glory. This allusion to a dual triumph, at once national and corporate, military and civilian, reveals the discursive synergy between propaganda and publicity. The advertisement's depiction of one of the highway's tunnels weds this victorious battle to the materiality of modernity. While the visionary battle waged by the military regime pioneered engineering solutions as a route to development, the Vencemos brand of cement provided the building blocks to make this new spatial logic a reality.[32]

Even after the fever pitch of the highway's ceremonial inauguration had passed, companies continued to mine the symbolic import of the road, its tunnels, and its towering bridges. An advertisement placed by the Socony Vacuum Oil Company a year after the highway's inauguration reveals how private companies sustained the momentum and continuity of official proclamations of progress even when the focus of state propaganda was placed elsewhere (fig. 3.11). The Socony advertisement singled out the Viaducto No. 1—the largest of the highway's three bridges—as an allegory of modernity and, in so doing, renewed the conception of built spaces as national monuments: concrete mirrors in which Venezuelans would see their modern selves. The advertisement combined a photograph of the bridge with a text that reinforced the construction's dual function to index progress and to tell the story of modernity. In this "miracle of engineering," the caption went, "cintas de concreto cuentan la historia de una nación"—the bridge's concrete strips (*cintas*) were making history and telling the story of the modern Venezuela.

Beyond specific public works, a host of companies redeployed the general premises of military-led modernization. One in particular, published in November 1952, just days before the anniversary of the coup, merits close analysis. In a full-page announcement in *El Nacional*, synthetic fiber manufacturer Celanese proclaimed: "Venezuela is industrializing!" Reiterating the military rulers' promises to return Venezuela to the country's deserved *puesto de honor* (place of honor), the company declared the nation was achieving a *lugar destacado* (a prominent place) among industrialized nations (fig. 3.12). The ad draws on the conventional lexicon that cast modernity as both a feat

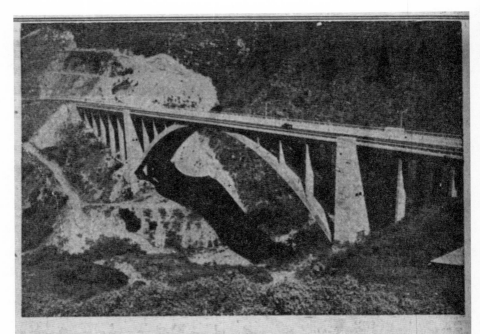

Cintas de concreto que cuentan

LA HISTORIA DE UNA NACION

Nuestra gran carretera que une a Caracas con la Guaira, con su fantástica cinta de cemento, sus túneles y sus puentes, es una de las más famosas carreteras del mundo.

Pero, más que su fama, este milagro de ingeniería cuenta la historia de la Venezuela moderna... es un ejemplo de la gran revolución industrial de nuestro país en las dos últimas décadas. En este enorme progreso industrial orgullosa-

mente hemos tomado parte lubricando la delicada maquinaria de grandes fábricas, equipo para la construcción de caminos y poderosos motores, utilizando para ello aceites y grasas de gran calidad que han contribuido a hacer la tarea más fácil, evitando descomposturas y pérdida de valioso tiempo.

La nueva carretera Venezolana fomentará la industria turística y automovilística en la que Mobiloil toma parte activa en el mundo entero desde hace 88 años.

SOCONY VACUUM OIL COMPANY OF VENEZUELA

Figure 3.11. "Cintas de concreto que cuentan." *El Nacional*, November 4, 1954.

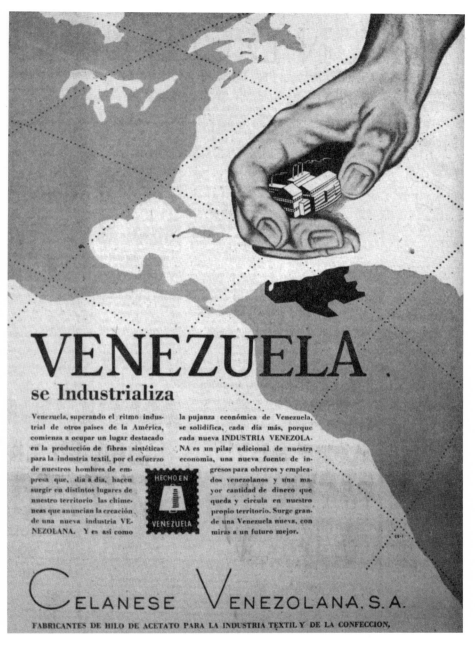

Figure 3.12. "Venezuela se industrializa." *El Nacional*, November 19, 1952.

of miraculous intervention and a result of technocratic governance. Against the backdrop of a Pan-American map, a huge hand holding a diminutive factory literally transplants industrial infrastructure onto Venezuela. By depicting the territory as a blank slate and the hand as either state or private agent, the advertisement confirms the pledge that mechanized production would put Venezuela on a global map of industrialized nations. Following the New National Ideal's causal association of national development to self-improvement, the accompanying text conjectured profit as the ultimate aspiration for nation and workforce alike. Much as official propaganda emphasized the capture and administration of oil revenues as the condition for modernity, the advertisement cast capital accumulation as the precondition for national stability and progress and, using an architectural metaphor that evoked the regime's bid to build modernity, claimed: "Venezuela's economic vigor becomes increasingly solid every day because each new VENEZUELAN INDUSTRY [*sic*] is an additional pillar for our economy, a new source of income for Venezuelan workers and employees and a greater amount of money that remains and circulates in our own territory. A grand new Venezuela is emerging, with its eyes set on a better future." As it summoned official discourse, capitalist tenets, infrastructure, and workforce onto common ground, this particular advertisement exemplifies how corporate publicity appropriated the official story of progress to enhance brand image, creating channels for positive feedback that looped right back to the military regime.

OIL, THE FUEL FOR THE NATION BRAND

Venezuela's consolidation as an oil economy brought a key shift in its nation brand and the concept of modernity. Although, as Fernando Coronil contends, the country's extractivist economy maintained it in a similar league to banana republics and plantation societies (which were considered underdeveloped in contrast to the industrialized economies of the so-called first world), official propaganda and corporate literature alike stressed that the nation was progressing toward the cultural distinction and material trappings associated with the "advanced" agents that extracted and consumed its primary materials.[33] Yes, Venezuela was an oil nation, went the standard narrative; but look how its flourishing economy is building progress!

Look how similar it is to the United States! To underscore this message, government propaganda largely eschewed the materiality of oil extraction and concentrated instead on the fruits of oil's booming dividends. Even as official publications featured photographs of shiny new refineries, oil derricks, and pipelines, the texts that accompanied such images were fixated on other issues. In a seven-page article on oil that appeared in *Así progresa un pueblo*, a cursory history of the petroleum industry soon gave way to the core message: oil was fueling the infrastructure and import economy that elevated Venezuela to the status of developed economies. "The main feature of today's Venezuela is that it is a rich country, an astonishingly rich country that lives at a rhythm approaching vertigo. . . . A country whose state . . . spent more in one year than it spent since Venezuela separated from Gran Colombia." Emphasizing profit over production, the same text went on to note with jovial irony that "prosperity brings its problems, but they're all down to overabundance [*superabundancia*]. There's nowhere to park the car—because everyone has a car. . . . Europe is really interesting,—thinks the Venezuelan—but Venezuela is much more comfortable. Here you can get hold of everything!"[34]

While the military government used the nation's status as a consumer of imported commodities to distinguish Venezuela from the cultural hierarchy ingrained by global capitalist flows, oil companies also drew on similar ideas, but with a different aim. Eager to attract expat workers to oil production hubs and to help them adapt to life in the tropics, oil corporations cast Venezuela as a rapidly developing modern nation that was not so different from its northern neighbor. This mission to confirm Venezuela's development on the basis of its embrace of the American way of life transpires clearly in the twenty-four-minute color film *Assignment Venezuela* (1956), produced by the Creole Petroleum Corporation, a subsidiary of Nelson Rockefeller's Standard Oil. The film follows Jeff—an American oil engineer—as he relocates to Venezuela and writes home to Ann and their two boys, who will join him once he has settled in. As a narrative devised to prepare staff for relocation to Maracaibo and to mitigate culture shock, the film synthesizes the positive feedback between propaganda and public relations. Even as it pursues different aims from those of the propaganda created in the service of the military regime, the film nonetheless disseminates a message of the oil nation's rapid transformation.[35] As the locations shift from Maracaibo

to Caracas and back to the oil camp at Lagunillas, Jeff's voice-over highlights Venezuela's economic, cultural, and architectural development at every turn.

Driving an American car through downtown Maracaibo, Jeff muses on the city's similarities to the United States, saying he almost feels as if he hasn't left home. In Caracas, the brand-new university campus where he studies Spanish gets a starring role, before he takes a tour of the city praising one flagship public works project after another, and even likening the Centro Simón Bolívar to New York's Radio City. Even the "tropical" environs of the camp and the temporary Quonset hut into which he will move while his family make their way south are a home away from home. This upbeat narrative reveals mutual positive feedback between oil culture and official propaganda, thus clarifying how corporate culture sowed ideals of social betterment that could be reaped by the military regime. Indeed, decades before the New National Ideal was formulated oil enclaves had been forerunners of paradigms of spatial modernization and social superación. As architectural historians have shown, even when camps were separated from society, their boundaries served as both "a fence and a window" and the separation of the enclave as a model site of hygienic and functionalist modernity helped to cement this mode of lifestyle as a paradigm to emulate.[36] Camps fostered the association between imported goods and social improvement that later informed the representation of Venezuela as a marketplace for foreign commodities, a representation dominating the military leaders' claim that the nation was more than a source of primary materials ripe for extraction; its citizens were becoming discerning consumers of modern merchandise.[37]

Corporate culture and communications laid groundwork that presaged the military ideology for superación and the reification of foreign culture as a marker of modernity during the 1950s. Even as they presented the corporation—rather than the government—as the main agent of development, publicity and media campaigns advocated ideals that were not too far from official propaganda. Under the banner of social improvement, companies advised locals to overcome their "backward" habits and embrace corporate models of efficiency that would further national development. Similarly, the Creole-sponsored weekly program *Aplauso al mérito* (Praise for Merit) awarded plaques to exemplary Venezuelans, which the company sin-

gled out for their contributions to national development. As Miguel Tinker Salas points out, this was an attempt "to remake the Venezuelan character—to promote a Western concept of time, labor, and management and to purge Venezuelans of 'negative traits' stereotypically associated with Latin American culture."[38] By embedding time management, individualism, respect, punctuality, and efficiency as paragons of modernity, oil companies sowed the idea that mañana (tomorrow) was a tainted word and briefed Venezuelans on the social models that would later be advocated by the military rulers.

Granted, companies were not beholden to the government in the same way that public contractors were, especially since oil companies sought to stymie nationalist sentiment so as to avoid the type of threats to corporate interests that had emerged when Mexico nationalized oil in 1938.[39] Yet even despite occasional editorial columns in corporate magazines where managers complained of the dictatorship's economic nationalism and repression of foreign capital, the expansion of company magazines in the 1950s generally promoted a positive nation brand.[40] After 1948 circulation of the monthly magazine *El Farol*, founded in 1939 by Standard Oil and published after 1943 by Creole, rose to twenty-one thousand, while January 1952 saw the creation of the three-yearly *Revista Shell*, which had a print run of seventeen thousand. Editorial policies resembled those of the state publications created to emphasize the associations of infrastructure, development, and social welfare. With contributions from emerging authors and talented photographers, oil company magazines depicted a national landscape undergoing changes but also rooted in enduring traditions—precisely the public image promoted by the regime. In sum, even as oil companies pursued their own agendas in line with vested interests, there is no doubt that their public communications reinforced the branding of Venezuela as a forward-looking nation on the rise.

•

During the 1950s the public relations agreement with HWO, the lucrative public works contracts, and the corporate agenda of oil companies reiterated the "gigantic leaps" Venezuela was making toward modernity. Whether advocates were beholden to the military regime or not, this nation brand of rapid development served to shore up

the political order and to mitigate the "clumsy" communications policies that Pedro Estrada had diagnosed during his reconnaissance trip in the wake of the 1948 coup. The blurred boundaries between overt and covert propaganda helped repackage official narratives for glossy pages and silver screens where they gained both prestige and gravitas. As doctrine was dressed up in alternate robes, the regime leaders sought to engage public consensus not because *they* said Venezuela was modern, but because *others* did. At the same time, economic relations and vested interests made corporations the mouthpieces to amplify similar messages of rapid growth, burgeoning industrialization, and modern architecture.

As print and audiovisual media certified Venezuela's progress the world over, and stakeholders advocated modernization and social improvement, the military rulers encountered ready-made foundations on which to consolidate the New National Ideal introduced after the coup of 1948 and to engage citizens at home in a common project that would, they promised, be of benefit to all. The result of the covert propaganda, corporate endorsements, and overlapping agendas shaping the nation brand was that in the 1950s it was not easy to discern precisely where state ideology ended and "independent" commentary began. These concomitant messages provide a further key to understanding the interlocking forces that shaped modernity as a cultural formation, showing how ideals of spatial transformation and social improvement penetrated deep into society, at once bolstering the regime's New National Ideal and retaining a degree of autonomy from it that evoked a general horizon of development beyond the immediate bounds of military rule.

CHAPTER 4

SPECTACULAR VISUALITY

ENFRAMING THE LANDSCAPE, TRAINING THE GAZE

The scenery and decoration call for new actors and so does
the public.

• LAUREANO VALLENILLA LANZ,
EL HERALDO, 1955

• In the pages that the annual government report of 1954 devoted
to the newly inaugurated Casa Sindical in Caracas, the trade union
center's theater was singled out for special admiration. The report
ventured that the regime had built what was likely the most mod-
ern performance space in all of South America: "It has an orchestra
pit, spinning stages, a cyclorama, electric decorations, projectors for
flat, panoramic, and three-dimensional films, five different colors of
lighting, cutting edge sound systems," the text noted. "In a nutshell,
it has everything one could ask of a top-notch space for spectacles."[1]
The image that accompanied the description depicted the brand-
new theater, empty, its scene set for the type of dazzling *espectáculos*
(spectacles) that would captivate viewers through a combination of
kinesthetic pyrotechnics and cutting-edge audiovisual technologies.
Stages would spin against the painted scenographies, moving images
would dart across screens, and electronically controlled props would
engross the audience.

101

This was no simple matter of stage and seating. The emphasis placed on equipping trade union centers with top-notch entertainment infrastructure was just one symptom of the policy of political demobilization that military rule entailed. The plan was that impressive displays of progress would compensate for the elimination of labor unionism and party politics. Taken in this political context, the technologies of display and pursuit of viewer engagement that dominated the design and descriptions of the Casa Sindical theater offer a more general insight into how modernity was configured as spectacle: a slick promise of progress designed to engross Venezuelans and divert their attention away from the truncated project of participatory democracy.

As the regime leaders set the stage on which public works would take precedence over political debate, they established a new cast of actors and a new distribution of roles: the military rulers emerged as authors of a New National Ideal and the main protagonists of modernity, and the people were called upon to watch and, of course, to applaud. The theater serves as a metaphor of how military rule staged modernity so it became an awe-inspiring spectacle. Forging an official libretto of spatial transformation and social improvement and implementing policies to those ends, the regime conjured cutting-edge visual technologies to view and represent the landscape and then set about staging scenes and displays devised to move Venezuelans to wonder, and, more importantly, to compliance.

Before analyzing in detail the modes of spectacle that emerged alongside the historiographical and ideological bedrock of military rule, it is important first to clarify the conceptual and theoretical implications of the term "spectacle." What affordances does it have for thinking through the nexus of dictatorship, space and vision?

THE POWER OF SPECTACLE

To invoke "spectacle" is to infer that vision, representation, and display are conditioned by power relations: a particular agenda deems certain things worth looking at; specific agents then capture those things and configure them for display; spectators are called upon to watch staged scenes. Here, the etymology of the term itself is instructive. Its modern usage to denote impressive displays and choreographed scenes grew out of the Latin verb *spectare* (to behold)

and noun *spectaculum* (a public show or theater). These definitions and the political context at hand refigure the notion of spectacle, placing the term in an expanded field where it encompasses actions, artifacts, and agents, as well as diverse gazes, visual technologies, displays, and performances. With this concept of spectacle comes one specific implication: that the term foregrounds the relations of power inherent in vision and display—suggesting that by *beholding* these dazzling displays, spectators are drawn into and perhaps become *beholden* to the ideological agenda of the agents who stage them.

This is precisely the thesis that Guy Debord parsed in *The Society of the Spectacle*, where he theorizes spectacle as a hegemonic formation that both mediates and organizes social relations, monopolizing the realm of appearances to entrench a given order that seems to become incontrovertible. In this attack on consumer culture and commodity fetishism, Debord claims that spectacular images circulated by the mass media stunt the potential for political and revolutionary uprisings because they have replaced human interaction. The ideologizing function Debord attributes to it in turn informs his contention that spectacle is much more than a visual repertoire; it entails the means by which the normative production and circulation of images—and their associated modes of representation, display, and spectatorship—determine dominant forms of power and political representation. Spectacle, in this sense, is "not a mere decoration added to the real world" but, rather, constitutes an ideologizing conduit for "the ruling order's non-stop discourse about itself, its never-ending monologue of self-praise."[2]

Although he arguably overstates the power of images and underplays the role of physical contact with space and people, the basic contentions of Debord's thesis and criticisms of spectacular images are germane to the context at hand. The official libretto forged by the Junta Militar claimed that the Armed Forces had a unique capacity to envisage Venezuela's transformation and the wherewithal to marshal top-down apparatuses that would deliver instant modernity. The New National Ideal entrenched a political order that bound the regime's legitimacy to the "deeds not words" mandate advocated by the rulers, thus making the "radical transformation" of the landscape a litmus test for efficiency. The monumental scale of novel infrastructure and the modernist aesthetics of state-funded constructions staged impressive displays of rapid change. And, finally,

the regime embraced varied visual technologies in order to engage spectators in Venezuela and across the world in acts of witnessing the "miraculous" feats of the country's rapid modernization.

Hence, much like the stage set for spectacles at the Casa Sindical, the Venezuelan landscape became a platform to perform the nation's entry into modernity. The military rulers conjured the territory as a blank surface on which they would found the nation anew; modern buildings were lauded as mirrors for collective identity; and images of these spaces became visual shorthand for progress, synthesizing heterogeneous realities into a coherent nation brand. In this sense, an "exhibitionary complex" converged on the landscape, updating precursory examples—when political power, whether of the sovereign or the nation-state, has been put on collective display to regulate social conduct. This is the scenario that Michel Foucault discusses in *Discipline and Punish*, by returning to eighteenth-century public executions as spectacles that encouraged restraint in subjects by exposing them to awe-inspiring horror. The shift from the staging of the sovereign's ability to mandate execution to the later development of the panoptical jail—where architecture pivoted on the modern state's disciplinary gaze and scientific rationale—shows that display and vision are lodged at the heart of political power.

Drawing on this background in *The Birth of the Museum*, Tony Bennett argues that exhibitionary spaces—such as the industrial fairs and public museums, which emerged alongside the modern nation-state in the nineteenth century—also exerted a disciplinary function through both architectural design and visuality. These open spaces created an honorific culture of display, rather than the punitive one Foucault discussed; by allowing for public congregation and engaging spectators in a "scopic reciprocity," in which they could see and be seen, these formative and noncoercive institutions also encouraged spectators to self-regulate their behavior in line with the prevailing social order.[3]

In 1950s Venezuela the military regime summoned similar mechanisms through the pledge that a transformed landscape would induce social improvement and instant modernity. The emphasis placed by political discourse and propaganda on architecture and infrastructure invited Venezuelans not only to view modernity but also to partake in the individual and social *superación* that modern spaces were to induce. In so doing, monumental buildings and the

constant circulation of images of them encouraged subjects to waive the possibility of political agency, identifying instead the changing landscape and recognizing that it was military rule, not democracy, that had paved this path to development. Regarded in this light, spectacle and spectatorship dovetail with the political order of military rule. The paradigm advocated by Pérez Jiménez—that modernity called for a society made up of docile and demobilized subjects marching in step with the visionary Armed Forces—also infers that the honorific image of the modern landscape would induce spectator-subjects to maintain the relations of power entailed in this model.

Still, the "practices, techniques, institutions and procedures of subjectification" inherent in the revised model of political representation were not all powerful.[4] The notion of spectacular visuality offers a useful caveat in this regard since it recognizes spectacle as the dominant visuality of the military regime but does not assume it to be the ultimate cipher of visual experience. As Nicholas Mirzoeff argues, even though dominant modes of visuality hinge on "the formation of a coherent and intelligible picture," they are also open to interruptions and negotiations.[5] The implications for the present context are clear: through spectacular visuality came additional battlegrounds on which the military rulers sought to secure Venezuelans' affective engagement in and compliant approval of the necessity of military rule as a condition for the heroic modernizing project to transform Venezuela.

SKEPTICAL VIEWERS OF THE DISFIGURED LANDSCAPE

The New National Ideal was founded on the idea that oil revenues should be channeled into transforming the landscape into a hallmark of Venezuela's modernity. Yet, governmental investment in awe-inspiring transformations was neither an entirely new phenomenon nor one that lacked detractors. From the 1930s onward, a number of intellectuals began voicing what might be termed a skeptical visuality. Amid the consolidation of the oil economy and the dramatic changes it entailed for the national landscape, writers evoked the spectacles of progress fueled by newfound revenues in a negative, skeptical modality. The changing landscape, they argued, was not proof of Venezuela's modern face but, rather, a sign of a widespread disfiguration

of all that was familiar and rooted in the nationscape. Witnessing with consternation the impact of oil, in 1936 the novelist and politician Arturo Uslar Pietri wrote a now famous newspaper column in which he called for policies to *sembrar el petróleo*—to "sow" oil reserves back into the land by creating economic policies that would reinvest the profits into Venezuela's agricultural and industrial production. The oil economy, he argued, was destructive, transitory, and contingent on foreign interests and would turn Venezuela into a parasitical nation, awash with a tide swell of revenues and headed for certain disaster. Fertile lands were becoming sterile, agricultural methods were out-of-date, deforestation was claiming trees for fuel but not replanting seedlings. Sowing oil profits back into the economy was the only way to offset a catastrophic crisis-scape. As a manifesto that set out to reimagine and remake the nation, the catchphrase "Sembrar el petróleo" summoned the human action of sowing seeds and the natural cycles of regenerative growth to envisage a metaphoric landscape that connoted economic productivity and deep-rooted identity. This prospective scene of diversified industries, a robust economy, and a fundamental respect for nature, he proposed, was what the Venezuela of the present and the future should look like.

This imaginary nationscape remained at the forefront of Uslar's writing just over a decade later when he published *De una a otra Venezuela* (1949), in which the prospect of national renewal took a more pessimistic turn. The central thesis, as the title suggested, was that the nation had undergone a fundamental shift, transforming from one Venezuela into a different one. This implied that the country's authentic image had been transfigured: no longer a predominantly agricultural economy, the nation was now shaped entirely by the oil economy. Against the regenerative potential he had posited earlier, Uslar now conjured a dialectics of space, economy, and identity. The Venezuelan landscape corresponded to a *nación fingida* (fake nation), "as transitory as the oil from which its appearance is constructed and no truer than a theater's decoration."[6] Inverting the linear telos of development, Uslar conjured falsehood as the cipher of a landscape that was mere spectacle: a slick theatrical mask contorted to display a glossy veneer of progress. As "artificial" imports, new service industries and international airplanes were implanted into Venezuelan soil, this "other" landscape uprooting traditional economies and ways of life and dislocating rural communities' modes of dwelling.

Uslar was not the only thinker to criticize the mission to dress Venezuela in modern robes. Other prominent critics invoked spectacular figurations to claim that rapid transformation was nothing but a theatrical illusion. Recalling Claude Levi-Strauss's comparison of modern cities in the tropics to "a trompe-l'oeil hastily erected to serve as a background for a film or a stage play," these thinkers expressed particular skepticism about the speed and the scope of urbanization that oil had fueled.[7] Rallying against "black gold" in Dantesque terms, Mariano Picón Salas evoked a satirical foundational scene in which the oil that burst forth from the earth, "illuminating with its flames the entire Lake [Maracaibo] and projecting fumaroles in the humid distance that resembled purgatory," was nothing but "the mirage of another El Dorado."[8] By 1954, when Caracas was firmly placed as the showpiece in the quest to build a New Venezuela, Picón Salas traced this mythical topology to the capital, dismissing the city's makeover as mere *peluquería tecnológica* (technological hairstyling). The historian and politician Mario Briceño Iragorry echoed this diagnosis by attacking architectural prosthetics as an attempt to compensate for the nation's *desfiguración* (defacement): skyscrapers were deceptive landmarks "made of foreign materials, with all manner of luxuries made of imported supplies" that created "an appearance of culture dressed up with artificial implants [*postizos*]."[9] As Caracas accommodated "little pieces of Los Angeles, San Pablo, Casablanca, Johannesburg, Jakarta[, and h]ouses in the style of Le Corbusier, Niemeyer, and Gio Ponti," the city became a deterritorialized mirror for other places: a spectacular "prism of appearances," as Picón Salas put it.[10]

These writers criticized rapid modernization by appealing to a series of dialectical formulations, pitting a natural landscape against a spectacular mirage, a real body against a prosthetic one, and local traditions against imported styles. Rather than interpreting the emerging skyscrapers as irrefutable beacons of a modernity writ large, the critics drew attention to the scaffolding that buttressed their hasty construction to claim that these landmarks were nothing but a glossy veneer. What is intriguing about this formulation, however, is that—rather than negating the idea that built space was a mirror for the nation—these critics revealed the persistent purchase this association had. Even as they interpreted the quest to stage spectacular displays of modernity in negative terms, they made it clear

that the post-1948 emphasis on spatial arrangements as markers of progress was itself built on solid foundations.

In this sense, the skeptical viewpoint adopted by critics also set the stage for continuing discussions about building modernity in Venezuela, albeit ones that ensued on the official side in diametrically opposite claims. If modernity was already associated with built space, all the military rulers had to do was make the spectacle of progress more dramatic, more exciting, and thus more engrossing. This context informed the claim that the changing landscape was not a disfiguration but a positive transformation that would enable national development and social improvement—hence the presentation of modernist skyscrapers as beacons of national renewal and the city's new highways as conduits of "la impetuosa corriente cosmopolita de la nueva Venezuela"—the cosmopolitan life force coursing through the nation's veins and making it new.[11] Recognizing the discrepancies between skeptical and celebratory appraisals of the quest to build modernity is not to arbitrate claims of truth and falsehood but, rather, to recognize that the changing landscape was a linchpin in the new rulers' related bid to materialize modernity and thus to engage Venezuelans in military-led progress. In short, the incoming military leaders leveraged the Venezuelan landscape in order to craft a set of visual relations and spectacular images that justified their seizure of power.

AERIAL PROSPECTS

The New National Ideal articulated a plan for territory-wide renewal, which would not just develop urban areas but would reach into the hinterlands through road networks, industrialization, and agriculture. This ambitious scale of development emerged in tandem with a growth of advanced visual technologies, which enabled centralized planners to survey and capture the land where the infrastructure of development could be set in place. Equipped with gridded maps and aerial photographs, planners devised nationwide transport networks and identified undeveloped lands ripe for deforestation. The types of images produced within development projects in turn projected horizons of progress by conjuring prospective landscapes that through top-down organization would become economically productive. This attempt to harness the nation's territory and refig-

ure it as prospect recalls the critical discussions of politics and vision developed by scholars such as W. J. T. Mitchell and Denis Cosgrove. The prospect, they contend, is no neutral viewpoint but, rather, a visual ideology that emanates directly from power linked both to the imperial desire for expansion, domination, and development and to the capitalist activity of prospecting.[12]

In Venezuela, military rule was synonymous with similar modes of prospective vision. The mandate to transform the physical environment generated an expansion of top-down planning, which depended on access to cartographic and aerial views that would enable engineers and scientists to devise modernization plans on a grand scale. To this end, after seizing power, the regime redoubled efforts to map the nation. The Dirección de Cartografía Nacional at its foundation, less than twenty years earlier in 1935, possessed a modest team of just fifty employees and a budget of 500,000 bolivars. After 1948 the workforce at the state cartographic body increased tenfold, the budget rose to 11 million bolivars, and the institute acquired three new aircraft, especially equipped for aerial photography. Official records show that the demand for images was so great that as of February 1954, the planes used for aerial mapping would be flown "uninterruptedly" by members of the Air Force.[13] By the end of 1953, the Dirección de Cartografía Nacional had already photographed more than two-thirds of the entire landmass of Venezuela, and its archive of aerial photographs comprised an area covering 677,000 square kilometers and some 537,800 square kilometers of *fotocroquis* (a hybrid of photograph and illustration).[14] According to the public works ministry's *Memoria y Cuenta* for that year, the aerial photography division had such an avalanche of work conducting flights, developing film, and printing and distributing images to government offices and third parties that it was simply impossible to keep up with demand. They had been forced to hire subcontractors to compose the patchwork *fotomosaicos* (photomosaics) and gridded fotocroquis that mapped and measured Venezuela's territory.

The ambition to create such a detailed photographic landscape evokes the scale of the map that Jorge Luis Borges conjured in his short story "Del rigor en la ciencia," where a guild of cartographers creates an imperial map so vast and perfect it coincides with the territory on a scale of 1:1.[15] To be sure, the aerial mapping of Venezuela's territory did not reach such fantastical dimensions, but the

demand for and the upsurge of cartographic capacity demonstrate that territorial capture was a core trope of the pledge to reengineer Venezuela's environment. The aerial prospect encapsulates the military regime's technocratic pursuit of internal imperialism: capturing and ordering the territory within the superimposed grids of the fotocroquis was the first step toward conceiving plans for modernization. The fact that, as it "flattened the topography as if it were a canvas, flight encouraged new aspirations to synoptic vision, rational control, planning, and spatial order," makes clear not only how flight was an apt tool with which to draft grand modernization plans but also how space, vision, and power intersect within the aerial prospect.[16] Interestingly, the renewed emphasis on territorial conquest in the 1950s—with the spatial and visual technics this conquest entailed—was symptomatic of the enthusiasm that high modernist planners expressed for air travel in the first half of the twentieth century. Le Corbusier, who dedicated an entire book to his ecstatic reaction to aerial vision, lauded the "airplane eye" as a "spectacle"—a bird's-eye view of the land, which collapsed the landscape into just the type of blank canvas on which ambitious spatial overhauls could be envisaged.[17]

As well as resonating with Le Corbusier's enthusiasm for the airplane, the military leaders' turn to the aerial prospect also updated an existing tradition of mapping. Alongside museum collections and displays, Jens Andermann proposes cartography as one of the core ways of seeing that have long been summoned to reinforce state agency in national cohesion and development. From the nineteenth-century quest to consolidate Latin America's fledgling republics up to mid-twentieth-century projects like Brasília, the panoptic—and here aerial—gaze inherent in cartography and planning has served as a buttress to state power, depoliticizing geography and refiguring the intervention of central planning as an "*architectonic* or *geometrical* ordering of, rather than *political* intervention into, the field of vision."[18] The disembodiment of the viewing subject and the foregrounding of the "scientific" gaze in the aerial perspective allow the state to become the principal agent in territorial unification. In turn, this protagonism empowers the state to act on behalf of citizens and thus make them objects, rather than subjects, of modernization. These ideas are germane to the demobilizing thrust of Venezuela's military regime and the replacement of political agency with spectatorship.

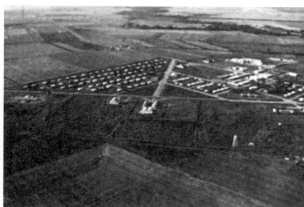

Figures 4.1 and 4.2. Stills from *Turén*, directed by Manuel Vicente Tinoco, undated.

Acknowledging the map as a covert portrait of state power adds a further critical dimension to the aerial prospect rolled out by the dictatorship, reframing it as a core component of a state optic that aspired to marshal subjects into the new forms of order set out in modernization plans.

The creation of state-run agricultural colonies, like Turén in the Venezuelan state of Portuguesa, is a clear example of the quest to reorder the land by "enframing" it (fig. 4.1). From the Heideggerian standpoint, "enframing" (*Gestell*) refers to humankind's application of modern technology to set upon nature and transform it from standing reserve to productive resource. This act of challenging forth nature comes to light in the aerial footage of deforestation produced by the state to advocate the development of Turén, as well as in gov-

ernment reports that made triumphant claims about economic productivity, such as the threefold increase in sugarcane yields, which rose from 50 to almost 150 tons from 1950 to 1955 (fig. 4.2).[19] Another relevant dimension of enframing transpires in Timothy Mitchell's use of the term. Drawing on Foucault's critical discussion of forms of discipline, he describes enframing as the way in which the state regulates the land and the populace through "modernization, technification, and mechanization."[20] By analyzing military discipline, peasant populations, and model housing in colonial Egypt, Mitchell elucidates the logic of enframing as the processes by which "the disordered was transformed, [and] the dispersed was articulated, forming a unity or whole whose parts were in mechanical or geometrical coordination."[21] The role that Turén was to play as an agricultural model of mechanized production and "improved bloodlines," where Venezuelan workers would mix with European immigrants, makes the colony a clear example of this mode of enframing, whereby a new mode of spatial and social order was conceived from the elevated vantage point made possible by aerial vision and centralized state planning.

As a core aspect of military-led modernization, aerial views of the new highways were also instrumental in underscoring the legitimacy of the technocratic quest to transform the physical environment. Aerial photographs were not just visual augurs of future progress; they also enabled the regime to prove that it had kept its promise to make literal inroads into rural backwaters and bring them into a network of modern industry and communications. Aerial depictions of public works were frequently disseminated in printed publications from institutional reports to mass media campaigns as proof that centralized planning had delivered real results. Photographs of vast stretches of road, surrounded by virgin forests, which had been built within the Plan Nacional de Vialidad, stand as compelling examples of the way aerial pictures buttressed an imaginary of territorial unification pursued under military rule (figs. 4.3–4.4). Alongside the significant investments in air traffic control systems, technology for night flights, and the acquisition of Super Constellation aircraft for local airline Aeropostal, the nationwide road network demonstrates the quest to reconfigure the space of the nation and, in so doing, to integrate disparate and distant regions into a unified functional organism.

Figures 4.3. *Venezuela bajo el Nuevo Ideal Nacional* (1954).

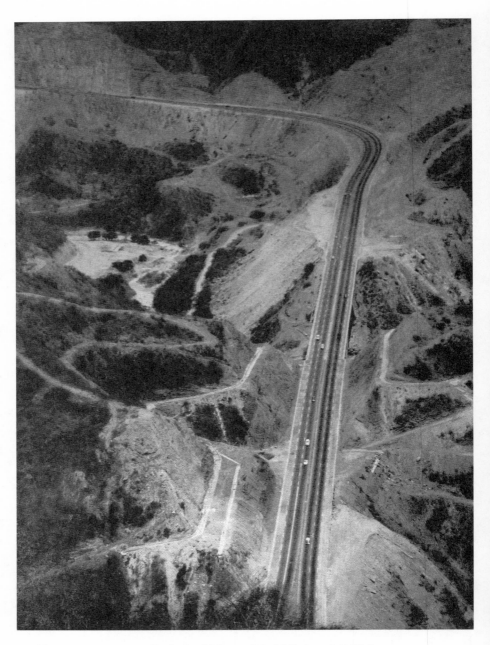

Figure 4.4. *Venezuela bajo el Nuevo Ideal Nacional* (1954).

One key example of the dissemination of nationwide plans and aerial photographs emerged in 1954, when delegates and engineers from across the Americas gathered at the Ciudad Universitaria in Caracas for the Sixth Congreso de Carreteras to discuss challenges and solutions to road building. Once Marcos Pérez Jiménez had taken the stage of the Aula Magna to officially inaugurate the conference, public works minister Julio Bacalao Lara gave delegates a historical overview of the nation's highway network. As he showcased the plans for the recent expansion of road building, he linked the envisaging of the national territory to the governmental commitment to increasing economic development by imposing normative order on the physical environment. Grand designs, he suggested, delivered modernity.

In the accompanying exhibition installed outside of the main auditorium, delegates had the opportunity to peruse diagrams of the national road network at their leisure and to look at aerial photographs of the network's most recent fruits, including the flagship highway from Caracas to La Guaira and other new roads. When the conference ended, the Road Builders Association organized a special ceremony in the lavish surroundings of the nearby Círculo de las Fuerzas Armadas. After a round of speeches, a representative of the association—aptly named Robert Raindollar—announced that the association was awarding Pérez Jiménez that year's Premio Panamericano de Carreteras: the Pan-American prize for highway building. The image from the customary photo shoot, in which Mr. Raindollar handed the dictator a large plaque, later appeared in the *Revista del Banco Obrero* couched in enthusiastic declarations of the significance of the distinction as "irrefutable proof" of progress and of Pérez Jiménez's "tireless pursuit of positive progress and outright patriotic dedication."[22] From the top-down plans of fotocroquis, via the aerial photographs of specific highways, and on to the photo shoot that honored the dictator's modernizing efforts, the aerial prospect stood as the bedrock that enabled the military leaders' technocratic bid to reenvisage the nation and to reengineer its landscape in step with development.

SUBLIME LANDSCAPES

Beyond the technical and economic milieux of Turén and the road builders' conference, aerial vistas and expansive landscapes also

played a key role in public displays devised to summon Venezuelans' affective engagement in military-led modernization. This was precisely the premise behind the hour-long government film *Paisaje de la Patria* (1954), which premiered on June 30, 1954, at the Centro Venezolano Francés in Caracas.[23] Shot on color film mainly from planes and helicopters, *Paisaje de la patria* tracks the nation's geography from the Andes down to the Amazon and then out via the coast to Margarita Island. In contrast to the disembodied vantage point of cartographic vistas, the film reembodies viewing subjects. It sweeps them up into a vicarious experience of airborne vision and lets them share in the lofty perspective that Tinoco enjoyed from the plane, which few Venezuelans would have had the opportunity to experience firsthand. After the title screen, the film is prefaced by a short text that would have acted as a primer for viewers watching in the 1950s. By pointing out that the film was made possible by the collaboration of Venezuela's Air Force and commercial airline, the text would have reminded the audience that modernity, like the film, was a state-sponsored function.

With the same, the on-screen text goes on to give self-referential details about the film's own status as cinematic spectacle. Tinoco confesses to viewers that he had filmed nearly twenty thousand meters of 16mm Kodakrome film but that less than a thousand made the final cut.[24] Far from disclosing a lack of directorial expertise, this admission suggests that in *Paisaje de la patria* the medium is a key part of the message. The inference is not only that the Venezuelan landscape is so spectacularly picturesque and modern it requires a vast amount of film to record it but also that the landscape demands an equally spectacular medium and setting to give justice to its visual representation. Here, the cinematic *appareil* (apparatus)—with its highly mediated condensation of time and space—buffers the ideological thrust of spectacular visuality that seeks to immerse viewers in the hypnotic spell of the idealized picture of the nation presented on the glossy screen. To film the landscape, the optical technics of the camera's airborne "eye" offers a privileged viewpoint; the chemical indexicality of film captures space; the editing suite allows for matter to be shaped into meaning; and the movie theater stages this illusion of reality and continuity in an isolated penumbra (figs. 4.5–4.6). Deploying these tools, *Paisaje de la patria* stitches together a string of disparate locales to create a seamless landscape that can be screened as a public spec-

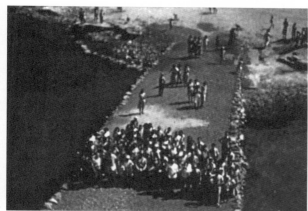

Figures 4.5 and 4.6. Stills from *Paisaje de la patria*, directed by Manuel Vicente Tinoco, 1954.

tacle for the collective gaze of Venezuelans immersed in a dark movie hall.[25] If the attempt were successful, upon leaving this cocoon, viewers would remain hypnotized and captivated by what they had seen, rather than wondering, as Roland Barthes famously did: "Had not the image, statutorily, all the characteristics of the *ideological?*"[26]

In any case, an hour of footage would have to pass before the credits rolled. After the primer, Tinoco's whistle-stop tour from mountain to coast began in earnest, set to a rousing orchestral score as the tour moved from one postcard-style scene to the next. Tinoco's voice-over oscillated between studious and gushing, now reaffirming military efficiency, now inspiring patriotic sentiment. At one point, in the Andean foothills, after wistful musings about fertile lands caressed "by God's own hand," Tinoco immediately offers information

about the loans the government was issuing for the purchase of agricultural equipment that would maximize productivity. At another moment, when high above the green trees and winding waterways of Bolivar state, Tinoco describes the dredging of the Orinoco River as an engineering solution to optimize river transport—only to liken, in the same breath, the remote tabletop mountains located nearby to fantastical castles peeking through the blue sky. Glossed by the code-switching voice-over, the film performs and elicits both rational observation of prospective sites ripe for industrialization and affected wonder before scenes evincing the ineffable spirit of Venezuela's natural bounty.

There is no doubt that this dual encoding of the landscape mimicked the New National Ideal's pledge to modernize and restore the nation to glory. With the press report's assurance that copies of the film would be screened throughout Venezuela, the cinema screen became a mirror for military ideology and the promise of national transcendence. The film's final scenes confirm this intention when, with a flourish, Tinoco translates the accumulated views of the national landscape into a didactic and cautionary tale. With gravitas, he announces: "Venezuela welcomes with open arms ideas of progress and investments devoted to propelling the nation forward. Well-being, progress and wealth do not grow on trees. It is the Venezuelans of today who must endeavor to realize the goals of the grand national ideal that our leaders have proclaimed as their purpose of their deeds."[27] As the spectator listens to this message, the map cuts to images of parading Venezuelans carrying flags, military airplanes on test maneuvers, and finally, to the Battle of Carabobo monument in Valencia that commemorates the nation's Independence. The model of subjectivity that corresponds to this portrait of the "fatherland" is unmistakable: militant patriotism, compliance, and discipline are the order of the day. Faced with the changing landscape, Venezuelans should be moved simultaneously to admiration for the military leaders and to patriotic joy.

LESSONS IN PHOTOGRAPHY

The recurrent tropes of landscape representation did not come from aerial vision alone. Photography at ground level also established a conventional repertoire of sites and vistas that indexed modernity

and encouraged Venezuelans to adopt the role of spectator. Also, in helping to designate what to look at and how to look, photographs coached Venezuelans on how to interpret the changing landscape around them. As a medium that offered authentication over invention, as Roland Barthes put it, photographs were a useful collaborator in entrenching spectacular visuality.[28] Much as mapping flourished under military rule, so too did its photographic representation. By the mid-1950s the tourism department's annual report complained that, even with an upgraded dark room and a specially cataloged *fototeca* (photo library) designed to improve the supply of images in Venezuela and abroad, the department's photography service simply could not keep up with demand.[29]

As well as authenticating progress, photographs could foster Venezuelans' familiarity with the new markers of modernity and reinforce the bond between built space and national identity. They enabled the isolation of specific sites and, as a result, crafted a compensatory compendium of views that smoothed the landscape's rough edges. In turn, the composition and framing of images could give viewers pointers on what this changing landscape meant. By exposing Venezuelans to a set of relatively standardized thematic motifs that appeared repeatedly across different media, photography helped transform modern sites from examples of disfigurement into familiar faces of modernity.

State publications served as vehicles to entrench a conventional repertoire of photographic typologies that instructed Venezuelans on what progress looked like. Roads, bridges, intersections, sewerage installations, as well as construction projects, land movement, and heavy machinery were singled out as worthy of attention. Other images captured time and again the snipping of ceremonial ribbons in public works inaugurations to restate the telos of development. Photographic typologies such as these identified *which* aspects of modernity should be looked at, while their composition exerted a didactic function by providing signposts that would help to instruct subjects on *how to look* at them.

Understanding spectacular visuality as a component of and complement to military ideology means tracing factors that shaped and molded the gaze. One specific photographic trope elucidates the way in which viewing itself became part of the ideologizing apparatus that encouraged Venezuelans to acquiesce in their role

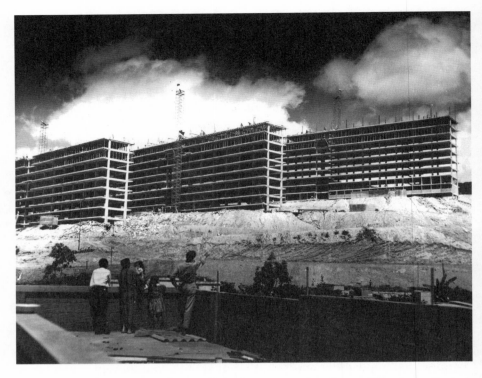

Figure 4.7. A group of people look up at a trio of superblocks under construction in Caracas. Archivo Histórico de Miraflores.

as spectators of progress. The recurrent inclusion in official photographs of people pictured with their backs to the camera, gazing at modern spaces, operated as a form of meta-spectatorial comment. That is, such photographs served as cues to encourage Venezuelans to participate—through the vicarious experience of the image or in their own encounters with the changing landscape—in a mode of viewing that reinforced the cornerstones of the military project of modernity.

One particular photograph, held at the Archivo Histórico de Miraflores, is an example of such a prompt for vision. The image depicts a group of adults and children looking at a cluster of superblocks under construction (fig. 4.7). The lead room that extends before the group anchors the image's invitation to regard the changing landscape as a modern marvel. This suggestion plays out in three main sections. Slightly out of focus, a section of wall in the bottom

left corner functions as a vantage point for the person looking at the photograph. Marking the photographer's implicit site just beyond the frame, this section of wall acts as a separating device from the scene that stages the act of viewing captured in the photograph. Slightly farther forward, still in the left-hand side of the image, the five people are captured from a ground-level vantage point. The men wear a mixture of clothes; one in formal attire, another bare-foot in a dressing gown, and the last in overalls. Except for one of the two young girls, they all gaze intently at the superblocks. The slight diagonal axis of the image mimics their line of sight, which moves up over the roofs of the old-fashioned homes nestled below, past the ground bulldozed into a new shape, and up to the three superblocks, situated in the central band of the photograph. If this invitation for the viewer to follow this line of sight were not enough, then the gesture of the man who points toward the blocks acts as a further didactic cue. This, he signals to his companions inside and outside the frame, should be the focal point of their attention.

In another photograph, from the front page of the *Revista del Banco Obrero*, the line of sight is inverted (fig. 4.8). Here, the photographer is positioned above a group of four young children, who stand barefoot on a dusty outcrop. This vertical image accentuates a visual and narrative trajectory that plots the projected curve of superación that the modernized environment should trigger. From shoeless children on the bare ground, the gaze moves down over the wood- and tin-roofed ranchos to a modern block under construction and onto industrial buildings on the other side. The composition can be read as a temporal course that puts human faces to the potential benefi-ciaries of the Banco Obrero's *Batalla contra el rancho* and suggests that built space will deliver Venezuelans' social improvement.[30]

A subsequent image, in the same edition of the magazine, picks up this temporal thread and presents readers with three more children, pictured looking at a housing block (fig. 4.9). This time the boys are older, better dressed, and wearing shoes. The horizontal axis of the photograph situates them in the bottom right-hand corner of the shot and traces their gaze leftward, toward the housing block that has now taken shape and whose painted façade suggests it is ready for inhabitants. The line of sight departs from the boys, moves past the new block and onto the next one under construction, and thus stages through space a progressive temporality of concerted efforts to build

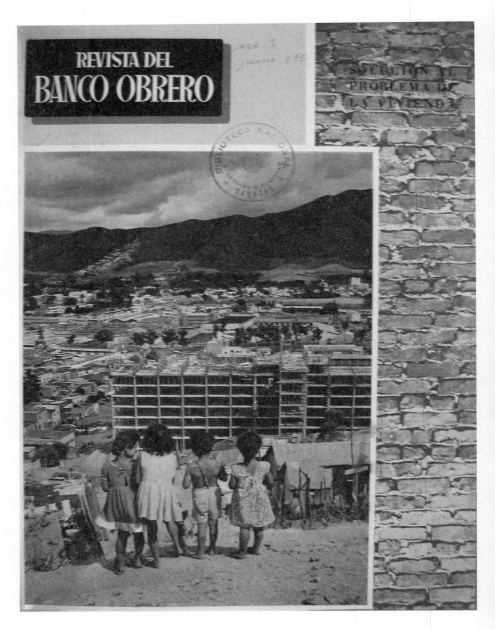

Figure 4.8. *Revista del Banco Obrero* 1.2 (June 1954).

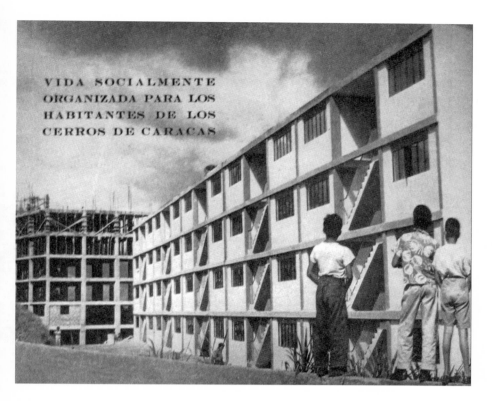

VIDA SOCIALMENTE
ORGANIZADA PARA LOS
HABITANTES DE LOS
CERROS DE CARACAS

Figure 4.9. *Revista del Banco Obrero* 1.2 (June 1954).

modernity whose trajectory stretches into the future. The image encourages the viewer to follow this prospective line and authenticates the idea of official commitment to build high-rise superblocks until the socially and aesthetically problematic ranchos have been erased from sight.

By contrast to the disembodied perspective of cartography and the apparent objectivity of photographic typologies, these staged acts of viewing entail a twofold engagement of the human body. They incorporate spectators into the photographic frame and invite viewers to mirror the gaze of the viewers depicted. The inclusion of viewers into the habitually depopulated vistas of state-built constructions thus turns the people pictured into didactic doubles for other Venezuelans: people with whom they can identify in the common journey toward national progress and social improvement. Such images drew Venezuelans into a clear-cut politics of the gaze that re-

inforced the military regime as agent of modernity and the regime's subjects as spectators of progress. That attentiveness, awe, and a degree of veneration recur in these pictures is thus no accident. As the caption next to the group of boys clarifies, the blocks represent "life socially organized for the inhabitants of Caracas's hills." As subject-spectators legitimized modernization by making it the object of their gaze, the credits could roll anew: this spectacular function of modernity was brought to the audience courtesy of the military rulers standing in the wings.

•

As the ultramodern theater at the Casa Sindical hinted, the official libretto of military-led modernity did not rely just on a convincing story line or ambitious modernization plans. The shift from democratic representation to antidemocratic rule set the stage for a mode of spectacular visuality in which feats of vision and display were leveraged to buttress military authority and to confirm the modernity foretold by the New National Ideal. Together, the theater's high-tech scenography and spectacle's etymological roots drew out theoretical implications that reframed the military project of modernity as more than just an official narrative and a mandate to transform the national landscape. Spectacular modernity was a political regime built on modes of visuality, in which power, vision, and display coalesced. Yet, even as spectacular visuality served the regime's pursuit of political demobilization, there were no guarantees that the changing landscape would induce compliant and awestruck spectators. In previous decades intellectuals had attacked the changing landscape in highly visual terms, as both a disfigurement and a theatrical illusion, and this posed a challenge. As much as modernization plans and official propaganda inflected modernity with spectacular visuality, the endurance of military rule depended on the regime's capacity to encourage Venezuelans to attend to particular landscape vistas as proof of its necessity.

The question regarding spectacular visuality does not concern what was true or false. Rather, in this context the concept offers two fundamental illuminations. First, by signaling the visual field as a site of negotiations rather than outright hegemony, spectacular visuality stands as a reminder that spectators were not a priori docile

or compliant constituents but, rather, heterogeneous subjects whose emotional engagement in the changing landscape was key to political stability. Second, as it pushes beyond established canons of aesthetic modernism engaged by art history and architectural criticism, the concept of spectacle expands the repertoire of primary materials that shed light on the entanglement of politics and aesthetics during the decade at hand. This expanded repertoire calls for the analysis of conventional artifacts such as photographs and films that uncover the tracks of modes of seeing and display to show how they acted as props for the political and social order of military rule. The visual technics of mapping, the synoptic gaze of state planning, the honorific culture of modernization that transpired in Pérez Jiménez's award for road building, all took a turn onstage against the backdrop of political demobilization.

The landscape served as common ground to begin tracking the strategic maneuverings of vision, representation, and display through modernization plans and official propaganda. Despite their apparent objectivity, the visual technologies used to map the territory stemmed from a state optic and an embrace of enframing as a means to shape the nation in a new social and spatial order. Similarly, the leveraging of aerial photographs as endorsements of Pérez Jiménez's leadership proves that such images were as much about *what* they depicted as *why* they were made and *for whom* they were displayed. In the pledge of spatial transformation at the heart of the New National Ideal, landscape views of various types became linchpins of the political order, whether they were cinematic displays of sublime scenes that called on spectators to rally behind their leaders or staged acts of viewing that trained the gaze of spectator-subjects onto specific scenes. These are just some of the strategies embedded in the spectacular visions of modernity in the 1950s that the military rulers devised to bid Venezuelans to behold scenes of dazzling progress and then to applaud them in silent awe.

CHAPTER 5

EXHIBITING
MODERNITY

CULTURES OF DISPLAY AND THE
DICTATOR'S VISIONARY GAZE

The spectacle . . . is a world-view that has actually been materialized, a view of the world that has become objective.

• GUY DEBORD

• On December 2, 1952, Venezuela awoke to the news that the Junta Militar had reneged on its promise of a return to democracy. Four years earlier, in the wake of the coup of 1948, Carlos Delgado Chalbaud had vowed to the Venezuelan people that the Junta would defend democracy and political transparency. An open or implicit military dictatorship, he insisted, was out of the question.[1] Yet, after almost two million Venezuelans went to the polls in the presidential elections of December 1 and gave the Unión Republicana Democrática candidate Mario Briceño Iragorry a clear lead from the lion's share of the votes, the Junta backtracked on its professed commitment to democracy, bypassing the results to claim victory for the Frente Electoral Independiente and its candidate, coup leader Coronel Marcos Pérez Jiménez. The decision was a game changer. Sullying the credibility of the leaders who had promised Venezuelans a role in determining political representation, the

126

transfer of power became a blot on the glossy spectacle of progress. Fraud was no secret to anyone, and even as the political opposition called for a strike, the Junta dug in its heels and foreign allies declared business as usual.[2] Now there could be no mistake as to the state of democracy in Venezuela; "Pérez Jiménez was in power by armed force and . . . the electoral votes were only an ornament for the rifle butt."[3]

As the Coronel moved from defense minister to dictator, the stakes in legitimizing military rule suddenly rose. Amid the pressure to conceal the rifle butt of military intercession, barely two weeks into his mandate Pérez Jiménez rushed to display gestures of benevolence, liberating political prisoners from jails and closing down Guasina, the infamous detention center in the midst of the Orinoco Delta.[4] In the long term, the electoral fraud prescribed a new political cosmogony—one that now revolved around this short taciturn figure, whose political authority depended on the credence of sustaining spectacles of progress and on convincing Venezuelans that he was uniquely endowed with modernizing vision. In this new scenario, the Junta Militar's position as protagonists of progress gave way to efforts to elevate Pérez Jiménez to the status of sole agent of modernity. During his six-year dictatorship a cult of personality emerged, which fused Pérez Jiménez's personal biography with the story of the nation and presented him as the visionary figure at the vanguard of Venezuela's transformation.

As one article published in *Time* magazine dubbed him, the dictator was the "skipper of the dreamboat"—an unstoppable force hurtling through Venezuela's underdeveloped hinterlands in a cutting-edge sports car. "Pérez Jiménez watched the speedometer needle of the Mercedes-Benz tremble around 160 kilometers (100 mph)," wrote the journalist. "He flashed by goats, banana plantations, royal palms and startled girls in magenta dresses; he hurried dustily on through villages where school children lined the streets for shrill vivas, through towns that tried to attract official attention to their rustic needs with crude banners impossible to read at high speed."[5] It is not just the dramatic contrast between the modern motor and the rural setting that makes this scene striking. The suggestion that Pérez Jiménez perceived these dusty villages as illegible blots on a blurry landscape is a compelling one, which evokes a

gulf between realities on the ground and the ideal of fast-paced modernity advocated by top-down development plans. It also raises questions about the modes of seeing and cultures of display associated with modernity under Pérez Jiménez. What role did spectacular visions of progress play in this transition from dictablanda (soft dictatorship) to dictadura? How did propaganda texts credit Pérez Jiménez with visionary capacity and leverage his gaze to naturalize the military ideology that cast citizens as mere spectators of modernity?

PUBLIC EXHIBITIONS AND POLITICAL LEGITIMACY

The quest to garner legitimacy for the Junta Militar and public engagement with the New National Ideal led to the organization of a range of events devised to render progress in carefully constructed displays and to reaffirm the association of military rule with Venezuela's transformation. To mark the anniversary of the coup of November 24, 1948, the leaders would perform a whirlwind of commemorations, executed with military precision, on a yearly basis. A typical itinerary would feature multiple inaugurations across the country. In the journeys from state to state public works projects from schools to hospitals served as proof of progress. Along with these fast-moving events, the Junta set great store in public exhibitions that underscored its "deeds not words" principle and confirmed the ambitious scale of modernization in miniaturized forms through the display of photographs, graphs, and maquettes.

Early exhibitions tended to focus on specific projects that clarified the Junta's doctrine that the transformation of space would induce national and social superación. For instance, in April 1950, the Ministerio de Obras Públicas and the Comisión Nacional de Urbanismo organized the *Exposición Doctrinaria* (Doctrinaire Exhibition) at the Colegio de Ingenieros in Caracas. The purpose was to present flagship construction projects, which included the modernist twin towers of the Centro Simón Bolívar and the Avenida Bolívar, a multilane artery that linked the capital city's traditional center to new developments farther east.[6] The next year at the same site, the Banco Obrero organized an exhibition of the *Plan Nacional de Vivienda* to coincide with celebrations of the third anniversary of the coup of November 1948. As well as a range of architectur-

al maquettes, the inclusion of charts that tracked the increase in construction from 1928 to 1950 and forecast the projected upsurge in housing over the next four years offered a clear message of the Junta's proven track record, while reiterating its promise of continued development.

By 1952 the scale of these official exhibitions had expanded significantly. The Junta Militar set about preparing the *Exposición Objetiva Nacional*—an ambitious display set to coincide with the fourth anniversary of the coup of 1948, which would mark the end of this period of "provisional" administration. As well as the date, the choice of the Avenida Bolívar as the location for the exhibition was significant. When the Junta Militar seized power, the avenue had been nothing but a scale model; now the brand-new space was a reality and would play host to the sprawling *Exposición Objetiva Nacional*. The *Exposición* was billed as an impartial (objective) display conceived to reflect the pledge that Venezuela was ever more prosperous, dignified, and strong.

Indeed, press reports to mark the inauguration of November 22, 1952, clarified the intention "to disseminate, in an objective manner, economic, social and cultural development that Venezuela has achieved" and offer the public an "irrefutable demonstration of the political, economic and social scope of the provisional government's work."[7] Part *Wunderkammer* (cabinet of curiosities), part institutional fair, the exhibition expanded the conventions of display to unprecedented dimensions. Its promise of a complete view of the government's work obeyed the logic of miniaturization associated with high modernist planning and museum display alike, which makes the spectacular scale of progress legible through its display as select objects, condensed views, and three-dimensional models.[8] The event was clearly conceived to induce spectatorial immersion; open to the public from ten in the morning until midnight seven days a week, the *Exposición* covered a vast forty-two-thousand-square-meter space, spanning four sites at the epicenter of the "New Caracas." Press advertisements promised that this "magnificent exhibition . . . will exhibit [*exhibirá*] our country as one of the most progressive in the world."[9]

To rise to this challenge, the head of the project, economist Oscar Pani, and his team of architects, engineers, decorators, model and scenery makers, painters, and more than five hundred artisans set

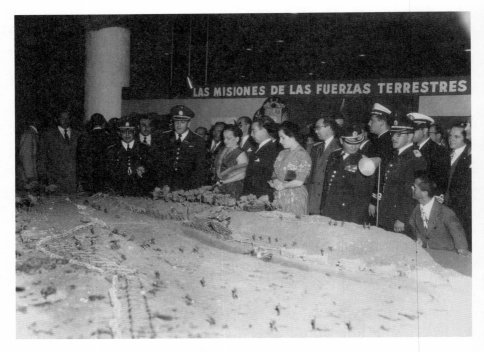

Figure 5.1. Model simulacrum of territorial warfare at the *Exposición Objetiva Nacional*. Archivo Audiovisual, Biblioteca Nacional.

about translating the Junta's official libretto into cutting-edge tech-
nologies of display. To signal the pledge for ever greater modern-
ization Pani's team assembled 250 architectural models, more than
2,000 square meters of graphs, and numerous photographs of public
works. The bulldozers put on display symbolized the technocratic
celebration of heavy machinery as insignia of the modern nation.
At the same time, the exhibition echoed the historical discourse of
the New National Ideal by paying tribute to the military glories of
the past and local traditions through 1,000 meters of painted mu-
rals, monuments to national heroes, and collections of weapons and
military uniforms, as well as paintings, books, and figurines that
depicted Venezuela's folk dances. In line with official discourse, the
inclusion of a model that featured scores of diminutive toy soldiers
in a simulated combat scenario and miniature tanks that thrust their
way over barricades reinforced the concept that the Armed Forces
were best placed to lead the nation (fig. 5.1).

Figure 5.2. Three-dimensional map of Venezuela at the *Exposición Objetiva Nacional.* Archivo Audiovisual, Biblioteca Nacional.

As impressive as this sprawling display might have been, the exhibition's true magnum opus was the *Mapa monumental de Venezuela*—a monumental, three-dimensional, and mechanized map of the nation controlled by a console located nearby (fig. 5.2). Surrounded by painted landscapes and enclosed by metal bars that kept viewers at a safe distance, the map replicated the national territory to miniature scale, updating the dioramic and panoramic displays made popular in the nineteenth century. The model was best observed from the vantage point of the watchtower that had been erected around one of the bus station's mosaic-clad columns. As uniformed men and ladies in fur stoles stood above the map, rivers crisscrossed the land before their eyes and the jagged peaks of the Andes rose up from the expansive flats of Los Llanos. Specters of the spinning stages at the trade unionists' theater surface in newspaper reports that hailed this cartographic spectacle as "a gigantic mechanical model" of around one hundred square meters that showed "the entirety of Venezuela's

geography, with its ports, aerodromes, roads, cities, etc., featuring the Caracas–La Guaira Highway and the port, passenger terminal and airport."[10] An ambitious expression of faith in synoptic visions, the map replicated the national landscape for spectators to consume not as cinematic or photographic image but as grand, three-dimensional display. Given the scale of the exhibition, it is perhaps unsurprising that the Junta dubbed this an *exposición apoteósica*—an apotheosis of spectacular display unprecedented under the Junta and never equaled in later exhibitions.

Beyond the event's function as a retrospective of government work, its date and location demonstrate a more tacit aim: the exhibition was also a strategically timed endorsement of Pérez Jiménez's candidacy in the presidential elections that would take place just days after its inauguration. By offering "irrefutable" proof of the efficiency of military-led modernization, the exhibition would encourage Venezuelans to invest in continuity by voting for the man who had been instrumental in bringing about the coups of 1945 and 1948 and who served the Junta as minister of defense. In plainspoken terms, the exhibition was to serve as a curtain raiser to stage a smooth transfer of power, thus bridging the triumphant conclusion of the Junta's administration with Pérez Jiménez's ceremonial investiture as president of Venezuela.

The timing and promotion of the event reveal how this public spectacle was leveraged to these ends. The government disseminated the exhibition through a publicity campaign in the national press and other official notices devised to reinforce the optimistic atmosphere. After a passing mention of the exhibition in an October article in *El Nacional*, on November 19 the real campaign began, rising to a crescendo of drama and heroic rhetoric as the inaugural date approached. Accordingly, the first advertisement was relatively somber in tone, illustrated only by an image of Simón Bolívar that revived the glories of independence. Two days later, another half-page announcement communicated a more dramatic message of titanic effort, spatial transformation, and social improvement, foregrounding a drawing of a sinuous muscular figure, holding aloft a geometric construction as he emerged from amid the two towers of the Centro Simón Bolívar (fig. 5.3). Other official articles in the paper reinforced this missive, such as a piece that appeared a few pages later, which celebrated the "implacable course" of the Banco Obrero's *Batalla contra el rancho*. Before the institution began build-

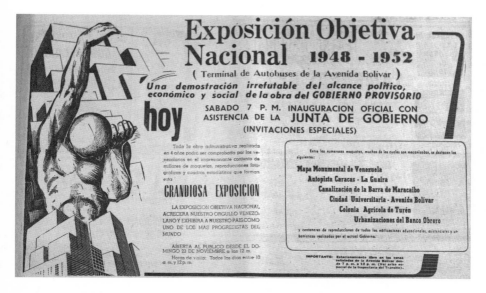

Figure 5.3. Public announcement of the private opening ceremony of the *Exposición Objetiva Nacional*. *El Nacional*, November 22, 1952.

ing homes in Ciudad Tablitas, the article stated, even the smiles on children's faces were sad.

State institutions increased promotional momentum by publishing invitations to other inaugurations over the same days. The Banco Obrero summoned the public to witness progress in the capital at the ribbon-cutting ceremony for 330 new apartments in Catia and a new avenue linking two neighborhoods.[11] Another full-page announcement presented an extensive list of works to be inaugurated across the nation, state by state, on November 24, precisely four years after the coup that toppled Rómulo Gallegos. On the eve of the inauguration, a final advertisement prepared the public for the exhibition—presaging its totalizing view by devoting half the full-page advertisement to a collage of modern buildings that assembled a fictionalized landscape of progress (fig. 5.4). Despite variations in style, the message was consistent: the military rulers' legitimacy was confirmed beyond reasonable doubt and simple *spectatorship* of this objective display would verify for one and all that modernity was a reality in Venezuela.

Between them, the exhibition's totalizing representation of progress, its monumental map, and the parallel inaugurations of public works ready to be brought into service nationwide, all conjured a

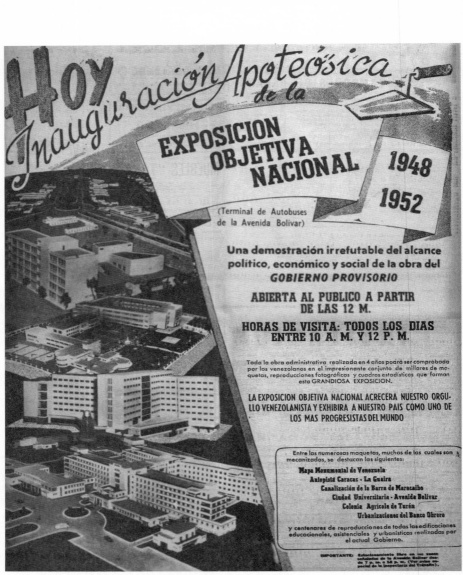

Figure 5.4. Invitation for the general public to visit the *Exposición Objetiva Nacional*. *El Nacional*, November 23, 1952.

new cartography of modernity whose itineraries signaled the next destination: the continuation of progress under the tutelage of Pérez Jiménez.

As the publicity campaign peaked, photographers captured soon-to-be successor Pérez Jiménez at the *Exposición Objetiva Nacio-*

Figure 5.5. Pro–Pérez Jiménez rally before the elections of November 20, 1952. Archivo Audiovisual, Biblioteca Nacional de Venezuela.

nal, standing atop the watchtower that afforded him a privileged view of the grand *Mapa monumental de Venezuela* (see fig. 5.2). The image prefigures the sycophantic and teleological accounts that were circulated later to naturalize his dictatorship by equating his capacity for synoptic vision with innate leadership qualities. Even though it is unsurprising that Pérez Jiménez, as minister of defense, appeared at the event, the significance of his presence should not be overlooked. The exhibition's inauguration was an overture for the massive rally that took place on November 24 to support his candidature for president, and the fact that both took place at the same location, at an underground square at the Avenida Bolívar, was no coincidence (fig. 5.5). The location at Caracas's busiest and most important avenue guaranteed a captive audience of commuters. As one government publication put it, "on a daily basis, hundreds of buses go through this underground square, equipped with a pow-

erful air conditioning system, to get to all parts of the metropolitan area. Its four lateral entry and exit ramps are a hotbed of Caracas's urban energy."[12]

These details lay bare the meticulously choreographed mechanisms the Junta devised to ensure a continuum of military rule. Bearing in mind that the rally took place on the anniversary of the 1948 coup, the elision of these events fortified the historical narrative initiated by military rule, while extending the promise of future stability and progress through the Junta's aspirant to power. Even a rapid glance of images from the Oficina Central de Información archives are testimony to this libretto: sixteen negatives from the rally show fervent supporters surrounded by banners declaring "Viva el Ejército de Venezuela" (Long live the Venezuelan Army) alongside posters of Pérez Jiménez. Whether they had intended to attend the political rally or not, people moving through the area were incorporated into the spectacle as a supporting cast for the electoral campaign, set against a triumphant backdrop in which military leaders were the lead characters in Venezuela's modernization. By all accounts, the intention was to present Pérez Jiménez's upcoming presidency as a foregone conclusion. When Pérez Jiménez was declared victor on December 2, 1952, and the voices of democracy were silenced by this obvious case of electoral fraud, it became clear that the New National Ideal had a built-in clause—the promise of the future was contingent on the continuity of military rule. The spectacular and fraudulent transferral of power staged in the events during the final months of 1952 not only marked a key shift in statecraft from dictablanda to a clear-cut dictadura but also signaled a transition to a cult of personality that would come to present the dictator as the sine qua non of stability and progress in Venezuela.

DEVELOPER ON THE WATCHTOWER

Under Pérez Jiménez, the same technocratic discourse prevailed as in the preceding years of state-led modernization projects. A self-confessed enemy of speeches, the dictator focused on providing concise information and figures to corroborate progress and reiterated that Venezuela was becoming ever more wealthy, dignified, and strong so as to induce national pride. However, to mitigate unrest caused by his fraudulent rise to power and to bolster his legitimacy

as leader, it was imperative that *his* ideas be singled out as the driving force of the nation. This man must be cast as being indispensable for the future of the nation. Perhaps in part thanks to the auspicious effect of the *Exposición*, Pérez Jiménez appeared to develop a taste for spectacular displays of progress. He perpetuated the rhythm of public festivities and inaugurations established under the Junta Militar, and although he was a man of few words, he had a certain propensity for grand gestures. As soon as he came to power, he called for constitutional reforms and changed the country's official name from the Estados Unidos de Venezuela to the República de Venezuela. By 1956, perhaps inspired by the Dominican dictator Rafael Trujillo's *Feria de la Paz y la Confraternidad del Mundo Libre* in Santo Domingo, he commissioned a team to design and plan a landscaped fairground to host a world's fair in 1960, which would be called the *Exposición Internacional de Caracas*. Much like its Dominican counterpart the site in La Carlota, in the east of Caracas, would put Venezuela on the world stage and then become the new political and administrative hub for the capital, complete with park, ministerial buildings, and Olympic village.[13]

The plans to build a cable car and luxury hotel on the Ávila Mountain, which flanks the city of Caracas and separates it from the Caribbean coast, reveals the bearing that Pérez Jiménez's *personal* vision came to have on the concept of modernity. Turning this previously undeveloped mountain into a leisure destination was the dictator's pet project, and the amenities inaugurated there in 1956 translated the ideals of synoptic vision, spatial transformation, and superación onto a monumental scale. After entering the cable car at the ultramodern station that Alejandro Pietri designed at Maripérez, visitors ascended to a height of over two thousand meters and, once at the summit, visited restaurants, or even glided around the skating rink. Another option was to board a smaller, horizontal cable car and continue along the ridge to the five-star Hotel Humboldt, whose fourteen-story cylindrical form was topped by a penthouse complete with 360-degree view and with landscaped gardens designed by the Brazilian modernist Roberto Burle-Marx (see fig. 5.6).

Given its accent on sweeping views, it is apt that the Hotel Humboldt's design was wedded to the aerial vision. The architect of the hotel, Tomás Sanabria, was a keen pilot who during his lifetime amassed almost eight thousand aerial photographs of Caracas and

Figure 5.6. An aerial view of Tomás Sanabria's Hotel Humboldt in Caracas. Archivo Histórico de Miraflores.

confessed to canceling appointments just so he could take to the skies and view the city "like a model."[14] The cable car and the hotel underscore the culture of display linked to Venezuelan modernity. After all, both were first and foremost conspicuous trophies of modernity that offered a landscape spectacle comprised of a series of elevated vantage points. The giddying ascent in the red metal cabins from the station at Maripérez and the hotel's glass façade both offered intensely visual experiences that removed the viewer from the city, transforming its uneven urban fabric into a flatter, more abstract image more akin to a blueprint than a real space. Much as Sanabria had made sense of the cityscape from the air, so too the ascent to the summit of Ávila staged the transformative experience of the gaze as the contingent features of the landscape took on a new order.

The physical feat of the project's construction also made a strong impression. The designation of the Ávila Mountain as a site ripe for

conquest and consumption through leisure activities mirrored the development of other picturesque places that could also be exploited for their impressive scenery and natural beauty. The creation of the Dirección de Turismo (Tourist Office) in 1954 signaled a broader move to incorporate nature into the narrative of progress alongside the more conspicuous modernist architecture. To this end, the state promoted the construction of hotels and edited official publications that lauded the country's many natural landmarks, comprising the Andes, Angel Falls, and the pristine beaches and resorts on the coast. The interior design of the Hotel Humboldt synthesized this blend of modernizing impetus and natural bounty. When visitors disembarked from the second cable car, which took them to the doors of the hotel, they would make their way to the lobby. Surrounded by lush gardens, constantly in sight because of the glass curtain walls, the lobby combined a striking black-and-white stone floor arranged in a grid pattern, with a painted mural that rendered the tropical vegetation in colorful texturized forms. Venezuelan modernity, the design suggested, was located here: at the marriage of cutting-edge engineering, modernist architecture, and a natural environment configured as an impressive landscape vista. If nature was once thought to be the "absolute monarch" beyond human control, as Raymond Williams proposes, then the Teleférico and Hotel Humboldt were unmistakable statements that nature too could be harnessed by the will to modernize that Pérez Jiménez used as his presidential stamp.[15]

Moreover, the dictator made no secret of his personal connection to this project. The cable car cabin created especially for presidential use was a luxury capsule: painted gold and emblazoned with the national crest on the outside, on the inside it featured a circular set of amply padded seats, complete with built-in ashtrays. The remaining cabins for use by the general public were basic modules fitted out with rows of hard, simple seats and no extra frills. Whether gazing out of the window of the presidential cabin or across the landscape from the penthouse at the Hotel Humboldt, or standing over the *Mapa monumental* at the *Exposición Objetiva Nacional*, Pérez Jiménez assumed the role of a Faustian developer in the most conspicuous manner and this visionary gaze became the central trope of his regime.

As the entanglement of power, vision, and space took on a more personal dimension after his rise to power, the dictator began to resemble Goethe's famous protagonist: "Standing on an artifi-

cial hill created by human labor," glosses Marshall Berman in his analysis of the play, "he overlooks the whole new world that he has brought into being, and it looks good. . . . It is a physical and natural space, but one that has been created through social organization and action."[16] As totems of the modern landscape, the cable car and Hotel Humboldt offered an "observation tower from which he and his public can 'gaze out into the infinite' at the new world they have made."[17]

The "watchtower" built atop the Ávila Mountain attests to a modulation in the visual regime of Venezuelan modernity after 1952. While up till then Venezuelans played spectators to a group of men in uniform who were agents of progress, the shift to outright dictatorship put the spotlight on one man in particular. So too, his personal tastes came to have a bearing on modernity through projects that sought "to domesticate the barbarous populace that had occupied the public space, to discipline its movements, speech and opinions within the imposing walls of the nation yet to be built, the dictator's castle writ large."[18] If mass housing and highways had laid groundwork for this metaphorical castle of modernity, the cable car and mountaintop hotel built after Pérez Jiménez seized power were architectural trophies: testaments to his ambitious vision of the future.

PERSONAL BIOGRAPHY AND NATIONAL HISTORY

Certifying Pérez Jiménez's status as chief modernizer needed more than architectural feats; it demanded a cult of personality to cast him as the ultimate cipher for national life. To present the leader as the embodiment of visionary capacity and modernizing endeavor, official propaganda started out with a simple question: *Who was this man?* A number of strategies were formulated to flesh out the figure of the taciturn dictator. A shift in visual communications strategies saw his portrait accompany media reports to reinforce the association between progress and president. Annuals like *Venezuela bajo el Nuevo Ideal Nacional* followed suit, presenting two permanent fixtures alongside their digests of public works projects: a full-page photograph of Pérez Jiménez and an abridged version of the New National Ideal. Finally, acolytes of the regime produced magazines and biographies to naturalize the Coronel's leadership as a teleological inevitability in Venezuelan history. Together, these associations and

narrative threads wove a sense of continuity and stability into national life as Venezuela transitioned from *dictablanda* to *dictadura*.

There are few better examples of the sycophantic tone of pro–Pérez Jiménez propaganda than the magazine entitled *Nuevo Ideal Nacional. Dos de Diciembre. Revista de Ilustración General*, whose first edition on December 2, 1955, marked the day, three years earlier, when Pérez Jiménez "won" the elections. The publication's intention to cement the dictator's legitimacy was stated in no uncertain terms; it was printed on high-quality color paper and had a significant print run, reaching nearly twenty thousand in the first year. Two epigraphs prefaced the inaugural editorial, one by Pérez Jiménez and another by Simón Bolívar, whose words were taken out of context to situate the dictator at the center of the nation's life: "In our Constitution, the President of the Republic became the sun that, firmly situated in its center, gives life to the universe." As Venezuela's founding father was invoked to endorse Pérez Jiménez, readers were effectively told that his presidency was both patriotically valid and as natural as the solar system. The magazine's purpose was clear: it would disseminate (only) information that certified "that magnificent and immortal national reality that is the creative attitude of President Pérez Jiménez."[19]

This goal became particularly evident in an article entitled "The Most Important Dates in the Year," an exercise in historiography that drew on the established strategy of commemorating dates related to the military interception of democracy. The article singled out dates that marked independence movements in Latin America, the foundation of Caracas, and other historical events, yet of the seventy-seven events, twelve related specifically to Pérez Jiménez's life and career. Personal biography and national history became intertwined in a single narrative: the dictator's promotion to general on January 1, 1941, the dates he received medals of distinction, and his election as president, all merited collective jubilation, the magazine suggested. To reinforce his eminent genealogy, the dictator's birth date now featured alongside those of founding fathers Francisco de Miranda and Simón Bolívar, thus elevating him to the same status. Delving further into myth, an article published at Christmas lauded December 2 as the beginning of a new era, summoning a creation tale to belie fraud and equate democratic suffrage to divine intervention and Christian devotion. "God and distinguished devotees of his earth made

abuses and immoralities disappear and elected then Coronel Marcos Pérez Jiménez Provisional President of the Republic of Venezuela," the editors continued in hyperbolic reverie. "Thence was born a new Venezuela with a NEW NATIONAL IDEAL [*sic*], whose political evolution has produced the most amazing results in progress and general well-being, unprecedented in any period of Venezuelan history."[20] Appealing to visual and spatial metaphors in phrases that inferred the nation's unstoppable march toward progress, the author hailed the dictator in quasi-religious terms as the *Gran Realizador* (Grand Maker). By stating that, unlike Venezuela's Independence forefathers, Pérez Jiménez would never die, the suggestion was that built space would guarantee him a timeless legacy.

This rhetoric endured in subsequent editions of the magazine, reaching a peak when, in an article published at Christmas 1956, the editors expressed their blind faith in Pérez Jiménez's *tenacidad de cíclope*—his cyclopean tenacity.[21] This motif of visionary power is a linchpin in understanding spectacular modernity. Tellingly, this analogy of Pérez Jiménez as a Cyclops whose gaze is fixated unblinkingly on progress was not a one-off analogy. Rather, it is echoed by other biographies of the dictator, such as Ladislao Tarnoi's *El Nuevo Ideal Nacional de Venezuela: Vida y obra de Marcos Pérez Jiménez,* published in Madrid in 1954. Tarnoi justifies his conflation of Pérez Jiménez's personal biography and Venezuela's geography, society, economics, history, and industry by claiming they constitute a single thread that is immune to his authorial intervention. "As I observed the efforts that one figure made to resolve [the challenges] my notes grew into a biography that was simultaneously a biography of the Nation," he writes.[22] Pérez Jiménez finds his mirror image in the nation and vice versa. More specifically, Tarnoi associates the dictator with Caracas's monumental architecture. Despite feigned appeals to objectivity and claims that Pérez Jiménez's work needs no eulogies, Tarnoi does not hesitate to compare the New Caracas to the immortal Egyptian pyramids. With this rhetorical flourish he sketches a portrait of man and nation that inserts both into the annals of pioneering civilizations.

The most engaging aspect of Tarnoi's obsequious biography is the way it naturalizes Pérez Jiménez's dictatorship by appealing both to visual conceits and to literal illustrations. A group of photographs included after the introduction sets up the connection between the dictator and his native landscape, the Andean mountains, which

Figure 5.7. Photograph of the dictator as a child, interpreted as proof of his innate military vocation. *Pérez Jiménez: Fuerza c readora* (1953).

the author claims conditioned Pérez Jiménez's ability to extend his all-encompassing gaze across the nation. The first images, which appear in an almost filmic arrangement over three pages, move from a panoramic view of the mountainous landscape to close-ups of two folksy Andean characters. Then come three images of Pérez Jiménez's family home, a family portrait with his siblings, and finally, a portrait of the dictator as a child posing with a rifle (fig. 5.7). These images preface the first chapter entitled "La visión de altura" (elevated vision), in which—much as in the proregime documentary *Paisaje de la Patria*—the prose sweeps over Venezuela's territory, detailing its landscape in a lyrical tone. Here, the author quotes statistics about Venezuela's main industries, before leaping backward in time to describe the pre-Columbian peoples who dwelled in the Andes before colonial times. Clearly, this preamble is intended to

construct a mythical Andean landscape, where, as indigenous legend has it, the snowy peaks of the Sierra Nevada were created from five eagles, as the locus of a deep belonging. The essentialist use of this genesis tale insinuates that Pérez Jiménez has assimilated both his native people's "eagle eye" and the bird's-eye view of the mythological eagles that fly through the Andes.

Through this textual grafting, the author embeds the rocky, steadfast essence of the Andes into Pérez Jiménez, implicitly underscoring authority and perpetuity by comparing Andean people to mountains: steadfast since time immemorial. The gaze of authority is definitively inscribed with a triumphant flourish as Tarnoi conjures the experience of the landscape he attributes to Pérez Jiménez, when still a boy: "The unprecedented and magnificent sensation of this vision from the heights made an indelible mark on the soul of young Marcos. The son of the Andes, looking at the world from the top of the mountains, understands that there are no insurmountable obstacles." With this gloss, Pérez Jiménez's ascent into the mountains as a young boy and the zenithal view he achieved there prefigure the privileged insight that would later shape his political doctrine; importantly, though, they also suggest the futility of opposing his dictatorship, since this is a man for whom all obstacles can be surpassed.

Tarnoi's second chapter, "En la tierra de los Incas" (In the land of the Incas), seeks further purchase for this interrelation of visionary seeing and dictatorial legitimacy. Tarnoi describes the time Pérez Jiménez spent at a Peruvian military academy in 1939 and narrates the young soldier's return journey to Venezuela as a second moment of epiphanic revelation and synoptic visions. In Tarnoi's tale, Pérez Jiménez is gazing out of the plane window as it flies him back to Venezuela and reflecting on Latin American geopolitics. Amid these musings, a revelation comes to him: patriarchal authority is the true backbone of society! Democracy does not depend on voting but on the provision of *bienestar común* (communal well-being)! Significantly, as the narrative endorses dictatorship as a necessary and benevolent act, democracy is reframed as autocratic efficiency in the provision of key services. Popular participation and political pluralism are, it suggests, of no use. The people cannot *envisage* their own needs; Pérez Jiménez can.

Predictably, the subsequent homecoming is that of the prodigal son, with Pérez Jiménez cast almost as a replacement for the exiled

Bolívar, a replacement who will realize the truncated dream of Venezuela's greatness. "When the plane reaches the point where the borders of the Bolivarian countries meet," the coming of age tale concludes with a concise phrase suggesting that, as he disembarks from the plane, he embarks on a new journey: "Lieutenant Pérez Jiménez was sent to Peru on a military mission and Capitan Pérez Jiménez returns with a national mission."[23] The accent on Pérez Jiménez's biography as a mirror of national history modulates the value of seeing. The modes of seeing associated with spectacular modernity are not limited to the high modernist synoptic vision that measures and rationalizes land so as to optimize it nor to the awestruck gaze that the regime hoped modernist buildings would elicit. Tarnoi's story also exemplifies a deterministic reification of vision, according to which the gaze arises from personal biography and whereby national development becomes contingent on one man's visionary capacity. In so doing, Tarnoi's literary propaganda constructs a teleological account in which the dictator is the quasi-mythical lead character whose homecoming sets the nation on its predestined course to progress.

Tarnoi was not alone in adopting this strategy. Francisco Aniceto Lugo's *Pérez Jiménez: Fuerza creadora* (Creative force), first printed in 1953 by the Imprenta Nacional, had heralded this tendency to bind personal and national histories. After allegedly becoming Venezuela's fastest selling book, it was reprinted in 1955 and translated into English for distribution by Exposition Press in the United States.[24] The book attempts to justify the ideological premise that political parties are a waste of valuable time that military rulers could dispose of much more efficiently in the modernization of Venezuela.[25] Around this central argument, photographs interspersed throughout the book compound the idea that Pérez Jiménez was destined to become president—an ambition that, like Tarnoi, Aniceto Lugo claims he had voiced when he was just a child.[26] Correspondingly, the book opens with the same childhood portrait of the future president, posing with a dog and a rifle in an open legged stance, with a caption that clarifies that "since he was a child, Coronel Pérez Jiménez showed his overwhelming military vocation" (see fig. 5.7).[27] Photographs from the family archive thus serve a dual purpose; they familiarize the reader with the dictator's human dimension, while providing apparent proof of his innate will to steer Venezuela to progress. Presidency, in this light, is almost a birthright.

In a more general sense, the images have the same didactic function as elsewhere in state propaganda. The photographs either accompany the text's chronological trajectory as it charts Pérez Jiménez's journey from child to soldier to president, or they reinforce the texts that celebrate military might as an antidote to "The uselessness of party political struggles," as one chapter puts it. While the emphasis on Pérez Jiménez's exemplary agency played down the roles of political constituents, the metaphorical references to the Venezuelan population as the *familia venezolana* (Venezuelan family) establish a patriarchal hierarchy in which subjects are beholden to Pérez Jiménez's paternalist statecraft. In short, the text sanctioned the political events that enabled this *hijo de los Andes* (prodigal son of the Andes) to become the firm-handed *pater patriae* (father of the homeland) who was strict yet benevolent. Although he was instrumental in eliminating political freedoms, this was for the good of the Venezuelan family since Pérez Jiménez's vocation was to ensure "all official protection of the masses in all the corners of the fatherland," as another official text put it.[28] The implication of this device was that a further and more intimate thread had been added to the narrative fabric that bound the dictator's personal story to the nation's history: now, by virtue of his depiction as benevolent father, Venezuelans might see Pérez Jiménez as part of the family.

The blurred boundaries between the private and public spheres of Pérez Jiménez's life and the embedded hierarchies of paternalist politics can also be traced to photographs from Venezuela's institutional archives. That the Oficina Central de Información archive, for instance, included images of intimate events such as birthdays and christenings signals that they were considered worthy of circulation in the public realm. One representative group of negatives depicts Pérez Jiménez's birthday party at his home in 1954. The cult of personality that grew around him is epitomized by *mise en abîme* representations of the dictator that depicted him multiple times in a single image, as can be seen in one photograph that presents the dictator with his guests, as a miniature statue, and in a painted portrait (fig. 5.8). While the family atmosphere of the party revisits the dictator's paternal role so as to soften the edges of his military image, official propaganda completed the motif of the familia venezolana by casting the First Lady, Doña Flor de Chalbaud, as a maternal figure, whose benevolent and charitable works recall the

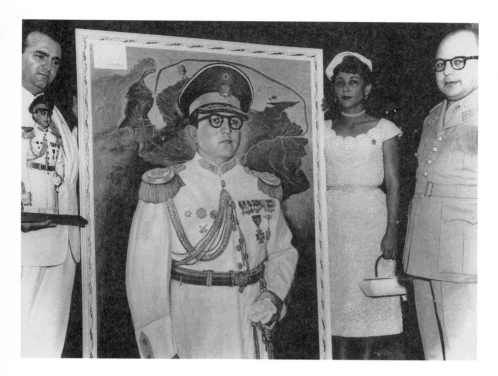

Figure 5.8. Marcos Pérez Jiménez poses alongside gifts at a party to celebrate his birthday in April 1954. Archivo Audiovisual, Biblioteca Nacional de Venezuela.

contemporaneous example set by Eva Perón in Argentina. Moreover, these familial images were synchronized so that in an edition of the *Revista del Banco Obrero* in 1954 Doña Flor appeared in full-color on the front page and Pérez Jiménez on the first pages of the magazine. The picture of Doña Flor embracing a child accentuated her protective feelings to present her as custodian of the subjects of the "Venezuela of tomorrow," while Pérez Jiménez's portrait at a microphone reading a speech cast him as the dominant father addressing the nation.

At the climax of the intertwining of biographical and historical narratives, the final and vital link between Pérez Jiménez's life and Venezuela's modern destiny can be found in *Pérez Jiménez: Fuerza creadora*. The chapter "Hacia un hermoso futuro" (Toward a beautiful future) intensifies the representation of the *creative force* driving

Venezuela's modernity by adopting a hyperbolic tone that implies that rapid modernization might put collective sanity and visual coherence in jeopardy: "We work ourselves up in vertiginous progress which envelops us in a whirlwind of intense sensations that occur so fast that they almost take our breath away and make us incapable of careful observation." The text presents the subject's modern body as the locus of transformation but also as the site of the destabilizing impact of progress that fragments sensory experience and annuls the capacity for careful observation that is so vaunted in Pérez Jiménez. Significantly, against this verbal evocation of maelstrom, the reader is presented with a close-up photograph of Pérez Jiménez, depicted sitting calmly and impassively at his desk. The clash of text and image tacitly presents him as the antidote to modern malaise, whose steadfast gaze can recompose the disorderly world. On this basis, it transpires that the hysteria permeating Aniceto Lugo's description is merely a rhetorical conceit, contrived to reaffirm the stabilizing figure of Pérez Jiménez as a necessary mediator of national life. Indeed, as the text goes on to note, the dictator's work is precisely to oversee the "foundation of cities, regulation of urban growth using scientific plans drafted with his sights set on the future."[29]

It is significant that, once again, a visual trope is instrumental in reestablishing order by maintaining the readers' sights set steadfastly on the future. Amid this rapidly changing world, Pérez Jiménez's sense-making gaze is a means of tempering and ordering flux and anxiety, casting the dictator as a reasonable, stabilizing response to unstable milieux. And to seal the deal, the text addresses the reader with a rhetorical question: "When opinions are divided, broken up, atomized, wouldn't it make more sense to form a common front around the personality of Coronel Pérez Jiménez?"[30]

•

Grounding stability on the firm gaze of the paternal autocrat situated at the center of the new political cosmology thus emerges as the core of political cosmology of the post-Junta years. The *Exposición Objetiva Nacional* served as a curtain raiser to the consolidation of the cult of personality that singled Pérez Jiménez out as a visionary leader who would ensure enduring stability for the four years of discernible progress evinced in the public display arranged before the elections.

Ultimately, the run-up to the elections of 1952 and the propaganda produced in the wake of the electoral fraud that installed Pérez Jiménez in the presidency elucidate the meticulous choreography that was deployed to safeguard political order. The miniaturized representations of the nation as mechanized map and the careful arrangements of all manner of objects assembled to quantify progress in the *Exposición* confirm that the regime summoned cutting-edge technologies of display as the foundations of political legitimacy and to engage Venezuelans in the continuation of the project of military-led modernization initiated after 1948. The subsequent dissemination of pseudo-biographical accounts that vouched for Pérez Jiménez's gifted *visión de altura* (elevated vision) leaves no doubt that the military regime had produced a sophisticated propaganda apparatus to mitigate each of the political crossroads at which Venezuela was diverted from democracy over the decade at hand. On this basis, it is evident that the historiographical strategies set in place after the coup of 1948 provided foundations for the specific visual and discursive devices deployed to smooth Pérez Jiménez's fraudulent entry to power and to craft legitimacy for his dictatorship. This emphatically visual and personal shift has offered new clues as to how this apparatus not only drew on its touchstones of military efficiency and patriotic sentiment but also mined the affective potentialities of presenting Venezuelans with a "visionary" leader with whom they could identify as pater patriae.

• PART III •

PERFORMING

PROGRESS

CHAPTER 6

SUBJECTS ONSTAGE

ORGANIZED WALKING IN SCRIPTED SPACES

• In October 1952, the Venezuelan daily *El Nacional* published a column that dubbed Caracas "La ciudad sospechada"—a "suspected" city whose definitive form was still taking shape. Against the monumental constructions and architectural maquettes habitually showcased in official propaganda, the capital was conjured in more precarious terms as a landscape in the making, still caught up in the rubble of sweeping demolition and construction works. As author Eduardo Blanco-Amor pined for the familiar contours of Caracas's colonial architecture, he suggested that the bond the military leaders sought to cement between space and subject had not yet set. "What will the new resident of Caracas [*caraqueño*] have to be like so that the city that is emerging from amid the rubble contains and justifies him?" he mused. "The city, when it functions naturally, does not superimpose some more or less daring structures onto an inadequate or carefree man, but is a symbiosis between man and city."[1] While the article left no doubt as to the transformation of the urban landscape, it did put a question mark over the idea that caraqueños would automatically see their reflections in the mirror of modernity.

This sense of estrangement and dislocation were by no means an anomaly. In a later article on Caracas for the *Revista Shell*, Blanco-Amor wrote: "It is not common to arrive at a city and not find it," casting the city as an undefined space "entre el ser y el no ser"—between being and not being.[2] Others too recounted disorienting experiences of the changing cityscape. In a chronicle entitled "La ciudad cambia" (The city changes), Augusto Márquez Cañizales describes the experience of getting lost in the subterranean labyrinth of the brand-new Centro Simón Bolívar. After losing sight of the Teatro Municipal, a nineteenth-century landmark in downtown Caracas, he plunged into the maelstrom of modernity in this "huge basement full of cars and cheery offices decked out with neon lights, stores selling electrical appliances, travel agencies, currency exchange offices, airlines and shipping lines, bookstores, small businesses selling fabric, jewelry and artistic artifacts." The Centro Simón Bolívar was generally lauded as the epicenter of the proposed symbiosis of military state, modern space, and transformed subject, which would redefine caraqueños and the nation at large under the banner of progress. Yet, for Márquez the new urban complex was an illegible space, a "dark underground labyrinth of a new, unknown city" to which he finds no logical exit. Márquez not only found it spatially disorienting, he also complained the building was "inhabited by beings whose physiognomy I found quite unfamiliar." As the author voices his struggle to identify with shifting spatial and social configurations, the chronicle lapses into dehumanizing portraits of city dwellers, lumped either into a mass of foreign faces or as "shoe wearing, apartment proprietors" equipped with "clean furniture, fridge and television." Far from an illuminating mirror that reflects a coherent portrait of society in the promised "New Venezuela," what surfaces from Márquez's account of the Centro Simón Bolívar is a sense of unease, perhaps at rising immigration, perhaps at the urban poor so stigmatized by the regime as a blot on the modern landscape.[3]

DEMOLITION AND DISPLACEMENT

If space is produced, as Henri Lefebvre suggests, in the "continual back-and-forth between the private speech of ordinary conversations and the public speech of discourses," then the articles cited above contain crackles of interference that problematize the alleged symbiosis of space and subject propagated by official missives.[4] And ambivalent

reactions to modern buildings were not only a feature of the odd first-person chronicle; the bid to bulldoze informal communities and rehouse them in superblocks also drew differing reactions. While some welcomed the change, others recoiled from the upheavals induced by the six-month cycles of the Banco Obrero's mass-housing project. From June to December, demolition and construction advanced "at breakneck speed [. . . so] that all work—from evictions, to temporary relocation, to leveling, to construction, to adjudication of new housing—took place simultaneously."[5] The radical transformations of the landscape were supposed to garner unreserved support for the military leaders, but the fact that Caracas's residents voted *against* Pérez Jiménez in the elections of December 1952 shows that this was no guarantee.

As the *Batalla contra el rancho* uprooted and scattered communities that had long-standing affective and political bonds to their surroundings, the regime pursued political demobilization under the cover of benevolent developmentalism. The stories of members of the tight-knit community of Tiro al Blanco—who were the first to get keys to apartments in the superblocks—that Alejandro Velasco recounts in his ethnographic history of the 2 de Diciembre superblocks reveal that some at least were uncomfortable about the sweeping housing plan. Not only was their neighborhood razed in a matter of days, the apartments they moved into were nothing like the "socially complex, physically heterogeneous spaces" of their self-built barrio, which even had its own biweekly newsletter, suggestively entitled *Laberinto* (Labyrinth).[6]

Evidently, even as modern constructions took center stage in the bid to build and display Venezuela's rapid transformation, the people who inhabited the new buildings were not necessarily in tune with the official script. These discrepancies between people's experiences of landmark constructions such as the Centro Simón Bolívar and the superblocks shed light on the dialectics at the heart of the production of space. Blueprint spaces based on the abstract, rational forms sketched onto blank pages by architects and urban planners are ultimately unpredictable, Henri Lefebvre argues. They lend excessive credence to "the delusion that 'objective' knowledge of 'reality' can be attained by means of graphic representations."[7] By congealing space as diagrams, such top-down plans risk becoming a caricatured imitation of the discourse of power that presumes to govern spatial interactions. However, these plans fail to account for the fact that everyday physical experiences of space are dynamic processes that

escape systemic orders, whether urban, ecological, economic, or political.[8] Even as planiform and geometrically ordered urban designs envisage ideal encounters between space and body, once set in place and used built environments are apt to be altered by the user's individual gestures and by shifting social relations.[9]

This conception of the production of space as an unfolding dynamic that resists total visual and institutional capture sheds critical light on the fetishization of synoptic vision and grand designs as guarantors of instant modernity in spectacular forms. Military rule and the New National Ideal's doctrine of spatial transformation and social *superación* not only refigured Venezuelans as docile spectators of modernity. Military rule also produced an official script for the interactions between space and subject, in which Venezuelans were not there just to watch and applaud. If their contact with modern spaces was to transform them, as the regime promised, then its political legitimacy also depended on making this apparent. Given the slippages in modern spaces described above, the question arises as to how the regime produced scripted experiences of modern spaces that drew on the performative aspect of spectacle. How did the regime choreograph people's encounters with the changing landscape and encourage Venezuelans to take part as spectators of and as actors in the nation's performances of progress?

CARNAVALES, ORDERLY PARADES, AND BEAUTY QUEENS

The carnival celebrations in Caracas from February 27 till March 2, 1954, were by all accounts among the most lavish, exuberant, and memorable in the city's history. Even today, websites and social media offer a plethora of films and photographs that show floats, carnival queens, and jolly crowds, who line the streets and lean out of their balconies to watch the spectacle as it passes by. A mock dragon full of devils, a huge papier maché tiger on a chain, floats decked out as trains (fig. 6.1), giant orchids, neo-classical columns, life-size model horses, a huge globe of planet Earth, all rolled along the Avenida Urdaneta up the Avenida Victoria and on to the Paseo de Los Próceres toward the Academia Militar. Against the verdant backdrop of the Ávila Mountain, even a troop of real-life elephants with bejeweled harnesses, ridden by girls clad in swathes of silken robes, paraded past the crowds, led by bare-chested men in turbans.

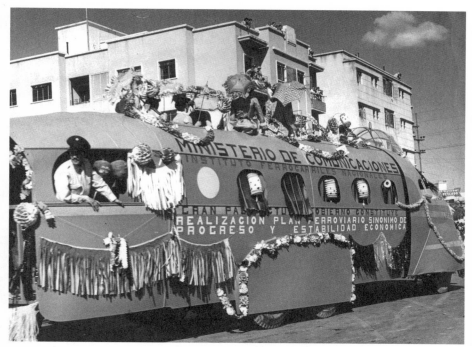

Figure 6.1. The Communications Ministry float at the carnival parades of 1954 represented the railway-building project as a "synonym of progress and economic stability." Archivo Histórico de Miraflores.

Winding the reel back sixty years paints a similar picture of the festivities and reveals their broad-ranging dissemination in local media. The May 1954 edition of the *Revista del Banco Obrero* featured photographs of the coronation of the carnival queen and her attendants alongside an upbeat text lauding the parades as a truly dazzling international event, which caused admiration in locals and visitors and "achieved this year rare sparkle and splendor." As the text continues, however, it reveals a further aspect of the carnival beyond the taffeta and tiaras. The Banco Obrero had entered two floats into the processions; one was a van, fashioned to imitate the rocky topography of Caracas's hillsides and topped by a series of model ranchos built from cardboard and finished off with tin roofs. The microcosmic barrio left no room for a carnival queen, hence the float paraded solo, adorned only with a sign saying "El Banco Obrero

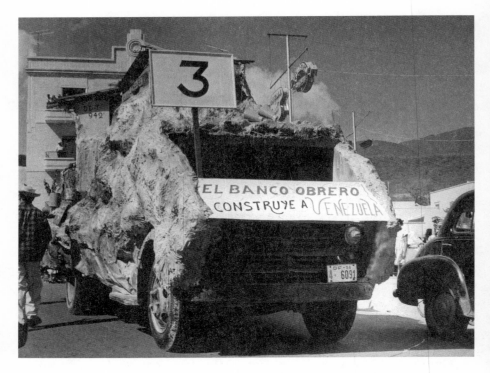

Figure 6.2. The Banco Obrero's float with miniature ranchos bore the slogan "The Banco Obrero builds Venezuela." Archivo Histórico de Miraflores.

construye a Venezuela" (fig. 6.2). The second entry could not have been more different. A modern tractor pulled a long trailer, packed with glamorous attendants—young pageboys and little girls in sparkly dresses. Atop the float was a model superblock that must have measured some two meters in height, which served as a backdrop for the carnival queen, who was decked out in a silk dress, fur stole, and ceremonial scepter. The "two monumental motifs" on the Banco Obrero floats "condensed the institute's work: the dilapidated and miserable ranchos, a strikingly realistic scene; and the superblock, with its sober, elegant lines." Evidently, the carnival was no mere public festivity; this was one more lesson in space-induced *superación*.[10]

The Banco Obrero entries are symptomatic of the regime's overall strategy to orchestrate the carnival parades as an awe-inspiring spectacle that would draw Venezuelans into the city's new spaces

and present spectators once again with the familiar prospects and imaginaries of the nation's progress. The detailed organization of the events shows that, for the dictatorship, carnival festivities were no laughing matter. At the end of 1953, Pérez Jiménez decided that these time-honored parades should be revived, so he initiated preparations for the following year in earnest by creating the Junta Central Directiva del Carnaval—an executive committee to oversee the events. Under the stewardship of the First Lady, Doña Flor, the carnivals became a choreographed display led by state institutions that marshaled bodies, space, and spectacle to put a "face" to Venezuelan modernity. A highlight of Pérez Jiménez's third year in power, the "grand parades, the dozens of beautiful floats marching among the crowds along the modern and beautiful avenues of Caracas spoke with their optimistic language and smiling face of the Venezuela that grows and becomes powerful," as another state publication had it.[11]

Much thought was put into optimizing the organization of the carnival parades. In the pre-event announcements published in national newspapers in the run-up to the four-day extravaganza, carnivalesque topsy-turvy was recast in a mold of military precision. One full-page notice featured no less than eighteen rules and two subnotes that explained exactly how the inaugural parade would be assembled. Floats should gather along the Avenida Victoria, located close to Villanueva's Ciudad Universitaria, ninety minutes before the parade was due to begin so as to ensure optimum organization. Once assembled, participants would then be allocated their predetermined positions in the order of appearance: riders from the equestrian clubs would lead off, followed "at a distance of no less than fifty meters" by motorcyclists from the Fuerzas Armadas Policiales and the Inspectoría General de Tránsito. Then, after "no less than twenty meters" would come the Distrito Federal's carnival queen, followed "no less than ten meters" later by floats representing seven different social clubs from the capital. And on it went.[12]

The distance between floats was of course devised to ensure the legibility of the spectacle, leaving space for onlookers to appreciate each one as it went by. At the same time, though, the order of their appearance was a taxonomic hybrid: on one hand, the organization emulated the hierarchical configuration of the nation-state, tracing routes from the heart of power in Caracas to provincial outposts; on the other, it grouped social and industrial participants into specific

categories. Spectators could apprehend the scope of the bureaucratic apparatus through a moving tableau of floats representing the fifteen government ministries, followed by their dependent institutes; carnival queens representing Caracas municipalities would then be followed by their provincial counterparts. Next came the turn of the private sector, arranged with equally meticulous care. The banks would lead off, shadowed by industry, trade, and individual entries, all methodically arranged in alphabetical order. Bringing up the rear, but no less significant, was the fifteenth and final category. Representing the new residential housing development at Prados del Este, in southern Caracas, pairs of elephants ridden by *lindas muchachas* (lovely ladies) would transform the cityscape into an exoticized land of opportunity.

Another centralized body, the Dirección de Espectáculos Públicos, would carry out the final pre-parade check to ensure that each float displayed its given number on a seventy-five-by-fifty-centimeter board attached by a two-meter pole. With no glimpse of irony, organizers went on to remind entrants that these must be on show *only* during the assembly line; if not, the parade might seem labored or unspontaneous.[13] Not content with shepherding the floats, announcements also primed spectators for the event; and also, on the eve of the festivities, reminding people of the parade routes, the notice contained a cautionary message. A section printed entirely in capital letters announced that the Junta was sure that "citizens will demonstrate the traditional culture [*cultura*] of the Venezuelan people." Drawing on the double meaning of *cultura* as both cultural manifestations and refined behavior, the message hinted at a watchful and potentially disciplinary presence that lurked behind the scenes.[14] In these carnival parades, dictatorship bore a mask of feigned frivolity to elicit rapturous applause from the crowds.

As they led off in their designated order, a number of ministerial floats served as literal vehicles for public works projects. Some presented as yet unrealized projects, like the Maripérez Cable Car and the Hotel Humboldt (fig. 6.3), supersizing the architectural maquettes usually found in the displays of the official exhibitions (discussed in the previous chapter). By enlarging the scale of the prospective models and placing people on board them, the floats had a dual effect. They staged a rehearsal of new spaces to present

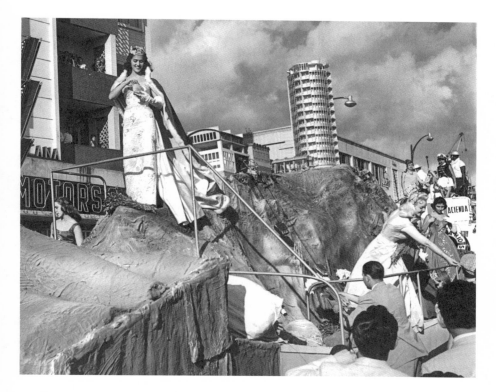

Figure 6.3. A carnival queen stands atop a miniature rendering of the Ávila Mountain, complete with model cable car and Hotel Humboldt. Archivo Histórico de Miraflores.

them to the public and to reinforce the didactic message that these novel constructions were worthy of fervent applause. Other floats replicated existing spaces, like the superblocks and the Caracas–La Guaira Highway (fig. 6.4), and in so doing musealized such sites as canonical objects in the nation's accumulation of markers of modernity. In short, the parades were yet another strategy to create scripted versions of space, which would safeguard their abstract qualities over and above their functional capacity as spaces to be used and lived in. These miniature monuments were there to remind people it was military rule that guaranteed their life-size counterparts were a tangible reality.

But the carnival was not just a stage to present scale models of modern constructions. By casting the carnival queens as central pro-

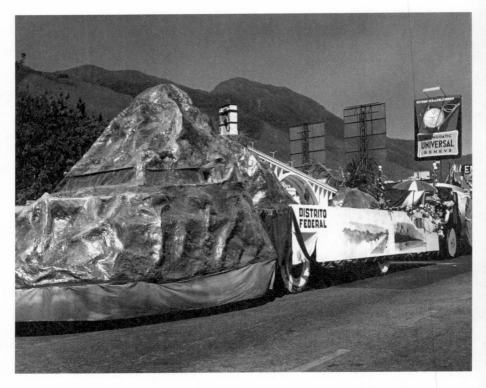

Figure 6.4. The local government for the Federal District area chose the flagship Viaducto No.1 as their entry to the carnivals. Archivo Histórico de Miraflores.

tagonists in the parades, the organizing committee also spectacular-ized a particular version of femininity and deployed corporeality as a medium to display progress. Through her ethnography and critical analysis of *transformista* (transvestite) and beauty pageant culture, Maria Ochoa proposes that "spectacular femininities" are means of leveraging beauty and glamour to negotiate power on a micropoliti-cal level.[15] In the context at hand, the celebration of the female body and the accent placed on the "regal" presence of carnival queens alongside public works projects demonstrate a more macropolitical way in which exhibitions of femininity situated Venezuela at the center rather than on the peripheries of modernity. Pageants and contests entrenched in Venezuelan culture a Eurocentric mode of femininity as a marker of distinction and modernity and these spec-

tacles have long been televised on shows in countries worldwide.[16] It is no secret that alongside oil, beauty queens serve as a core currency of a nation brand of Venezuela that is in transnational circulation. More significant still is the fact that the value of beauty as a marker of modernity really took root during the 1950s within the broader framings of space, spectacle, and military-led modernization.

Beauty contests date from the early twentieth-century Señorita Venezuela contest, in which the public chose their queen from postcards sold with La Hidalguía cigars. The following decades saw Miss Caracas contests, the rise of carnival queens, and even a campaign in 1929 to choose a national contender for a contest in Argentina, which apparently never came to fruition.[17] In 1952, however, the Miss Venezuela contest took on national dimensions after a committee organized and sponsored by Pan American World Airways selected the first delegate for the Miss Universe pageant in Long Beach, California. The selection of the winning *Señorita Venezuela de cuerpo entero* (full body Miss Venezuela) from a bevy of beauties from different states and municipalities cemented a symbolic pact between the nation-scape and the female body: establishing a correlation between beauty, prestige, spectacle, and modernity that endures to this day.

The inaugural contest of 1952 involved a protracted performance of several days, summoning the recipe for modern life that was championed by the dictatorship: air travel, fast cars, city life, and military power. The candidates were flown to Maiquetía from across the country, whisked up to the city in shiny new Pontiacs (albeit not yet on the superhighway), and then paraded on the cars through Caracas's new avenues to the delight of the public who lined the streets. A few days into the contest, the girls were taken to the Military Academy in El Valle where, dressed only in bathing suits, they paraded around the swimming pool. Marcos Pérez Jiménez and Luis Felipe Llovera, representatives of the Junta Militar, were in the front row. By the 1955 edition of the contest at the ultramodern Hotel Tamanaco, after which Susana Duijm became the first Venezuelan Miss Universe, rear admiral and then director of sports Wolfgang Larrazábal was among the judges.[18]

As public interest grew in the contest, the nation's military rulers were keen to show that the female body, much like the landscape, was *en la mira* (in the public gaze). As they set their sights on the Miss Venezuela contest, they circulated the nation's exemplary fe-

male bodies as currency to display the nation's progress. After Duijm was crowned Miss Universe in London, Pérez Jiménez even had her flown straight to Santo Domingo to participate in the grand display of modernity that his friend, dictator Rafael Trujillo, had organized to celebrate his quarter century in power and in which his daughter Ángelita was crowned queen of the carnival.[19] Later on, Dujim continued to Caracas, where she took part in the carnival processions of 1955—the jewel in the crown of the modern city.

The honorific culture of female beauty clarifies the predominant role given to carnival queens on ministry floats in the processions of 1954.[20] Standing alongside miniaturized public works—or representing state institutions, from the tax office to the Navy—the beauty queens resembled outsized living statues who hailed the spectators. Capitalizing on rising interest in Miss Venezuela, the regime aped regal paragons to enhance public perception of modernization. At the same time, the exclusion of a carnival queen from the Banco Obrero's rancho-float reinforced the idea that such spaces were not worthy of celebration, thus driving home the official claim that informal dwellings were an aesthetic and social problem unfit for occupation even in simulated forms. Following Fernando Coronil and Julie Skursi, bodies in the carnival parades served as a means of communication so that "states that have but partial control over populations and territories [. . . can inscribe] on the bodies of their subjects assertions of power directed to collective audiences. These inscriptions encode not only the reasons of the state but the unquestioned foundations of these reasons, the bedrock of common sense that makes a social landscape seem natural."[21] In this case the message was clear: if spatial transformation was a route to superación, the honorific paradigm of beauty embodied by the carnival queens was one signpost that Venezuela was on course to a better future.

In this choreography of progress, one final aspect is worthy of note. The parades rendered spectacle as a kinesthetic spatial experience that not only entailed lavish displays of modern spaces and ideal bodies but also involved onlookers' physical movement in the modern spaces of the growing city. Notwithstanding the people who hung out over their balconies watching the parades, the vast majority of attendees were a mobile audience that had at least four possible urban itineraries available to them over the successive days. While public works and carnival queens had a starring role, the city offered

both a modern backdrop and a supporting cast. Its new arteries established viewing circuits that would encourage people to engage with the new shape Caracas was taking. The inaugural parade of February 27, 1954, headed south across the city, following the Avenida Los Ilustres before culminating at the new military parade ground past the Avenida de Los Próceres, which was still under construction at the time. To see the parades over the following days, spectators would visit the new Avenidas Urdaneta and Bolívar, beacons of modernization built over the rubble of the old city, and would trace the city's expanding horizons eastward along the Avenida Francisco de Miranda toward Plaza Altamira, or westward along the newly inaugurated Avenida San Martín and the blocks that flanked it. In making such routes visible and integrating them into the festivities, the carnival parades of 1954 inscribed fresh itineraries that showcased the Nueva Caracas and associated the new city with the festive atmosphere of carnival. By guiding mobile spectators through the growing city and making the urban landscape more familiar, the carnivals mediated public use of modern space in ways that might counter the disorientation and estrangement that some had experienced. In short, the careful orchestration of the carnivals incorporated social bodies into spectacular performances of progress: modernity was not just something to be seen but to be experienced firsthand.

SCRIPTED STROLLING THROUGH THE SISTEMA DE LA NACIONALIDAD

For all their sparkle and joviality, the carnival parades mediated Venezuelans' contact with modern spaces only once a year. By contrast, monumental sites could permanently set in place narratives of progress and encourage patriotic sentiment through contact with organized itineraries. There is no better example of scripted space than the Sistema de la Nacionalidad (Nationality System), conceived as a sort of Venezuelan Champs Elysees that runs southward from the neighborhood of Santa Mónica to the military complex of Fuerte Tiuna in El Valle. The urban complex was presented to the world on its opening as the "largest art extravaganza in modern history" (fig. 6.5).[22] While by no means modernist in style, the monumental idiom and grand scale of this spatial arrangement gained its entry into the history of architecture as an exponent of Venezuela's modern

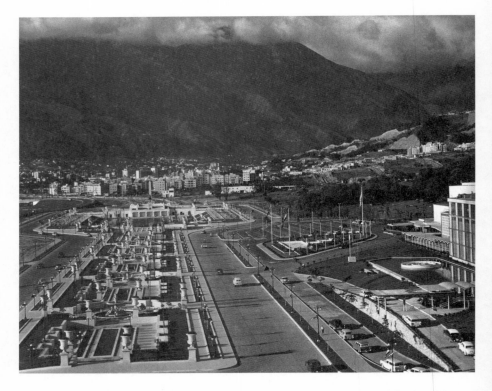

Figure 6.5. Aerial view of the Paseo de Los Próceres, with the Círculo Militar to the right and the valley of Caracas and Ávila Mountain in the background. Archivo de Fotografía Urbana.

architecture. The Sistema articulates a linear trajectory that begins at Carlos Raúl Villanueva's Ciudad Universitaria and culminates at the Academia Militar, taking in avenues, roundabouts, walkways, fountains, statues, and a parade ground along the way. Designed between 1950 and 1952 by Venezuelan architect Luis Malaussena, and inaugurated by Pérez Jiménez on December 2, 1956, the monumental axis spatialized fundamental cornerstones of the New National Ideal. As an urban itinerary that connects educational and military institutions, it advocates the articulation of civil society and military nodes. As a network of avenues bisected by pedestrian *paseos* (walkways) and punctuated by monuments that allegorize national identity and narrate independence, the Sistema was conceived to engage Venezuelans in patriotic sentiment and collective superación.

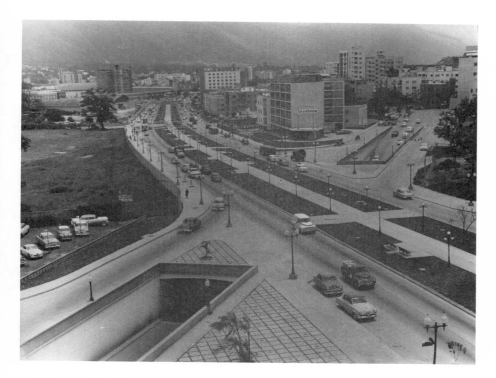

Figure 6.6. The Paseo Los Ilustres at the start of the Sistema de la Nacionalidad runs from the Ciudad Universitaria, visible in the background, over the Avenida Victoria and up to the Plaza Los Símbolos. Archivo de Fotografía Urbana.

But how exactly did the itinerary incorporate citizens into a common narrative of identity and progress? What features of the Sistema performed the ideology of modernity advocated under military rule? During the 1950s the Sistema encompassed a range of functions; it had roads for general transit, a parade ground for carnival processions and military demonstrations, walkways for leisurely strolling. It was even used as a track for Grand Prix competitions. The itinerary itself begins at the Paseo de Los Ilustres, a pedestrian walkway flanked by broad avenues for vehicles that runs alongside the perimeter of Villanueva's university campus, which stands as a symbolic starting point: a node of education and culture (fig. 6.6). The route runs parallel to the campus before reaching the roundabout at the Paseo de Los Símbolos, in whose center Ernesto Mar-

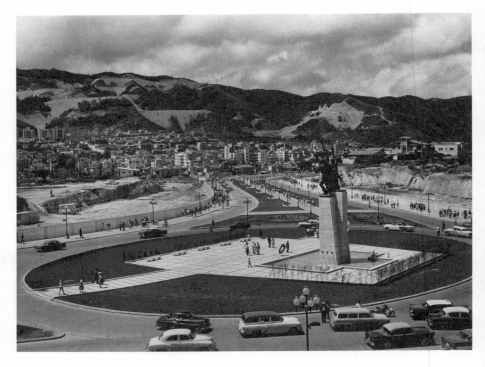

Figure 6.7. The Plaza Los Símbolos in the Sistema de la Nacionali-
dad allegorized national identity with its central sculpture. Archivo
de Fotografía Urbana.

agall's bronze statue of three figures allegorize Venezuelan identity
by holding aloft symbols of nationhood (fig. 6.7). The broad avenue
then approaches Maragall's *Monumento a Los Precursores*, an eclectic
assembly including an obelisk, a bronze Indian horseman, and li-
ons on pedestals, which honors precursory quests for independence
(fig. 6.8). The monument marks the start of an extensive network
of thirty thousand square meters of symmetrical marble walkways,
featuring a large reflecting pond, a series of smaller ponds, foun-
tains, nymphs, and oversize ornamental cups that serve as plant pots.
Bordered on the east by the modernist Círculo Militar, the Paseo de
Los Próceres leads pedestrians up to the *Monumento a Los Próceres*:
two tall monoliths, inscribed with the names of combatants in inde-
pendence battles, and two shorter parallelepipeds, topped by full-
body statues of eleven Venezuelan independence heroes (fig. 6.9).

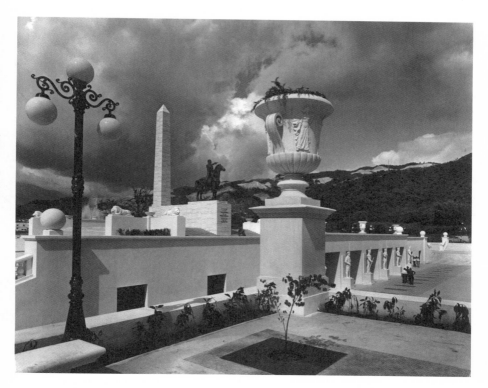

Figure 6.8. The *Monumento a Los Precursores* marks the start of the Paseo de Los Próceres, Sistema de la Nacionalidad. Archivo de Fotografía Urbana.

The monument serves both as a roundabout and as the entry to the two-kilometer-long parade ground, flanked by grandstands, which culminates at the Academia Militar and a sculpture by Alejandro Colina entitled *Vigilancia, inteligencia y observación* (1946).[23]

The Sistema spatializes a linear narrative of Venezuelan history that echoes the New National Ideal's promise of a return to the military glories of independence and the horizon of ever more prosperity, dignity, and strength. The monuments cite the leading lights of Venezuelan history. Astride a black marble horse, the indigenous rider of the *Monumento a Los Precursores* looms above the central walkways, signaling the route to independence, while the bronze-cast forefathers of independence stand high above the pedestrians walking below them. As if in a historical relay race, these illustrious

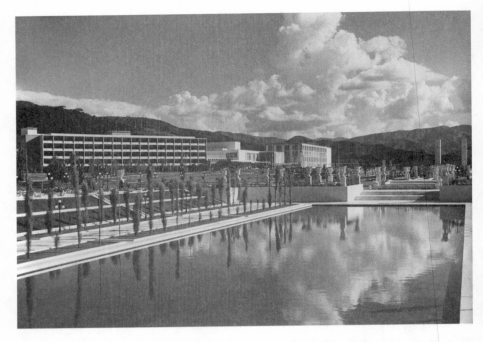

Figure 6.9. The Espejo de Agua reflecting pool at the Paseo de Los Próceres and the Círculo Militar to the left and *Monumento a Los Próceres* monoliths in the far right. Archivo de Fotografía Urbana.

combatants mark the entry point to the sober neoclassical façade of the Academia Militar, the cradle for military discipline and order, which the post-1948 leaders vaunted as safeguards for Venezuela's distinguished history and the country's glorious future. Analyzed in this way, the Sistema was more than a scenography: the space was intended to be both didactic and formative. True to the prescriptive logic of monumental sites identified by Lefebvre, its design shaped a sense of what may and may not take place there.[24] The Sistema created spatial conditions to assemble Venezuelans into a scripted ideal of national belonging by setting in place a historical itinerary that correlated to the New National Ideal propagated under military rule.

Furthermore, a regulatory function can also be intuited in the Sistema. In his history of the modern museum, Tony Bennett sheds light on the meeting point of spectacle and surveillance that emerged in public spaces of congregation and display founded in

the nineteenth century. He proposes the term "scopic reciprocity" to describe the way in which public spaces gave rise to a proliferation of gazes that exposed people to the scrutiny of others and, in so doing, led to the self-regulation of behavior in line with prevailing social mores. Spatial itineraries, in this sense, found their place among a host of formative and disciplinary apparatuses devised by the modern state.

Strolling around the Sistema's staged historical allegory meant being both a spectator of the monumental landscape and also an object of other gazes overseeing that the usage of the space fell in line with the politics of control exerted through military statecraft. Following the Foucauldian logic that Bennett explores in relation to spaces of display and discipline, the Sistema offered individuals contact with an edifying modern space as well as serving to exhibit and legitimize the modernizing impetus of military rule. The unwritten rules governing use of this space were apt to have a supervisory effect, engendering a self-regulation that encouraged the physical containment and reverent viewing befitting monumental space and, incidentally, the role of spectator assigned to Venezuelans by the military rulers.[25] In more prosaic terms, the Sistema's core at the Paseo de Los Próceres was a site of the scopic reciprocity that Bennett discusses. Not only were the monuments and statues designed to draw attention, but visitors themselves were subject to the scrutiny of both their fellow strollers and the troops and officers stationed at the adjacent Academia Militar and the Círculo Militar.

While the general layout of the Sistema advocated a revival of the spirit of independence by connecting the university and the military academy, Los Próceres emplaced an itinerary that encouraged visitors *to perform* their endorsement of this union and *to envisage* through space the renewed glory heralded by the New National Ideal. Indeed, during a speech he delivered to crowds at the Paseo de Los Próceres while it was still under construction in 1953, Pérez Jiménez suggested precisely this. Evoking the bygone glory of independence, he established a genealogy whereby the present generation—under military direction—would resuscitate Venezuela's inherent splendor. "Our Fatherland emerged among the nations of America embellished by glory and heroism that transpired in other peoples' freedom," he proclaimed. "That extraordinary human action, which gave Venezuela spiritual predominance in America, demands an answer from

today's generations about what we have done to continue that lega-cy."[26] As Pérez Jiménez called on Venezuelans to respond in kind to the exemplary action evoked in the Paseo's tributes to the precursors and founding fathers of independence, he summoned monumental space as a stimulus for patriotic sentiment and social *superación*.

Given the New National Ideal's pledge to reshape subjects by transforming space and Pérez Jiménez's own gloss on the Paseo, its design suggested more than ornamental conceit; it was both didac-tic and persuasive. It follows that, much like the carnival, the *paseo* (stroll) that the site nominally invited people to embark upon did not imply carefree leisure. On the contrary, the incitement to revive a tradition of *extraordinaria acción humana* (extraordinary human ac-tion) implied that subjects should follow in the footsteps of military leaders from the past and the present. Briefly put, *debían dar la talla*: they had "to measure up" to the monumental landscape envisaged by military rulers. In this regard, the *Espejo de Agua* (reflecting pool) at the foot of the *Monumento a Los Precursores* gains particular res-onance. First, the pool posits a vantage point for the gaze to rove around the symmetrical landscape, moving past the monuments and on to the Academia Militar at the end of the axis. Second, the *Espejo* invites users to immerse themselves in both literal and contemplative reflection. By contrast to the unyielding stonework, bronze, and mar-ble around it, the reflecting pool posits mutability. Its liquid screen serves to display to visitors their integration into the monumental surroundings designed to herald the promise of national renewal.

In summary, the Paseo de Los Próceres evokes the tacit rules of museum spaces—where one may look but not touch, where speech is hushed, and where the vigilant presence of guards is never far off. The Sistema's monumental site is founded on an "exhibitionary com-plex," a spectacular display of national cohesion and a regulatory framework to encourage a particular use of space. Transit through such a site is no unmediated paseo but, following Bennett, an "'or-ganized walking' in which an intended message is communicated by a (more or less) directed itinerary."[27] In this case, in Pérez Jiménez's "organized reading" of Los Próceres, the site would fold the subject into the national project. What began as a leisurely stroll around some fountains and an artificial pool now emerges as an encoded itinerary to shore up the New National Ideal: "a performative im-perative in which the visitor, exercising in the intersections of the

evolutionary time of progress and the evolutive time of discipline, is *enlisted* for the limitless project of modernity."[28]

MARCHING IN TIME WITH MODERNITY AT
THE SEMANA DE LA PATRIA

If Venezuelans were "enlisted" into the project of modernity, the goal of getting them to march in step with the Armed Forces was taken to its most literal realization in the Semana de la Patria (Week of the Fatherland). This event was created by presidential decree in 1952 and ran from 1953 until 1957, its seven days of festivities culminating on July 5 to mark Venezuela's declaration of independence in 1811.[29] Much like the New National Ideal, the events wedded past to present, intensifying the deification of Simón Bolívar that began in the late nineteenth century and casting the military leaders as heirs to Bolívar's illustrious legacy.[30] The roster of activities followed suit, tapping a deep sense of nationalism and exalting the modern landscape. New public works were unveiled nationwide; hotels held gala dinners; theaters put on special programs of the Orquesta Sinfónica Venezuela and the Ballet Nacional; the Concha Acústica in Bello Monte hosted a folklore festival. The Roman Catholic Church honored the nation's patron saints. Pérez Jiménez lit a flame at the foot of the statue of Simón Bolívar in Caracas's historic square. Ministers watched sporting competitions at the Olympic stadium at the Ciudad Universitaria. The nation's military arsenal and citizens paraded along the Paseo de Los Próceres for Venezuelans and foreign dignitaries, and new cohorts of officers were graduated (figs. 6.10–6.11).

Coverage of the Semana de la Patria included newsreels by Tiuna Films, Bolívar Films, and Pathé, press releases by Hamilton Wright, a documentary by Manuel Vicente Tinoco, and the usual local print media. In the "main event" of this military spectacle, which received wide-ranging media coverage, sirens brought the city to a standstill for a simulation of nighttime bomb raids. People turned out the lights at home or stopped their cars in the streets for the light show of firepower, cast in the propaganda as both a pragmatic lesson in citizen self-defense and a *motivo de multiplicidad emocional* (a stimulus for all sorts of emotions).

In general, the Semana de la Patria was cast in a similar mold to other commemorations and spectacles that shaped public life and

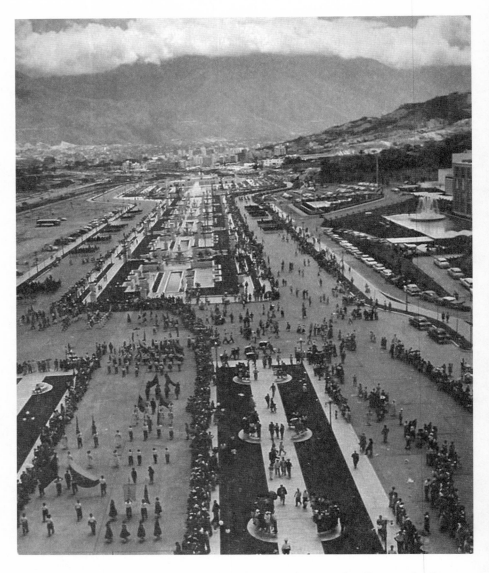

Figure 6.10. Semana de la Patria parades at the Paseo de Los Próceres, Sistema de la Nacionalidad. Archivo de Fotografía Urbana.

legitimized military rule—with one difference. While the carnival parades or taking a stroll at the Paseo de Los Próceres were voluntary activities, the Semana mandated that Venezuelans participate in civic-military parades displaying adherence to the New National

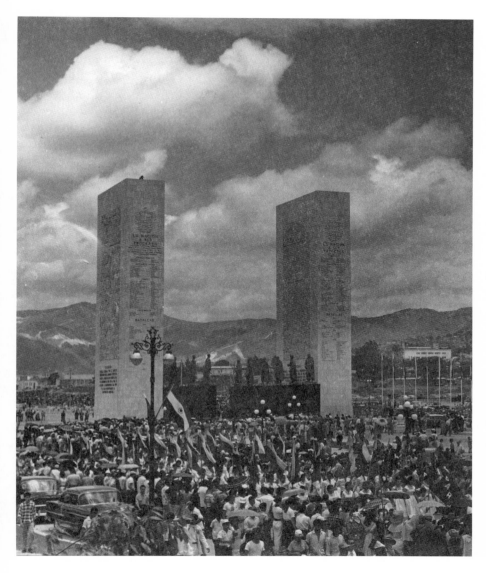

Figure 6.11. Semana de la Patria parades at the *Monumento a Los Próceres*. Archivo de Fotografía Urbana.

Ideal.[31] As an article published in the *Revista del Banco Obrero* in July 1954 put it, the aim of the Semana was to "sow in every Venezuelan the spiritual and *democratic* legacy of the liberators."[32] However, the fact that Pérez Jiménez's fraudulent rise to power birthed the com-

memoration clarifies that this was "democracy" on military terms. The article reveals how the Semana de la Patria performed territorial integration, endorsed technocratic hierarchy, and cultivated military discipline. In the first edition in 1953, more than 120,000 people from public institutions, schools, colleges, universities, and even private companies with ties to the government were assembled into uniformed groups that marched in formation through the city to the drumming of school bands. Venezuelans from the far reaches of the nation were brought to the heart of the metropolis for them to show support for Pérez Jiménez and to participate in a folklore festival held at the brand-new, open-air Concha Acústica, only to have indigenous tribal music passed off disdainfully as "strange songs." At the crowd-filled Olympic stadium at the Villanueva's campus, the dictator and his entire cabinet watched as thousands of young men in identical white sports uniforms paraded past the grandstand making a fascist salute. The mass display of synchronized gymnastics and men jumping through rings of fire were all lauded as exemplars of the *disciplina recreativa* (recreational discipline) advocated by the regime.

Putting subjects onstage in these different ways composed scenes of national cohesion and broad-ranging support for the military leaders and literally mobilized patriotic sentiment through sporting activities and parades. "The Fatherland is not just material progress," went the script. "Some light, true light, must be placed in humanity's route so people march decidedly toward their own truth." The carefree engagements with space and nondirectional itineraries implicit in strolling were here not even an option; the parades' "perfect lines [were] a grand civic demonstration" of collective order.[33] At once an act of conscription and of scripted space, participants' movements were coordinated into intricate choreographies of saluting, marching, twirling, and jumping. In this sense, the Semana de la Patria harnessed the microgestural terrain that Lefebvre associates with the affective agency and individual experiences of space.[34]

Quite to the contrary of the deeply interior experience of dancing that Lefebvre describes, in which the performer's individual limbs are invested with symbolic, cosmic significance, marching shuns sensorial improvisation and physical autonomy. Marching posits, instead, collective coordination and discipline—the articulation of a single mass that leaves little room for unpredictable movements

or meanderings beyond the set itinerary. The staged parades were thus devised as a march toward enlightenment, while the gymnastic displays marshaled diverse bodies into a choreographed mass—set against the backdrop of the modern city and observed from the balconies or grandstands where Pérez Jiménez sat, binoculars in hand. "Gestural systems embody ideology and bind it to practice," Lefebvre notes, and the parades were the ultimate performance of the ruling ideology of military-led modernity. They created a gestural idiom to be repeated year after year whereby "ideology escapes from pure abstraction and performs actions."[35] In this case, ideology enlisted Venezuelans to embody abstract values of discipline and order and to perform the nation's advancement toward a horizon of progress as they marched along the streets of the city.

•

Carnival parades and beauty queens, monumental sites and patriotic strolls, gymnastics displays and military-style marching, all attest to the varied ways in which the regime staged performances of progress and engaged Venezuelans as both actors and spectators. To bring the changing landscape in line with the official script, Caracas's new avenues and parade ground became scenographies for public spectacles of progress that put Venezuelans onstage. The government-endorsed carnival queens, the parading civil servants, the marching youth of Venezuela—this troupe of normalized characters served the dictatorship as a cast of honorific role models of social improvement whose beauty, order, vigor, and discipline were made the center of attention. Uses of modern space in these events were in no way left to chance. Instead, the carnivals, the Sistema de la Nacionalidad, and the Semana de la Patria summoned the city as a ready-made canvas that allowed the regime to assemble collective portraits of compliant and patriotic bodies engaged in the common quest for superación.

By scripting experiences of urban space, the regime found ways to compose a coherent representation of progress that kept the changing landscape congealed in the mold of official discourse. This performative dimension of spectacle marked an attempt to harness the social relations and physical experiences with which space becomes permeable to unpredictable and dynamic meanings such as those ambivalent responses examined at the start of this chapter.

In this sense, focusing on scripted sites and events does not imply that they determined the production of space during the period at hand nor that Venezuelans' experiences of them were homogenous or compliant.[36] The point, rather, is that the meticulous way in which public displays were choreographed and the sheer quantity of media coverage they received disclose the fact that spectacular modernity did not only propose the subject as *spectator*. It also entailed concerted efforts to choreograph subjects as *performers* of the spectacles of progress devised to legitimize military rule.

In this sense, it is significant that the accent placed on enlisting Venezuelans to perform progress emerged alongside the shift from dictablanda to dictadura brought by Pérez Jiménez's ascent to power. Attempts to compose the nation into coherent spectacles must be understood as an extension of the politics of the gaze that affirmed Pérez Jiménez's visionary capacity and that cast Venezuelans as objects of modernization. Against this backdrop, the fact that schools issued certificates that falsely claimed *all* students and teachers had participated in the Semana de la Patria parades (to shield them from reprisals) takes on great resonance. And so too do the voices of exiled members of Acción Democrática, who condemned the marches as part of a repressive apparatus that operated through mental and physical coercion. For them, parades had a dual purpose: "to create the impression of popular support for the regime for external consumption; and to try to kill the people's rebellious instinct, instilling in them a feeling of impotence and recognition that they have a master who can humiliate them by making them parade before him with heads hung low, while he assumes the pose of conquistador who watches the vanquished walk past him."[37]

Whether Venezuelans construed marching in such oppressive terms or actually enjoyed the festive events, the image of Pérez Jiménez playing the part of ruler up on high is a striking one and illuminates another way that the culture of display served the dictatorship. Although stage-managed spectacles offered opportunities for mass gatherings and public assembly, without democracy such events were first and foremost examples of militarized crowd control.

CHAPTER 7

BRINGING
PROGRESS
HOME

MODERN MYTHOLOGIES
IN DAILY LIFE

¡Ni un día de retraso! (Not a day's delay!)
• ADVERTISEMENT FOR
POWDERED MILK, 1953

• Under a gray sky thick with clouds, two men dressed in shirts and trousers gingerly carry a new television up a dirt track. Having just crossed a section filled with stones and debris washed down by a stream of rainwater, they make their way up a steep path, among patches of vegetation, toward a string of bare brick shacks and painted wooden huts that stand on either side of channels dug out in the ground (fig. 7.1). A man walks alongside them, his hair slicked back and his fresh white shirt tucked into elegant blue pants, perhaps nervous in case they slip and send the precious merchandise falling to the ground. Another man, dressed in vest and trousers, has stopped in his tracks to watch their careful ascent. Somewhere farther up, past the ladies chatting next to a plank that serves as a bridge for residents over the improvised drainage channels, a family is waiting with excitement to open the door and bring the shiny new television into the home they have built up on the hill.

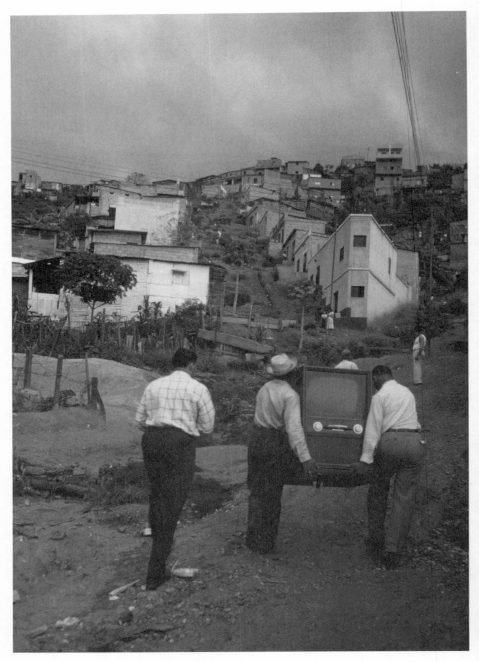

Figure 7.1. Cornell Capa, from the *Life* magazine article "Latin Boom Town." Getty Images/The Life Picture Collection.

The year is 1954, and the scene is the La Planicie barrio in Caracas. Of the myriad images from the 1950s, this particular photograph has endured in the public imaginary, evoked in recent years as a visual archetype of the intersection of rapid urbanization, technological innovation, and consumer culture, associated with Venezuela's uneven modernity.[1] When this photograph was first published, though, its connotations were expressed in unreservedly enthusiastic terms. The caption that appeared alongside the image equated the scene depicted to a nascent "TV craze" that was evidence of Venezuela's entry to modernity. That this humble family had purchased a television set shored up the claim of "the new prosperity [that] has enabled many Venezuelan workers, whose average wage has doubled in 10 years, to replace their rope-soled sandals with shoes, buy canned goods in supermarkets and satisfy a craving for chicken and ice-cream."[2]

Much as the military regime advocated social policies to *nivelar hacia arriba* and *aburguesar el proletariado* (to upscale society and to make the proletariat bourgeois), the caption suggested that modernity was realized when humble men and women kicked off their rustic footwear and became consumers of modern commodities.[3] In this view, credit-fueled consumer spending and novel domestic appliances were antidotes to urban marginality. Even against the odds, modernity was coming home. This portrait of superación through consumption raises questions about how the ideology of progress became part of the wallpaper of everyday life across the social spectrum. If modernist architecture and public spectacles set out national development before Venezuelans' eyes, what mechanisms promised to put progress at individuals' fingertips? To address this question it is necessary to peel away the familiar veneer of everyday life and examine how commodities and consumer culture shaped the particular inflection that modernity acquired—and still preserves—as a depoliticized, naturalized discourse of progress.

PRIVATE SPACES, PUBLIC DISCOURSES

What does it mean to take progress home? And what interfaces can be tracked between broad sociocultural and politicoeconomic settings, on one hand, and the intimate territories of everyday life and domestic space, on the other? First, commodities and consum-

er culture have long served as bridges between private space and prevailing public ideologies, both providing entry points for the naturalization of certain doctrines and also creating terrains on which those doctrines can be contested. As well as modulating public space by effecting sea changes in economic production and societal formations, consumer culture shapes intimate dwelling spaces. As Walter Benjamin showed in his pioneering *Arcades Project*, objects and realms of consumption offer a fertile ground on which to trace ideologies of modernization and histories of capitalism.

Despite obvious differences in context and geography, when working through the promises of progress that circulated in Venezuela in the middle of the twentieth century, the interconnected ideas of *Zeitraum* (space time) and *Zeit-traum* (dream time) that feature in Benjamin's writing offer conceptual departure points. These two terms summon the simultaneously rational and mythical basis of modernity and point toward the traction it gains through technological advances, innovations in everyday life, and the excitement this inspires. Zeitraum invites analysis of the implications that technologies of architecture, vision, display, and production had for consumer culture, advertising, and fashion, while Zeit-traum interrogates the experiential fabric of modernity by suggesting that modernity reactivated "mythic forces" that naturalized social and economic upheavals, enabling the capitalist ideology of progress to seep into daily life through specific commodities.[4] Put simply, these ideas create a critical framework to analyze the interfaces between the military project of modernization and the way that consumer culture, to paraphrase Adorno, made mute things speak as symbols of progress and encouraged people to embrace modernity on their home turf.[5]

Shifts in traditional modes of production and consumption, and changes in consumer patterns and tastes largely emerged in twentieth-century Venezuela through the culture of oil. Initially, oil enclaves were "social laboratories" where foreign culture was celebrated as a marker of modernity. Later, when fences came down and expat employees moved to corporate headquarters in urban centers, imported commodities and foreign lifestyles expanded into towns and cities.[6] By the economic boom of the 1950s, changes in lifestyle and consumer patterns had become much more visible. In just a decade, the value of imports more than trebled, reaching 1,776 million

dollars in 1957, thanks to a trade treaty with the United States that maintained low tariffs and favorable conditions for imports. Local manufacturers who managed to dodge government policies curbing industrial growth invested in the production of textiles, shoes, and clothing, which fared well against foreign competitors.[7] With shoppers on a range of budgets entering this expanding marketplace, consumer activity in the 1950s grew to twelve times its size two decades earlier.[8] The situation served private capital and military government alike. The growing market enhanced sales for companies, while allowing the regime to substantiate its boast that Venezuela was not just an exporter of natural resources but a developed nation chock-full of imported goods.[9]

As well as shedding light on the intersections of global capitalism and local economies, commodities and consumer spaces serve as reminders that social order is not only shaped by state policy. The "social law maintains its hold on bodies and its members, regulates them and exercises them through changes in fashion as well as military maneuvers," argues Michel de Certeau, and the point applies to the context at hand.[10] The uniforms that Venezuelans were given to wear in the Semana de la Patria parades are an obvious example of a formal bid to regulate identity through clothing, but what of everyday clothes that seem so commonplace and innocuous? The idea of freedom that is attached to consumer choice can mask the regulatory and physical impacts everyday objects have on both individual bodies and social relations. Car seats train a person's posture like orthopedic instruments, foods alter bodies as they nourish them, and clothes provide a means of communicating self-image in public spheres. To recognize these impacts does not render consumers passive recipients of masked ideologies, incapable of "making" or "doing" things with the goods or media they consume, just as the postulation of spectatorship does not annul individual subjectivity.[11] What this recognition does suggest, however, is that familiar objects play a role in naturalizing specific forms of social order that are often overlooked. Turning to the ways in which particular commodities are marketed offers a means of unearthing the promises they make consumers and placing such promises in critical light.

Significantly, the rise of imports in Venezuela in the 1940s and 1950s also stimulated an expansion of the advertising and marketing

sector. As new advertising agencies opened in Venezuela, profession-als from American firms relocated down south, bringing with them a wellspring of analogies and metaphors inspired by the imaginaries and discourses of the consumer culture of postwar America.[12] Eco-nomic growth and industrial expansion during the mid-twentieh century had created a propitious environment to boost consumer spending and credit schemes in the United States. Moreover, in the chill of the Cold War and its ideological battles, novel commodities acquired the status of modern mythologies and were leveraged by governments and corporations alike as literal embodiments of the freedom of democracy, capitalism, and First World development.[13] These ideals dripped down from cultural diplomacy to the lives of ordinary consumers, who were encouraged to buy into the fast-paced world of mass-produced objects. As speed and convenience became synonyms for progress, mass-produced and disposable products filled the supermarkets, while modern appliances appeared on the shelves of warehouse-style stores.[14]

In the same period in postwar Europe, the French cultural crit-ic Roland Barthes was writing sharp analyses of advertising, mass media, and daily life, which were later published under the title *Mythologies* (1957). Barthes teased out the socially constructed as-sumptions and narratives embedded in a range of phenomena, and in so doing he built a critical framework with which to approach collective representations from material and visual culture as mod-ern myths.[15] The lustrous finish of "ornamental" recipes glossed over the economic hardships of purchasing cooking ingredients. Travel guides promised to open up a world of adventure only to congeal the complex topographies of that world into picturesque scenes ready for consumption. And advertisements of soap powder subli-mated the mundane toil of removing dirt with pictures of bright white foam.

A similar analytical method can then be applied to examine the underlying assumptions that were embedded in advertise-ments from the same period in Venezuela. As Venezuelans flicked through the inky pages of local newspapers, they encountered a plethora of optimistic messages and images that told them the clothes they wore, the food they ate, and the appliances they used were all material embodiments of modernity. Building on Barthes's contention that advertisements repackaged historical, political,

and cultural contingencies as naturalized essences and simple com-
mon sense, a closer analysis of three particular advertisements can
answer two key questions: How were specific commodities framed
as an opportunity to take modernity home? And what relation did
advertising messages have to the broader project of military-led
modernity?

TV SETS, POWDERED MILK, AND FAST CARS

In the 1950s TV sets became coveted additions to people's homes. As
American companies made their way into the Venezuelan market-
place, they summoned an established repertoire of utopian promis-
es: television was a portal to the accelerated Zeitraum of modernity,
bringing distant worlds into the living room.[16] This was precisely the
message sent out to potential consumers in an advertisement for
Emerson televisions published in *El Nacional* in 1953. Alongside the
corporate promise of *imágenes más reales* (more realistic images), was
a drawing of a cat that sat licking its lips at the sight of a bird that
appeared on the television screen. By way of this visual analogy, the
advertisement conjured an image of consumers who were hungry for
televisual spectacles, ready to be dazzled by the most modern visual
technics (fig. 7.2).

As well as drawing on the standard tropes of American market-
ing, the message resonated with the local context in which television
emerged as a marker of modernity. The launch of the state's first
television channel and the inaugural transmission featuring a bless-
ing by the Archbishop of Caracas and images of monumental sites
had coincided with the opening of the *Exposición Objetiva Nacional* in
November 1952. The next day, American manufacturer Philco used
the feverish rhetoric about the launch, the exhibition itself, and the
run-up to the elections to cement the bond between television and
national progress. The firm placed a notice in *El Nacional* to thank
the nation and its leaders for the "huge welcome" they had given this
new technology and to assure clients that extra staff would be hired
to meet the backlog of aerials and TV sets that needed installing.[17] By
1953, private channels had already taken off, and official messages
about public works appeared on a nightly basis in a ten-minute news
slot on the Televisora Nacional.[18] All in all, the wooden and glass
boxes served a number of agents, each equally invested in associat-

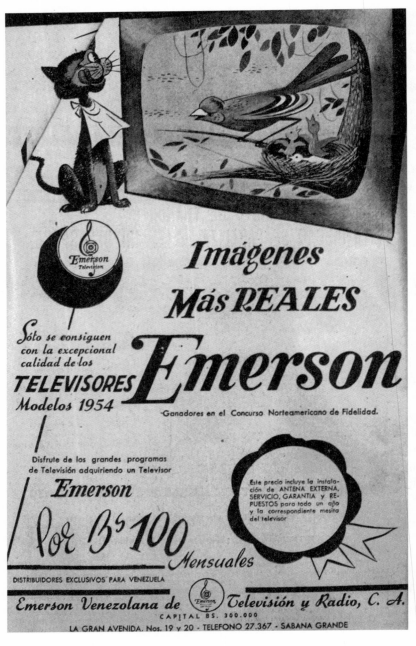

Figure 7.2. "Imágenes más reales." *El Nacional*, November 15, 1953.

ing themselves with the cutting edge of progress, whether individual, national, or corporate.

It was not just television sets that brought modernity home. Advertisements for a whole host of manufactured groceries like instant coffee, margarine, powdered milk, canned tomatoes, pasteurized juices, vegetable oil, and deviled ham made similar promises to Venezuelans, offering to incorporate them into the networks of industrialization and development by linking assembly lines to their dinner tables. An advertisement for Reina del Campo powdered milk conveys this very message and makes it clear that a range of agents were stakeholders in the imagery of progress (fig. 7.3). The bilingual branding in Spanish and English dovetailed with the military regime's claim that Venezuela was more than a resource for extractive industries by casting the country as a transcultural hub, connected to the developed world of industrial production. The abstract collage of machinery and architecture that appeared in the advertisement also reinforced this idea as it staged Venezuela's entry into this developed world. By declaring powdered milk an improvement on fresh milk, the advertisement also resonated with the official narrative associated with projects like the agricultural colony of Turén, which suggested the nation had overcome (*superado*) its pastoral underpinnings and had embraced mechanized production. Finally, much as modern spaces were lauded as catalysts for social improvement, the company declared that a diet of canned goods would automatically keep Venezuelans' bodies up-to-date with the relentless technological and scientific innovations of the modern age. Because worldwide laboratories ensured "Dairy Queen" remained at the cutting edge, consumers were guaranteed ¡Ni un día de retraso!—not even a day's delay. This was more than an innovative formula for powdered milk; Reina del Campo was also a recipe for instant modernity.

In line with this desire to keep up with development, throughout the 1950s car companies launched the subsequent year's model in the run-up to Christmas. By launching their *línea del futuro* (future line) as Chrysler dubbed their cars, before the future had actually arrived these companies summoned modernity's Zeitraum as their selling point: their cars, they promised, would not just keep Venezuelans apace with the time, they would propel them into the future. Itself a child of the 1950s, the American-designed car brand Aero Willys was founded on this claim. Indeed, the brand identity hinged

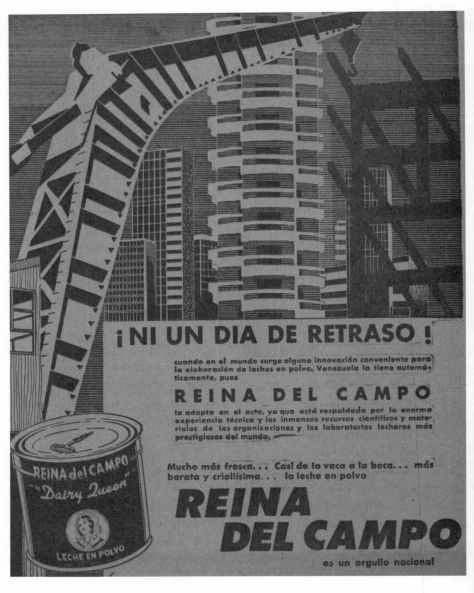

Figure 7.3. "¡Ni un día de retraso!" *La Esfera*, **December 10, 1953.**

on analogies of lightning-fast locomotion, which compared the cars
to "the closest thing to an airplane" (fig. 7.4). While the futuristic jet
featured in the advertisement brought science fiction connotations,

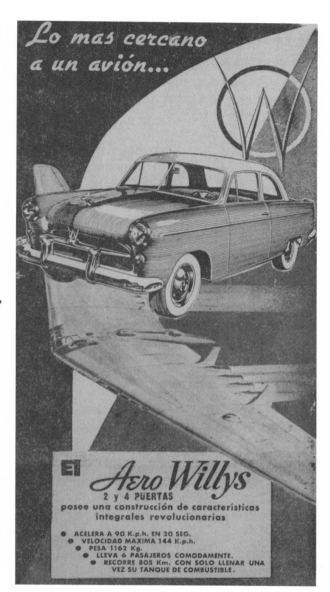

Lo mas cercano
a un avión...

El *Aero Willys*
2 y 4 PUERTAS
posee una construcción de características
integrales revolucionarias

● ACELERA A 90 K.p.h. EN 20 SEG.
● VELOCIDAD MAXIMA 144 K.p.h.
● PESA 1162 Kg.
● LLEVA 6 PASAJEROS COMODAMENTE.
● RECORRE 805 Km. CON SOLO LLENAR UNA
VEZ SU TANQUE DE COMBUSTIBLE.

Figure 7.4. "Lo más cercano a un avión ..." *El Nacional,* **November 19, 1953.**

the picture of the solid two-door model was glossed by pragmatic details about the car's "revolutionary" construction: 0 to 90 kph in 20 seconds, a maximum speed of nearly 144 kph, and a tank that would take you for 800 kilometers. Beyond the affective appeal to imbue daily life with speed and excitement, these marketing tropes

were just the tip of the iceberg. As the Junta Militar rolled out the construction of the nationwide road network, the rise of automobile culture began to reshape Venezuela's economic, physical, and cultural landscape, fostering innovations in leisure from drive-in movie theaters and *automercados* (supermarkets) to internal tourism routes and coastal resorts.

Once again, this cultural shift reflected the changes afoot in the United States, where the number of cars on the roads doubled between 1945 and 1955.[19] Companies saw similar potential in Venezuela, and 90 percent of all cars on the nation's roads by 1956 were imported from the country's northern neighbor, making Cadillacs, Pontiacs, and Packards household names. While a host of affiliated industries, from motor oil to tires, became stakeholders in advocating state-led modernization and the American Way of Life, urban planner Robert Moses and American architect Don Hatch set about laying foundations for automobile culture to expand in Venezuela, expanding arteries and designing automercados where consumers could fill their trunks up with groceries.[20] By the mid-1950s the synergy between automobile culture and national development was unmistakable. Feeding back to official discourse, a full-page advertisement by the tire company Cauchos General published the pragmatic message that pegged car sales, communications infrastructure, and tire production to national growth. Arranging visual and textual content along a time line that went from 1941 to 1954, the advertisement showed a succession of factories, each one bigger than the next, substantiating the company's message that it was *progresando firme con la nación* (progressing firmly with the nation). Echoing the military promise to deliver modernity through industrialization and communications infrastructure, the company declared that the rise of car culture was "another result of the healthy and progressive collaboration of the Venezuelan nation as it builds toward the future."[21]

STOREFRONTS AND SHOPPING MALLS

When *Time* magazine described Caracas as "the national show window" in the mid-1950s, the idea was more than just another glib metaphor. Consumer culture was growing across the country. As the country's seventh Sears department store opened in Ciudad Bolívar, in Venezuela's southern reaches, the event was deemed significant

Figure 7.5. Sears stores became popular in the 1950s in Venezuela; this one is in Caracas. Archivo Histórico de Miraflores.

enough that even the bishop was in attendance to give his official blessing to this temple of consumerism.[22] Meanwhile, in the capital, the huge Sears Roebuck store was crowned by a huge sign, encouraging people to "¡Compre hoy y pague mañana!" (Buy today, pay tomorrow!), an option that offered a ticket to a world of imported goods without the challenge of paying the price tag up front. Publicity campaigns compounded the invitation, declaring that as "women in pipeless hillside shanties buy U.S.-made washing machines, and happily lug water in buckets on their heads to fill them," they too set the wheels of progress in motion. Storefronts stocked with canned Spanish cuttlefish, rhinestone-studded yo-yos, and the latest fashions proved that modernity was not only realized through mass housing, new avenues, or infrastructure, or by the official forms of display deployed by the government (fig. 7.5).[23]

Shifts in consumer culture, which birthed supermarkets and luxury boutiques alike, were part of changing lifestyle patterns altered

by a mix of oil boom and government investment. The late 1940s development of the area of Bello Monte in Caracas, south of the River Guaire, synthesizes some of the transformations in urban space, car culture, and consumer habits.[24] As the capital expanded, the area became an urban hub for oil interests and public works projects. The custom-built Creole Petroleum Corporation headquarters opened there in 1955. Public projects such as the Sistema de la Nacionalidad and the Ciudad Universitaria were located nearby, as was the Valle Arriba Golf Club, conceived as a social club for Creole and Shell employees excluded from the elite membership of the Caracas Country Club. The emerging urban hub's neighboring areas of Las Mercedes and Santa Mónica also boasted a range of leisure and lifestyle innovations, including the new Sears Roebuck department store, the U.S.–funded Hotel Tamanaco, the country's first drive-in cinema, and an outlet of the new Cada supermarket chain created by Nelson Rockefeller.[25]

Supermarkets, which emerged on the cusp of the 1950s, were a particularly significant shift in consumer trends, encapsulating the embrace of automobile culture, urbanization, and U.S. influence on lifestyle patterns. The first supermarket—Todos—opened in 1949 in Maracaibo; the following year a similar store opened in Valencia; and by the early 1950s, Nelson Rockefeller was expanding his early investments in wholesale markets to the nationwide supermarket chain Cada. Now, mass-produced goods went from assembly lines to large stores that gave shoppers freedom to peruse aisles and shelves, selecting products on their own time, rather than ordering goods from clerks at the store counter. And this was just the beginning. As the trend took off, supermarkets soon expanded into shopping centers. By 1953 Todos in Maracaibo became a mall, and from the middle of the decade similar developments cropped up across Caracas.

Like commercial islands set in seas of parking lots, the malls cloned the style of window dressing and bargain offers in vogue in the United States, while hosting local dance and music groups in the parking lots to draw locals in and entice them back. The buildings themselves became talking points in the city because of their unfamiliar designs and imported construction materials. These self-contained compounds contrasted dramatically with the traditional *pulperías* and *quincallerías*, the grocery and hardware stores arranged along commercial streets. Replicating their American forebears, the

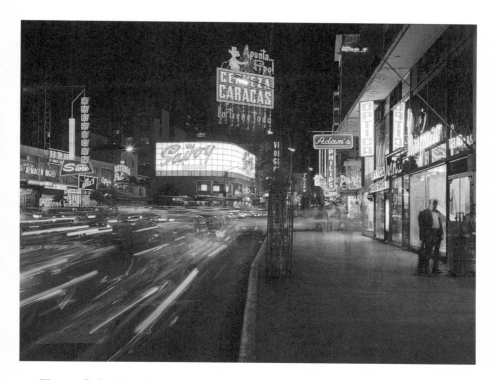

Figure 7.6. Tito Caula captured the neon lights of the Gran Avenida, Sabana Grande, in 1960. Archivo de Fotografía Urbana.

new commercial compounds offered multiple services and stores on a single site. Visitors could go from the beauty salon to the bank, and from pharmacy to clothes and furniture stores, without once getting back in their cars. Indeed, the idea was that they did not leave the site to socialize, since there they had at their fingertips cinemas and bowling alleys, and landscaped areas, whose reflecting pools and terraces adapted models of public parks to commercial enclaves.[26]

Although malls began sprouting up around the city in the 1950s, one slightly different commercial hub retained enduring prestige. At the start of the decade, Caracas's most vaunted shopping street was still the Gran Avenida: a strip in Sabana Grande that was part drive-through mall and part open-air arcade. Set among roadside billboards, the modern strip of stores had floor to ceiling windows, and dedicated parking spaces outside (fig. 7.6). The twinkling neon signs of brand names like Ferrari, Ile de France, Gathman, and Betty Modes

connected Caracas to global commodity flows and reinforced the bid to confirm Venezuela's status as a nation of discerning consumers rather than a source of primary materials for extraction and export.

The Gran Avenida served as another spectacle of progress, offering shoppers a heady experience of visual pleasure through the display of goods on sale. Promotional texts made this clear as they described the storefronts in exalted tones: "The merchandise is presented in such a way as to dominate the onlooker's gaze. Sumptuous suits, stylish furniture, jewelry, crystal ware, perfumes, ornaments, pictures, rugs, flowers, toys, etc., are optimally exhibited. All this makes the Gran Avenida in Sabana Grande a place where people go in need of certain products, but where people contemplate bazaars that give them moments of true pleasure for the eyes."[27] Here, object, display, and the customer's gaze converged in what Arjun Appadurai terms a "regime of value," which presented commodities as a means for Venezuelans to demonstrate their own performance of spectacular modernity.[28] This emphasis on the dazzling storefronts inevitably recalls the spectacular tropes that claimed onlookers would be awestruck by modern buildings. This similarity in turn suggests that architecture and commodities shared in the logic of the military ideology that associated modernity with the glossy sheen of metropolitan culture.

Indeed, both the design of and the publicity about the stores on the Gran Avenida lend weight to the idea that consumer culture and state-led modernization were imbricated with similarly optimistic narratives. After the imposing storefronts, the sumptuous modern interiors of the boutiques reinforced the regime of value that conjured commodities as portals to modernity, turning the site of exchange into a dream house that facilitated social ascent and superación. The mid-century modern décor and up-to-date furniture at Betty Modes, for instance, created a space that looked more like a sitting room than a store in which selling clothes was the bottom line. Neither cash registers nor racks of clothes were immediately apparent; instead these "vulgar" clues to conditions of production, labor, and price tag had all been removed from sight. In their place, this reified setting emphasized the value of fashion as a marker of social status—a way to show others the wearer was a cut above the rest.[29]

Along the sidewalk at the Krysthian boutique, the décor also created a sumptuous setting, but this time it combined decorative styles from past and present (fig. 7.7). While mock neoclassical columns,

Figure 7.7. Storefront of the Krysthian boutique that featured in *Así es Caracas* **(1951).** Archivo Histórico de Miraflores.

chandeliers, and velvet-covered sofas preserved the boutique's footings in historical splendor, its modern fittings proved that the store had kept apace with the changing times in Venezuela. Promotional material claimed that the floor-to-ceiling mirrors inside the boutique offered simultaneous glimpses into social improvement and national development. As well as creating a world of mirrors that surrounded clients with their own image as they tried on different outfits, the "sumptuosity and elegance" of the glass fittings produced locally by Cristalerías Venezolanas were presented as a reflection of Venezuela's burgeoning industrialization that had gained the country a place among prosperous nations.[30]

Store design, as this example shows, complemented the function of sites like the Paseo de Los Próceres, the superblocks, and the

Figure 7.8. Window display of women's underwear in Caracas in the 1950s. Archivo Histórico de Miraflores.

Caracas–La Guaira Highway, in which Venezuelans were encouraged to see reflected both their personal improvement and the nation's development. As advertisements and shopwindows displayed permanently updated merchandise and coveted foreign brands, clear parallels emerged between the quest to clad Venezuelan bodies in modern clothing and the bid to remake the nation's landscape in steel, glass, and concrete (fig. 7.8). Incidentally, this was exactly the message that a local tailoring firm, Creaciones Pimentel, conveyed in an advertisement published to coincide with the peak of a host of public works inaugurations organized in December 1954 to mark Pérez Jiménez's second year in power. In the half-page ad, the company posited fashionable clothing and built space as markers of modernity, presenting the suit as a springboard that would elevate Venezuelans to the status of their changing surroundings (fig.

Figure 7.9. "Creaciones Pimentel." *El Nacional*, December 10, 1954.

7.9). The sketch showed a man dressed in a suit as he floated over the modern skyline like a human zeppelin. "Creaciones Pimentel's already-famous suits are rising over our modern, dynamic, welcoming Caracas. We are proud to live up to [*estar a la altura*] Venezuela's modern capital," went the text. The right clothes did not just offer Venezuelans instant social ascent so they could live up to the modern city; here tailor-made modernity offered the wearer access to the elevated *visión de altura*—the elevated vantage point so frequently fetishized in official discourse as a marker of farsighted leadership and the threshold to a glorious future.

EL HELICOIDE MALL AS DREAMHOUSE OF MODERNITY

As Venezuelans were encouraged to buy into the regime of value where commodities provided instant social ascent, it is clear that optimistic promises were not limited to official spectacles but were also part of a wider mythologization of modernity. In this vein, one particular site exemplifies the overlaps of military-led development, architecture, consumer culture, and spectacle that shaped the cultural formation

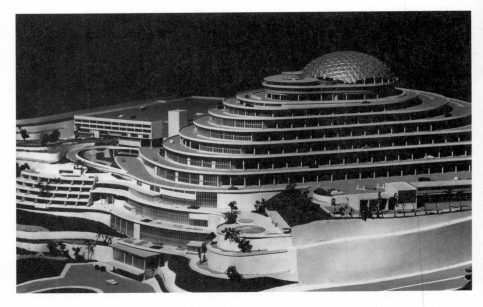

Figure 7.10. Model of El Helicoide. Studios Jacky, undated. Archivo Fotografía Urbana/Proyecto Helicoide.

of modernity in mid-twentieth-century Venezuela. In 1955 architects Jorge Romero Gutiérrez, Pedro Neuberger, and Dirk Bornhorst, at the Arquitectura y Urbanismo C.A. firm, drew up ambitious plans for the El Helicoide Centro Comercial y de Exposición de Industrias, a spiral-shaped shopping and industiral exhibit in Caracas (fig. 7.10). The center covered a site measuring more than a hundred thousand square meters called the Roca Tarpeya, located to one side of the Avenida de las Fuerzas Armadas as the avenue runs south, bisecting Caracas's eastward expansion along the valley before cutting through a steep canyon called El Portachuelo.

The building was designed especially for cars, and the architects stressed its privileged position of easy access from the Avenida Fuerzas Armadas, which linked to the city center, and the Autopista del Este, which served the capital's eastward reaches. The mall was integrated into the topography; machines literally bulldozed through the hill to carve dual helix tracks that rose from the valley to the summit of the hill before descending. Clad in reinforced concrete, the ramps would enable cars to access and exit the huge complex of more than three hundred stores, offices, hotel, cinema, car showrooms, gas station, ex-

hibitions, and numerous other distractions.[31] For those who did not yet have a car, public transport would connect them with four Austrian-built elevators at street level at the complex's northern side, which would whisk a total of 384 pedestrians up to the *palacio de espectáculos* (palace of spectacles) at the summit (fig. 7.11). Those coming from the south would enter via a pedestrian tunnel and take elevators and escalators to the various levels of El Helicoide's three buildings. The North Building would house the mall's administrative and communications offices and a social club for proprietors. The Palace of Spectacles comprised stores, parking space, mobile stages, the Grand Exhibition Hall, and a restaurant, accessed by escalators that could transport six thousand visitors per hour. The parking lot would feature a playground, a multiplex cinema, shops, offices, and a thirty-lane bowling alley.

Although the building's spiral shape evoked time-honored forms, from the ziggurat to the Tower of Babel, critics then and now have celebrated El Helicoide for the audacity and huge scale of its trailblazing modernist style. Intrigued by its design, curators from the Museum of Modern Art visited the construction site. The project was "among the very few truly significant applications of modern technology . . . a 'natural' architecture on the scale of the landscape itself," wrote curator Arthur Drexler in a letter to the main architect Jorge Romero Gutiérrez in 1961.[32] El Helicoide was showcased later that year at the MoMA exhibition *Roads*, where it was dubbed "the most remarkable integration of road design and architecture that has yet been attempted."[33] Today, studies of Venezuela's architectural heritage continue to cite the building as a high point of the 1950s architectural modernism that put the nation on the global map as an urban utopia.[34] Other analyses establish enlightening aesthetic genealogies with Frank Lloyd Wright's Gordon Strong Automobile Objective and Planetarium (1924–1925) and Le Corbusier's unrealized expansion of Rio de Janeiro (1930).[35]

However, focusing on form alone leaves little room to consider El Helicoide's relation to the political and socioeconomic contexts from which it emerged.[36] El Helicoide was not a state commission. Nevertheless, its foundations were conjoined to the dictatorship (indeed, Pérez Jiménez had been among the first to view models of the building when they were exhibited in 1955). When the architectural firm was looking for a new project in which to reinvest returns they had made on the Centro Profesional del Este (an innovative complex of offices, garage, gym, and art gallery inaugurated in 1954 a stone's throw from

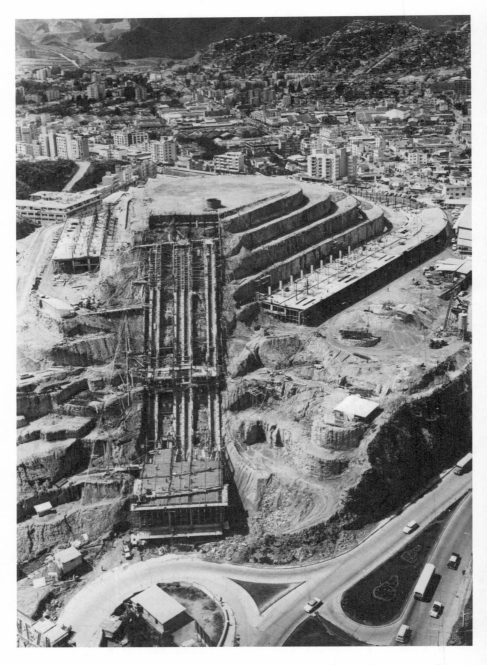

Figure 7.11. The street-level elevators would connect directly to the summit. Studios Jacky, undated. Archivo Fotografía Urbana/Proyecto Helicoide.

the Gran Avenida in Caracas), Romero Gutiérrez hit upon the idea of developing the Roca Tarpeya and the partners agreed on the plan. The firm, as Bornhorst jotted in his diary in January 1955, would build a "super project; a mountain of exhibitions in Las Acacias, with ramps!"[37] They set about drafting designs for the site, called in market researchers, and before long were signing contracts with the builders. Amid clinking champagne glasses and great enthusiasm at the contract-signing ceremony, Romero Gutiérrez exclaimed: "Now to start pouring reinforced concrete!" In Bornhorst's memoirs, published some fifty years later, he casts the building as the sign of the times: a symptom of the same "spirit" of progress that ran through official discourse and corporate publicity. His staccato sentences evoke a metronome set to the quick pace of modernity and a time when a hazy sketch on a napkin could become a concrete project: "The fifties. An intense era. There was lots to do. Buildings went up by the fastest and most spontaneous means. That's how El Helicoide was born. . . . [The] atmosphere was charged with optimism which made one think that anything was possible, innovative, audacious, and daring things."[38]

The architects' exhilaration at this "super project" is not the only connotation of Bornhorst's musings, though. The silence regarding the political conditions of the time infers that the excitement of building modernity prevailed over plans to build democracy. Bornhorst's quick-fire sentences evoke the same "deeds not words" mandate that predominated in official discourse, suggesting that this modernizing zeal had purchase beyond military ideology and state propaganda. Of course, El Helicoide was built on the conviction that rapid development, modernist design, novel materials, car culture, and consumerism would all deliver modernity. Tellingly, in a letter Drexler wrote to Romero Gutiérrez about the MoMA's *Roads* exhibition, he pushed him to clarify how exactly El Helicoide represented the architects' long-term vision of modern design and urban development. Yet, much as the regime pressured contractors to deliver public works in time for official inaugurations that marked political milestones, so too, El Helicoide was imbued with a sense of urgency and a faith in rapid development fueled by a booming oil economy.

In this sense, the building's political foundations were decidedly ambivalent. Although a privately funded endeavor, the project's realization depended on the stability of the dictatorship. The architects

were funding round-the-clock construction on a "sell to build" basis, enticing investors with blueprint prospects, while mortgaging the mall on the enduring buoyancy of the military regime. The novelty of this financing strategy meant that the leap of faith and the need for political continuity were even greater. Perhaps for this reason, the publicity campaign for El Helicoide endorsed and drew support from the military leaders as the architects lifted conventional scripts and strategies of display straight out of the state's copybook. Just as the *Exposición Objetiva Nacional* of 1948 took place against a backdrop of flagship modern constructions, the El Helicoide model was unveiled in September 1955 at the architects' recently finished Centro Profesional del Este, one of the few high-rise buildings in Caracas at the time. When Pérez Jiménez attended a private viewing of the miniature model of El Helicoide, the new icon received official endorsement—not regarded as competition for the state's monumental works but, rather, a welcome addition to the city's modern repertoire.[39] As well as making the model available for public viewing, the firm founded *Integral* magazine in 1955 and released newsletters and brochures—including the *Boletín informativo* and *Espiral de noticias*—to update the public on the project's progress. The local press got behind the plan, and *Time* magazine likened the design for the twenty-five-million-dollar project to "a stack of flying saucers in close formation flight [that would] match any man-made wonders anywhere."[40] By 1958, when the completed earthwork had revealed the shape of the spiraling mall, 183 of the 320 stores had been sold.[41]

The details of El Helicoide's design elucidate further overlaps with official discourse, not least in the premise that spatial itineraries performed progress. The spiral form itself drew corporeal analogies. Bornhorst explained the shape to a group of befuddled engineers by comparing it to the gyrating hips of Tongolele, an American-born dancer who had performed in Caracas. The helicoidal movements lifted from her "Tropicalísimo Show" served as a graphic analogy to claim the architecture of tropical modernism as an object of desire.[42] For all its frivolity, the analogy signals the aspiration to stage, through El Helicoide, a seamless interface of space, body, and spectacle. In effect, the mall was to be the ultimate performative itinerary of Venezuelan modernity, a radial sculpting of the city's topography to create a building that was part shopping mall, part palace of spectacles. The building's vehicular ramps and elevators stood

as thresholds to a self-contained modern world promising a haptic journey through modernist design, aspirational consumption, and spectacular displays, all gathered under one roof.

The itinerary, which El Helicoide's architects envisaged, invites a similar analysis to Benjamin's excavation of the innovative architectures of nineteenth-century "dreamworlds." If the arcade's passage was "a city, a world in miniature" and grand exhibitions were "places of pilgrimage to the commodity fetish" where novel goods interpellated visitors as customers and embodied national progress, then El Helicoide was a twentieth-century fusion of the two.[43] Projected as the biggest shopping mall in Latin America, its continuous four kilometers of stores would have made the celebrated Gran Avenida look like a provincial street. The circular ramps would ascend past hundreds of storefronts flanked by parking spaces, allowing visitors to drive from one area to another, or to walk under the covered walkways that offered protection from the weather as they window-shopped. Novelty was El Helicoide's flagship brand as the architects promised to revolutionize the shopping experience by zoning stores into ten different categories that would offer visitors a "great variety to choose from [and] . . . a great attraction."[44] Beyond the novelty factor, the plan to categorize content and satisfy all consumer needs on one site also obeyed the logic of exhibition, whereby the accumulation, classification, and exhibition of merchandise established the goods on display as paragons of modernity. Much as nineteenth-century exhibitions quantified modernity on the assumption that "everything, in principle, could be classified, listed, and receive a price tag," El Helicoide proposed a sheer abundance of storefronts as a marker of progress.[45]

The itinerary was organized with a degree of dogmatism that exposed visitors to this extensive display of consumer goods. Visitors could only descend once they had reached a point halfway up the ramps and if they were not distracted by El Helicoide's seven-screen movie theater. The architects' plans boasted that this was the cutting edge of cinematic technology. The complex catered for more than a thousand viewers—a car-borne crowd that was guaranteed stress-free parking because each screen played the same movie and start times were staggered so that waiting times would never exceed fifteen minutes.[46] Evidently, much as the state molded public parades into meticulous order, the twelve thousand plans in El Helicoide's

design left little to chance. Visitors to the construction site received a handout, which jested that it might "be more difficult for the reader to find his way through this narrative picture of the helicoid, than through the building itself." They should not worry, though. When completed, the building's "internal television system will guide the visitor. Information centers will be strategically placed."[47] The efficiency of zoning, crowd control, and signposting would ensure that the real spectacle—whether commodity, movie, or the building itself—was always center stage.

This updated version of a grand exhibition spread out along the ramps. The true culmination of El Helicoide's spectacular display would be located at the summit, however, where visitors could witness to a display of Venezuela's industrial capacity on a scale usually reserved for state exhibitions. It was here, against the panoramic backdrop of the city, that the dual concept of shopping and exhibition center came into full force. The exhibition was conceived as a showcase for the nation's natural resources and industrial capacity, with corporate stands from the oil, petrochemicals, gas, iron, aluminum, and agriculture sectors spread over some twenty-three hundred square meters all covered by a dome that was fifty-two meters wide.[48] The size and scope of El Helicoide's *exposición de industrias* (exhibition of industries) meant that the building could easily have been mistaken for another propaganda campaign by the military regime. But this was not one of the comprehensive depictions of progress staged by state institutions. It was a private initiative to organize Venezuela's modernizing prospects into a single, permanent display.

In this sense, El Helicoide would house a twofold spectacle, staging consumer culture and industrial development as the two faces of Venezuelan modernity. Vehicular arcade and grand exhibition, social ascent and national progress, all merged into a single edifying itinerary, culminating at a summit whose designs epitomized the aspiration for the building to be Caracas's ultimate modern monument. Although Bornhorst's initial proposal to top the building with a concrete "mini-helicoid" was ultimately shelved, the architects decided on a no less iconic Buckminster Fuller geodesic dome.[49] According to the architects' plans, after visitors had shopped, marveled at the views, and witnessed the industrial fair, they could stop at a kiosk to buy a souvenir before descending the ramps back to the city below.

Perhaps they would take home a model of the building, a magnet for a new refrigerator, or a decorated ashtray and then give the souvenir pride of place in their own domestic exhibition of progress that mirrored the nation's modernity.

Venezuela's political and economic tides changed, however, and these prospective visions became an unrealized blueprint. The footholds El Helicoide had found in promises of unstoppable progress crumbled when the coup of January 23, 1958, ousted the military regime. Bornhorst's laments in this regard are a telling revelation of the sense of buoyancy on which the building was contingent. "In the face of the overriding uncertainty at the end of Pérez Jiménez's dictatorship," he notes, "that simple 'sell to build' method, which was based on faith in rapid construction, made visible by the various teams who were at work, came to an abrupt stop."[50] Even the high-speed spectacle of the building's round-the-clock construction would not outpace the dictatorship's demise. Despite receiving assistance from banks and the provisional postdictatorship government to help bring the building to completion, the architects went bankrupt, construction slowed, and the project eventually ground to a definitive halt three years later. This lofty modernist dream—its twelve thousand plans and acres of concrete—came tumbling back down to earth.[51]

•

While the project's demise might be read as the hiatus in a modernist utopia never fully realized, a more productive interpretation sees in its halted construction the exposure of the very "dreamwork" on which Venezuela's spectacular modernity was built. El Helicoide synthesized the core tropes of spectacle and myth, which makes it the ultimate "dream house" of modernity. The building's spiraling forms were to gather together official prospects of industrialization, corporate interests, consumer culture, and cutting-edge technologies so as to materialize a microcosm of the developed nation that Venezuela was set to become. Seen in this context, the relative concurrence of the building's paralysis and the dictatorship's end stands as a problematic milestone, a testament to a hiatus in the hubristic finale that the New National Ideal foretold yet did not deliver. Far from an index of an innocuous "spirit" of progress or a purely aesthetic adventure in modernism, the truncated monument stands as a reminder that

the project of modernity in mid-twentieth-century Venezuela was built on dictatorship and ideology, spectacle and myth.

Bornhorst was right. This was an intense era, a time in which dictatorial rule, political demobilization, and monologic propaganda were offset by the many mythologizations of progress in which "mute things" promised people that modernity was within reach if only they bought into the growing market of TV sets, fashion trends, new-fangled groceries, and fast cars. Amid the oil boom and postwar capitalist expansion, consumer culture and commodities became imbricated with the dreamwork of progress, promising a piece of tomorrow today. Rather than undermine or draw attention away from the technocratic and martial spectacles propagated by the dictatorship, advertisements, window displays, and shopping malls helped to soften the firm grip of military rule, echoing similar ideals of superación in an idiom of capitalist developmentalism and telling Venezuelans that consumer culture was a means to build a better life for home and family.

This mixture of monologic propaganda and modern mythologies is exemplified in the story of El Helicoide, showing that the optimistic narratives buttressing the New National Ideal were not just the preserve of institutional magazines and propaganda campaigns. It is a telling fact that today many Venezuelans still credit Marcos Pérez Jiménez with devising the plans for this spiral-shaped mall and forget the trio of architects and the private capital that rallied behind its construction. The confusion is warranted, though. The promise of instant modernity that underpinned military rule was precisely the foundation on which El Helicoide, this modernist colossus, was envisaged. Its impressive dimensions, audacious design, and emphasis on visual spectacles and technics could easily have emerged from the copybook of flagship projects that the regime vaunted as proof of Venezuela's newfound modernity. These intersections of political ideology, consumer culture, and modernist architecture thus serve an important end. They disclose a more detailed and complex picture of the cultural formation of modernity in mid-twentieth-century Venezuela—one whose malleable form enabled different spectacular visions to surface and overlap, as they moved on and off stage, from public scenes to private realms, and back again.

EPILOGUE

SPECTERS OF SPECTACLE

• The initial aim in this book was to rethink modernity in Venezuela by developing a critical framework that departed from the conventional paradigms of recent cultural history, which play down the political upheavals of the mid-twentieth century and commemorate that period as an unsurpassed age of aesthetic innovation. The exploration of the nexus of politics and aesthetics, rather than the separation between them, has generated a revised conception of Venezuelan modernity from 1948 to 1958 as a cultural formation whose spatial arrangements, modes of seeing, and cultures of display were bound to the contingencies of dictatorship. Returning the modern sites typically lauded as proof of "peak" modernity to the complex sociopolitical contexts in which they materialized attends to the built environments as testaments to the past. Instead of innocuous monuments exempted from ideological projects, the spatial artifacts wrought in the 1950s were imbricated with the burgeoning oil economy, the incipient system of democratic rule, and the restless military cliques whose seizure of power brought a decade of political demobilization, censorship, and dictatorial rule. Likewise, revisiting historical archives to examine the wealth of texts and images from the official

propaganda apparatus reframes such documents as constituents of a strategic writing of history devised to buttress the redistribution of political representation imposed on Venezuelans by the coup of 1948.

Here, the lenses of cultural history and theory have not produced a chronological reconstruction of the decade of military rule or uncovered the "real" story of modernity but, rather, pushed the concept of modernity beyond the bounds of *either* politics *or* aesthetics by probing it as spectacle. The theory of spectacular modernity has provided a means of gathering modernization projects, spatial arrangements, visionary gazes, and performances of progress onto a critical common ground. The analysis has exposed the narratives and imaginaries devised to make modernity *feel like the truth* and to pursue Venezuelans' emotional investment in ideals of progress that spanned public realms and domestic spaces. For all the claims that the New National Ideal transcended politics, the military rule's rupture of democracy fostered a new political order characterized by the increased regulation of the properties of space and time, of what could be seen and said, and who could see and speak, to adapt Jacques Rancière's terms.[1] This redistribution of political roles—and with it the restructuring of narratives and imaginaries linked to national life—hinged on the principle that democracy was a hindrance to rapid modernization. Hence, the politico-aesthetic grounds of spectacular modernity transpired in the diversity of mechanisms leveraged to articulate the telos of progress and to shore up political and social order. As the logic of spectacle inflected politics, space, and visuality, forward-looking aesthetics and cutting-edge technologies reinforced one fundamental claim: modern ends justified dictatorial means.

The coup's inscription as "inaugural rupture" showed how political legitimacy became contingent on a "scriptural apparatus" that was summoned to inscribe a new order based on the time-honored authority of the Armed Forces, the technocratic rationale of modernization plans, and optimistic promises of superación.[2] Unearthing the foundation stones of this official libretto showed how the Junta Militar justified the rupture of democratic rule to present the new leaders' mandate as a necessary rerouting of the nation on its path to progress. As it empowered the Armed Forces to lead Venezuela's "radical transformation" for the national good, the New National Ideal served as a foil for institutionalizing political demobilization and the dubious redefinition of democracy. Its "true meaning" no

longer derived from the forum of popular politics enshrined by the constitution but, rather, from the military's authority to rewrite the nation's future, reimagining it as a "place where the ambiguities of the world have been exorcised."[3]

Yet, if the coup explained the beginning of this story and the New National Ideal foretold its triumphant denouement, the middle still had to be fleshed out. Censorship, propaganda, and savvy public relations, in this context, were much more than communicational policies. They were the mechanisms that soundproofed the echo chamber in which official discourse provided a meticulously crafted account of Venezuela's changing political and physical landscapes. Similarly, modern architecture became an indispensable ingredient to bolster the claim that military rule had delivered modernity writ large. Although star architect Villanueva eschewed ideology and claimed that his modernist designs served his countrymen, not the men in uniform, the monumental contours of flagship buildings, their novel construction materials, and speedy construction, all fortified the official narrative of a nation reborn. Hence, even as it resorted to repression and coercion, the Junta Militar purported to be an innocuous sign of the times, foregrounding images of high-rise modernism and driving home messages of social improvement. In the shift from dictablanda to dictadura, democracy was sidelined even further and compelled more meticulously choreographed spectacles. The celebration of Pérez Jiménez's visionary capacity and the politics of the gaze that cast Venezuelans as viewers—not agents—of modernity stand as glaring proof of the extent to which political power, visual regimes, and social order became entangled in spectacular modernity.

The cult of personality that emerged around Pérez Jiménez demonstrated that political representation in the 1950s was heir to the earlier paradigm of the *gendarme necesario* (necessary strongman). In a similar sense, the visual representation of the landscape as exploitable resource and sublime scene showed that mid-twentieth-century spectacles of progress were indebted to visual tropes from the nineteenth century. Depictions of the New Venezuela incorporated and updated the legacy of territorial conquest and nation-building projects in Latin America. Yet, the imaginary of progress disseminated in Venezuela and abroad was also in tune with the synoptic visions, developmentalist agendas, and media formats in vogue in the 1950s. Official propaganda was buttressed by the widely held

conviction that cutting-edge visual technologies such as Technicolor film and aerial photographs were themselves cognates of the progress pursued through modernization policies. It is also significant that the imaginary of the New Venezuela was forged at a time when mass media formats were still associated with red carpet glamour and pioneering technology. The critical backlash epitomized by the counter-cultural movements of the 1960s and by Debord's attack on the society of the spectacle had yet to cast its shadow on the buoyant messages of mid-century modernity.

In this sense, spectacular modernity in Venezuela was very much a sign of the times. The paradigm of development propagated there throughout the 1950s was informed by the cultural politics and economic policies of the Cold War, when the American Way of Life and the rise of consumerism became embroiled in the ideological conflicts between Capitalism and Communism. The backdrop of oil culture, foreign investment, and the regime's vocal opposition to left-wing ideologies all shaped the mythologies of progress that emerged within the state but also in Venezuela's expanding consumer culture, in which the advertisements for novel goods propagated narratives about the modern world that complemented the model of aspirational society and industrialization envisaged by military doctrine. The undeniable common ground between the government's advocacy of good health, hard work, and modern housing as keys to a bourgeois life, on one hand, and the dreamwork of capitalist ideology, on the other, cast disposable incomes as passports to social ascent, consumer choice as liberating self-realization, and novel commodities as portals to progress. Ultimately, these overlaps elucidated the idea that the 1950s were *edifying* in both literal and emotional senses of the word. This was the "real world" that Cabrujas remembered fondly, even if it was built on spectacle, myth, and dictatorship.

While Debord's critique of ideologizing images and Coronil's analysis of political representation offer insight into thinking about spectacle, they also have limitations. The former assumes viewers are passive onlookers, and the latter makes cursory mention of the incorporation of Venezuelans' bodies into displays of progress. This is why the concept of spectacular modernity developed here pushed beyond paradigms of passive looking to encompass performative and physical dimensions. The New National Ideal envisaged a model society of aspirational and obedient individuals who would articulate

progress on a daily basis by participating in welfare and housing programs. Yet, this meant that an effective performance of modernity was predicated on the prospect that Armed Forces and citizens would move in synchrony as a single unified organism. In turn, this model implied that dislocated members would be put back into place by disciplinary and regulatory means. The possibilities for superación thus came with caveats. Mass housing projects meant that the land was bulldozed and clad in concrete in the name of social well-being and modernization but also that the barrios and the urban poor were stigmatized as aesthetic and social problems. Likewise, for all their positive missives of national development, propaganda campaigns came with the inescapable condition that all public information was vetted by and vulnerable to the censor's red pen.

These simultaneous thrusts of liberation and subordination, superación and repression, draw out further complexities of modernity. When modernist designs and modernization projects are beholden to authoritarian regimes, developmentalist agendas, and capitalist interests, they are apt to deal violent blows to land and body, whose absorption creates contact zones between auspicious prospects and material destruction.[4] In the context at hand, these ideas cast critical light on the quest for radical spatial transformation and the technocratic dogma that elevated bulldozers to the status of national insignia. Recognizing the physical impacts of modernity thus brings into focus the disciplinary undercurrents that ran through the performative dimension of public spectacles and the "congealed" forms of monumental sites as they were made to mimic the discourse of power. Even as carnival processions and civic-military parades created opportunities for public assembly, their normative casts of New Venezuelans, standing atop proregime floats and marching to military bands, were haunted by the phantom limbs of democracy. At bottom, the meticulous choreography of these staged scenes exposed the framework of spectacular modernity: under military direction, the official libretto told a story of national renewal performed by docile bodies in congealed spaces.

Still, the demise of the dictatorship in 1958 serves as a reminder that even such carefully crafted spectacles of progress have their limitations, just as bids for political hegemony encounter slippages. For all the strategies used to justify dictatorship, after a decade of military rule Venezuelans demanded a return to the political stage as actors rather than spectators of the nation's future development.

And this, in turn, gave rise to a new rewriting of history: one in which the coup of January 23, 1958, marked an inaugural rupture for the nation, as popular politics returned to the stage and the project of rebuilding participatory democracy began. That January 23 is still commemorated today shows that some rewritings of history are more enduring than others, even if political groups contest and shape their meaning in-line with new agendas.

•

Although a single decade has remained the focal point here, the concept of spectacular modernity synthesizes topics and mechanisms that have abiding relevance. The narratives that prop up political projects and that justify their leaders as indispensable figureheads, the promises of progress fueled by developmentalist agendas, and the behind-the-scenes roles played by political and economic stakeholders to buttress regimes, each of these phenomena suggests that a theory of spectacle is germane to thinking about periods of rapid modernization and authoritarian politics in other latitudes.

At the same time, it is no challenge to see that the concept of spectacle has a bearing on other periods in Venezuelan history when the idea of instantaneous modernity has been revived and refashioned amid fluctuating ideological and geopolitical contexts and shifting spatial and visual regimes. Even a sweeping look at the landscape produced over the almost sixty years since the fall of Pérez Jiménez restates the relevance of asking how spatial arrangements and visual regimes help to set in place particular forms of political and social order, and how narratives of development buttress dreams of definitive progress. The list of grand designs conceived and built since 1958 is a long one, which stretches the length and breadth of the territory from the 1960s' plan to tap Venezuela's mineral riches by developing a purpose-built settlement in Ciudad Guayana to the vast Guri Dam, erected in the oil-rich 1970s to harness hydroelectric power from the Caroní River, and from the Centro Financiero Confinanzas banking complex (better known as La Torre de David), designed in the 1980s as Caracas's answer to Wall Street, to the mass project of social housing initiated under the socialist government of Hugo Chávez.

It is not just the geneses of spectacles of progress that merit study. The turbulent afterlives of monumental constructions also call for

inquiries that show how they are refracted through present lenses and political agendas. If the specters of spectacle are alive and kicking in the present, it is not least because the phantoms of past bids to build modernity often live on in dramatically different forms that undermine the linear telos of progress. From the stunted dreams of consumer paradise embodied in El Helicoide through to the precariousness of speculative finance symbolized by La Torre de David's transformation into an improvised squat, the leftovers of frustrated development projects are apt to inspire heated debates among Venezuelans.[5] Only a critical attitude to the past will bring back into focus the political contingencies of spectacles of progress and stop modernity from being reduced to a cultural imaginary imbued with nostalgia. Because outsized buildings continue to have purchase in the collective imaginary as heralds of definitve development, it is crucial to place them in their historical context and to understand the political and social orders buttressed by their steel structures and reinforced concrete. This approach reframes built environments as discursive sites where promises of elusive modernity play out before the eyes of the nation.

When flagship constructions from the 1950s have haunted recent disputes about what shape the nation should take, their spectral presence has not only proved that the correlation of built space to progress still holds sway over political discourses in Venezuela. Their reappearance in public debates also demonstrates that the political conditions of dictatorship are apt to be forgotten so the ideal of building modernity can be preserved intact.

To take just one example, in 2005 engineers discovered cracks in the largest viaduct on the Caracas–La Guaira Highway, and the following year the government of then president Hugo Chávez announced its demolition. The superstructure that was an emblem of military efficiency returned to the spotlight and became embroiled in the nation's divisions into pro- and anti-Chávez groups. As they leveraged the bridge as symptom of contemporary decline, critics of Chávez's socialist revolution silenced the links between spectacular modernity and dictatorship. Drawing on a dystopian lexicon, one newspaper columnist presented the viaduct's rubble as relics of bygone modernity. The claim that looking at the ruined bridge was like *viendo la película al revés* (watching the film backward) implied that Chávez was rewinding the reels of progress.[6] Ever media-savvy, Chávez responded in kind. The bridge had reached its natural end and critics should re-

ally let Señor Viaducto (Mister Viaduct) rest in peace, he said.[7] Some months later, as Chávez inaugurated the replacement bridge, a live broadcast transmitted in *cadena nacional* (chained broadcast) across television and radio channels revived the same triumphant rhetoric of the newsreels from sixty years earlier. To a rousing orchestral score, aerial shots that circled the bridge cut to a close-up of a ceremonial plaque as the voice-over remarked that this novel construction confirmed Venezuela's place at the vanguard of world development.[8] The nation continued to make giant leaps toward progress.

Spectacular modernity was built on the conviction that modern spaces were mirrors of superación in which Venezuelans would see themselves reflected. The collapse and reconstruction of the viaduct demonstrates that this belief lives on today, albeit reshaped in line with changing political agendas and visual technologies. The impressions that grand designs leave on the landscape call for inquiries that delve into their ideological underpinnings and the economic and cultural settings in which plans to remake the nation emerged. The fact that after the new viaduct's inauguration debates shifted rapidly from public outcry to generalized oblivion signals the sporadic nature of engagements with monumental constructions.

The political, spatial, and visual dimensions of modernity demand more than selective attention—since if past spectacles return only as flashbacks, then their capacity to clarify the ways that modernity takes shape is similarly evanescent. Recognizing frictions between bygone ideals of modernity and new promises of progress only accentuates the importance of examining the formation of common narratives and imaginaries, as well as their endurance beyond specific historic periodizations. In this sense, the concept of spectacle developed here offers more than just tools to examine the way military rule affected what modernity looked and felt like in the mid-twentieth century. It has the potential for broader applications as a means to unearth other inaugural ruptures marshaled to rewrite history, to analyze other grand designs devised to transform space and society, and to study how promises of progress circulated in public realms. Engaged as a critical paradigm, the concept of spectacle might foster a more productive terrain for thinking about modernity: one that does not reduce political and aesthetic regimes to amnesia and nostalgia but that recognizes their role in shaping collective horizons of the future.

NOTES

INTRODUCTION

1. Carlos Raúl Villanueva, "The Problem of Integration," in Ariel Jiménez, ed., *Alfredo Boulton and His Contemporaries* (New York: MoMA, 2008), 197–99.

2. "La Nueva Capital Venezolana," *La Esfera*, December 11, 1953, 1.

3. Fernando Coronil, *The Magical State: Nature, Money, and Modernity in Venezuela* (London: University of Chicago Press, 1997), 182; Miguel Tinker Salas, *The Enduring Legacy: Oil, Culture, and Society in Venezuela* (Durham: Duke University Press, 2009), 220.

4. Unless otherwise noted all translations from the original Spanish are my own. Editorial by Laureano Vallenilla Lanz (under the nom de plume RH) in *El Heraldo*, September 8, 1954, cited in Ocarina Castillo d'Imperio, *Los años del buldózer: Ideología y política, 1948–1958* (Caracas: Ediciones Tropykos, 1990), 111. Vallenilla Lanz (1912–1973) should not be confused with his father, Laureano Vallenilla Lanz (1870–1936), a noted positivist and apologist for dictator Juan Vicente Gómez.

5. Plinio Apuleyo Mendoza, ed., *Así progresa un pueblo: Diez años en la vida de Venezuela* (Caracas: Mendoza y Mendoza, 1956), 27.

6. Coronil, *The Magical State*, 183–89. Coronil cites Mostafa Hassan, *Economic Growth and Employment Problems in Venezuela* (New York: Praeger, 1975), 44, and Banco Central de Venezuela figures from 1958.

7. Vallenilla Lanz cited in Castillo, *Los años del buldózer*, 108.

8. "Adhesion," *Time*, December 16, 1957. The quote comes from a speech Pérez Jiménez gave before the plebiscite of 1957 in which free elections were replaced by a yes/no vote to ratify his rule.

9. José Agustín Catalá, *Pérez Jiménez: El dictador que en 40 años olvidó sus crímenes* (Caracas: Ediciones Centauro, 1997) 25.

10. Coronil, *The Magical State*, 206.

11. The Junta Patriótica was founded by Unión Republicana Democrática (URD) politician Fabricio Ojeda and Communist Party member Guillermo García Ponce in June 1957 and comprised representatives from Acción Democrática (AD) and the Comité de Organización Política Electoral Independiente (COPEI), who demanded respect for the constitution, free elections that would bar Pérez Jiménez from office, and democratic rule. On the demise of the dictatorship and political shifts and myths that followed, see Coronil, "The Twenty-Third of January of Democracy," in *The Magical State*, 201–36; Helena Plaza, *El 23 de enero de 1958 y el proceso de la consolidación de la democracia representativa en Venezuela* (Caracas: Garbizu & Todtmann, 1978).

12. In 1968, the Venezuelan Supreme Court sentenced the former dictator to four years, one month, and fifteen days of prison on embezzlement charges; see Judith

Ewell, *The Indictment of a Dictator: The Extradition and Trial of Marcos Pérez Jiménez* (College Station: Texas A&M University Press, 1981). Pérez Jiménez fought back with two texts: Marcos Pérez Jiménez, *Frente a la infamia* (Caracas: Ediciones Garrido, 1968), and *Mensaje al pueblo de Venezuela* (N.p., 1968).

13. There are too many examples of publications and exhibitions to list here, but broad-ranging studies of architecture include Carlos Brillembourg, ed., *Latin American Architecture, 1929–1960* (New York: Monacelli Press, 2004); Luis Carranza and Fernando Luiz Lara, *Modern Architecture in Latin America: Art, Technology, and Utopia* (Austin: University of Texas Press, 2015); Valerie Fraser, *Building the New World: Studies in the Modern Architecture of Latin America, 1930–1960* (London: Verso, 2000); Jean-François Lejeune, ed., *Cruelty and Utopia: Cities and Landscapes of Latin America* (Princeton, NJ: Princeton University Press, 2005). Exhibitions from the Patricia Phelps de Cisneros Collection, such as *Concrete Invention* (Museo Reina Sofía, Madrid, 2013) and *Radical Geometry* (Royal Academy, London, 2014), have disseminated optimistic narratives of geometric abstraction that play down political contentions. Recent exhibitions on design and architecture include *Moderno: Design for Living in Brazil, Mexico, and Venezuela, 1940–1978* (Americas Society, New York, 2015) and *Latin America in Construction: Architecture 1955–1980* (MoMA, 2015).

14. In 2015, MoMA conjured this idea of Latin America "in construction"; see Barry Bergdoll et al., *Latin America in Construction: Architecture, 1955–1980* (New York: MoMA, 2015). Fifty years earlier, MoMA's *Latin American Architecture since 1945* assembled a regional lexicon of modern architecture, leading Henry-Russell Hitchcock to echo Le Corbusier's enthusiasm for air travel as he likened the region to a land that belonged to planes. Hitchcock quoted in Patricio del Real, "Building a Continent: MoMA's Latin American Architecture since 1945 Exhibition," *Journal of Latin American Cultural Studies* 16.1 (2007): 99.

15. For a representative précis of the conflation of pioneering aesthetics with progressive politics, see Museo Reina Sofía, "Concrete Invention," accessed October 9, 2014, at http://www.museoreinasofia.es/en/exhibitions/concrete-invention-patricia -phelps-cisneros-collection/.

16. Although related to pre-Columbian heritage in Mexico, Néstor García Canclini's discussion of the shortcomings of commemoration are germane to thinking about the tensions mentioned here; see Néstor García Canclini, "The Future of the Past," in *Hybrid Cultures: Strategies for Entering and Leaving Modernity*, trans. Christopher L. Chiappari and Silvia L. Lopez (Minneapolis: University of Minnesota Press, 1995), 107–44.

17. On cultural treasures, see Walter Benjamin, "Theses on the Philosophy of History," in *Illuminations*, trans. Harry Zohn (London: Pimlico, 1999), 245–55. For a critique of "jovial" framings of geometric abstraction, see Mónica Amor, *Theories of the Non-Object* (Oakland: University of California Press, 2016), 7–11. For case studies of uneven experiences of modernity, see Patricio del Real and Helen Gyger, eds., *Latin American Modern Architectures: Ambiguous Territories* (London: Routledge, 2013).

18. Marshall Berman teases out different meanings and components of modernity, recovering the vitality of modern life and its aesthetic expressions while critiquing authoritarian agendas of modernization. See Marshall Berman, *All That Is Solid Melts into Air: The Experience of Modernity* (London: Penguin Books, 1988). For a discussion of these terms in the Latin American context, see Néstor García Canclini, "Modernismo sin modernización," *Revista Mexicana de Sociología* 51.3 (1989): 163–89.

19. On the "transition to modernity," see Fraser, *Building the New World*, 96–102. The late critic and curator William Niño Araque, who produced numerous cultural outputs from 1998 to 2015, largely advanced this commemorative turn to the 1950s' "modern spirit," using it as the rationale for an exhibition and accompanying catalog in 1950, along with the periodizations of "early modernity" and "full modernity," which appeared in other texts and exhibitions; see William Niño Araque, *1950: El espíritu moderno* (Caracas: Fundación Corp Group, 1998); *Caracas: La ciudad moderna*, CD-ROM (Caracas: Universidad Católica Andrés Bello, 1998); William Niño Araque, *Carlos Raúl Villanueva: Un moderno en Sudamérica* (Caracas: Galería de Arte Nacional, 1999).

20. For detailed descriptions of El Silencio, see Arturo Almandoz, *Urbanismo europeo en Caracas (1870–1940)* (Caracas: Fundación para la Cultura Urbana, 2006), 344–48; Fraser, *Building the New World*, 104–10.

21. Domínguez lectured on the "Five Points towards a New Architecture" in 1936; see Fraser, *Building the New World*, 112.

22. An exception is Valerie Fraser's brief analysis of El Silencio's paternalist agenda and president Isaías Medina Angarita's opportunistic use of demolition works as a photo shoot on July 25, 1942, the 375th anniversary of the city's foundation, appearing in the image armed with a pickaxe to start demolition work on the existing structures in El Silencio. That said, Fraser's analysis of the military rulers' leveraging of the aesthetic "progress" of urban developments in the 1950s is scant. See Fraser, *Building the New World*, 109.

23. This was precisely the reading of the Centro Simón Bolívar presented in the propaganda publication, Servicio Informativo Venezolano, comp., *Venezuela bajo el Nuevo Ideal Nacional* (Caracas: Imprenta Nacional, 1954), n.p.

24. Midcentury modern architects and critics debated the issue of monumentality in, among other texts, José Luis Sert, Fernand Léger, and Siegfried Giedion, "Nine Points on Monumentality" (1943), in *Architecture Culture*, ed. Joan Ockman (New York: Rizzoli, 1993), 29–30, and Gregor Paulsson et al., "In Search of a New Monumentality," *Architectural Review* 104 (1948): 117–28.

25. This is the label Jiménez uses for the texts he collates in the section spanning 1949 to 1974 in *Alfredo Boulton y sus contemporáneos*.

26. Los Disidentes, "Manifesto," in Jiménez, *Alfredo Boulton and His Contemporaries*, 178. Heated debates about figurative and abstract art played out in *El Nacional*; see Miguel Otero Silva and Alejandro Otero, "Polemic," in Jiménez, *Alfredo Boulton and His Contemporaries*, 180–96.

27. Francine Birbragher-Rozencwaig, "Embracing Modernity: Origins of Geometric Abstraction in Venezuela," in *Embracing Modernity: Venezuelan Geometric Abstraction*, ed. Francine Birbragher-Rozencwaig and María Carlota Pérez (Miami: Patricia and Philip Frost Art Museum, 2010), 10. Among the many studies of the Ciudad Universitaria are Enrique Larrañaga, "Toward the Visibility of the Invisible," in Lejeune, *Cruelty and Utopia*, 240–53; Sibyl Moholy-Nagy, *Carlos Raúl Villanueva and the Architecture of Venezuela* (New York: Praeger, 1964); Fraser, *Building the New World*, 124–40.

28. The work of Pedro Centeno Vallenilla, who was commissioned by the military regime to paint grand historical scenes in the Círculo Militar, epitomizes the endurance of figurative art; see Lorenzo González Casas and Orlando Marin Castañeda,

"Tiempos superpuestos: Arquitectura moderna e 'indigenismo' en obras emblemáti-cas de Caracas de 1950," *Apuntes Revista de Estudios sobre Patrimonio Cultural* 21.2 (2008): 266–79. For a critical analysis of the exceptionalism thesis, see Marguerite Mayhall, "Modernist but Not Exceptional: The Debate over Modern Art and National Identity in 1950s Venezuela," *Latin American Perspectives* 32.2 (2005): 124–46. Uruguayan critic Marta Traba famously lambasted the pretension to "universal" values in geometric abstraction; see Marta Traba, *Mirar en Caracas* (Caracas: Monte Ávila, 1974).

29. The campus was inaugurated on March 2, 1954. Hamilton Wright Organi-zation (HWO), "Caracas Ready for Tenth Inter-American Conference; Twenty-Five Buildings Completed in University City," press release, February 1954 (Esso Álvarez private collection).

30. "Caracas Declaration of Solidarity, 28 March 1954," *The Avalon Project: Docu-ments in Law, History and Diplomacy*, Yale Law School, accessed September 8, 2014, at http://avalon.law.yale.edu/20th_century/intam10.asp. The resolution was not the priority of the Latin American countries, whose delegates focused on economic issues and trade agreements such as high price guarantees for raw material exports. Nevertheless, the United States managed to lobby the vote, which passed seventeen to one, with abstentions from Argentina and Mexico.

31. Top Secret Eyes Only documents reveal the United States' intentions; see "Memorandum of Discussion at the 189th Meeting of the National Security Council on Thursday, March 18, 1954," in *Foreign Relations of the United States, 1952–1954*, Vol. 4, *The American Republics*, ed. N. Stephen Kane and William F. Sanford Jr. (Washing-ton, DC: Department of State, 1983), 304–6.

32. Milagros Socorro, *Catia, tres voces* (Caracas: Fundarte, 1994), 60. Rather than report it verbatim, Socorro paraphrased the interview, which in the original Spanish states: "Pensábamos que era de cajón que Pérez Jiménez hiciera lo que hacía, que no faltaba más, pero que alguien podía hacer mejor . . . a la larga descubrimos que no, que nadie lo hizo mejor—es casi blasfemo para mí mismo decirlo, pero es la verdad, o siento que es la verdad." For more recent insights into the ambivalence of recollections of the period through archive footage and interviews with politicians and activists from the 1950s, see Carlos Oteyza's box-office-hit documentary *Tiem-pos de dictadura: Tiempos de Marcos Pérez Jiménez*, directed by Carlos Oteyza (Caracas: Bolívar Films, 2013).

33. Raymond Williams, *Marxism and Literature* (Oxford: Oxford University Press, 1977), 108.

34. Coronil, *The Magical State*, 2.

35. Coronil, *The Magical State*, 5.

36. Coronil, *The Magical State*, 167.

37. Jonathon Crary, *Techniques of the Observer: On Vision and Modernity in the Nine-teenth Century* (Cambridge, MA: MIT Press, 1991), 6 (emphasis in original).

38. See Martin Heidegger, "The Question concerning Technology" and "The Age of the World Picture," in *The Question Concerning Technology & Other Essays*, trans. William Lovitt (New York: Garland, 1977), 3–35, 115–54.

39. On the intersection of social order and high modernist designs, see Marshall Berman, "Goethe's Faust: The Tragedy of Development," in Berman, *All That Is Solid Melts into Air*, 37–86; James C. Scott, *Seeing like a State: How Certain Schemes to Improve the Human Condition Have Failed* (London: Yale University Press, 1998).

40. Timothy Mitchell, "Enframing," in *Colonising Egypt* (Berkeley: University of California Press, 1991), 34–62.

41. Adrian Gorelik, "Nostalgia e plano: O estado como vanguarda," in *Das vanguardas a Brasília: Cultura urbana e arquitetura na América Latina*, trans. Maria Antonieta Pereira (Belo Horizonte: Universidade Federal de Minas Gerais, 2005), 15–57.

42. Dirección Nacional de Información, *Venezuela 1954: Expresiones del Nuevo Ideal Nacional* (Caracas: Mendoza y Mendoza, 1954), 13.

43. María Sol Pérez Schael, *Petróleo, cultura y poder en Venezuela* (Caracas: Monte Ávila, 1993), 137–38.

44. Revisionist scholarship that emerged in the 1980s has questioned the way post-1958 historical narratives claimed 1936, 1945, and 1958 as watershed moments in Venezuela's transition to democracy. For an overview, see Steve Ellner, "Venezuelan Revisionist Political History, 1908–1958: New Motives and Criteria for Analyzing the Past," *Latin American Research Review* 30.2 (1995): 91–121; Michael Derham, "Undemocratic Democracy: Venezuela and the Distorting of History," *Bulletin of Latin American Research* 21.2 (2002): 270–89.

45. Coronil notes Mariano Picón Salas's affiliation to Acción Democrática to suggest his vested interests in this periodization; see Coronil, *The Magical State*, 68.

46. Alejandro Velasco, *Barrio Rising: Urban Popular Politics and the Making of Modern Venezuela* (Oakland: University of California Press, 2015).

47. Lisa Blackmore, "El Helicoide and La Torre de David as Phantom Pavilions: Rethinking Spectacles of Progress in Venezuela," *Bulletin of Latin American Research* (2016), available at doi:10.1111/blar.12524/.

48. "Skipper of the Dreamboat," *Time*, February 28, 1955.

CHAPTER 1. TELLING STORIES

1. Marcos Pérez Jiménez, "Discurso de Clausura de la Semana de la Patria," in Servicio Informativo Venezolano, *Venezuela bajo el Nuevo Ideal Nacional* (1954).

2. Vallenilla Planchart (under the nom de plume RH) in *El Heraldo*, September 8, 1954, cited in Castillo, *Los años del buldózer*, 111.

3. Rugeles wrote: "La patria es . . . un patrimonio del espíritu y no de la material. Es como una ciudad ideal . . . porque en ella tiene tanta realidad el pasado remoto como el instante actual. . . . Un amor que nace de la tierra con profundas raíces, como nacen los árboles, y que extiende sus ramas y abre sus flores bajo el celeste signo de los ideales. . . . Asistimos al nacimiento de una Venezuela nueva." Cited in Carlos Alarico Gómez, *Marcos Pérez Jiménez: El último dictador (1914–2001)* (Caracas: Libros El Nacional, 2007), 105.

4. Catalá, *Pérez Jiménez*, 25.

5. On the sculpting of time and the scriptural apparatus, see Michel de Certeau, "The Historiographical Operation," in *The Writing of History*, trans. Tom Conley (New York: Colombia University Press, 1988), 56–114.

6. de Certeau, *The Writing of History*, 11.

7. Obviously, politically motivated historiography is not exclusive to the period under discussion. See Ellner, "Venezuelan Revisionist Political History," 91–121; Derham, "Undemocratic Democracy," 270–89.

8. The recovery of Simón Bolívar as a marker of former glory is a long-standing political tradition in Venezuela. See Germán Carrera Damas, *El culto a Bolívar* (Cara-

cas: Instituto de Antropología e Historia, Universidad Central de Venezuela, 1969); Ana Teresa Torres, *La herencia de la tribu (Del mito de la Independencia a la Revolución Bolivariana)* (Caracas: Alfa, 2009).

9. Pérez Jiménez, "Discurso de Clausura," n.p.

10. Benjamin Keen and Keith Haynes, *A History of Latin America* (Boston: Wadsworth, 2013), 495.

11. Coronil, *The Magical State*, 132.

12. "Grandes obras entrarán en servicio desde esta fecha en toda la República," *La Esfera*, December 1, 1953, 16 (emphasis added).

13. Marcos Pérez Jiménez, "La Obra del Gobierno," in Mendoza, *Así progresa un pueblo*, 25.

14. Marcos Pérez Jiménez, "La Obra del Gobierno," 25.

15. Marcos Pérez Jiménez, "La Obra del Gobierno," 27.

16. There is some disagreement with regard to the authorship of the New National Ideal. Laureano Vallenilla claimed to have created it, but Pérez Jiménez denied this and told Blanco Muñoz that he spearheaded it in 1945; see Agustín Blanco Muñoz, *Habla el General Marcos Pérez Jiménez* (Caracas: Universidad Central de Venezuela, 1983), 347.

17. Laureano Vallenilla Lanz, *Cesarismo democrático y otros textos* (Caracas: Biblioteca Ayacucho, 1991). Vallenilla Lanz Sr. developed this apology for the caudillo strongman to justify the autocrat Juan Vicente Gómez's grip on power.

18. Castillo proposes that the doctrine blended Positivism and technocratic thought with the advocacy of military leadership based on Venezuela's past; a Peronist celebration of the army, nationalism, and folklore; and national modernization plans from Nasserism. See Castillo, *Los años del buldózer*, 80–162.

19. Servicio Informativo Venezolano, comp., *Venezuela bajo el Nuevo Ideal Nacional* (Caracas: Imprenta Nacional, 1956), n.p. The original bears citing in full: "El Nuevo Ideal Nacional consiste en lograr que Venezuela ocupe el sitio de honor entre las naciones y que sea cada día más digna, próspera y fuerte. Se fundamenta en nuestro tradición histórica, nuestros recursos naturales y nuestra posición geográfica. Tiene por objetivos la transformación del medio físico y el mejoramiento moral, intelectual y material de los habitantes del país y posee como doctrina la del bien nacional, según la cual la obra del gobierno se concibe en función de los intereses nacionales."

20. Servicio Informativo Venezolano, *Venezuela bajo el Nuevo Ideal Nacional* (1956).

21. Coronil, *The Magical State*, 5.

22. Castillo, *Los años del buldózer*, 32–70. Coronil uses a slightly different periodization, proposing the shift took place in 1950 after Delgado Chalbaud was murdered; see Coronil, *The Magical State*, 166.

23. Carlos Delgado Chalbaud, Marcos Pérez Jiménez, and Luis Llovera Paéz led the Junta Militar. Delgado's death was left unresolved. The man who allegedly kidnapped him, Rafael Simón Urbina, was killed the same day and rumors began that Pérez Jiménez—who stood to benefit from the crime—had orchestrated the murder, although this was not proved. Federico Vegas's *Sumario* (Caracas: Alfaguara, 2010) offers a fascinating, albeit fictionalized, version of these events.

24. Coronil, *The Magical State*, 204.

25. Laureano Vallenilla Lanz, "El Coronel Pérez Jiménez," *El Heraldo*, October 26, 1954, cited in Castillo, *Los años del buldózer*, 103.

26. For discussions of the national project, see Germán Carrera Damas, *Una nación llamada Venezuela* (Caracas: Monte Ávila, 1991); Germán Carrera Damas, *Venezuela: Proyecto nacional y poder social* (Mérida: Universidad de Los Andes, 2006), 28.

27. For an overview of the nexus of nation-building, national identity, and architecture, see Arturo Almandoz, *La ciudad en el imaginario venezolano: Del tiempo de Maricastaña a la masificación de los techos rojos* (Caracas: Fundación para la Cultura Urbana, 2002); Azier Calvo Albizu, *Venezuela y el problema de su identidad arquitectónica* (Caracas: Universidad Central de Venezuela, 2002), 195–251; Juan José Martín Frechilla, "Construcción urbana, profesiones e inmigración en el origen de los estudios de urbanismo en Venezuela, 1870–1957," *Estudios Demográficos y Urbanos* 11.3 (1996): 477–519.

28. On nineteenth-century visual culture and modernization, see Pedro Enrique Calzadilla, "El olor de la pólvora: Fiestas patrias, memoria y Nación en la Venezuela guzmancista, 1870–1877," *Carvelle* 73 (1999): 11–130; Beatriz González Stephan, "Tecnologías para las masas: Democratización de la cultura y metáfora militar (Venezuela siglo XIX)," *Revista Iberoamericana* 30 (2008): 89–101; Paulette Silva, *Una vasta morada de enmascarados* (Caracas: Fundación Casa Andrés Bello, 1993).

29. Juan José Martín Frechilla, *Planes, planos y proyectos para Venezuela, 1908–1958* (Caracas: Universidad Central de Venezuela, Consejo de Desarrollo Científico y Humanístico, Fondo Editorial Acta Científica Venezolana, 1994), 80.

30. The post-Gómez period is associated with a twin birth: of urban modernization, on one hand, and a new cross-party national consensus on the other. The latter posits a democratic awakening whereby the nation at large reformulated the ideological core of the national project and the existing state formation. See Tomás Straka, "Críticas de la modernidad criolla: Caracas como espacio para la democracia," in *Ciudad, espacio público y cultura urbana*, ed. Tulio Hernández (Caracas: Fundación para la Cultura Urbana, 2010).

31. Martín Frechilla, *Planes, planos y proyectos*, 363–65.

32. For a comprehensive overview, see Martín Frechilla, *Planes, planos y proyectos*.

33. Michel Foucault, "The Historical a Priori and the Archive," in *The Archaeology of Knowledge*, trans. A. M. Sheridan Smith (New York: Vintage, 2010), 126–31.

34. Jacques Derrida, *Archive Fever: A Freudian Impression*, trans. Eric Prenowitz (Chicago: University of Chicago Press, 1998), 1–5.

35. The text where Le Goff explains this idea has not been translated to English; see Jacques Le Goff, "Documento/Monumento," in *El orden de la memoria: El tiempo como imaginario*, trans. Hugo F. Bauzá (Barcelona: Paidós, 1991), 238.

36. Plinio Apuleyo Mendoza, ed., *Así es Caracas* (Caracas: Ministerio de Fomento, 1951), n.p.

37. Alois Riegl, "The Modern Cult of Monuments: Its Essence and Its Development," in *Historical and Philosophical Issues in the Conservation of Cultural Heritage*, ed. Nicholas Stanley Price et al. (Los Angeles: Getty Conservation Institute, 1997), 69.

38. The archive was founded in 1959 to preserve documents, correspondence, and photographs from each of the presidential periods beginning with Cipriano Castro's administration (1899–1908). Its taxonomies and internal classifications mix existing organization and retrospective ordering, hence their absence from the analysis developed here. Photographs from the Pérez Jiménez period (1952–1958) came from thirty-three photographers and studios, numerous state institutions, and

their publications, including Ministerio de Fomento, Ministerio de Relaciones Interiores, Oficina Nacional de Información y Publicaciones, Ministerio de la Defensa, Ministerio de Obras Públicas, Mes Financiero y Economómico de Venezuela, Ministerio de Fomento Turístico, Oficina Nacional de Turismo.

39. Many others, like the *Revista de Hacienda* and *Boletín del Banco Central de Venezuela*, however, predated the coup and can be traced back to 1909. For a thorough list and analytical overview, see Juan José Martín Frechilla, "*La gran ilusión*: El petróleo en las revistas institucionales venezolanas entre 1907 y 1957," in *Petróleo nuestro y ajeno: La ilusión de modernidad*, ed. Juan José Martín Frechilla and Yolanda Texera Arnal (Caracas: Universidad Central de Venezuela, Consejo de Desarrollo Científico y Humanístico, Fondo Editorial Acta Científica Venezolana, 2005), 279–360.

40. Mendoza, *Venezuela 1954*, 6.

41. Benedict Anderson, *Imagined Communities: Reflections on the Origin and Spread of Nationalism* (London: Verso, 2006), 6.

42. On the recent use of murals to bond state-built housing to political projects, see Lisa Blackmore, "Capture Life: The 'Document-Monument' in Recent Commemorations of Hugo Chávez," *Journal of Latin American Cultural Studies* 23.3 (2014): 235–50.

CHAPTER 2. RULING IDEOLOGY

1. Blanco Muñoz, *Habla el General*, 40. Pérez Jiménez said: "Quiero ser muy claro en esto: con la aparición de la Junta Militar de Gobierno lo que se pretendió fue volver por los fueros de las Fuerzas Armadas como institución básica de la nación. Lo que Venezuela significó en la función liberadora del siglo pasado se le debe a la función de sus Fuerzas Armadas en el continente. Si después de la independencia, Venezuela decayó debilitándose notablemente, a medida que sus Fuerzas Armadas dejaban de tener la mística, la moral y la eficiencia guerrera que tuvieron cuando El Libertador, eso quiere decir entonces que la nación venezolana marcha al ritmo de sus Fuerzas Armadas. Esa teoría la he sostenido y creo fervorosamente en ella. No habrá una nación grande venezolana sin unas Fuerzas Armadas igualmente grandes. . . . Eso es lo que buscábamos nosotros con el Nuevo Ideal Nacional: construir una nación próspera, digna y fuerte."

2. David Harvey, *The Condition of Post-Modernity: An Enquiry into the Origins of Social Change* (Oxford: Basil Blackwell, 1989), 35.

3. Castillo, *Los años del buldózer*, 170.

4. Louis Althusser, *Essays on Ideology*, trans. Ben Brewster et al. (London: Verso, 1984).

5. Cartay cites a number of figures who recall compliance in the period; see Rafael Cartay, "La filosofía del régimen pérezjimenista: El Nuevo Ideal Nacional," *Revista Economía* 15 (1999): 8.

6. Le Corbusier, *Towards a New Architecture: Essential Le Corbusier L'Esprit Nouveau Articles*, trans. Frederick Etchells (Oxford: Architectural Press, 1998), 4. The Swiss architect pioneered these innovations in residential design in his famed *Pavillon de l'Esprit Nouveau* (1925) at the Paris *Exposition des Arts Décoratifs* and later at his twelve-story Unité d'Habitation in Marseille (1947–1952). He took a particular interest in South America where he delivered lectures and formulated urban designs from the 1930s through to the 1950s.

7. Villanueva's team of architects included Carlos Celis Cepero, José Manuel Mijares, Carlos Brando, Víctor Mantilla, Juan Centellas, José Hoffman, and Guido Bermúdez.

8. For a detailed discussion of these plans, see Beatriz Meza Suniaga, "Proyectos del Taller de Arquitectura del Banco Obrero (TABO) para el Plan Nacional de la Vivienda en Venezuela (1951–1955)," *Tecnología y construcción* 21.2 (2005): 8–22.

9. Meza Suniaga cites the *Cuadernos de Información Económica* (1950, 1951, 1953).

10. Untitled editorial by Vallenilla Lanz in *El Heraldo*, June 30, 1955, cited in Castillo, *Los años del buldózer*, 116.

11. Dirección Nacional de Información, *Venezuela 1954*, 47.

12. Velasco explores political mobilization in the Tiro al Blanco barrio in Caracas, which was established in the 1930s and 1940s and dismantled in the 1950s. See Velasco, *Barrio Rising*.

13. Dirección Nacional de Información, *Venezuela 1954*, 48–49.

14. For a taste of the modernist and functionalist precepts in vogue in the twentieth century, see Le Corbusier, *Towards a New Architecture*.

15. Original designs from 1951 were quite varied, featuring balconies, external stairways, and variations in apartment typology, but these were later removed to create a model that maximized speed and ease of construction. For details on the changes, see Viviana d'Auria, "Caracas' Cultural (Be)longings," in Real and Gyger, *Latin American Modern Architectures*, 115–34. Valerie Fraser notes similarities between the superblocks and housing developments in Mexico and Brazil, in Fraser, *Building the New World*, 113–21.

16. Velasco, *Barrio Rising*, 6. Interestingly, though, Velasco links this rapid increase to the role played by the Urbanización 2 de Diciembre communities in Pérez Jiménez's political demise.

17. Fraser, *Building the New World*, 120. The praise was no passing comment but was featured in Henry-Russell Hitchcock, *Latin American Architecture since 1945* (New York: MoMA, 1955), 137.

18. Interestingly, Tinker Salas identifies a similar persistence of rural habits in the oil camps' "modern" housing, which was meant to "de-ruralize" laborers, noting the use of hammocks in bedrooms and chickens kept for fresh eggs. See Tinker Salas, *Enduring Legacy*, 175–76.

19. Velasco, *Barrio Rising*; d'Auria, "Caracas Cultural (Be)longings."

20. "Primer nacimiento en el Cerro Piloto," *Revista del Banco Obrero* 1.6 (1954): 39.

21. Blanco Muñoz, *Habla el General*, 67–69.

22. Mendoza, *Así progresa un pueblo*, 202. The greatest number of immigrants came from Italy (118,338), followed by Spain (97,888), United States (36,121), Portugal (28,982), and Colombia (21,987). In total, the article lists seventy-four countries.

23. Foucault's designation of the threshold of modernity at the nexus of science, politics, and capitalism, extends much further back from the temporal frame addressed here. Even so, his discussion of how scientific disciplines mapped the body and how states became life-administering agents that adapted subjects to capitalist ideals of productivity and profit is enlightening. Michel Foucault, "Right of Death and Power over Life," in *The Foucault Reader*, ed. Paul Rabinow (New York: Pantheon Books, 1984).

24. Mendoza, *Así progresa un pueblo*, 133.

25. Mendoza, *Así progresa un pueblo*, 202.

26. Mendoza, *Así progresa un pueblo*, 133.

27. "4 años: 12,425 inmigrantes colocados por el Instituto Agrario Nacional," *El Nacional*, November 25, 1952, 20.

28. *Turén* (18 minutes, Cromocine, undated) was written and directed by Manuel Vicente Tinoco and René Borges Villegas. The same footage also appeared in *Miracle in Venezuela* (10 minutes, Cromocine, 1956), which was distributed internationally by Republic Pictures.

29. Dirección Nacional de Información, *Venezuela 1954*, 73.

30. Mendoza, *Así progresa un pueblo*, 225.

31. Servicio Informativo Venezolano, *Venezuela bajo el Nuevo Ideal Nacional* (1954), n.p.

32. Servicio Informativo Venezolano, *Venezuela bajo el Nuevo Ideal Nacional* (1954), n.p.

33. Michel de Certeau, *The Practice of Everyday Life*, trans. Steven Rendall (Berkeley: University of California Press, 1984), 139.

34. Servicio Informativo Venezolano, *Venezuela bajo el Nuevo Ideal Nacional* (1954), n.p.

35. Mendoza, *Así progresa un pueblo*, 192.

36. Mendoza, *Así progresa un pueblo*, 196.

37. *Venezuela bajo el Nuevo Ideal Nacional* (1954), n.p.

38. Coronil, *The Magical State*, 184–85.

39. Eleazar Díaz Rangel, *Libertad de prensa en Venezuela* (Caracas: Ministerio de Comunicación e Información, 2006), 8.

40. On the clandestine press, see Humberto Cuenca, *Imagen literaria del periodismo* (Caracas: Editorial Cultura Venezolana, 1961).

41. Jorge Rivas Rivas, ed., *Historia gráfica de Venezuela: El Gobierno de Pérez Jiménez (Primera parte)*, Vol. 5 (Caracas: Centro Editor, 1972), 50.

42. Catalá, *Pérez Jiménez*, 28.

43. José Agustín Catalá, *Pedro Estrada y sus crímenes* (Caracas: Ediciones Centauro, 1983), 61.

44. José Vicente Abreu, "Un poemario para la subversión," in José Agustín Catalá, ed., *Libro Negro: Venezuela bajo el signo del terror* (Caracas: Ediciones Centauro, 1974), vi. Including himself, Catalá identifies its compilers as fellow AD activists Leonardo Ruiz Pineda, Alberto Carnevali, Jorge Dáger, Ramón J. Velásquez, Simón Alberto Consalvi, René Domínguez, and Héctor Hurtado. Although attributed to a fictional "Editorial Centauro" in Mexico, the book was produced entirely in Venezuela at Catalá's Editorial Ávila Gráfica, Hoyo a Santa Rosalia 18-1, Caracas, which was later raided by the Seguridad Nacional; see Catalá, *Pérez Jiménez*, 171.

45. The Ministerio de Obras Públicas, *Memoria y Cuenta* (Caracas: Ministerio de Obras Públicas, 1954) details the expansion of jails.

46. Mendoza, *Así progresa un pueblo*, 217.

47. Catalá, *Libro negro*, 121.

48. Catalá, *Pedro Estrada*, 65.

49. Catalá gives an exhaustive account of torture methods that he gathered during his three years in prison. See the "Nómina parcial de torturados" in José Agustín Catalá, *Documentos para la historia del pérezjimenismo: Los crímenes impunes de la dict-*

adura (Caracas: Ediciones Centauro, 1972), 86. Censorship and torture dominate testimonial literature such as Miguel Otero Silva, *La muerte de Honorio* (1963) and José Vicente Abreu, *Se llamaba SN* (1964), among others.

50. I have written elsewhere about Guasina, clandestine counternarratives, and memory. See Lisa Blackmore, "Tecnologías visuales y el 'archivo' de la desmemoria: El caso de *Se llamaba SN*," *Estudios* 20.39 (2012): 127–56.

51. The seminal discussion of spaces of repression that undermine basic physical well-being is Giorgio Agamben, *Homer Sacer: Sovereign Power and Bare Life*, trans. Daniel Heller-Roazen (Stanford: Stanford University Press, 1998).

52. Catalá, *Libro negro*, liii–lxvi.

53. For a description of Guasina, see Catalá, *Libro negro*, 179; Alarico Gómez, *El último dictador*, 89–90. Although his claims are not corroborated elsewhere, Catalá states that Guasina was first opened by General Eleazar López Contreras in 1939 and used in World War II as a concentration camp for what he terms "Nazi fascists," before being reopened in 1948 for immigrants who arrived in Venezuela without identity documents. See Catalá, *Documentos*, 113. Shortly after coming to power in 1952, Pérez Jimenez ordered the closure of Guasina and transferred the prisoners to other jails.

CHAPTER 3. NATION BRANDING

1. Letter from Pedro Estrada to Miguel Moreno, secretary of the Junta Militar, dated June 9, 1949, reproduced in Catalá, *Pérez Jiménez*, 10–16.

2. The hotel still exists but is now the Ritz-Carlton. Estrada stopped in Trinidad, the Dominican Republic, Haiti, Puerto Rico, Jamaica, Miami, Washington, and New York. His letter suggests he would then travel south to Mexico.

3. Keith Dinnie, *Nation Branding: Concepts, Issues, Practice* (London: Routledge, 2016); Nadia Kaneva, "Nation Branding: Toward an Agenda for Critical Research," *International Journal of Communication* 5.25 (2011). Accessed February 4, 2016, at http://ijoc.org/index.php/ijoc/article/view/704/514/.

4. For an overview of the history of public relations, see Scott M. Cutlip, *The Unseen Power: Public Relations, a History* (London and New York: Routledge, 1994).

5. Cornell Capa, "New Latin Boom Land," *Life*, September 13, 1954, 123. See also Cornell Capa, "Auge en Venezuela," *Life en español*, May 19, 1954, n.p. The article in English can be viewed online via the *Life* archive hosted by Google Books.

6. Catalá, *Pérez Jiménez*, 16–17.

7. In his detailed research of internal communications held at the Archivo Histórico de Miraflores, Alejandro Cardozo also underlines the role played by Humberto Spinetti Dini, Director Nacional de Información, with regard to direct and indirect propaganda. See Alejandro Cardozo Uzcátegui, "La propaganda política durante el perezjimenismo: En la búsqueda de la legitimidad de ejercio y la diplomacia velada, 1952–1957," *Tiempo y Espacio* 19.52 (2009): 206–15.

8. For a history of the company, see Cutlip, "The Hamilton Wright Organization— The First International Agency," in *The Unseen Power*, 73–91.

9. Vila Ramírez detected 165 official propaganda films from the period 1951–1958, many of them produced by HWO; see Yelitza Vila Ramírez, "El cine de encargo oficial (1952–1958): Una visión de Venezuela" (Bachelor's thesis, Universidad Central de Venezuela, 1998), 58.

10. Scott Cutlip, "Pioneering Public Relations for Foreign Governments," *Public Relations Review* 13. 1 (1987): 25.

11. William Fox-Talbot, *The Pencil of Nature* (London: Longman, Brown, Green and Longmans, 1846).

12. John Berger, *About Looking* (New York: Vintage, 1991), 54.

13. John Berger, *Another Way of Telling* (Cambridge: Granta Books, 1989), 91. See also Roland Barthes, "The Photographic Message," in *Image, Music, Text*, trans. Stephen Heath (London: Fontana Press, 1977), 15–31.

14. Mendoza, *Así es Caracas*, n.p.

15. Cutlip, "Pioneering Public Relations," 19. The ambiguous interface of public relations and journalism first came to public light in the mid-1960s when the Fulbright Committee (created by the Senate Foreign Relations Committee) began to question the influence of "Non-diplomatic Activities," propaganda, and lobbying, disputing the credibility of companies such as HWO, who were damaged by the hearings and subsequently disbanded in 1969 or 1970; see Cutlip, "Pioneering Public Relations," 16–18.

16. Vila Ramírez cites a document entitled "Anexo al Contrato," dated April 1952, which she appends to her thesis, "El cine de encargo oficial," n.p. The document details HWO's responsibilities; it originally appeared in the *Memoria y Cuenta del Ministerio de Relaciones Interiores, 1948–1952*.

17. Whether a direct product of the HWO contract or not, probusiness *Time* presented the government in a favorable light throughout the 1950s, reflecting the rise of U.S. capital invested in oil and mining. Pro–Pérez Jiménez articles continued to appear in the magazine through September 1956 when new concessions were released, but the frequency then waned considerably in 1957 amid the demise of other military strongmen such as Peruvian leader General Manuel Odria, Perón in Argentina, and General Gustavo Rojas Pinilla in Colombia and the plebiscite that was described as "cynically rigged" in the article "Venezuela: Five More Years," *Time*, December 30, 1957.

18. The different companies served different cinemas: Universal newsreels were shown at Cines Imperial, Broadway, Cines Unidos; Fox Movietone went to Junín, Boyacá, Ayacucho, Lido, and México; Pathé was screened at the Autocine, and Florida, Río, Royal, Rialto, Caracas, and Pinar movie theaters. Documentaries included *Horizontes sin límites* (1953), *Bonus Land* (1953), *Fabulous Venezuela* (1953), *Caracas Carnival Parade 1954* (1954), *Venezuela Builds City of Tomorrow* (1955), among others. See Vila Ramírez, "El cine de encargo oficial," 74–75, 91.

19. HWO, letter to the government, December 11, 1953, cited in Vila Ramírez, "El cine de encargo oficial," 83.

20. "Fabulosa carretera venezolana" (Servicios Mundiales Paramount); "Venezuela inaugura 'autopista'" (Noticiario Metro); "Inauguración de una carretera de $60,000,000 en Venezuela" (Noticiario Movietone), all from 1953.

21. "Inauguración de Obras Públicas" (Paramount News, 1953); Untitled Newsreel (United Universal Newsreel/Universal Pictures, December 1953).

22. Tiuna Films signed a contract with Tropical Films in 1954 to disseminate their Noticiario Sucesos in some ninety-seven cinemas nationwide and in the Dominican Republic, Curaçao, Puerto Rico, Cuba, and Aruba; see Vila Ramírez, "El cine de encargo oficial," 77.

23. "La Cinemateca del Aire," Bolívar Films, December 10, 1955.

24. The credits were as follows: *Caracas hoy y mañana* (Allend'or Production Hollywood, 1953); *La Nueva Venezuela* (Servicio Informativo Venezolano, 1954); *Paisaje de la patria* (Dirección Nacional de Información/Cromocine, 1954); *Baluarte de la Patria* (Cromocine, 1954); *Turén* (Cromocine, undated); *La Semana de la Patria* (Cromocine, 1954); *Dinámica de un ideal* (Servicio Informativo Venezolano, 1955); *Miracle in Venezuela* (Republic Presentation, 1956); and *Paraíso del Trabajador: Colonia Vacacional Los Caracas* (Cromocine, 1957). Manuel Vicente Tinoco (1913–1992) was born to a landowning family on a large coffee and cocoa farm in San Felipe in Yaracuy. He studied political science at the Universidad Central de Venezuela and worked as a journalist at *El Universal* in the 1930s and returned there in the 1960s. He was a lawyer, senator, and subsecretary of the president's office under Pérez Jiménez and established close ties to the dictator, who was a godfather to a daughter from Tinoco's second marriage. After becoming interested in filmmaking in the 1940s he took a course in Los Angeles and set up two production companies, Cromocine and Cineduca. He was recurrently hired by the regime and worked with the Hamilton Wright Organization on at least two occasions, when HWO distributed his *Dinámica de un ideal* (1955) and when he was editorial supervisor and scriptwriter for *La Nueva Venezuela* (Twentieth Century Fox, 1954). After 1958 Tinoco worked for Acción Democrática and his archive at the Archivo Fílmico in Venezuela features a film on AD politician Jóvito Villalba entitled *Jóvito en Maracaibo* made soon after 1958. Author's conversation with Vicente Ignacio Tinoco, Caracas, October 25, 2010.

25. "Dinámica de un ideal," *El Nacional*, March 30, 1955.

26. "Estreno de Dinámica de un ideal," *El Nacional*, April 19, 1955; "Película," *El Nacional*, May 21, 1955.

27. Mendoza, *Así progresa un pueblo*, 284.

28. Ewell describes the extent of insider trading, claiming that three-quarters of contractors were linked to members of government; see Judith Ewell, "Venezuela since 1930," in *The Cambridge History of Latin America*, ed. Leslie Bethell, Vol. 8 (Cambridge: Cambridge University Press, 1991), 750. On the relationship between private enterprise and the military government, see Castillo, *Los años del buldózer*, 178–81; Coronil, *The Magical State*, 180–201. Coronil draws on Glen L. Kolb, *Democracy and Dictatorship in Venezuela, 1945–1958* (Hamden: Connecticut College Press, 1974) and Winfield J. Burggraaff, *The Venezuelan Armed Forces in Politics, 1935–1959* (Columbia: University of Missouri Press, 1972).

29. Hamilton Wright Organization, "Venezuela Big Buyer of US Automobiles," press release, January 1956.

30. "Vivir en Playa Grande es vivir en Caracas," *El Nacional*, November 19, 1954, 65.

31. The image of the Litoral Central as a coastal idyll and symbol of national identity continued through the next decade as the Macuto Sheraton opened and became the site of the Miss Venezuela contest.

32. On the cultural value of cement, see Rubén Gallo, *Mexican Modernity: The Avant-Garde and the Technological Revolution* (Cambridge, MA: MIT, 2005), 172.

33. Coronil, *The Magical State*, 35.

34. Mendoza, *Así progresa un pueblo*, 147.

35. Oil companies were by no means beholden to the government but maintained agendas focused on safeguarding investment interests. For a detailed discussion of the role of oil companies in the political upheavals of the twentieth century, see Tinker Salas, "Staying the Course: United States Oil Companies in Venezuela, 1945–1958," *Latin American Perspectives* 32.2 (2005): 147–70; Terry Lynn Karl, "Petroleum and Political Pacts: The Transition to Democracy in Venezuela," *Latin American Research Review* 22.1 (1987): 63–94.

36. Lorenzo González Casas and Orlando Marin Castañeda, "El transcurrir tras el cercado: Ámbito residencial y vida cotidiana en los campamentos petroleros de Venezuela (1940–1975)," *Espacio Abierto* 12.3 (2003): 381.

37. Coronil, *The Magical State*, 109. On the integration of the oil camps, see also Tinker Salas, *Enduring Legacy*, 199–203.

38. Tinker Salas, *Enduring Legacy*, 190.

39. Tinker Salas explains that foreign companies engaged local workers in an attempt to avoid a bid in Venezuela to nationalize oil, as had occurred in Mexico in 1938. See Tinker Salas, *Enduring Legacy*, 246. On U.S. oil interests, see Margarita López Maya, *E.E.U.U. en Venezuela, 1945–1948* (Caracas: Universidad Central de Venezuela, 1996); Tinker Salas, "Staying the Course."

40. Editorials by Creole and Standard bosses in *El Farol* served as soapboxes for complaints about the dictatorship's policies. See Martín Frechilla. "*La gran ilusión*," 287. See also Luis Ricardo Dávila, "El imaginario petrolero (Petroleros e identidades nacionales en Venezuela)," in Martín Frechilla and Arnal, *Petróleo nuestro y ajeno*, 361–96.

CHAPTER 4. SPECTACULAR VISUALITY

1. Servicio Informativo Venezolano, *Venezuela bajo el Nuevo Ideal Nacional* (1954), n.p.

2. Guy Debord, *The Society of the Spectacle*, trans. Ken Knabb (London: Rebel Press, 2002), 13.

3. Michel Foucault, *Discipline and Punish: The Birth of the Prison*, trans. Allen Lane (London: Penguin Books, 1991); Tony Bennett, *The Birth of the Museum: History, Theory, Politics* (London: Routledge, 1995).

4. It is worth noting that Jonathon Crary opts for the term "observer," which suggests the observance of rules, codes, and practices, over the word "spectator," which connotes unmitigated passivity in the face of a totalized power. Crary, *Techniques of the Observer*, 5.

5. For a discussion of the term "visuality" and its implications, see Nicholas Mirzoeff, "On Visuality," *Journal of Visual Culture* 5.1 (2006): 53–79. Mirzoeff builds on the idea of the scopic regime in Martin Jay, "Scopic Regimes of Modernity," in *Vision and Visuality*, ed. Hal Foster (Seattle: Bay Press, 1998), 3–23, and draws on Dipesh Chakrabarty's work in the field of subaltern studies, where dominant inscriptions of history (which mobilize the forces of capitalism and imperialism) are pitted against peripheral histories (which interrupt these totalizing thrusts with alternate accounts).

6. Arturo Uslar Pietri, *De una a otra Venezuela* (Caracas: Monte Ávila, 1985), 45.

7. Claude Levi Strauss, *Tristes Tropiques*, trans. John Weightman and Doreen Weightman (London: Penguin, 1973), 97.

8. Mariano Picón Salas, "Regreso de tres mundos," in *Autobiografías*, ed. Guillermo

Sucre and Cristían E. Álvarez (Caracas: Monte Ávila, 1987), 152, cited in Almandoz, *La ciudad en el imaginario venezolano II: De 1936 a los pequeños seres* (Caracas: Fundación para la Cultura Urbana, 2004), 75.

9. Mario Briceño Iragorry, *Mensaje sin destino y otros ensayos* (Caracas: Biblioteca Ayacucho, 1988), 97.

10. Mariano Picón Salas, *Suma de Venezuela* (Caracas: Controlaría General de la República, 1984), 133. Anala and Armando Planchart engaged Italian architect Gio Ponti to design a house for them on a hill in San Román, overlooking Caracas. The much-lauded Villa Planchart (1953–1957) is considered a jewel of modernist design; see Gio Ponti, "Villa Planchart, Caracas, 1953–1957," *Domus*, February 2, 2011.

11. Mendoza, *Venezuela 1954*, n.p.

12. W. J. T. Mitchell, "Imperial Landscape," in *Landscape and Power*, ed. W. J. T. Mitchell (Chicago: University of Chicago Press, 2002), 5–34. See also Denis Cosgrove, "Prospect, Perspective and the Evolution of the Landscape Idea," *Transactions of the Institute of British Geographers* 10.1 (1985): 45–62.

13. Ministerio de Obras Públicas, *Memoria y Cuenta*, 145.

14. Ministerio de Obras Públicas, "Dirección de Cartografía Nacional," in *Memoria y Cuenta*, 143–236.

15. Jorge Luis Borges, "Del rigor en la ciencia," *El hacedor* (Madrid: Alianza, 1997).

16. Denis Cosgrove, "The Meaning of America," in *Taking Measures across the American Landscape*, ed. James Corner and Alex Maclean (New Haven: Yale University Press, 1996), 4, cited in Scott, *Seeing like a State*, 56.

17. Le Corbusier is the core advocate of aerial vision. See Le Corbusier, *Airplane* (London: The Studio, 1935).

18. Jens Andermann, *The Optic of the State: Visuality and Power in Argentina and Brazil* (Pittsburgh: University of Pittsburgh Press, 2007), 124 (emphasis in original).

19. Heidegger's original term in German is *Gestell*; see Heidegger, "The Question Concerning Technology"; Heidegger, "The Age of the World Picture." The statistics are from the Servicios Estadísiticos del Ministerio de Agricultura y Cría, cited in Mendoza, *Así progresa un pueblo*, 131.

20. Mitchell, "Enframing," in *Colonising Egypt*, 34–62; Mendoza, *Así progresa un pueblo*, 126.

21. Mitchell, *Colonising Egypt*, 38.

22. "VI Congreso Panamericano de Carreteras," *Revista del Banco Obrero* 1.3 (1954): 20.

23. The film was produced by the Dirección Nacional de Información, but it was directed, written, and narrated by Manuel Vicente Tinoco and supervised by American producer Al Walker. Most of the footage is taken from the air, with shots also from cars and boats.

24. "Estrenaron anoche 'Paisaje de la Patria,'" *El Nacional*, June 19, 1954.

25. Jean-Louis Baudry, "Ideological Effects of the Basic Cinematographic Apparatus," *Film Quarterly* 28.2 (1974–1975): 44.

26. Roland Barthes, "Leaving the Movie Theater," in *The Rustle of Language*, trans. Richard Howard (Berkeley: Hill and Wang, 1986), 348; originally published as "En sortant du cinéma," *Communications* 23 (1975): 10–107.

27. The original voice-over is as follows: "Venezuela está dispuesta generosamente a recibir en su seno las ideas del progreso y los capitales resueltos a impulsarlo. El

bienestar, el progreso y la riqueza no se cosechan en las ramas de los árboles. Esta forzada empresa corresponde a los venezolanos de este tiempo para realizar los fines del gran ideal nacional que nuestros dirigentes han proclamado como fin de su obra."

28. Roland Barthes, *Camera Lucida*, trans. Richard Howard (London: Vintage, 1993), 87.

29. Ministerio de Fomento, "Dirección de Turismo," in *Memoria y Cuenta correspondiente al año 1954, del período administrativo 1ro de julio de 1953 al 30 de junio de 1954* (Caracas: Ministerio de Fomento, 1955), 85–96.

30. For a discussion of this social housing program, see Chapter 2.

CHAPTER 5. EXHIBITING MODERNITY

1. After the coup, Delgado Chalbaud promised that the Junta "does not intend to install an open or underhanded military dictatorship"; see Alarico Gómez, *El último dictador*, 76.

2. Declassified U.S. Department of State documents provide fascinating insight into the embassy's awareness that Pérez Jiménez was emerging, even before the election, as the strong man of the Junta, and that even in the face of electoral fraud U.S. trade interests were such that "there is no other course to follow than the continuation of normal relations under present circumstances," as a memorandum by the assistant secretary of state for inter-American affairs, Edward G. Miller, explained to the secretary of state. Edward G. Miller, "Memorandum by the Assistant Secretary of State for Inter-American Affairs (Miller) to the Secretary of State, December 5, 1952," in *Foreign Relations of the United States, 1952–1954*, Vol. 4, 1635.

3. Coronil, *The Magical State*, 163.

4. Alarico Gómez, *El último dictador*, 100.

5. "Skipper of the Dreamboat."

6. On this exhibition, see Martín Frechilla, *Planes, planos, proyectos*, 393. For an excellent survey of Venezuela's rising participation in international exhibitions under military rule, see Orlando Marin Castañeda, "Construir la nación, construir sus imágenes: Los pabellones de Venezuela en las exposiciones internacionales," in *La tradición de lo moderno: Venezuela en diez enfoques*, ed. Tomás Straka (Caracas: Fundación para la Cultura Urbana, 2006), 312–13.

7. "Una Concha Acústica y un teatro para mil doscientos espectadores," *El Nacional*, October 3, 1952, 24; "Exposición Objetiva Nacional," *El Nacional*, November 22, 1952, 7.

8. On synoptic vision and miniaturization, see Scott, *Seeing like a State*; on museum collections and displays, see Andermann, *Optic of the State*.

9. "Hoy inauguración apoteósica de la Exposición Objetiva Nacional," *El Nacional*, November 23, 1952, 7.

10. "Exposición Objetiva Nacional," *El Nacional*, November 19, 1952, 5.

11. "Aviso Banco Obrero," *El Nacional*, November 22, 1952, 21; "Invitación," *El Nacional*, November 23, 1952, 41.

12. Dirección Nacional de Información, *Venezuela 1954*, 13.

13. The end of the dictatorship put paid to this idea. The plans were abandoned under incoming president Rómulo Betancourt's drive for austerity. The project was coordinated by Alejandro Pietri, who was to design some of the buildings, with

help from architect Carlos Guinand Sandoz, Brazilian landscape designer Roberto Burle Marx, American ornithologist George Scout, ornithologists William and Katy Phelps, fish scientist Agustín Fernández Yépez, and the archaeologist José María Cruxent, who was to direct a museum on the grounds. See Marin Castañeda, "Construir la nación," 300.

14. Johan M. Ramírez, "Tomás Sanabria," *El Universal*, section Estampas, September 30, 2007, accessed December 9, 2009, at http://www.eluniversal.com/estampas/anteriores/300907/caracasde.shtml/. Sanabria also hiked up the Ávila and made careful sketches of its climatic conditions during the design process.

15. Raymond Williams, "Ideas of Nature," in *Problems in Materialism and Culture* (London: Verso, 1980), 67–85.

16. Berman, *All That Is Solid*, 65. A recently published book and documentary narrate the story of the hotel's construction; see Joaquín Marta Sosa, Gregory Vertullo, and Federico Prieto, *El Hotel Humboldt: Un milagro en el Ávila* (Caracas: Fundavag Ediciones, 2014). The French engineer Count Vladimir de Bertren, who had experience with cable car construction in Switzerland, proposed the cable car project in 1954 to public works minister Julio Bacalao Lara.

17. Berman, *All That Is Solid*, 67.

18. Coronil, *The Magical State*, 177.

19. *Nuevo Ideal Nacional. Dos de diciembre. Revista de Ilustración General* 1 (December 2, 1955): 2. Founded and managed by naval engineer Vicente Lorentty Carriel with editor in chief Carlos Parra Bernal, the magazine had at least four editions in the first year; gaps in the Biblioteca Nacional archive make it hard to ascertain how long it ran. The editors did not have explicit backing from the government and claimed to be independent journalists, yet close ties to power are suggested by their use of images that had appeared previously in official publications and their shameless sycophancy—the final page of the first edition featured a telegram to Pérez Jiménez in which the editors told him they were fully engaged with the policy of bien nacional.

20. Vicente Lorentty Carriel, "Doctrinarias: Nuevo Ideal Nacional," *Nuevo Ideal Nacional. Dos de diciembre. Revista de Ilustración General* 1 (December 2, 1955). The original text bears quoting for the hyperbole: "Dios y distinguidos amantes de su tierra hicieron que abusos e inmoralidades desaparecieran y fuera elegido el 2 de diciembre de 1952 Presidente Provisional de la República de Venezuela el entonces Coronel Marcos Pérez Jiménez. Así nació la nueva Venezuela con un NUEVO IDEAL NACIONAL, cuya evolución política ha dado los más asombrosos resultados de progreso y bienestar general jamás visto en ninguna época de nuestra historia venezolana."

21. A year later, the editors express their "fe ciega en los destinos de la Patria, cuyo glorioso porvenir, pujante y poderoso, va perfilando con paso seguro y tenacidad de cíclope el General Marcos Pérez Jiménez, cuya figura se agiganta día a día en proporciones extraordinarias y cuya labor clara, eficaz y tesonera se hace acreedora al agradecimiento eterno de la Nación venezolana." *Nuevo Ideal Nacional. Dos de diciembre. Revista de Ilustración General* 6 (December 26, 1956).

22. Ladislao T. Tarnoi, *El Nuevo Ideal Nacional de Venezuela: Vida y obra de Marcos Pérez Jiménez* (Madrid: Ediciones Verdad, 1954), 338.

23. Tarnoi, *El Nuevo Ideal Nacional*, 338.

24. Aniceto Lugo makes this claim at the start of the second edition, so it should be viewed with skepticism.

25. Chapter titles include "Inutilidad de la lucha partidista" (Uselessness of party political struggle), "Protección médico-asistencial" (Medical and welfare protection), "Las Fuerzas Armadas al servicio de la república" (The Armed Forces at the service of the republic), "La pasión por las construcciones" (Passion for constructions), and "Organización científica de la Administración de Justicia" (Scientific organization of the law).

26. Tarnoi, *El Nuevo Ideal Nacional*, 36.

27. Francisco Aniceto Lugo, *Pérez Jiménez: Fuerza Creadora* (Caracas: Imprenta Nacional, 1953), 23.

28. Dirección de Información Nacional, *Venezuela 1954*, 73.

29. Aniceto Lugo, *Pérez Jiménez: Fuerza Creadora*, 20.

30. "Cuando la opinión se encuentra fraccionada, desmenuzada, atomizada, ¿no sería más cuerdo formar un frente común alrededor de la personalidad del Colonel Pérez Jiménez?" Aniceto Lugo, *Pérez Jiménez*, 27.

CHAPTER 6. SUBJECTS ONSTAGE

1. Eduardo Blanco-Amor, "La ciudad sospechada," *El Nacional*, October 5, 1952, 34.

2. Eduardo Blanco-Amor, "Caracas entre el ser y el no ser," *Revista Shell* 7 (June 1953): 60–67.

3. Augusto Márquez Cañizales, "La ciudad cambia," *El Nacional*, November 1, 1953, 4.

4. Henri Lefebvre, *The Production of Space*, trans. Donald Nicholson-Smith (London: Blackwell, 2005), 224.

5. Alejandro Velasco, "'We Are Still Rebels': The Challenge of Popular History in Bolivarian Venezuela," in *Venezuela's Bolivarian Democracy: Participation, Politics, and Culture under Chávez*, ed. David Smilde and Daniel Hellinger (Durham: Duke University Press, 2011), 164.

6. Velasco offers fascinating insight into the significance of Tiro al Blanco as the proto-residents of the Urbanización 2 de diciembre in his chapter "Landscapes of Opportunity," in *Barrio Rising*, 21–51, 34.

7. Lefebvre, *Production of Space*, 361–62.

8. For an enlightening discussion of Lefebvre's approach to body and space, see Kirsten Simonsen, "Bodies, Sensations, Space and Time: The Contribution from Henri Lefebvre," *Geografiska Annaler* 87.1 (2005): 1–14, accessed March 3, 2016, at http://www.jstor.org/stable/3554441/.

9. Lefebvre, *Production of Space*, 361–62. For a discussion of the distinctions between space and place, see Edward S. Casey, *The Fate of Place: A Philosophical History* (Berkeley: University of California Press, 1998).

10. "Carnavales de Caracas," *Revista del Banco Obrero* 1.1 (1954).

11. "El Carnaval de Caracas," in Servicio Informativo Venezolano, *Venezuela bajo el Nuevo Ideal Nacional* (1955), n.p.

12. "Orden para los desfiles de carrozas durante los días 27 y 28 de febrero y 1 y 2 de marzo," *El Nacional*, February 26, 1954, 32.

13. "Orden para los desfiles de carrozas durante los días 27 y 28 de febrero y 1 y 2 de marzo," *El Nacional*, February 26, 1954, 32.

14. "Carnaval de Caracas 1954: Programa oficial," *El Nacional*, February 27, 1954, 14.

15. Marcia Ochoa, "Spectacular Femininities," in *Queen for a Day:* Transformistas, *Beauty Queens, and the Performance of Femininity in Venezuela* (Durham: Duke University Press, 2014), 201–32. It should be noted that in Ochoa's fascinating study, the focus and methodology are distinct from those used here. Rooted in what she terms a queer ethnography, her focus is on contemporary Venezuelan *transformistas* as much as the now deep-seated tradition of Miss Venezuela. As such, her analysis focuses on daily life and mass media spectacle by drawing on theoreticians such as Jean Baudrillard and Judith Butler to address gender, the performativity of identity, transvestism, and queer theory. In her words, her definition of spectacle "focuses on performativity and mediation rather than ideology per se." See Ochoa, *Queen for a Day*, 202.

16. On the complexities of race and beauty pageants in Venezuela, see Ochoa, *Queen for a Day*, 32–40; Elizabeth Gackstetter-Nichols, "Virgin Venuses: Beauty and Purity for 'Public' Women in Venezuela," in *Women in Politics and Media: Perspectives from Nations in Transition*, ed. Maria Raicheva-Stover and Elza Ibroscheva (London: Bloomsbury, 2014), 233–48.

17. On the history of the contest, see Ochoa, *Queen for a Day*, 21–57.

18. Albor Rodríguez, comp., *Misses de Venezuela: Reinas que cautivaron un país* (Caracas: Libros de El Nacional, 2005), 55–62. Curiously, Larrazábal's selection was overruled. Carola Reverón de Behrens, the only female member of the jury, opposed his selection of Mireya Casa Robles and opened the vote to public applause. At the behest of the audience, Susana Duijm was declared the winner; see Rodríguez, *Misses de Venezuela*, 57.

19. Lauren Derby, *The Dictator's Seduction: Politics and the Popular Imagination in the Era of Trujillo* (Durham: Duke University Press, 2009), 124.

20. No Miss Venezuela contest took place that particular year, though. Pan Am withdrew its sponsorship of the event after only two editions (1952, 1953). When the journalist Reinaldo Espinoza became organizer in 1955, the contest was reactivated with the event held at the Hotel Tamanaco. See Ochoa, *Queen for a Day*, 31–32.

21. Fernando Coronil and Julie Skurski, "Dismembering and Remembering the Nation: The Semantics of Political Violence in Venezuela," *Comparative Studies in Society and History* 33.2 (1991): 330.

22. Hamilton Wright Organization, "Venezuela Dedicates Her 'Avenue of the Heroes,'" press release, July 5, 1957.

23. A detailed description of the Sistema can be found in Calvo Albizu, *Venezuela y el problema de su identidad arquitectónica*, 248–49; Silvia Hernández de Lasala, "La Nacionalidad: Un escenario urbano para conmemorar 'La Semana de la Patria,'" *Revista CAV* (1986): 50–51.

24. Lefebvre, *Production of Space*, 224.

25. Bennett, *Birth of the Museum*, 51.

26. Servicio Informativo Venezolano, *Venezuela bajo el Nuevo Ideal Nacional* (1954), n.p. The speech was given at the closing events of the Semana de la Patria on July 6, 1953.

27. Bennett, *Birth of the Museum*, 6.

28. Bennett, *Birth of the Museum*, 214.

29. See also Castillo, *Los años del buldózer*, 116–20; Coronil, *The Magical State*, 169–70. For a detailed account of the program of events in 1955, see David Ocanto,

"Imágenes con vida pública: Las celebraciones de la Semana de la Patria, Caracas 1953–1957," *Prácticas de Oficio: Investigación y reflexión en Ciencias Sociales* 10 (2012), accessed March 3, 2016, at http://ides.org.ar/wp-content/uploads/2012/12/Dos sier-Las-imágenes-Ocanto.pdf/.

30. On nineteenth-century festivities, see Calzadilla, "El olor de la pólvora"; González Stephan, "Tecnologías para las masas"; Beatriz González Stephan, "Fundar el estado/narrar la nación: *Venezuela heroica* de Eduardo Blanco," *Revista Iberoamericana* 63 (1997): 33–46.

31. Tinker Salas makes similar observations regarding the oil companies' support of corporate sporting activities, which were presented as a route to modernity, while they discouraged activities such as cockfighting and gambling that were considered inappropriate and undesirable. See Tinker Salas, *Enduring Legacy*, 181–83.

32. "Semana de la Patria," *Revista del Banco Obrero* 1.3 (July 1954): 10 (emphasis added).

33. "Semana de la Patria," *Revista del Banco Obrero* 1.3 (July 1954): 10.

34. Lefebvre, *Production of Space*, 212–18.

35. Lefebvre, *Production of Space*, 215.

36. Some schoolteachers and students refused to participate in the parades; see Salomó Marquès Sureda and Juan José Martín Frechilla, *La labor educativa de los exiliados españoles en Venezuela* (Caracas: Universidad Central de Venezuela, 2002), 84. In Carlos Oteyza's documentary *Tiempos de dictadura*, a number of interviewees recall the events, some with excitement and others with disdain.

37. Gustavo León Miranda, "La Semana de la Patria," *El desafío de la historia* 16 (2010): 44.

CHAPTER 7. BRINGING PROGRESS HOME

1. Tulio Hernández, "La mirada del otro," *Extracámara* 10 (1997): 32–36.

2. Capa, "New Latin Boom Land."

3. Laureano Vallenilla Lanz, editorial in *El Heraldo*, June 30, 1955, cited in Castillo, *Los años del buldózer*, 116. Capa's photograph was part of the covert HWO publicity campaign discussed earlier.

4. Walter Benjamin, *The Arcades Project*, trans. Howard Eiland and Kevin Mclaughlin (Cambridge, MA: Belknap Press of Harvard University Press, 1999), 389–91.

5. Theodor Adorno, *Kierkegaard* (Tübingen: J. C. B. Mohr, 1933), 46–48, cited in Benjamin, *The Arcades Project*, 220.

6. For the links between consumerism and oil culture, see Tinker Salas, *Enduring Legacy*, 188–89.

7. The United States–Venezuela Commercial Treaty of 1939 was updated in 1952, creating particularly favorable conditions for importers. In his overview of the economy, Coronil notes that few local industries enjoyed government protection and industrial growth was relatively slow since, although the regime promoted growth, its policies also curbed economic entrepreneurship. See Coronil, *The Magical State*, 186–89.

8. Lorenzo González Casas, "Nelson A. Rockefeller y la modernidad venezolana: Intercambios, empresas y lugares a mediados del siglo XX," in Martín Frechilla and Arnal, *Petróleo nuestro y ajeno*, 201.

9. On the cultural hierarchies established through commodity flows, see Arjun

Appadurai, "Commodities and the Politics of Value," in *The Social Life of Things: Commodities in Cultural Perspective*, ed. Arjun Appadurai (Cambridge: Cambridge University Press, 1986), 3–63.

10. de Certeau, *The Practice of Everyday Life*, 147.

11. For a discussion of "making" and "doing" as tactical activities and productive consumption, see de Certeau, *The Practice of Everyday Life*, 29–42.

12. The first Venezuelan advertising agency, ARS, opened in 1938, and in 1946 the first transnational agency, McCann Erickson, opened offices and brought teams from the United States. Two years later, the Corporación Publicitaria Nacional (CORPA) was founded by five local businessmen to promote their companies, which included Santa Teresa and Electricidad de Caracas as well as transnational companies like Shell. On the nexus of advertising agencies, corporate interests, and televisual media, see Tibisay Soto, "La televisión en Venezuela, 1952–1986," in *40 años de comunicación social en Venezuela, 1946–1986*, ed. Eleazar Díaz Rangel (Caracas: Universidad Central de Venezuela, 1988), 265.

13. For a fascinating discussion of how this played out, see Karal Ann Marling, "Nixon in Moscow: The Kitchen Debate," in *As Seen on TV: The Visual Culture of Everyday Life in the 1950s* (Cambridge, MA: Harvard University Press, 1994), 243–50, 271–76.

14. Consumer culture was widely exported, as advertising agencies set up offices across the world to promote U.S.–produced goods abroad in foreign markets. See William H. Young and Nancy Young, *The 1950s: American Popular Culture through History* (Westport, CT: Greenwood Press, 2004).

15. Roland Barthes, "Myth Today," in *Mythologies*, trans. Annette Lavers (London: Vintage, 2000), 109–59.

16. Lynn Spigel, "Installing the Television Set," in *The Everyday Life Reader*, ed. Ben Highmore (London: Routledge, 2002), 327.

17. "Philco," *El Nacional*, November 23, 1952, 21.

18. Vila Ramírez, "El cine de encargo oficial," 91. Although limited mainly to the capital, where three stations opened in the first two years, channels soon opened in Zulia and Carabobo states. Programmers avoided potential conflicts by keeping opinion shows off the grid—a control that slackened only after the dictatorship collapsed and the first opinion show, *La Voz de la Revolución*, began transmission in 1958 on Radio Caracas de Televisión (RCTV). For an overview of the evolution of television in Venezuela, see Soto, "La televisión en Venezuela," 229–41.

19. Young and Young, *The 1950s*, 247.

20. Hamilton Wright Organization, "Venezuela Big Buyer of US Automobiles." Famous for his transformation of New York, Moses was hired in 1948 to formulate an *Arterial Plan for Caracas*. Hatch's 1954 design for the shopping mall in Las Mercedes, Caracas, was a veritable hub for U.S. car and leisure culture, located near the Centro Venezolano-Americano, a gas station, the Colegio Americano, and the new Hotel Tamanaco. The move toward shopping centers will be discussed below. See also González Casas, "Nelson A. Rockefeller," 197–201.

21. "Cauchos General: Progresando a paso firme con la nación," *La Esfera*, December 4, 1953, 20.

22. "Fue inaugurado en Ciudad Bolívar la séptima tienda Sears," *El Nacional*, December 6, 1954, 11.

23. "Skipper of the Dreamboat."

24. Henry Vicente, "La arquitectura urbana de las corporaciones petroleras: Conformación de 'Distritos Petroleros' en Caracas durante las décadas de las 1940 y 1950," *Espacio Abierto* 12.3 (2003): 401. Creole, Royal Dutch Shell, Mobil, and Atlantic all had offices in Caracas. Curiously, the Seguridad Nacional moved into the Creole building, relocating from the western district of El Paraíso.

25. As well as Standard Oil/Creole and Cada, Nelson A. Rockefeller invested in Venezuelan agriculture, fishing, and dairy sectors. Standard Oil supported the Venezuelan pavilion at the 1939 World Fair in New York, which cast the country as a buoyant modern nation navigating the global flows of capital. See González Casas, "Nelson A. Rockefeller."

26. For a fascinating discussion of the emergence of supermarkets and malls, and Don Hatch's design for the Centro Comercial Las Mercedes in Caracas, see González Casas, "Nelson A. Rockefeller," 197–201.

27. Mendoza, *Así es Caracas*, n.p.

28. Appadurai, "Commodities," 6.

29. Against Marx's focus on conditions of production, Appadurai's corrective is to trace the object from inception to consumption, thus expanding the scope of the analysis of commodities; see Appadurai, "Commodities," 13.

30. Mendoza, *Así es Caracas*, n.p.

31. Information from two promotional brochures, both entitled *Helicoide de la Roca Tarpeya*, both undated; a pamphlet entitled "The Helicoid" given to visitors of the construction site, dated 1958–1961; and the *Espiral de noticias* newsletter sent out to investors during the construction period, all courtesy Proyecto Helicoide.

32. Letter from Arthur Drexler to Jorge Romero Gutiérrez, June 28, 1961 (Archivo Fotografía Urbana/Proyecto Helicoide archive).

33. The quote is from Bernard Rudofsky and Arthur Drexler's curatorial text for the *Roads* exhibition, reproduced in Dirk Bornhorst, *El Helicoide* (Caracas: Oscar Todtmann, 2007), 96.

34. See Carola Barrios, "El Museo de Arte de Niemeyer: Su lugar en el paisaje moderno de Caracas," *Arquine Revista Internacional de Arquitectura* 37 (2007): 76–91; José Rosas and Iván González, "El Helicoide de Caracas," *ARQ* 52 (2002): 14–17, accessed March 3, 2016, at doi: 10.4067/S0717-69962002005200008/.

35. For discussions of form and El Helicoide's fusion of car and city, see Carola Barrios, "Transcrições arquitetônicas: Niemeyer e Villanueva em diálogo museal," *Arquitextos* 151.3 (2012); Jorge Villota Peña, "Reshaping the Hill: From Sugarloaf Mountain to the Tarpeian Rock," in "The Hyper Americans! Modern Architecture in Venezuela during the 1950s" (PhD thesis, University of Texas at Austin, 2014), 418–77.

36. This consideration of form, context, and politics informed two exhibitions organized in 2014 by Proyecto Helicoide, a research initiative directed by cultural historian Celeste Olalquiaga. See *Helicoides posibles: Visiones fantásticas at the Centro Cultural Chacao, Caracas, September–October 2014*, and *Helicoides fallidos: Proyectos, usos y ocupaciones de El Helicoide de la Roca Tarpeya: 1955–2014* (Museo de Arquitectura, Caracas, November 2014). A forthcoming volume of essays assesses the building from a number of disciplinary perspectives, from architectural criticism to anthropology and philosophy. See Celeste Olalquiaga and Lisa Blackmore, eds., *From Mall to Prison: El Helicoide's Downward Spiral* (New York: Urban Research, 2017).

37. Bornhorst, *El Helicoide*, 10.

38. Bornhorst's attitude can be grasped better from the original Spanish: "Años 50. Época intensa. Había mucho que hacer. Las obras se hacían de la forma más espontánea y rápida. Así nació El Helicoide. . . . [había] una atmósfera de mucho optimismo, que hacía sentir que todo era possible, lo nuevo, lo audaz, lo atrevido."

39. Villota, "The Hyper Americans!" 433.

40. "Shapes of the Future," *Time*, April 22, 1957, 36.

41. Bornhorst, *El Helicoide*, 17.

42. Bornhorst, *El Helicoide*, 15. Yolanda Ivonne Montes Farrington "Tongolele" was born in 1932, in Washington. She performed in Caracas on several occasions.

43. Benjamin, *The Arcades Project*, 3. Benjamin took the first quote from an *Illustrated Guide to Paris*.

44. Information from the pamphlet "The Helicoid."

45. Andermann, *Optic of the State*, 21.

46. Villota, "The Hyper Americans!" 437.

47. "The Helicoid."

48. Villota, "The Hyper Americans!" 428.

49. Bornhorst, *El Helicoide*, 13.

50. Bornhorst, *El Helicoide*, 17–18.

51. Villota, "The Hyper Americans!" 438. Villota cites the figure from interviews he conducted with Bornhorst. Although not a state project, the curtailment of El Helicoide was symptomatic of the contraction of building as incoming president Rómulo Betancourt instituted austerity measures that halted grand plans (and not least, the project to hold a world fair in La Carlota, as discussed earlier).

EPILOGUE

1. Jacques Rancière, "The Distribution of the Sensible: Politics and Aesthetics," in *The Politics of Aesthetics*, trans. Gabriel Rockhill (London: Bloomsbury, 2013).

2. de Certeau, "The Scriptural Economy," in *The Practice of Everyday Life*, 131–53.

3. de Certeau, *The Practice of Everyday Life*, 134.

4. "Absorbing Modernity" was the curatorial concept that Koolhaas developed for the 2014 Venice Biennial *Absorbing Modernity 1914–2014*. Although incipient, some recent studies engage with the complexities of modern sites in ways that go beyond questions of architectural form. See Beatriz Jaguaribe, "Modernist Ruins: National Narratives and Architectural Forms," *Public Culture* 11.1 (1999): 294–312; Rubén Gallo, "Modernist Ruins: The Case Study of Tlatelolco," in *Telling Ruins in Latin America*, ed. Michael J. Lazzara and Vicky Unruh (London: Palgrave Macmillan, 2009), 107–20.

5. The occupation of the Torre Confinanzas (Torre de David) entered the international spotlight in 2010 after a number of media reports featured the community of more than four thousand people who moved into the unfinished skyscraper in 2007. On the dilemmas of these two buildings, see Lisa Blackmore, "El Helicoide and La Torre de David as Phantom Pavilions: Rethinking Spectacles of Progress in Venezuela," *Bulletin of Latin American Research* (2016), at doi:10.1111/blar.12524/.

6. Miguel Carpio, "La muerte del viaducto," *El Universal*, March 23, 2006, accessed March 3, 2016, at http://www.eluniversal.com/2006/03/23/opi_art_23491G (no

longer available); Miguel Carpio, "Memorias del viaducto," *El Universal*, April 6, 2006, accessed March 3, 2016, at http://www.eluniversal.com/2006/04/06/opi_art_06491D (no longer available).

7. Sara Carolina Díaz, "Dejen que el viaducto descanse en paz," *El Universal*, March 20, 2006, accessed March 28, 2016, at http://www.eluniversal.com/2006/03/20/ccs_apo_20144B2 (no longer available).

8. The bridge was inaugurated on June 18, 2007; videos of its construction and inauguration produced by state channel Venezolana de Televisión are readily available online.

BIBLIOGRAPHY

Abreu, José Antonio. *Se llamaba SN.* Caracas: Monte Ávila, 2005.

Abreu, José Antonio. "Un poemario para la subversión." In *Libro Negro: Venezuela bajo el signo del terror,* edited by José Agustín Catalá, vi–xvii. Caracas: Ediciones Centauro, 1974.

Adorno, Theodor. *Kierkegaard.* Tübingen: J. C. B. Mohr, 1933.

Agamben, Giorgio. *Homo Sacer: Sovereign Power and Bare Life.* Translated by Daniel Heller-Roazen. Stanford: Stanford University Press, 1998.

Alarico Gómez, Carlos. *Marcos Pérez Jiménez: El último dictador (1914–2001).* Caracas: Libros El Nacional, 2007.

Almandoz, Arturo. *La ciudad en el imaginario venezolano: Del tiempo de Maricastaña a la masificación de los techos rojos.* Caracas: Fundación para la Cultura Urbana, 2002.

Almandoz, Arturo. *La ciudad en el imaginario venezolano II: De 1936 a los pequeños seres.* Caracas: Fundación para la Cultura Urbana, 2004.

Almandoz, Arturo. *Urbanismo europeo en Caracas (1870–1940).* Caracas: Fundación para la Cultura Urbana, 2006.

Althusser, Louis. *Essays on Ideology.* Translated by Ben Brewster et al. London: Verso, 1984.

Amor, Mónica. *Theories of the Non-Object.* Oakland: University of California Press, 2016.

Andermann, Jens. *The Optic of the State: Visuality and Power in Argentina and Brazil.* Pittsburgh: University of Pittsburgh Press, 2007.

Anderson, Benedict. *Imagined Communities: Reflections on the Origin and Spread of Nationalism.* London: Verso, 2006.

Appadurai, Arjun. "Commodities and the Politics of Value." In *The Social Life of Things: Commodities in Cultural Perspective,* edited by Arjun Appadurai, 3–63. Cambridge: Cambridge University Press, 1986.

Auerbach, Ruth, and William Niño Araque. "Torres de Caracas: Modernidad silenciada." *El Nacional,* September 17, 2005, section Papel Literario, 2.

"Aviso Banco Obrero." *El Nacional,* November 22, 1952, 21.

Barrios, Carola. "El Museo de Arte de Niemeyer: Su lugar en el paisaje moderno de Caracas." *Arquine Revista Internacional de Arquitectura* 37 (2007): 76–91.

Barrios, Carola. "Transcrições arquitetônicas: Niemeyer e Villanueva em diálogo museal." *Arquitextos* 151.3 (2012).

Barthes, Roland. "Leaving the Movie Theater." In *The Rustle of Language,* translated by Richard Howard, 345–49. Berkeley: Hill and Wang, 1986. Originally published as "En sortant du cinéma," *Communications* 23 (1975): 10–107.

Barthes, Roland. "The Photographic Message." In *Image, Music, Text*, translated by Stephen Heath, 15–31. London: Fontana Press, 1977.

Barthes, Roland. *Camera Lucida*. Translated by Richard Howard. London: Vintage, 1993.

Barthes, Roland. *Mythologies*. Translated by Annette Lavers. London: Vintage, 2000.

Baudry, Jean-Louis. "Ideological Effects of the Basic Cinematographic Apparatus." *Film Quarterly* 28.2 (1974–1975): 39–47.

Benjamin, Walter. *The Arcades Project*. Translated by Howard Eiland and Kevin Mclaughlin. Cambridge, MA: The Belknap Press of Harvard University Press, 1999.

Benjamin, Walter. *Illuminations*. Translated by Harry Zohn. London: Pimlico, 1999.

Bennett, Tony. *The Birth of the Museum: History, Theory, Politics*. London: Routledge, 1995.

Bergdoll, Barry, Carlos Eduardo Comas, Jorge Francisco Liernur, and Patricio del Real, eds. *Latin America in Construction: Architecture 1955–1980*. New York: MOMA, 2015.

Berger, John. *Another Way of Telling*. Cambridge: Granta Books, 1989.

Berger, John. *About Looking*. New York: Vintage, 1991.

Berman, Marshall. *All That Is Solid Melts into Air: The Experience of Modernity*. London: Penguin Books, 1988.

Birbragher-Rozencwaig, Francine. "Embracing Modernity: Origins of Geometric Abstraction in Venezuela." In *Embracing Modernity: Venezuelan Geometric Abstraction*, edited by Francine Birbragher-Rozencwaig and María Carlota Pérez, 10–14. Miami: Patricia and Philip Frost Art Museum, 2010.

Blackmore, Lisa. "Tecnologías visuales y el 'archivo' de la desmemoria: El caso de *Se llamaba SN*." *Estudios* 20.39 (2012): 127–56.

Blackmore, Lisa. "Capture Life: The 'Document-Monument' in Recent Commemorations of Hugo Chávez." *Journal of Latin American Cultural Studies* 23.3 (2014): 235–50.

Blackmore, Lisa. "El Helicoide and La Torre de David as Phantom Pavilions: Rethinking Spectacles of Progress in Venezuela." *Bulletin of Latin American Research* (2016). Available at doi:10.1111/blar.12524/.

Blanco-Amor, Eduardo. "La ciudad sospechada." *El Nacional*, October 5, 1952.

Blanco-Amor, Eduardo. "Caracas entre el ser y el no ser." *Revista Shell* 7 (June 1953).

Blanco Muñoz, Agustín. *Habla el General Marcos Pérez Jiménez*. Caracas: Universidad Central de Venezuela, 1983.

Borges, Jorge Luis. *El hacedor*. Madrid: Alianza, 1997.

Bornhorst, Dirk. *El Helicoide*. Caracas: Oscar Todtmann Editores, 2007.

Briceño Iragorry, Mario. *Mensaje sin destino y otros ensayos*. Caracas: Biblioteca Ayacucho, 1988.

Brillembourg, Carlos, ed. *Latin American Architecture, 1929–1960*. New York: Monacelli Press, 2004.

Burggraaff, Winfield J. *The Venezuelan Armed Forces in Politics, 1935–1959*. Columbia: University of Missouri Press, 1972.

Calvo Albizu, Azier. *Venezuela y el problema de su identidad arquitectónica*. Caracas: Universidad Central de Venezuela, 2002.

Calzadilla, Pedro Enrique. "El olor de la pólvora: Fiestas patrias, memoria y Nación en la Venezuela guzmancista, 1870–1877." *Carvelle* 73 (1999): 11–130.

Capa, Cornell. "Auge en Venezuela." *Life en español,* May 19, 1954.

Capa, Cornell. "New Latin Boom Land." *Life,* September 13, 1954.

Caracas: La ciudad moderna. CD-ROM. Caracas: Universidad Católica Andrés Bello, 1998.

"Caracas Declaration of Solidarity, 28 March, 1954." *The Avalon Project: Documents in Law, History and Diplomacy* (2008). Yale Law School. Accessed September 8, 2014. http://avalon.law.yale.edu/20th_century/intam10.asp.

Cardozo Uzcátegui, Alejandro. "La propaganda política durante el perezjimenismo: En la búsqueda de la legitimidad de ejercio y la diplomacia velada, 1952–1957." *Tiempo y Espacio* 19.52 (2009): 199–230.

"Carnaval de Caracas 1954: Programa oficial." *El Nacional,* February 27, 1954, 14.

Carpio, Miguel. "Memorias del viaducto." *El Universal,* April 6, 2006. Accessed March 3, 2016. http://www.eluniversal.com/2006/04/06/opi_art_06491D.

Carpio, Miguel. "La muerte del viaducto." *El Universal,* March 23, 2006. Accessed March 3, 2016. http://www.eluniversal.com/2006/03/23/opi_art_23491G.

Carranza, Luis, and Fernando Luiz Lara. *Modern Architecture in Latin America: Art, Technology, and Utopia.* Austin: University of Texas Press, 2015.

Carrera Damas, Germán. *El culto a Bolívar.* Caracas: Instituto de Antropología e Historia, Universidad Central de Venezuela, 1969.

Carrera Damas, Germán. *Una nación llamada Venezuela.* Caracas: Monte Ávila, 1991.

Carrera Damas, Germán. *Venezuela: Proyecto nacional y poder social.* Mérida: Universidad de Los Andes, 2006.

Cartay, Rafael. "La filosofía del régimen pérezjimenista: El Nuevo Ideal Nacional." *Revista Economía* 15 (1999): 8–24.

Casey, Edward S. *Fate of Place: A Philosophical History.* Berkeley: University of California Press, 1998.

Castillo d'Imperio, Ocarina. *Los años del buldózer: Ideología y política, 1948–1958.* Caracas: Ediciones Tropykos, 1990.

Catalá, José Agustín. *Documentos para la historia del pérezjimenismo: Los crímenes impunes de la dictadura.* Caracas: Ediciones Centauro, 1972.

Catalá, José Agustín. *Libro Negro: Venezuela bajo el signo del terror.* Caracas: Ediciones Centauro, 1974.

Catalá, José Agustín. *Pedro Estrada y sus crímenes.* 3rd ed. Caracas: Ediciones Centauro, 1983.

Catalá, José Agustín. *Pérez Jiménez: El dictador que en 40 años olvidó sus crímenes.* Caracas: Ediciones Centauro, 1997.

"Cauchos General: Progresando a paso firme con la nación." *La Esfera,* December 4, 1953.

"La Cinemateca del Aire." Bolívar Films, December 10, 1955. Newsreel. Biblioteca Nacional, Caracas.

"Una Concha Acústica y un teatro para mil doscientos espectadores." *El Nacional,* October 3, 1952, 24.

Coronil, Fernando. *The Magical State: Nature, Money, and Modernity in Venezuela.* London: University of Chicago Press, 1997.

Coronil, Fernando, and Julie Skurski. "Dismembering and Remembering the Nation: The Semantics of Political Violence in Venezuela." *Comparative Studies in Society and History* 33.2 (1991): 288–337.

Cosgrove, Denis. "Prospect, Perspective and the Evolution of the Landscape Idea." *Transactions of the Institute of British Geographers* 10.1 (1985): 45–62.

Cosgrove, Denis. "The Meaning of America." In *Taking Measures across the American Landscape*, edited by James Corner and Alex Maclean, 3–15. New Haven: Yale University Press, 1996.

Crary, Jonathon. *Techniques of the Observer: On Vision and Modernity in the Nineteenth Century*. Cambridge, MA: MIT Press, 1991.

Cuenca, Humberto. *Imagen literaria del periodismo*. Caracas: Editorial Cultura Venezolana, 1961.

Cutlip, Scott M. "Pioneering Public Relations for Foreign Governments." *Public Relations Review* 13.1 (1987): 13–34.

Cutlip, Scott M. *The Unseen Power: Public Relations, a History*. London: Routledge, 1994.

d'Auria, Viviana. "Caracas' Cultural (Be)longings." In del Real and Gyger, *Latin American Modern Architectures*.

Dávila, Luis Ricardo. "El imaginario petrolero (Petroleros e identidades nacionales en Venezuela)." In Martín Frechilla and Arnal, *Petróleo nuestro y ajeno*, 361–96.

Debord, Guy. *The Society of the Spectacle*. Translated by Ken Knabb. London: Rebel Press, 2002.

de Certeau, Michel. *The Practice of Everyday Life*. Translated by Steven Rendall. Berkeley: University of California Press, 1988.

de Certeau, Michel. *The Writing of History*. Translated by Tom Conley. New York: Colombia University Press, 1988.

del Real, Patricio. "Building a Continent: MoMA's Latin American Architecture since 1945 Exhibition." *Journal of Latin American Cultural Studies* 16.1 (2007): 95–110.

del Real, Patricio, and Helen Gyger, eds. *Latin American Modern Architectures: Ambiguous Territories*. London and New York: Routledge, 2013.

Derby, Lauren. *The Dictator's Seduction: Politics and the Popular Imagination in the Era of Trujillo*. Durham: Duke University Press, 2009.

Derham, Michael. "Undemocratic Democracy: Venezuela and the Distorting of History." *Bulletin of Latin American Research* 21.2 (2002): 270–89.

Derrida, Jacques. *Archive Fever: A Freudian Impression*. Translated by Eric Prenowitz. Chicago: University of Chicago Press, 1998.

Díaz, Sara Carolina. "'Dejen que el viaducto descanse en paz.'" *El Universal*, March 20, 2006. Accessed March 28, 2016. http://www.eluniversal.com/2006/03/20/ccs_apo_20144B2/.

Díaz Rangel, Eleazar. *Libertad de prensa en Venezuela*. Caracas: Ministerio de Comunicación e Información, 2006.

"Dinámica de un ideal." *El Nacional*, March 30, 1955.

Dinnie, Keith. *Nation Branding: Concepts, Issues, Practice*. 2nd ed. London and New York: Routledge, 2016.

Dirección Nacional de Información. *Venezuela 1954: Expresiones del Nuevo Ideal Nacional*. Caracas: Mendoza y Mendoza, 1954.

Los Disidentes. "Manifesto." In Jiménez, *Alfredo Boulton and His Contemporaries*, 178.

Ellner, Steve. "Venezuelan Revisionist Political History, 1908–1958: New Motives and Criteria for Analyzing the Past." *Latin American Research Review* 30.2 (1995): 91–121.

"Estrenaron anoche 'Paisaje de la Patria.'" *El Nacional,* June 19, 1954.

"Estreno de Dinámica de un ideal." *El Nacional,* April 19, 1955.

Ewell, Judith. *The Indictment of a Dictator: The Extradition and Trial of Marcos Pérez Jiménez.* College Station: Texas A&M University Press, 1981.

Ewell, Judith. "Venezuela since 1930." In Vol. 8 of *The Cambridge History of Latin America,* edited by Leslie Bethell, 727–90. Cambridge: Cambridge University Press, 1991.

"Exposición Objetiva Nacional." *El Nacional,* November 19, 1952, 7.

"Exposición Objetiva Nacional," *El Nacional,* November 22, 1952, 7.

"Fabulosa carretera venezolana." Servicios Mundiales Paramount, 1953. Newsreel. Biblioteca Nacional, Caracas.

Foucault, Michel. "Right of Death and Power over Life." In *The Foucault Reader,* edited by Paul Rabinow, 258–72. New York: Pantheon Books, 1984.

Foucault, Michel. *Discipline and Punish: The Birth of the Prison.* Translated by Allen Lane. London: Penguin Books, 1991.

Foucault, Michel. "The Historical a Priori and the Archive." In *The Archaeology of Knowledge,* translated by A. M. Sheridan Smith, 126–31. New York: Vintage, 2010.

Fox-Talbot, William. *The Pencil of Nature.* London: Longman, Brown, Green and Longmans, 1846.

Fraser, Valerie. *Building the New World: Studies in the Modern Architecture of Latin America, 1930–1960.* London: Verso, 2000.

Fraser, Valerie. "Cannibalizing Le Corbusier: The MES Gardens of Roberto Burle Marx." *Journal of the Society of Architectural Historians* 59.2 (2000): 180–93.

"Fue inaugurado en Ciudad Bolívar la séptima tienda Sears." *El Nacional,* December 6, 1954, 11.

Gackstetter-Nichols, Elizabeth. "Virgin Venuses: Beauty and Purity for 'Public' Women in Venezuela." In *Women in Politics and Media: Perspectives from Nations in Transition,* edited by Maria Raicheva-Stover and Elza Ibroscheva, 233–48. London: Bloomsbury, 2014.

Gallo, Rubén. *Mexican Modernity: The Avant-Garde and the Technological Revolution.* Cambridge, MA: MIT Press, 2005.

Gallo, Rubén. "Modernist Ruins: The Case Study of Tlatelolco." In *Telling Ruins in Latin America,* edited by Michael J. Lazzara and Vicky Unruh, 107–20. London: Palgrave Macmillan, 2009.

García Canclini, Néstor. "Modernismo sin modernización." *Revista Mexicana de Sociología* 51.3 (1989): 163–89.

García Canclini, Néstor. *Hybrid Cultures: Strategies for Entering and Leaving Modernity.* Translated by Christopher L. Chiappari and Silvia L. Lopez. Minneapolis: University of Minnesota Press, 1995.

González Casas, Lorenzo. "Nelson A. Rockefeller y la modernidad venezolana: Intercambios, empresas y lugares a mediados del siglo XX." In Martín Frechilla and Arnal, *Petróleo nuestro y ajeno,* 173–215.

González Casas, Lorenzo, and Orlando Marin Castañeda. "El transcurrir tras el cercado: Ámbito residencial y vida cotidiana en los campamentos petroleros de Venezuela (1940–1975)." *Espacio Abierto* 12.3 (2003): 377–90.

González Casas, Lorenzo, and Orlando Marin Castañeda. "Tiempos superpuestos: Arquitectura moderna e 'indigenismo' en obras emblemáticas de Caracas de 1950." *Apuntes Revista de Estudios sobre Patrimonio Cultural* 21.2 (2008): 266–79.

González Stephan, Beatriz. "Fundar el estado/narrar la nación: *Venezuela heroica* de Eduardo Blanco." *Revista Iberoamericana* 63 (1997): 33–46.

González Stephan, Beatriz. "Coleccionar y exhibir: La construcción de patrimonios culturales." *Hispamérica* 86 (2000): 3–17.

González Stephan, Beatriz. "Tecnologías para las masas: Democratización de la cultura y la metáfora militar (Venezuela siglo XIX)." *Revista Iberoamericana* 30 (2008): 89–101.

Gorelik, Adrian. *Das vanguardas a Brasília: Cultura urbana e arquitetura na América Latina.* Translated by Maria Antonieta Pereira. Belo Horizonte: Universidade Federal de Minas Gerais, 2005.

"Grandes obras entrarán en servicio desde esta fecha en toda la República." *La Esfera*, December 1, 1953, 16.

Hamilton Wright Organization. "Caracas Ready for Tenth Inter-American Conference: Twenty-Five Buildings Completed in University City." Press release, February 1954. Esso Álvarez private collection.

Hamilton Wright Organization. "Venezuela Big Buyer of US Automobiles." Press release, January 1956. Esso Álvarez private collection.

Hamilton Wright Organization. "Venezuela Dedicates Her 'Avenue of the Heroes.'" Press release, July 5, 1957. Esso Álvarez private collection.

Harvey, David. *The Condition of Post-Modernity: An Enquiry into the Origins of Social Change.* Oxford: Basil Blackwell, 1989.

Hassan, Mostafa. *Economic Growth and Employment Problems in Venezuela.* New York: Praeger, 1975.

Heidegger, Martin. "The Age of the World Picture." In *The Question Concerning Technology & Other Essays*, translated by William Lovitt, 115–54. New York: Garland, 1977.

Heidegger, Martin. "The Question Concerning Technology." In *The Question Concerning Technology & Other Essays*, translated by William Lovitt, 3–35. New York: Garland, 1977.

"The Helicoid." Pamphlet given to visitors of the construction site. Courtesy Proyecto Helicoide. 1958–1961.

Hernández, Tulio. "La mirada del otro." *Extracámara* 10 (1997): 32–36.

Hernández de Lasala, Silvia. "La Nacionalidad: Un escenario urbano para conmemorar 'La Semana de la Patria.'" *Revista Colegio de Arquitectos de Venezuela* 50–51 (1988): 67–75.

Holston, James. *The Modernist City: An Anthropological Critique of Brasília.* Chicago: University of Chicago Press, 1989.

"Hoy inauguración apoteósica de la Exposición Objectiva Nacional." *El Nacional*, November 23, 1952, 7.

"Inauguración de Obras Públicas." Paramount News, 1953. Newsreel. Biblioteca Nacional, Caracas.

"Inauguración de una carretera de $60,000,000 en Venezuela." Noticiario Movietone, 1953. Newsreel. Biblioteca Nacional, Caracas.

"Invitación." *El Nacional*, November 23, 1952, 41.

Jaguaribe, Beatriz. "Modernist Ruins: National Narratives and Architectural Forms." *Public Culture* 11.1 (1999): 294–312.

Jay, Martin. "Scopic Regimes of Modernity." In *Vision and Visuality*, edited by Hal Foster, 3–23. Seattle: Bay Press, 1998.

Jiménez, Ariel, ed. *Alfredo Boulton and His Contemporaries*. New York: MOMA, 2008.

Kaneva, Nadia. "Nation Branding: Toward an Agenda for Critical Research." *International Journal of Communication* 5.25 (2011). Accessed February 4, 2016. http://ijoc.org/index.php/ijoc/article/view/704 2016.

Karl, Terry Lynn. "Petroleum and Political Pacts: The Transition to Democracy in Venezuela." *Latin American Research Review* 22.1 (1987): 63–94.

Keen, Benjamin, and Keith Haynes. *A History of Latin America*. 9th ed. Boston: Wadsworth, 2013.

Kolb, Glen L. *Democracy and Dictatorship in Venezuela, 1945–1958*. Hamden: Connecticut College Press, 1974.

Larrañaga, Enrique. "Toward the Visibility of the Invisible." In Lejeune, *Cruelty and Utopia*, 240–53.

Le Corbusier. *Airplane*. London: The Studio, 1935.

Le Corbusier. *Towards a New Architecture: Essential Le Corbusier L'Esprit Nouveau Articles*. Translated by Frederick Etchells. Oxford: Architectural Press, 1998.

Lefebvre, Henri. *The Production of Space*. Translated by Donald Nicholson-Smith. London: Blackwell, 2005.

Le Goff, Jacques. *El orden de la memoria: El tiempo como imaginario*. Translated by Hugo F. Bauzá. Barcelona: Paidós, 1991.

Lejeune, Jean-François, ed. *Cruelty and Utopia: Cities and Landscapes of Latin America*. Princeton, NJ: Princeton University Press, 2005.

León Miranda, Gustavo. "La Semana de la Patria." *El desafío de la historia* 16 (2010).

Levi Strauss, Claude. *Tristes Tropiques*. Translated by John Weightman and Doreen Weightman. London: Penguin, 1973.

López Maya, Margarita. *E.E.U.U. en Venezuela, 1945–1948*. Caracas: Universidad Central de Venezuela, 1996.

Lugo, Francisco Aniceto. *Pérez Jiménez: Fuerza Creadora*. 1st ed. Caracas: Imprenta Oficial, 1953.

Marin Castañeda, Orlando. "Construir la nación, construir sus imágenes: Los pabellones de Venezuela en las exposiciones internacionales." In *La tradición de lo moderno: Venezuela en diez enfoques*, edited by Tomás Straka, 265–316. Caracas: Fundación para la Cultura Urbana, 2006.

Marling, Karal Ann. "Nixon in Moscow: The Kitchen Debate." *As Seen on TV: The Visual Culture of Everyday Life in the 1950s*, 243–50, 271–76. Cambridge, MA: Harvard University Press.

Marquès Sureda, Salomó, and Juan José Martín Frechilla. *La labor educativa de los exiliados españoles en Venezuela*. Caracas: Universidad Central de Venezuela, 2002.

Márquez Cañizales, Augusto. "La ciudad cambia." *El Nacional*, November 1, 1953.

Martin, Gerald. *The Cambridge Introduction to Gabriel García Márquez*. Cambridge: Cambridge University Press, 2012.

Martín Frechilla, Juan José. *Planes, planos y proyectos para Venezuela, 1908–1958 (Apuntes para una historia de la construcción del país)*. Caracas: Universidad Central de Venezuela, Consejo de Desarrollo Científico y Humanístico, Fondo Editorial Acta Científica Venezolana, 1994.

Martín Frechilla, Juan José. "Construcción urbana, profesiones e inmigración en el origen de los estudios de urbanismo en Venezuela, 1870–1957." *Estudios Demográficos y Urbanos* 11.3 (1996): 477–519.

Martín Frechilla, Juan José. "*La gran ilusión*: El petróleo en las revistas institucionales venezolanas entre 1907 y 1957." In Martín Frechilla and Arnal, *Petróleo nuestro y ajeno*, 279–360.

Martín Frechilla, Juan José, and and Yolanda Texera Arnal, eds. *Petróleo nuestro y ajeno: La ilusión de modernidad.* Caracas: Consejo de Desarrollo Científico y Humanístico, Universidad Central de Venezuela, 2005.

"Más de 120,000 personas participan en desfile." *El Universal,* July 2, 1953.

Mayhall, Marguerite. "Modernist but Not Exceptional: The Debate over Modern Art and National Identity in 1950s Venezuela." *Latin American Perspectives* 32.2 (2005): 124–46.

Mbembe, Achilles. "The Power of the Archive and Its Limits." In *Refiguring the Archive*, edited by Carolyn Hamilton, Verne Harris, Jane Taylor, Michele Pickover, Graeme Reid, and Razia Saleh, 19–26. Dordecht, Boston, London: Kluwer Academic Publishers, 2002.

"Memorandum of Discussion at the 189th Meeting of the National Security Council on Thursday, March 18, 1954." In *Foreign Relations of the United States, 1952–1954*, Vol. 4, *The American Republics*, edited by N. Stephen Kane and William F. Sanford Jr., 304–6. Washington, DC: Department of State, 1983.

Mendoza, Plinio Apuleyo, ed. *Así es Caracas.* Caracas: Ministerio de Fomento, 1951.

Mendoza, Plinio Apuleyo, ed. *Así progresa un pueblo: Diez años en la vida de Venezuela.* Caracas: Mendoza y Mendoza, 1956.

Meza Suniaga, Beatriz. "Proyectos del Taller de Arquitectura del Banco Obrero (TABO) para el Plan Nacional de Vivienda en Venezuela (1951–1955)." *Tecnología y construcción* 21.2 (2005): 8–22.

Miller, Edward G. "Memorandum by the Assistant Secretary of State for Inter-American Affairs (Miller) to the Secretary of State, December 5, 1952." In *Foreign Relations of the United States, 1952–1954*, Vol. 4, *The American Republics*, edited by N. Stephen Kane and William F. Sanford Jr., 1635–36. Washington, DC: Department of State, 1983.

Ministerio de Fomento. *Memoria y Cuenta correspondiente al año 1954, del período administrativo 1ro de julio de 1953 al 30 de junio de 1954.* Caracas: Ministerio de Fomento, 1955.

Ministerio de Obras Públicas. *Memoria y Cuenta.* Caracas: Ministerio de Obras Públicas, 1954.

Ministerio de Relaciones Interiores. *Memoria y Cuenta: 1948–1952.* Caracas: Ministerio de Relaciones Interiores, 1952.

Miracle in Venezuela. Documentary directed by Manuel Vicente Tinoco. 1956. Caracas: Cromocine.

Mirzoeff, Nicholas. "On Visuality." *Journal of Visual Culture* 5.1 (2006): 53–79.

Mitchell, Timothy. *Colonising Egypt.* Berkeley: University of California Press, 1991.

Mitchell, W. J. T. "Imperial Landscape." In *Landscape and Power*, edited by W. J. T. Mitchell, 5–34. 2nd ed. Chicago: University of Chicago Press, 2002.

Moholy-Nagy, Sibyl. *Carlos Raúl Villanueva and the Architecture of Venezuela.* New York: Praeger, 1964.

Museo Reina Sofía. "Concrete Invention." Museo Reina Sofía. Accessed October 9, 2014. http://www.museoreinasofia.es/en/exhibitions/concrete-invention-patricia-phelps-cisneros-collection.

Niño Araque, William. *1950: El espíritu moderno.* Caracas: Fundación Corp Group, 1998.

Niño Araque, William. *Carlos Raúl Villanueva, un moderno en Sudamérica.* Caracas: Galería de Arte Nacional, 1999.

"Nivelan las becas para estudios especiales en el exterior." *El Nacional,* October 5, 1952, 34.

"La Nueva Capital Venezolana." *La Esfera,* December 11, 1953, 1.

Nuevo Ideal Nacional. Dos de diciembre. Revista de Ilustración General 1 (December 2, 1955).

Nuevo Ideal Nacional. Dos de diciembre. Revista de Ilustración General 4 (April–May 1956).

Nuevo Ideal Nacional. Dos de diciembre. Revista de Ilustración General 6 (December 26, 1956).

Nye, Joseph S. "Soft Power." *Foreign Policy* 80 (1990): 153–71.

Ocanto, David. "Imágenes con vida pública: Las celebraciones de la Semana de la Patria, Caracas 1953–1957." *Prácticas de Oficio: Investigación y reflexión en Ciencias Sociales* 10 (2012). Accessed March 3, 2016. http://ides.org.ar/wp-content/uploads /2012/12/Dossier-Las-imágenes-Ocanto.pdf.

Ochoa, Marcia. "Spectacular Femininities." In *Queen for a Day: Transformistas, Beauty Queens, and the Performance of Femininity in Venezuela,* 201–32. Durham: Duke University Press, 2014.

Olalquiaga, Celeste, and Lisa Blackmore, eds. *From Mall to Prison: El Helicoide's Downward Spiral.* New York: Urban Research, 2017.

"Orden para los desfiles de carrozas durante los días 27 y 28 de febrero y 1 y 2 de marzo." *El Nacional,* February 26, 1954, 32.

Otero Silva, Miguel. *La muerte de Honorio.* Barcelona: Seix Barral, 1975.

Otero Silva, Miguel, and Alejandro Otero. "Polemic." In Jiménez, *Alfredo Boulton and His Contemporaries,* 180–96.

Oteyza, Carlos, dir. *Tiempos de dictadura: Tiempos de Marcos Pérez Jiménez.* DVD. Caracas: Bolívar Films, 2013.

Paulsson, Gregor, Henry-Russell Hitchcock, William Holford, Sigfried Giedion, Walter Gropius, Lúcio Costa, and Alfred Roth. "In Search of a New Monumentality." *Architectural Review* 104 (1948): 117–28.

"Película." *El Nacional,* May 21, 1955.

Pérez Jiménez, Marcos. "Discurso de Clausura de la Semana de la Patria." In Servicio Informativo Venezolano, *Venezuela bajo el Nuevo Ideal Nacional,* n.p. Caracas: Imprenta Nacional, 1954.

Pérez Jiménez, Marcos. "La Obra de Gobierno." In *Así progresa un pueblo: Diez años en la vida de Venezuela,* edited by Plinio Apuleyo Mendoza, 24–34. Caracas: Mendoza y Mendoza, 1955.

Pérez Jiménez, Marcos. *Frente a la infamia.* Caracas: Ediciones Garrido, 1968.

Pérez Jiménez, Marcos. *Mensaje al pueblo de Venezuela.* N.p., 1968.

Pérez-Oramas, Luis. "Inventing Modernity in the Land of Adam: Alfredo Boulton, Armando Reverón and Bárbaro Rivas." In Jiménez, *Alfredo Boulton and His Contemporaries,* 324–30.

Pérez Schael, María Sol. *Petróleo, cultura y poder en Venezuela.* Caracas: Monte Ávila, 1993.

"Philco." *El Nacional,* November 23, 1952, 20.

Picón Salas, Mariano. *Suma de Venezuela*. Caracas: Controlaría General de la República, 1984.

Picón Salas, Mariano. "Regreso de tres mundos." In *Autobiografías*, edited by Guillermo Sucre and Cristían E. Álvarez, 168–69. Caracas: Monte Ávila, 1987.

Plaza, Helena. *El 23 de enero de 1958 y el proceso de la consolidación de la democracia representativa en Venezuela*. Caracas: Garbizu & Todtmann, 1978.

Ponti, Gio. "Villa Planchart, Caracas, 1953–1957." *Domus*, February 2, 2011. Originally published in *Domus* 375, February 1965. Accessed March 3, 2016. http://www.domusweb.it/en/from-the-archive/2011/02/02/villa-planchart-caracas-1953-57.html/.

"Primer nacimiento en el Cerro Piloto." *Revista del Banco Obrero* 1.6 (1954): 39.

"4 años: 12,425 inmigrantes colocados por el Instituto Agrario Nacional." *El Nacional*, November 25, 1952, 20.

Ramírez, Johan M. "Tomás Sanabria." *El Universal*, section Estampas, September 30, 2007. Accessed December 9, 2009. http://www.eluniversal.com/estampas/anteriores/300907/caracasde.shtml.

Rancière, Jacques. "The Distribution of the Sensible: Politics and Aesthetics." In *The Politics of Aesthetics*, translated by Gabriel Rockhill, 7–14. London: Bloomsbury, 2013.

Riegl, Alois. "The Modern Cult of Monuments: Its Essence and Its Development." In *Historical and Philosophical Issues in the Conservation of Cultural Heritage*, edited by Nicholas Stanley Price, Mansfield Kirby Price, and Alessandra Melucco Vaccaro, 69–83. Los Angeles: Getty Conservation Institute, 1997. First published as *Der moderne Denkmalkultus, seine Wesen und seine Entstehung* by W. Braumüller Verlag, 1903.

Rivas Rivas, Jorge, ed. *Historia gráfica de Venezuela: El Gobierno de Pérez Jiménez (Primera parte)*. Vol. V. Caracas: Centro Editor, 1972.

Rodríguez, Albor. *Misses de Venezuela: Reinas que cautivaron un país*. Caracas: Libros de El Nacional, 2005.

Rosas, José, and Iván González. "El Helicoide de Caracas." *ARQ* 52 (2002): 14–17. Accessed March 3, 2016. doi: 10.4067/S0717-69962002005200008/.

Russell-Hitchcock, Henry. *Latin American Architecture since 1945*. New York: MOMA, 1955.

Scott, James C. *Seeing like a State: How Certain Schemes to Improve the Human Condition Have Failed*. London: Yale University Press, 1998.

"Semana fabulosa en Venezuela, la nación inaugura sus grandes obras públicas." *Life*, January 18, 1954.

Sert, José Luis, Fernand Léger, and Siegried Giedion. "Nine Points on Monumentality." In *Architecture Culture*, edited by Joan Ockman, 29–30. New York: Rizzoli, 1993. First published in *Harvard Architectural Review*, 1943.

Servicio Informativo Venezolano, comp. *Venezuela bajo el Nuevo Ideal Nacional*. Caracas: Imprenta Nacional, 1954.

Servicio Informativo Venezolano, comp. *Venezuela bajo el Nuevo Ideal Nacional*. Caracas: Imprenta Nacional, 1955.

Servicio Informativo Venezolano, comp. *Venezuela bajo el Nuevo Ideal Nacional*. Caracas: Imprenta Nacional, 1956.

"VI Congreso Panamericano de Carreteras." *Revista del Banco Obrero* 1.3 (1954): 20.

"Shapes of the Future." *Time*, April 22, 1957, 36.

Silva, Paulette. *Una vasta morada de enmascarados*. Caracas: Fundación Casa Andrés Bello, 1993.

Simonsen, Kirsten. "Bodies, Sensations, Space and Time: The Contribution from Henri Lefebvre." *Geografiska Annaler* 87.1 (2005): 1–14. Accessed March 3, 2016. http://www.jstor.org/stable/3554441.

"Skipper of the Dreamboat." *Time*, February 28, 1955.

Socorro, Milagros. *Catia, tres voces*. Caracas: Fundarte, 1994.

Sontag, Susan. *On Photography*. 2nd ed. London: Penguin Books, 1979.

Sosa, Joaquín Marta, Gregory Vertullo, and Federico Prieto. *El Hotel Humboldt: Un milagro en el Ávila*. Caracas: Fundavag Ediciones, 2014.

Soto, Tibisay. "La televisión en Venezuela, 1952–1986." In *40 años de comunicación social en Venezuela, 1946–1986*, edited by Eleazar Díaz Rangel, 229–58. Caracas: Universidad Central de Venezuela, 1988.

Spigel, Lynn. "Installing the Television Set." In *The Everyday Life Reader*, edited by Ben Highmore, 325–38. London: Routledge, 2002.

Straka, Tomás. *La tradición de lo moderno: Venezuela en diez enfoques*. Caracas: Fundación para la Cultura Urbana, 2006.

Straka, Tomás. "Críticas de la modernidad criolla: Caracas como espacio para la democracia." In *Ciudad, espacio público y cultura urbana*, edited by Tulio Hernández, 379–92. Caracas: Fundación para la Cultura Urbana, 2010.

Tarnoi, Ladislao T. *El Nuevo Ideal Nacional de Venezuela: Vida y obra de Marcos Pérez Jiménez*. Madrid: Ediciones Verdad, 1954.

Tinker Salas, Miguel. "Staying the Course: United States Oil Companies in Venezuela, 1945–1958." *Latin American Perspectives* 32.2 (2005): 147–70.

Tinker Salas, Miguel. *The Enduring Legacy: Oil, Culture, and Society in Venezuela*. Durham: Duke University Press, 2009.

Tinoco, Manuel Vicente, dir. *Caracas hoy y mañana*. Caracas: Cromocine. Postproduction, Los Angeles: Allend'or Production Hollywood, 1953. Biblioteca Nacional, Caracas.

Tinoco, Manuel Vicente, dir. *Baluarte de la Patria*. Caracas: Cromocine, 1954. Biblioteca Nacional, Caracas.

Tinoco, Manuel Vicente, dir. *La Nueva Venezuela*. Produced for Servicio Informativo Venezolano. Caracas: Cromocine, 1954. Biblioteca Nacional, Caracas.

Tinoco, Manuel Vicente, dir. *Paisaje de la patria*. Caracas: Dirección Nacional de Información, 1954. Biblioteca Nacional, Caracas.

Tinoco, Manuel Vicente, dir. *La Semana de la Patria*. Caracas: Cromocine, 1954. Biblioteca Nacional, Caracas.

Tinoco, Manuel Vicente, dir. *Dinámica de un ideal*. Caracas: Servicio Informativo Venezolano, 1955. Biblioteca Nacional, Caracas.

Tinoco, Manuel Vicente, dir. *Miracle in Venezuela*. N.p.: Republic Presentation, 1956. Biblioteca Nacional, Caracas.

Tinoco, Manuel Vicente, dir. *Paraíso del Trabajador: Colonia Vacacional Los Caracas*. Caracas: Cromocine, 1957. Biblioteca Nacional, Caracas.

Tinoco, Manuel Vicente, dir. *Turén*. Caracas: Cromocine, n.d. Biblioteca Nacional, Caracas.

Torres, Ana Teresa. *La herencia de la tribu (Del mito de la Independencia a la Revolución Bolivariana)*. Caracas: Alfa, 2009.

Traba, Marta. *Mirar en Caracas*. Caracas: Monte Ávila, 1974.

Untitled Newsreel. United Universal Newsreel/Universal Pictures, December 1953. National Library, Caracas.

Uslar Pietri, Arturo. *De una a otra Venezuela*. 2nd ed. Caracas: Monte Ávila, 1985.

Vallenilla Lanz, Laureano. *Cesarismo democrático y otros textos*. Caracas: Biblioteca Ayacucho, 1991.

Vegas, Federico. *Sumario*. Caracas: Alfaguara, 2010.

Velasco, Alejandro. "'We Are Still Rebels': The Challenge of Popular History in Bolivarian Venezuela." In *Venezuela's Bolivarian Democracy: Participation, Politics, and Culture under Chávez*, edited by David Smilde and Daniel Hellinger, 156–84. Durham: Duke University Press, 2011.

Velasco, Alejandro. *Barrio Rising: Urban Popular Politics and the Making of Modern Venezuela*. Oakland: University of California Press, 2015.

"Venezuela: Five More Years." *Time*, December 30, 1957.

"Venezuela inaugura 'autopista.'" Noticiario Metro, 1953. Newsreel. National Library, Caracas.

Vicente, Henry. "La arquitectura urbana de las corporaciones petroleras: Conformación de 'Distritos Petroleros' en Caracas durante las décadas de las 1940 y 1950." *Espacio Abierto* 12.3 (2003): 391–413.

Vila Ramírez, Yelitza. "El cine de encargo oficial (1952–1958): Una visión de Venezuela." Bachelor's thesis, Universidad Central de Venezuela, 1998.

Villanueva, Carlos Raúl. "The Problem of Integration." In Jiménez, *Alfredo Boulton and His Contemporaries*, 197–99.

Villota Peña, Jorge. "The Hyper Americans! Modern Architecture in Venezuela during the 1950s." PhD thesis, University of Texas at Austin, 2014.

"Vivir en Playa Grande es vivir en Caracas." *El Nacional*, December 19, 1954, 65.

Williams, Raymond. *Marxism and Literature*. Oxford: Oxford University Press, 1977.

Williams, Raymond. "Ideas of Nature." In *Problems in Materialism and Culture*, 67–85. London: Verso, 1980.

Young, William H., and Nancy Young. *The 1950s: American Popular Culture through History*. Westport, CT: Greenwood Press, 2004.

INDEX

Note: Page references in *italics* indicate figures.

Cuadernos de Información Económica Venezolana (periodical), 46

cult of personality around Pérez Jiménez, 25, 81–82, 127, 136, 140–49, 209, 226n17, 231nn19–21

cultural projects instituted under military rule, 11, 18, 23, 49, 66–67, 129, 217n19. *See also* carnavales (carnivals); Casa Sindical; Ciudad Vacacional Los Caracas; Orquesta Sinfónica de Venezuela; Retablo de las Maravillas (Tableau of Marvels); Teatro de Pueblo troupe

cultural theory and history, 10, 19, 23, 207, 208

Cumaná, 70

Cumanocoa (agricultural unit), 59

Cutlip, Scott M., 77

Dáger, Jorge, 224n44

Debord, Guy, 103, 126, 210

de Certeau, Michel, 30, 64–65, 183

deforestation, 58, 106, 108, 111

Delgado Chalbaud, Carlos, 6, 32, 36, 126, 220nn22–23, 230n1. *See also* Junta Militar

"Del rigor en la ciencia" (Borges), 109

demobilization, 24, 67, 105, 110; and the New National Ideal, 66, 71, 208–9; and the plebiscite of 1957, 8, 36, 49; political demobilization, 7, 102, 124, 125, 155, 205, 207; use of spectacular visuality and patriotic projects, 47, 124; and suppression of syndicalism and trade unions, 7, 67; and the synoptic gaze entrenching Pérez Jiménez's leadership capacity, 136–49. *See also* the national good (*bien nacional*) as justification of military coup

democracy, 35, 127, 184; justification for dictatorship rather than, 19, 33, 104, 126, 144, 149, 212; on military terms, 175–76, 208; and New National Ideal, 6, 208; periods of in Venezuela, 23, 32, 219n44; redefini-

tion of, 209; reneging on promise of return to, 7, 9, 126

Derrida, Jacques, 41

detention centers. *See* incarceration

De una a otra Venezuela (Uslar Pietri), 106

dictablanda ("soft dictatorship") shift to *dictadura* (repressive dictatorship), 36, 128, 178, 209. *See also* Junta Militar; military dictatorship

Dinámica de un ideal (documentary film), 87, 88, 227n24

Dirección de Cartografía Nacional, 109

Dirección de Espectáculos Públicos, 160

Dirección de Turismo (Tourist Office), 139

Dirección Nacional de Información, 45, *45,* 46, 225n7, 227n24, 229n23

Discipline and Punish (Foucault), 104

Disidentes, Los (The Dissidents), 15

Distrito Federal's carnival, 159, *162*

documentaries and newsreels, as propaganda, 79, 82–85, 225n9, 234n36; Chávez's use of, 213, 238n9; coverage of Semana de la Patria, 173; news segments as propaganda, 85–87

"document-monument," use of to justify military rule, 43–47

domestic life in Venezuela, 179–91; stores and shopping malls, 190–206

Domínguez, Cipriano, *12,* 12, 13, 14

Dominican Republic, Pérez Jiménez fleeing to, 9

Drexler, Arthur, 199, 201

Duijm, Susana, 163–64, 233n18

economy and economic growth, 19, 35, 38, 39, 96, 106, 183, 234n7; growth of imports, 35, 97, 106, 182–84; insider trading, 227n28. *See also* agriculture; capitalism and capital development; housing projects; industry and industrialization; oil industry

Editorial Ávila Gráfica, 69, 224n44

"Editorial Centauro," 224n44

disfigured representations of, 105–8; in miniaturized depictions, 64, 128, 131, *131,* 149; and the New National Ideal, 34; as proof of modernity, 14, 21, 34, 132; radical transformation of, 39–40, 71, 103, 155, 208; representation and industrialization, 77–79, *95,* 99; as route to *superación* (overcoming), 51–52, *51,* 55, 59–62, 121–24; as stimulus for patriotic sentiment, 29, 35, 115–18. See also *Paisaje de la patria* (documentary film)

Latin American Architecture since 1945 (exhibition), 55

La Torre de David. *See* Torre de David (Torre Confinanzas)

Le Corbusier, 50, 54, 107, 110, 199, 216n14, 222n6; and Cipriano Domínguez, 13, 14

Lefebvre, Henri, 154, 155, 170, 176–77

Léger, Férnand, 15

Legion of Merit awarded by US to Pérez Jiménez, 18

Le Goff, Jacques, 41, 44

Levi Strauss, Claude, 107

Libro negro de una dictadura: Venezuela bajo el signo del terror, 1948–1952 (Catalá), 69

Life (magazine), 77–78, 80, *180*

Litoral Central, 227n31

Llovera Páez, Luis Felipe, 6, 163, 220n23

Lobo, Baltasar, *16*

López Contreras, Eleazar, 32, 225n53

Lorentty Carriel, Vicente, 231nn19–20

Los Disidentes (The Dissidents), 15

Luce, Barnard J., 78

Luce, Henry, 78

Lugo, Francisco Aniceto, *143,* 145–48, 231n24

Macuto Sheraton, 227n31

Magical State, The (Coronil), 19

Malaussena, Luis, 166

Manaure, Mateo, 15, *16*

mapping of Venezuela, 105–15, 119; *Mapa monumental de Venzuela, 131–32,* 131–32, 135, 139. *See also* Dirección de Cartografía Nacional

Maracaibo, 3, 21, 70, 97–98, 192

Maracay, 86

Maragall, Ernesto, 167–68

Marina Grande, 91

Maripérez Cable Car, 3, 86, 160, *161,* 231n16

Márquez Cañizales, Augusto, 154

Maternidad (Lobo), *16*

Matiz, Leo, 45

Maturín, 3, 70

McCann Erickson (advertising agency), 235n12

Medina Angarita, Isaías, 31, 32, 39–40, 217n22

mejorar la sangre (improving bloodlines), 57–62

Memoria y Cuenta (Ministerio de Obras Públicas), 109

Mendoza, Plinio Apluyeo, 45–46

Mendoza y Mendoza (editor), 46

Las Mercedes, 192, 235n20, 236n26

mestizaje (miscegenation), 59, 71. See also *mejorar la sangre* (improving bloodlines)

Mexico's nationalization of oil industry, 98, 228n39

Mijares, José Manuel, 223n7

military dictatorship: association of military rule with progress and transformation, 103, 109, 124, 128, 130, 136; efforts to create legitimacy through modernity and construction, 18–24, 126–49; ending in 1958, 211, 212; historiographical foundations of military rule, 29–47; ideology and repression of, 48–72; Junta Militar, promise not to institute, 230n1; justification for rather than democracy, 19, 33, 104, 126, 144, 149, 212; legacy of, 9–18; political conditions for, 213; reneging on promise of return to democracy, 7, 9,

museums and spectacle, 170–71
Mythologies (Barthes), 184

El Nacional (newspaper), 59, 93, 132,
153, 185
nación fingida (fake nation), 106
Narváez, Francisco, 13
National Agrarian Institute (Instituto
Agrario Nacional [IAN]), 58–59
National Assembly, Pérez Jiménez as
senator in, 9
the national good (*bien nacional*) as
justification of military coup, 48, 49,
72, 208–9; in propaganda, 220n19,
231n19
Nationality System. *See* Sistema de la
Nacionalidad
nation branding, 75–100
Neuberger, Pedro, 198, 199
"New Latin Boom Land" (*Life*), 77–78,
180
New National Ideal (Nuevo Ideal
Nacional), 8, 24, 33–37, 47, 205,
206, 208–9, 220n19; aerial views
showing nationwide scope of,
108–15, *113–14;* authorship of,
220n16; citizens mandated to
participate in civic-military parades,
174–75; claiming only military could
transform Venezuela, 48–50, 103,
136; claim to transcend politics, 208;
and the coup of 1948, 34, 36, 46, 100;
and demobilization, 66, 71, 208–9;
instituted by the coup of 1948, 33;
intensifying deification of Simón
Bolívar, 173; and Junta Militar, 6,
36, 66, 103, 128; military view of
progress, 35–37, 42, 102, 124, 128;
and the necessary strongman, 34;
need for repression in order to create
improvements, 66, 71; NUEVO IDE-
AL NACIONAL, 142, 231n20; and
oil industry, 98; pledge to modernize
and restore nation to glory, 118;
pledge to transform housing, 56–57;
positive feedback for, 77; promise

of material, moral improvements,
62, 64, 72, 82; propaganda efforts
for, 86, 93, 96, 100; represented by
Exposición Objetiva Nacional, 130; and
Sistema de la Nacionalidad, 166, 169,
170, 171, 172; spatial transformation,
156; *superbloques* as flagship moderniz-
ation plan of, 56; vision of a model
society, 211
newsreels. *See* documentaries and
newsreels, as propaganda
New Venezuela (Nueva Venezuela), 68,
76, 154; critics of rapid moderniza-
tion of, 105–8; documentation of,
41, 46–47, 79, 210–11; regulating
non-compliant constitutents of, 49;
symbols of, 14, 40–41, 47, 210–11
Niemeyer, Oscar, 21, 107
Niño Araque, William, 217n19
"Nómina parcial de torturados"
(Catalá), 70
Noticiario Metro (newsreel), 82
Noticiario Sucesos (newsreel), 226n22
Noticias de Venezuela (Acción Democráti-
ca anti-dictatorship bulletin), 68
Nubes (Calder), *17, 18*
Nueva Caracas, 3, 165
La Nueva Venezuela (documentary film),
87, 227n24
Nuevo Ideal Nacional. *See* New National
Ideal (Nuevo Ideal Nacional)
*Nuevo Ideal Nacional. Dos de Diciembre.
Revista de Ilustración* (magazine), 141,
231nn19–21
*El Nuevo Ideal Nacionale de Venezuela:
Vida y obra de Marcos Pérez Jiménez*
(Tarnoi), 142–45, 220n19

"observer," role of, 228n4. *See also*
"spectator" role of
Ochoa, Maria, 162, 233n15
OCI. *See* Oficina Central de Infor-
mación (OCI)
Odria, Manuel, 226n17
Oficina Central de Información (OCI),
44, 45, 136, 146

of the Exposición Banco Obrero, *53;* interviews of, 18, 48, 57, 218n32, 222n1; legacy of, 9–10, 142, 171–72; and Manuel Vicente Tinoco, 227n24; and modernity, 9–10, 25, 36, 105, 127, 137, 139, 140; as the necessary strongman, 209; and the New National Ideal, 33–37, 48, 220n16, 222n1; overthrow of in 1958, 9, 48, 79, 205, 212, 215nn11–12; on the Paseo Los Próceres, 171–72; photographs from Pérez-Jiménez period in official archives, 44, 221n38; plebiscite of 1957, 8, 36, 49, 215n8, 226n17; photos of, *83,* 142–43, *143,* 145–48, *147;* promoting public works, 17, 18, 44, 48–72, 115, 124, 140, 196; propaganda efforts of, 80–82, *83,* 85, 86, 87, 226n17; Pro-Pérez Jiménez rally before election of 1952, *135,* 135–36; and the Revolución de Octubre of 1945, 32–34, 35; and Semana de la Patria, 173, 176, 177, 178; and Sistema de la Nacionalidad, 166; Supreme Court sentence, 215n12; and the United States, 18, 218n30

Pérez Jiménez: Fuerza creadora (creative force) (Lugo), 145–48

Pérez Schael, María Sol, 22

Péron, Eva, 147

Perón, Juan, 226n17

personality, cult of. *See* cult of personality around, Pérez Jiménez

Phelps, William and Katy, 230n13

Philco (television company), 185

photographs, as propaganda, 77–82, 145–48; aerial views, 108–15, *111, 113–14,* 125, 137, 210, 229n23; HWO's contract to disseminate, 79; of people with backs to camera, 119–24, *120, 122, 123;* as way to show modernity and encourage the viewer as spectator, 118–24. *See also* Archivo Histórico de Miraflores; Barthes, Roland; Hamilton Wright Organization (HWO) (public relations firm);

Oficina Central de Información (OCI); propaganda

Picón Salas, Mariano, 107, 219n45

"pictorial publicity." *See* photographs, as propaganda

Pietri, Alejandro, 137, 230n13

Planchart, Anala and Armando, 229n10

Plan de Urbanismo (urban plan commissioned by Medina Angarita), 39, 40

Plan Monumental de Caracas (Rotival), 12, 39

Plan Nacional de Vialidad, 112

Plan Nacional de Vivienda (exhibition), 128

Plan Nacional de Vivienda (National Housing Plan) for 1951–1955, 50–57

Plaza Cubierta, *15*

Plaza Los Símbolos, *167, 168,* 168. *See also* Paseo de Los Símbolos

Plaza Mayor, remade as Plaza Bolívar, 38

Plaza O'Leary, *11, 13*

plebiscite of 1957, 8, 36, 49, 215n8, 226n17

Ponti, Gio, 107, 229n10

El Portachuelo, 198

Portugal, immigrants from, to Venezuela, 223n22

powdered milk, 187, *188*

Prados del Este, 159–60

Premio Panamericano de Carreteras award, 115, 125

prisons. *See* incarceration

private investments and growth of consumer culture, 179–206

Progresamos porque edificamos (We progress because we build), 18

propaganda, 24, 209, 211; corporate endorsements of dictatorship, 89–96, *90;* exhibitions as a way to celebrate the dictatorship and modernization, 126–49; growth and use of mass media formats, 209–10; nation branding, 75–100; public relations and propaganda, 85–88; state propagan-

Rockefeller, Nelson, 97, 192, 236n25
Rockefeller Center, 79; comparisons of Centro Simón Bolívar to, 80, 85, 98
Rodríguez, Albor, 163
Rojas Pinilla, Gustavo, 226n17
Rotival, Maurice, 12, 39
Royal Dutch Shell, 236n24
Rugeles, Manuel Felipe, 219n3
Ruiz Pineda, Leonardo, 224n44

Sabana Grande, *193,* 193, 194. *See also* Gran Avenida
St. Moritz Hotel (now Ritz-Carlton) in New York City, 76, 225n2
Sanabria, Tomás, 137–38, *138,* 231n14
San Cristóbal, 70
sanitation, 38, 40, 71; and education, 62–65
San Juan de los Morros (jail), 69–70
Santa Mónica, 165, 192
Santa Teresa (company), 235n12
science's impact on modernity, 58, 223n23
Scott, James C., 20
Scout, George, 230n13
Sears department stores, 190–91, *191,* 192
Seguridad Nacional (National Security), 8, 68–69, 75, 224n44, 236n24; and torture, 70. *See also* Estrada, Pedro
Seguros Sociales, 62
La Semana de la Patria (documentary film), 87, 227n24
Semana de la Patria (Week of the Fatherland), 173–78, *174, 175,* 183
sembrar el petróleo (to "sow" oil) (Uslar Pietri column), 106
Senate Foreign Relations Committee. *See* Fulbright Committee
Sentido Emocional de la Patria (Rugeles), 29, 219n3
Servicio Informativo Venezolano, 44, 217n23, 220n19, 227n24
Shell (company), 192, 235n12
shopping malls. *See* stores and shopping malls

El Silencio. *See* Reurbanización El Silencio
Sistema de la Nacionalidad, 25, 165–73, 177, 192; photos of, *166, 167, 168, 169, 170, 174*
Skursi, Julie, 164
social improvement (*superación*), 7, 98, 121, 177, 195, 209; and architecture, 51, 52, 57; ideals of, 7; and national development, 24, 35, 48, 49, 100, 108, 123; and spatial transformation, 66, 71, 100, 102, 104, 132, 187
social order, 64–65, 104, 112, 183; and the archive, 41; and the military, 36, 48–72, 125; and spectacular modernity, 208, 209
Society of the Spectacle, The (Debord), 103
Socony Vacuum Oil Company, 93, *94*
space, 190–206; dissonant experiences of, 153–56, 176; domestic space, 181–85; modern spaces as mirrors of *superación*, 214; *zeitraum* (space time), 182, 185, 187. *See also* architecture; landscape; spatial order and transformation
Spain, immigrants from, to Venezuela, 223n22
spatial order and transformation, 132, 211; in housing projects, 50–57, 154–56; and the military, 39, 48–72, 102, 156; and New National Ideal (Nuevo Ideal Nacional), 48, 100, 102, 125, 156; open spaces creating a culture of display, 104; scripted space of Sistema de la Nacionalidad, 165–73; and *superación*, 48, 89, 98, 128, 137, 156, 158, 164
spectacle, 102–3, 126, 128; commemorations and parades, 158–60, 173–74; El Helicoide synthesizing spectacle and myth, 205; and landscape, 104, 115–17; and limits of Debord's theory of, 103–5, 210; and modernity, 207–14; and the "magical state" (Coronil), 19; and the modern museum, 170–71, 172; modes of,

101–25; *Palacio de Espectáculos* (Palace of Spectacles) at El Helicoide, 198; "spectacular femininities" in beauty queen contests and carnival parades, 162, 233n15. *See also* Debord, Guy; *Society of the Spectacle, The*

spectacular visuality, 105, 116, 119, 124, 125, 128, 206

"spectator" role of, 105, 133, 140, 228n4; at carnival parades, 159–60, 165; photographs as way to show modernity and encourage viewer as spectator, 118–24; at Semana de la Patria, 173–74, 177–78, 234n36; use of term "observer" instead, 228n4; Venzuelans demanding to be actors rather than spectators, 212. *See also* Casa Sindical; demobilization

Spinetti Dini, Humberto, 225n7

sporting activities as a route to modernity, 234n31

Standard Oil, 97, 99, 228n40, 236n25

stores and shopping malls, 190–206, *191, 193,* 235n20; beginning of malls in Venezuela, 192–93; growth of supermarkets (*automercados*), 181, 184, 190, 192, 236n26; store windows, *195, 196. See also* consumer culture; El Helicoide; Gran Avenida; Sabana Grande

Studios Jacky, *198, 200*

sucursal del cielo, 3

superación ("overcoming") as improvement, 7, 48, 61, 104, 166, 172, 177; and consumer culture, 181, 194, 206; downsides to, 211; modern spaces as mirrors of superación, 214; spatial transformation as route to, 48, 89, 98, 128, 137, 156, 158, 164; state plans for, 21–22, 48, 71, 98, 208, 211; ways to illustrate, 52, 62, 63–64, 121

superbloques (superblocks), 3, 22, 23, 66, 120–21, 158; designs for, 223n15; as focus of Taller de Arquitectura del Banco Obrero (TABO) and Plan

Nacional de Vivienda, 52–57; as means of dismantling communities, 53, 1953; naming of, 43; photos of, *4, 5, 43, 54, 120, 122, 123;* residents bringing old rural habits to, 56, 223n18; as solution in the *Batalla contra el rancho* (Battle against makeshift homes), 6–7, 40, 53, 56, 64, 121, 132–33, 155; speed at which they could be built, 55, 155. *See also* Cerro Piloto; El Paraíso; housing projects; Tiro al Blanco; Unidad Residencial 2 de Diciembre (now 23 de Enero); Urbanización 2 de Diciembre (now 23 de Enero)

Super Constellation aircraft, 112

Supreme Court, 215n12

syndicalism, reformulating of, 67. *See also* demobilization

synoptic vision, 20; and the *Exposición Objetiva Nacional,* 128–36; fetishization of, 156; and miniaturized representations, 64, 128–29, 164; Pérez Jiménez's innate leadership capacity, 136–49; and spatial order, 110; and state planning, 125

"Synthesis of the Arts" (Villanueva), 3

Taller de Arquitectura del Banco Obrero (TABO), 40, 50, 52. *See also* Banco Obrero (Workers' Bank)

Tarnoi, Ladislao, 142–45

Teatro de Pueblo troupe, 66

Teatro Municipal, 154

Teleférico, 139. *See also* Maripérez Cable Car

television, impact of, on Venezuela, 179–81, *180,* 185–87, 206; advertisement for, *186; cadena nacional* (chained broadcast) inauguration of new viaduct in 2007, 213; television stations, 235n18, 238n9

Televisora Nacional, 185

Tiela (publication), 68

Tiempos de dictadura (documentary film), 234n36